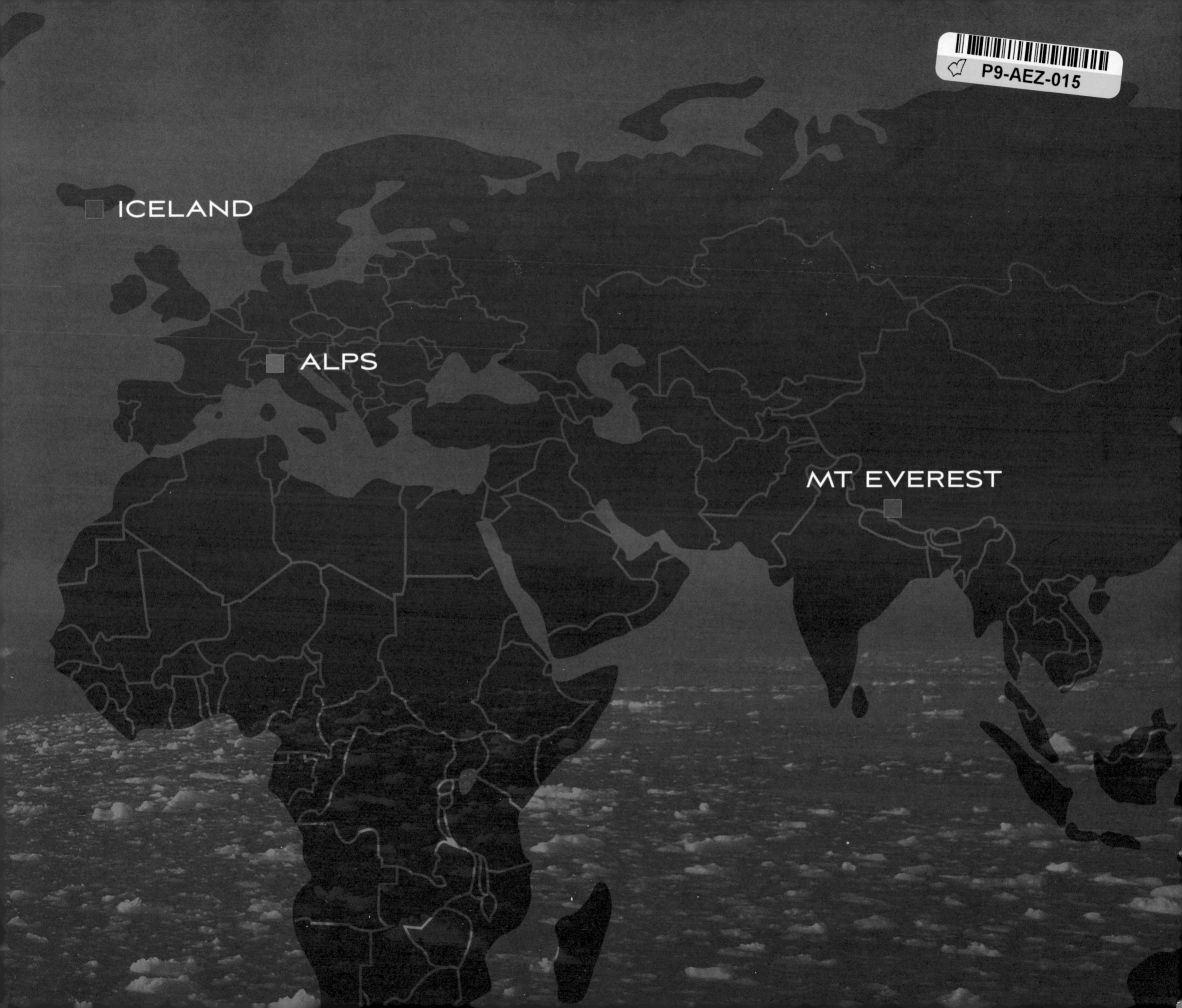

ICELAND

ALPS

MT EVEREST

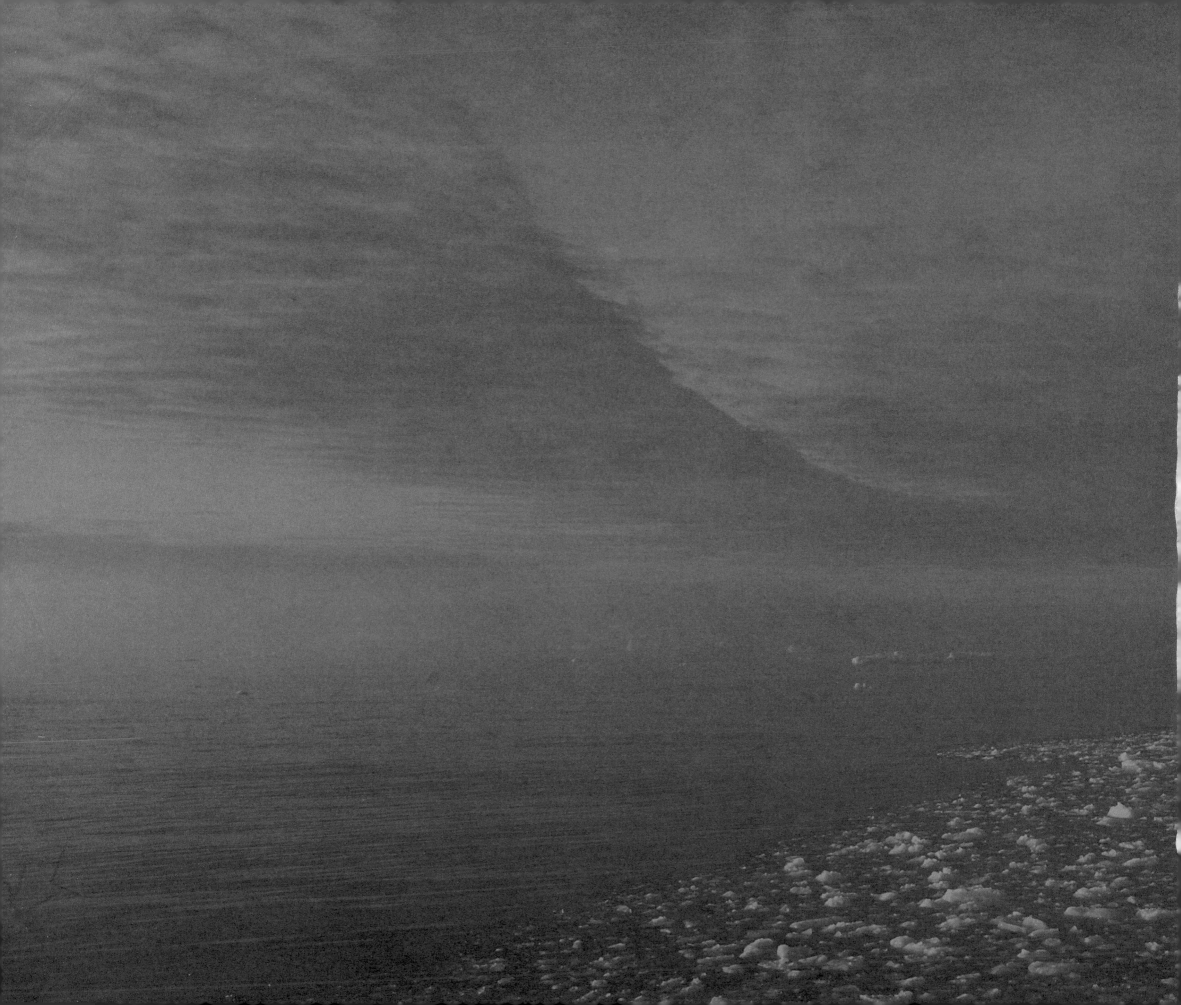

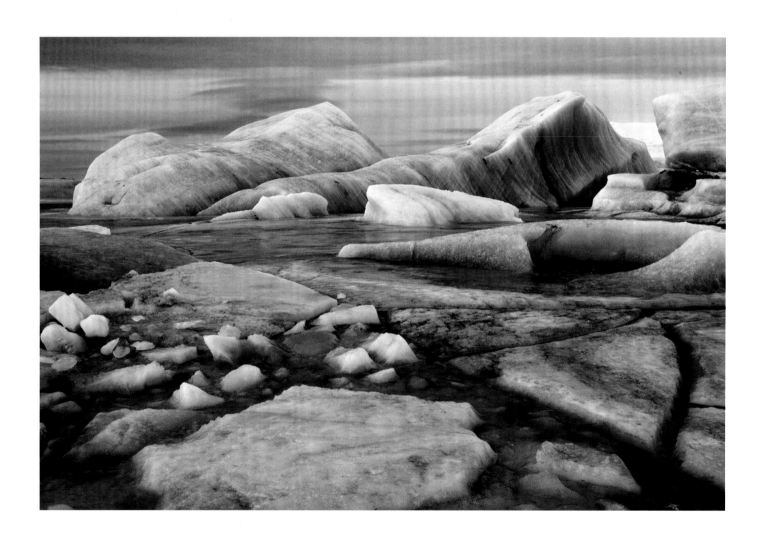

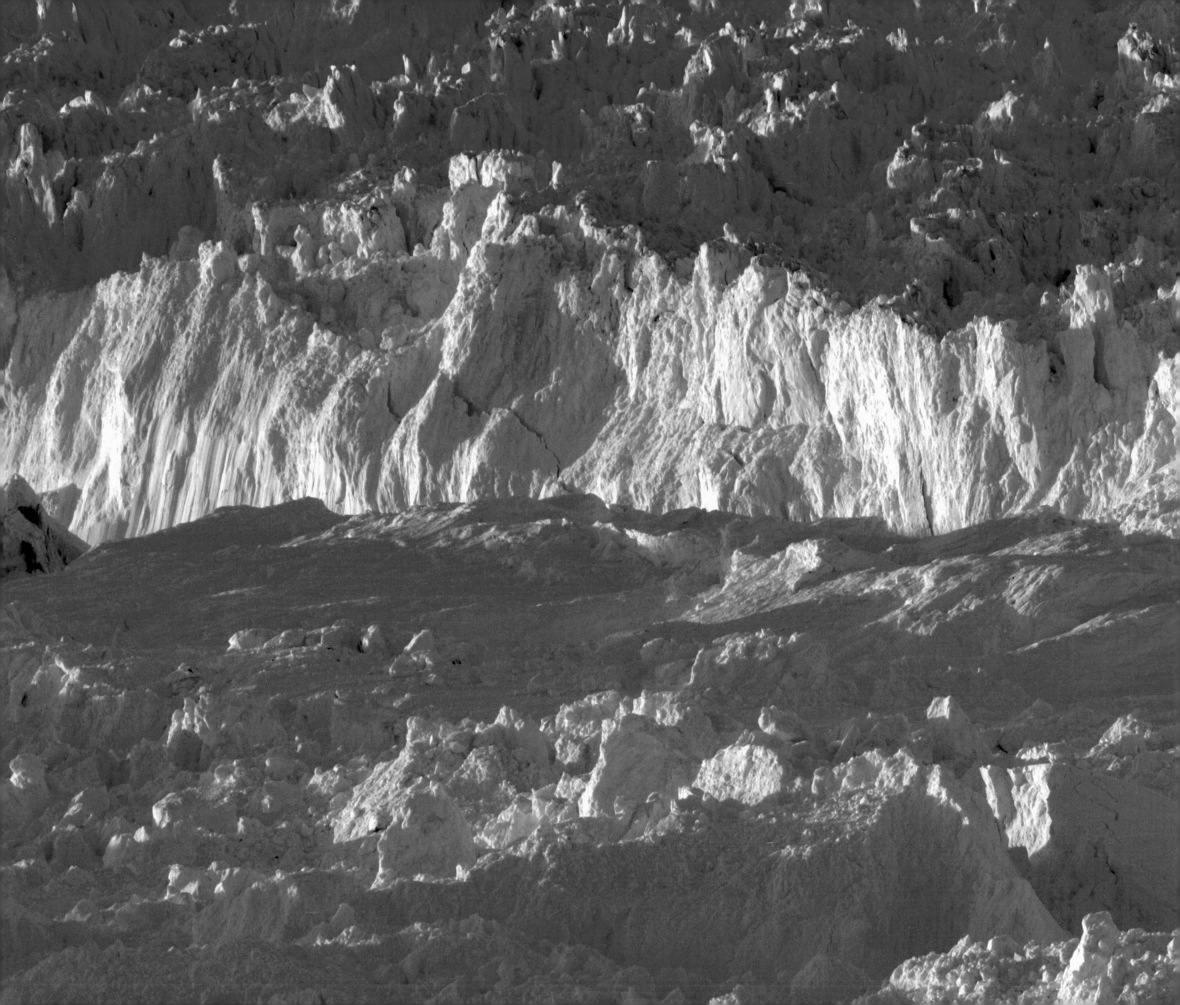

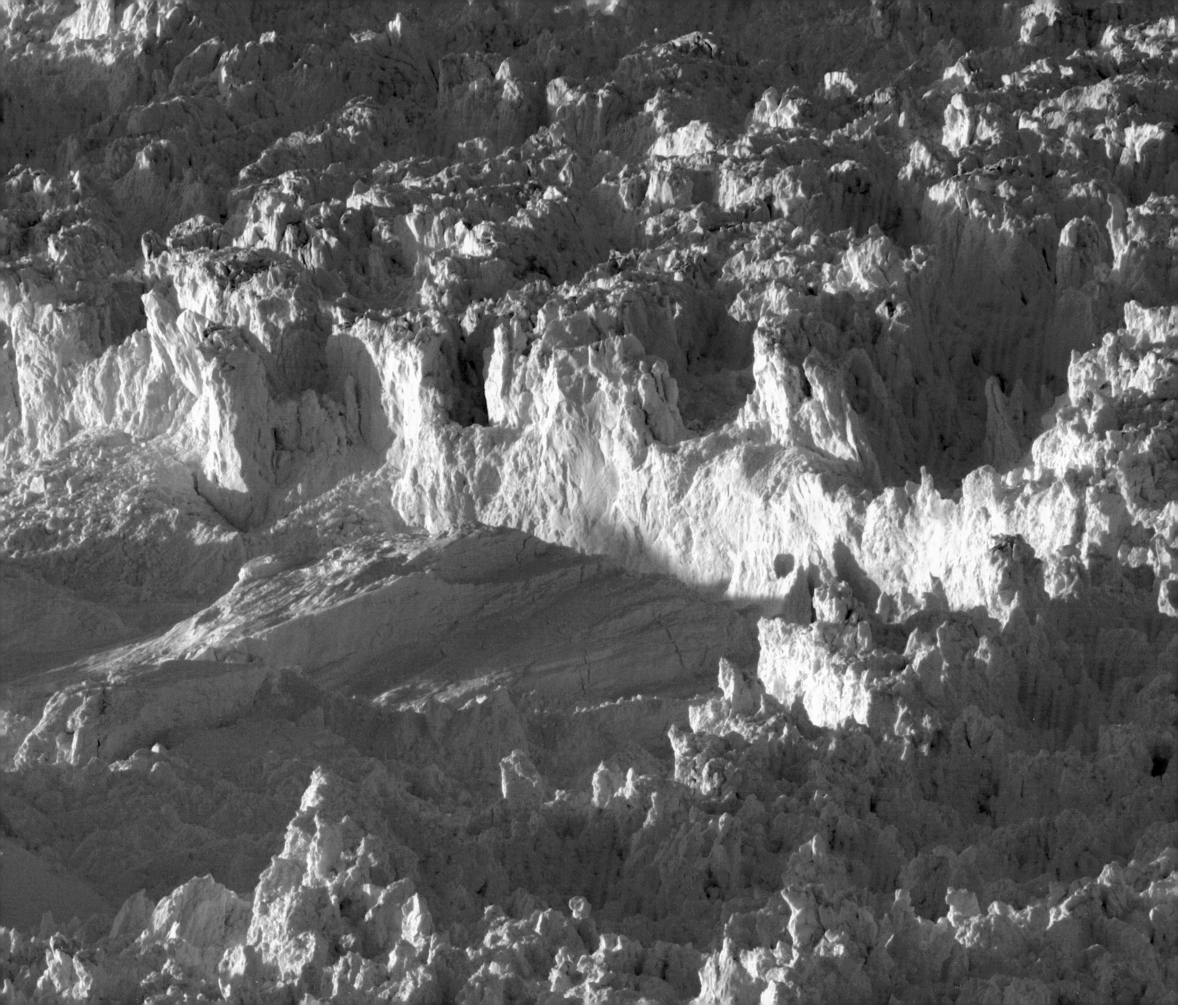

FOR OUR CHILDREN AND THE CHILDREN OF UNCOUNTABLE GENERATIONS YET TO COME.

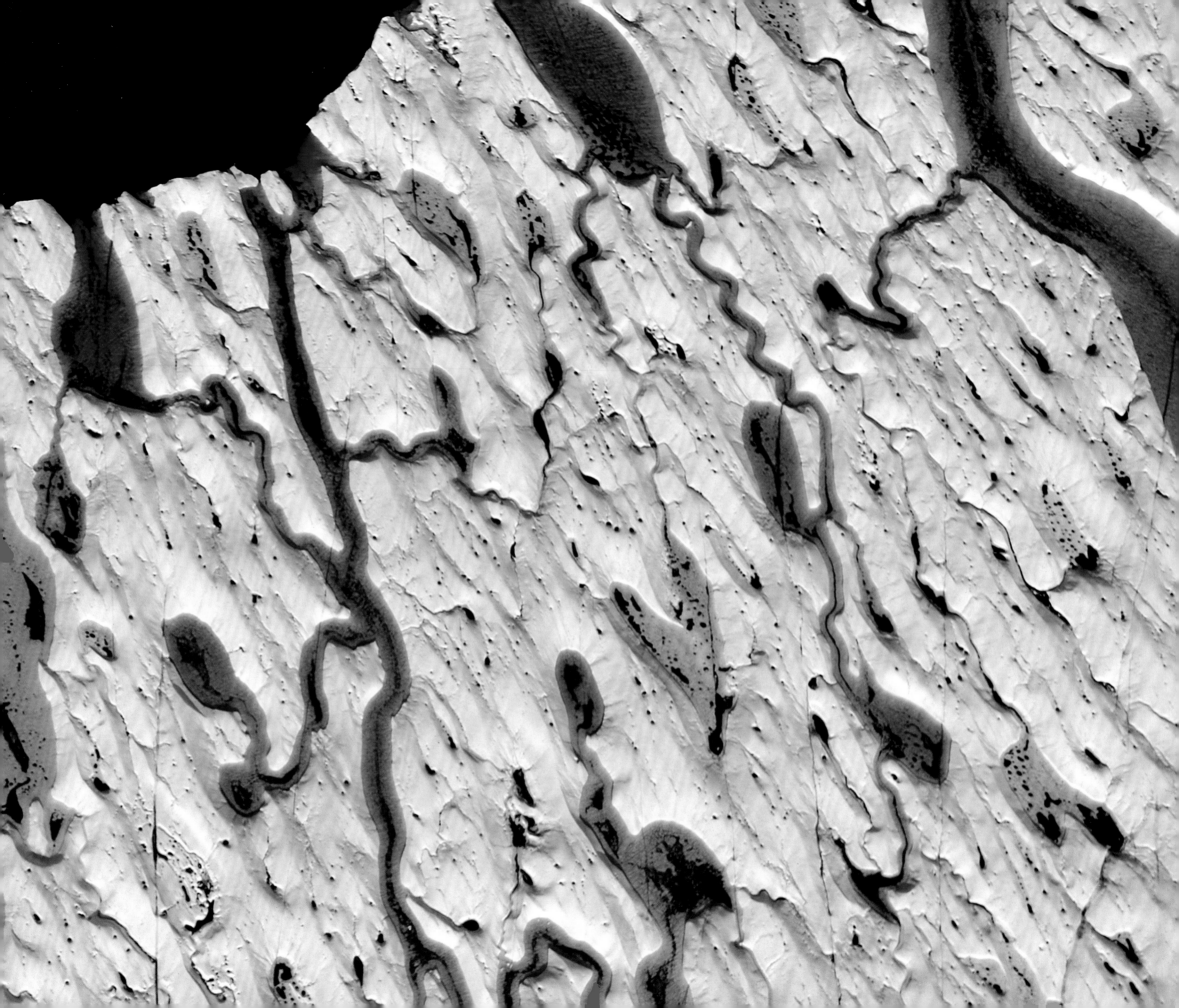

JAMES BALOG

and the

EXTREME ICE SURVEY TEAM:

Conrad Anker • Jason Box • Eran Hood • Svavar Jónatansson
Adam LeWinter • Matthew Kennedy • Shad O'Neel • Jeff Orlowski
W.T. Pfeffer • Sport • Konrad Steffen

EXTREME ICE SURVEY is a project of EARTH**VISION**TRUST

RIZZOLI
NEW YORK
New York · Paris · London · Milan

ICE

PORTRAITS OF VANISHING GLACIERS

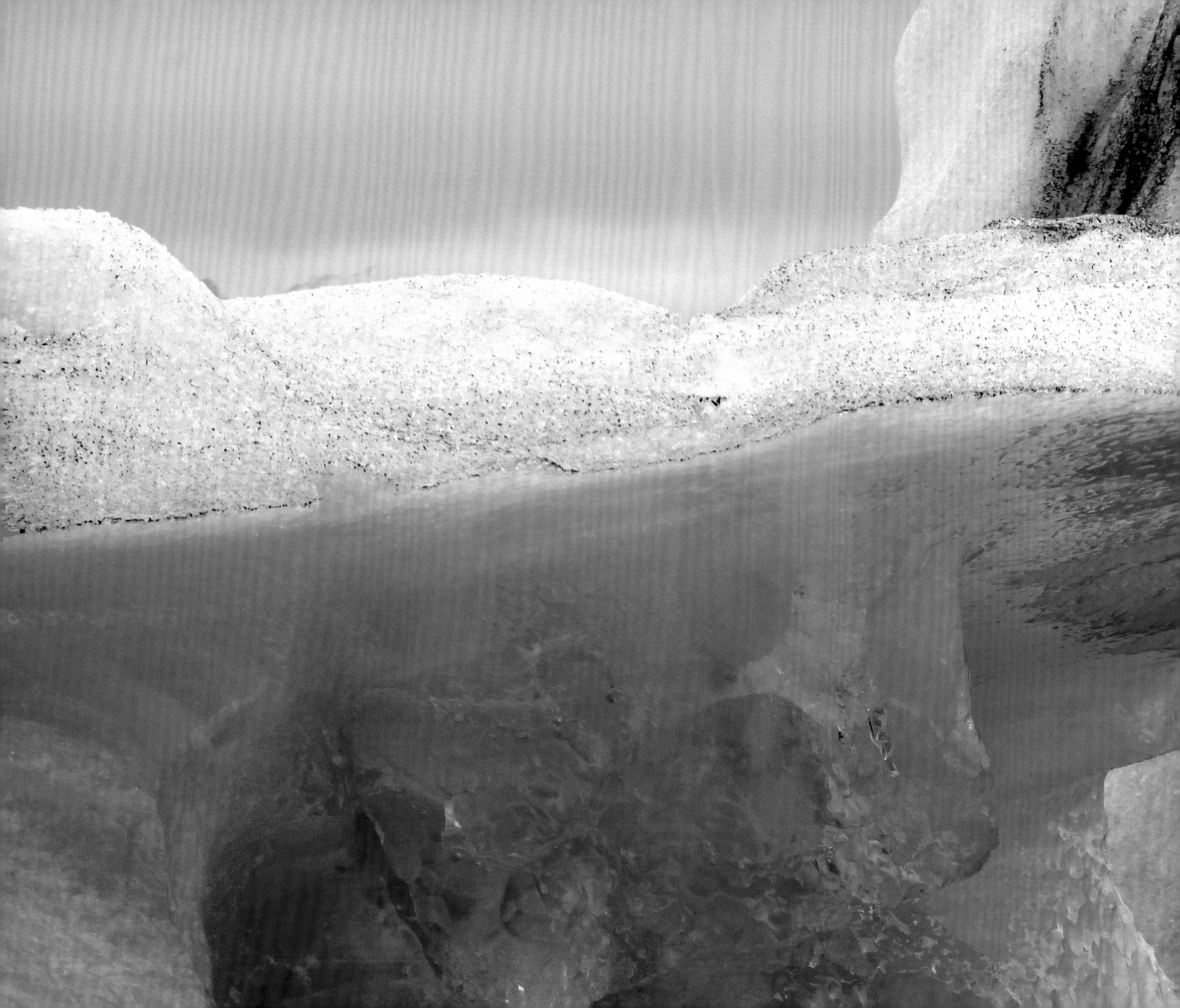

CONTENTS

PAGE 1: Jökulsárlón, Iceland, 4 March 2005
PAGES 2-3: Ilulissat Glacier, Greenland, 7 June 2007, Calving face, thirty to forty stories high above sea level.
PAGE S4-5: Petermann Glacier, Greenland, 5 August 2009, Floating ice tongue and surface drainage channels.
PAGES 6-7: Disko Bay, Greenland, 24 August 2007, Remains of the Ilulissat Glacier float toward the North Atlantic.
PAGES 8-9: Jökulsárlón, Iceland, 16 June 2011

INTRODUCTION

BY JAMES BALOG

IN ICE IS THE MEMORY OF THE WORLD. Of sunlight and darkness, of air and water, of molecules hot and cold, of our spinning planet plunging through galactic space. On secret diamond faces, ice has written runic codes of time past foretelling a world that is still to come.

As *Homo sapiens* motors forward through the waves of time, our culture and civilization are forgetting what makes nature natural before we even notice what it is we're supposed to remember. Earth's primal reality vanishes without a trace. Baselines shift. Natural amnesia and nature deficit disorder breed in the vacuum where memory once thrived.

To this, our book is an antidote. The Extreme Ice Survey's thousands of days, tens of thousands of miles and hundreds of thousands of pictures are too. We came. We saw. We understood. And we do our best to speak for the glistening landscapes of white and sapphire and emerald that would otherwise have neither voice nor witness.

· · ·

DURING THE PAST FOUR DECADES, I have traveled the world as a photographer, mountaineer and student of the natural sciences (particularly geology, geography and geomorphology). I haven't always loved ice and snow. Cold has frozen my nose and fingers and toes. Ice has been terrifying to climb, a place of death narrowly avoided. More friends than I care to count have met their destinies on slopes of crystal water.

Yet ice is more than that. Fickle as air, obdurate as rock, ice mutates into forms that seem more the substance of dreams than the dimensional world. Its colors and textures are so improbable, so elegant, so exquisite they seem to have emerged from some alternate world hiding beneath the surface of quotidian appearances.

That makes me a pagophile, I suppose, a distinction I am pleased to share with other ice lovers like penguins and polar bears. I was entranced by winter as a child: I vividly remember the whisper and softness of two fluttering white snowfalls when I was five and six years old. My enthusiasm grows, too, from decade after decade of mountaineering trips in the world's great ranges, from the Himalaya to the Alps, Alaska to the Andes. It comes from dozens of photographic projects in high altitudes and high latitudes, where the lavender light of deep winter and the honey sun of high summer paint the world in hues no sensible person could possibly resist.

In the wake of assignments from *The New Yorker* and *National Geographic* in 2005 and 2006, work that showed me how dramatically the gelid world was changing, I assembled a loose collective of photographers, scientists, filmmakers and engineers into the "Extreme Ice Survey," or EIS for short (*eis*, by the way, is the German word for "ice"). One aspect of what we have produced is a portfolio of single-frame photographs celebrating the beauty–aka, the art and architecture–of ice. Another part of the EIS mission has been to deploy and maintain a network of time-lapse cameras to document the evolution of glaciers through time. It is the most widespread, ground-based, photographic glacial survey ever conducted; its temporal resolution is unmatched even by satellites. As of this book's publication, 27 cameras will be shooting at 18 glaciers in Greenland, Iceland, Alaska, Canada, the Nepalese Himalaya by Mount Everest, and the Rocky Mountains of the U.S. (previously, as many as 43 cameras have been in the field at once). The cameras shoot year-round, every half hour of daylight. We supplement the time-lapse record by occasionally repeating shots at fixed locations in Iceland, Bolivia, the Canadian province of British Columbia and the French and Swiss Alps.

A dry term like "time-lapse photography" doesn't quite do justice to the cameras. I have come to think of them as my little robot friends, integral members of our team, keeping watch for us through thick and thin. They work in temperatures of -35 degrees Fahrenheit, winds to 160 miles per hour, dozens of feet of snow, torrential rain, rockfall. We refer to them by their site names, like Kadin or Swiftcurrent or IL-5 or Rink-1. Each camera generates roughly 8,000 frames per year. In toto, the EIS time-lapse archive now holds more than 800,000 frames.

We humans assume that we see the world in three dimensions. In fact, we also see in a fourth: time. Time is with us in every moment of every thing observed. It is with us every time a camera clicks. In snapshot photography, or the street photography made famous by Henri Cartier-Bresson, that's obvious. But a different relationship with time is at work in EIS glacier photography. Time is an active character, visually explicit at times, implicit at others, constantly re-sculpting every molecule of frozen water. Everything you see on these pages will have changed substantially, if not vanished entirely, by the time you hold this book.

All the while, the eyes of our photo-robots blink open every 1,800 seconds, recording landscapes that will never be seen again in the foreseeable history of civilization. If a tree falls in the forest and no one is there to hear the sound, did it ever really fall? Or exist? If a glacier crumbles in the Arctic or liquefies in America but there is no witness, did IT ever really exist? The cameras make sure that at least a pictorial memory remains.

▶ Disko Bay | **Greenland** | 17 July 2006

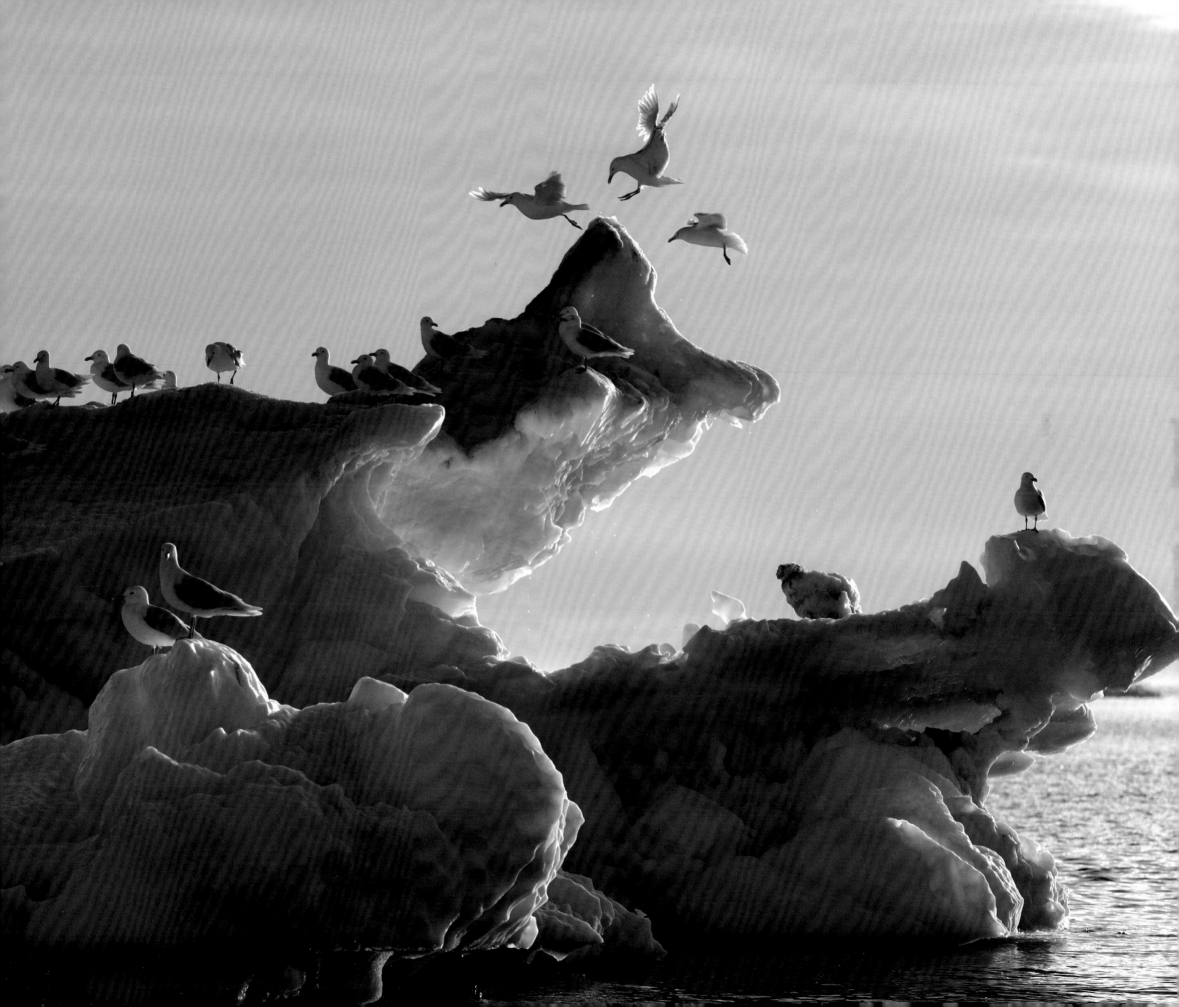

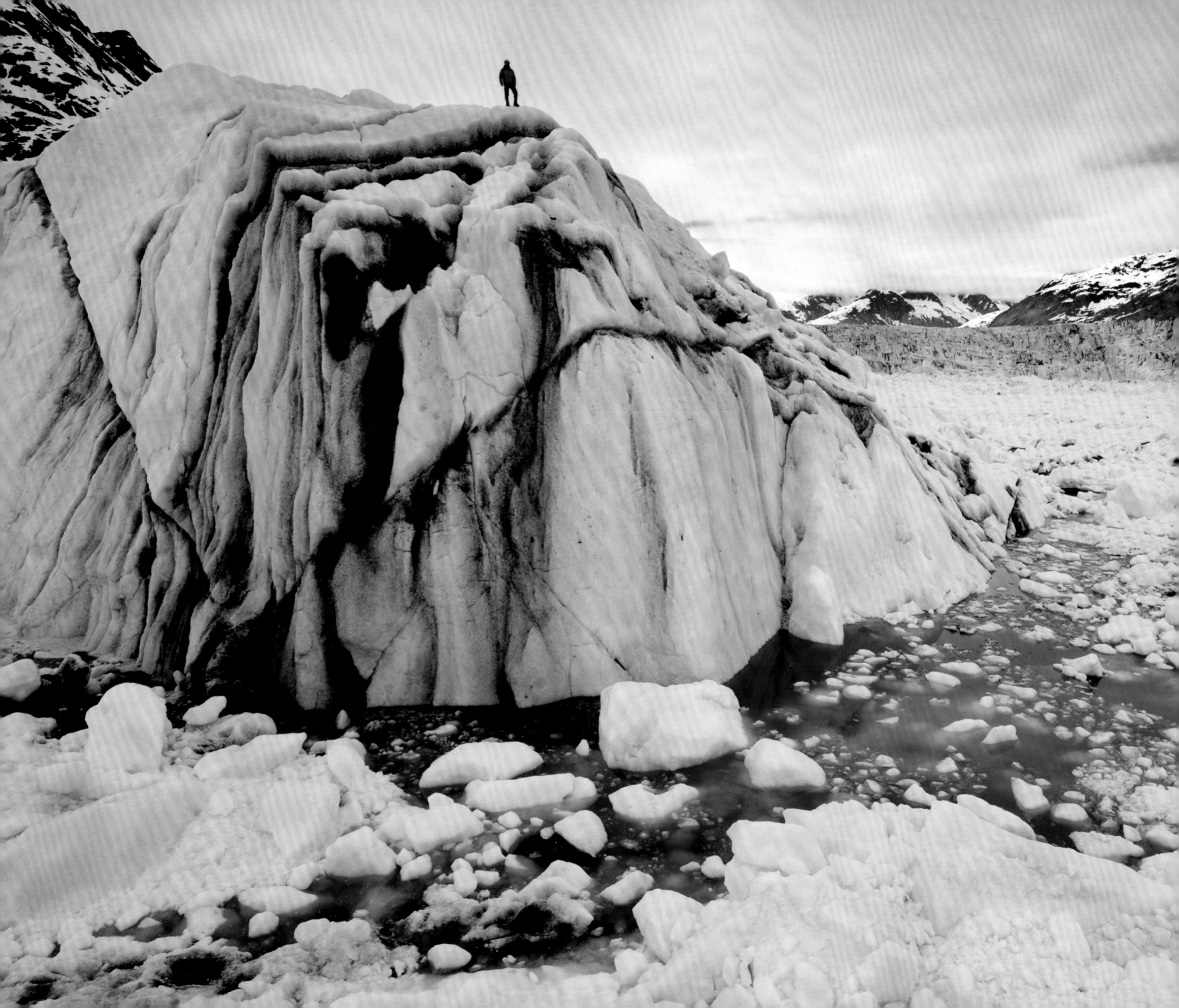

SEEING CLIMATE CHANGE

ICE MATTERS. It's the place where we can see and hear and feel climate change in action. When ice melts, everyone—regardless of age or ideological persuasion—can understand what it means.

Most glaciers, in most places where they're found, are shrinking dramatically. North America. South America. Europe. Greenland. Asia. Africa. New Zealand. The Antarctic Peninsula and West Antarctica. Accelerating "de-glaciation," the opposite of the process that sent ice sheets crawling across continents during the Pleistocene, dominates polar and alpine regions today. Noteworthy exceptions are East Antarctica, where the ice is more or less static, and the slightly advancing glaciers in Pakistan's Karakoram Range. (See Afterword for more detail.)

What causes atmospheric warming and changing snowfall to nibble away at the ice? The answer is simple: the atmosphere is filling with too much carbon dioxide, methane and nitrous oxide. It makes our atmospheric blanket—roughly five miles deep at the poles and twelve miles deep at the equator—hotter. There's nothing hypothetical about this process; the science has been understood in general terms for more than a century and quantified by real-world measurements for half a century.

The excess gasses, which all contain carbon, belch from many sources. Oddly enough, the flatulence of cattle, sheep, pigs and goats is responsible for a significant amount of methane. Melting permafrost might be too. Cutting down forests reduces the carbon absorption that would otherwise occur during photosynthesis. But the most important issue by far is that we use the air—the invisible substance we inhale twelve to eighteen times each minute, the cerulean vault arching plain as day over our heads—as a garbage dump.

We burn a huge amount of oil, coal, wood and natural gas to move ourselves around, heat and cool our buildings, grow and cook food, produce light and manufacture everything from paper clips to rocket ships. Excess carbon released by all that burning ends up in our air supply. These alien gasses have turned the air into an unnatural substance. In just the past couple centuries, its chemistry has gone far beyond the range of what has been normal and natural during the past million years. We are now in the midst of a gigantic, unplanned, uncontrolled experiment involving the entire planet.

Every person alive today, me included, is dependent on burning carbon-rich fuels. In fairness, let's acknowledge that those fuels have given life to much of what we—as individuals and as a civilization—have accomplished and experienced. They have been and will continue to be an important positive force. But until recently, we never knew that carbon fuels also crush us under an avalanche of negative consequences: extreme weather, drought, wildfire, floods, sea level rise, acidifying oceans, strained food and water supply; the health impacts of dirty air; military and national security problems; and tremendous financial cost. The only rational response is to cut back on using carbon fuels.

Science and art seek clarity and vision. Lobbyists and pundits seek confusion and controversy, for it is within a noise cloud of false information that ignorance hides. As long as the general public thinks climate change isn't real or that science is still debating it, fossil fuel industries protect their profits. Without social clarity, political leaders—who are often financially beholden to fossil fuel industries—have no motivation to act. Finally, when the military, health and environmental costs of fossil fuels are spread far and wide in the economic system and don't show up in gasoline prices and electricity bills, market signals don't help us make correct decisions either. (It is worth noting that both the tobacco and carbon industries sell black, sooty, vaporous, toxic stuff and have used propaganda campaigns to sow social confusion. Similarly, public health campaigns of a century ago to reduce urban pollution from coal smoke were met with industry's attempts to baffle the public.)

Clear perception is thus the key for at least beginning to change the impact we're having on the planet. With clarity, the technological, economic and policy solutions to energy use and climate change—a zillion of them that have already been mapped out—can be widely implemented. The path forward is being traveled by individuals committed to improving their own lives and communities, by schoolchildren who can't stand the inaction of their elders, by innovative entrepreneurs and corporations eager to make or save money, by military generals seeking to protect their country and their soldiers and by political leaders of courage and vision. We are all complicit in the problem and we can all be participants in the solution.

Every human being has an inalienable right to a stable climate. The time to act is now, not tomorrow, when the storm of crisis will have broken upon us and whatever action we take will be too little, too late. Climate change is not a political issue. It is not a question of belief systems. It is a universal issue about real-world facts that should be addressed with rationality and intelligence.

If inaction is the course we settle on, we will have kicked today's consequences onto uncountable human generations to come. Whether that choice turns out to be stupid, unethical, immoral or even criminal remains for our children to judge. I hope—for the sake of my sanity, and for my hope that my two daughters will live in a peaceful, healthy and prosperous world—that we have not debased our ethics that far.

The better angels of our nature are still with us, waiting to break free of the carbon chains that bind. It is time, right now, to unchain those angels and do what we all know, in our heart of hearts, must be done.

◀ Columbia Glacier | **Alaska, United States** | 19 June 2008
Layers of eroded sediment stripe an iceberg.

▼ Coast Mountains | **British Columbia, Canada** | 2 September 2008
Algae colors ice and meltwater on the surface of an unnamed lake.

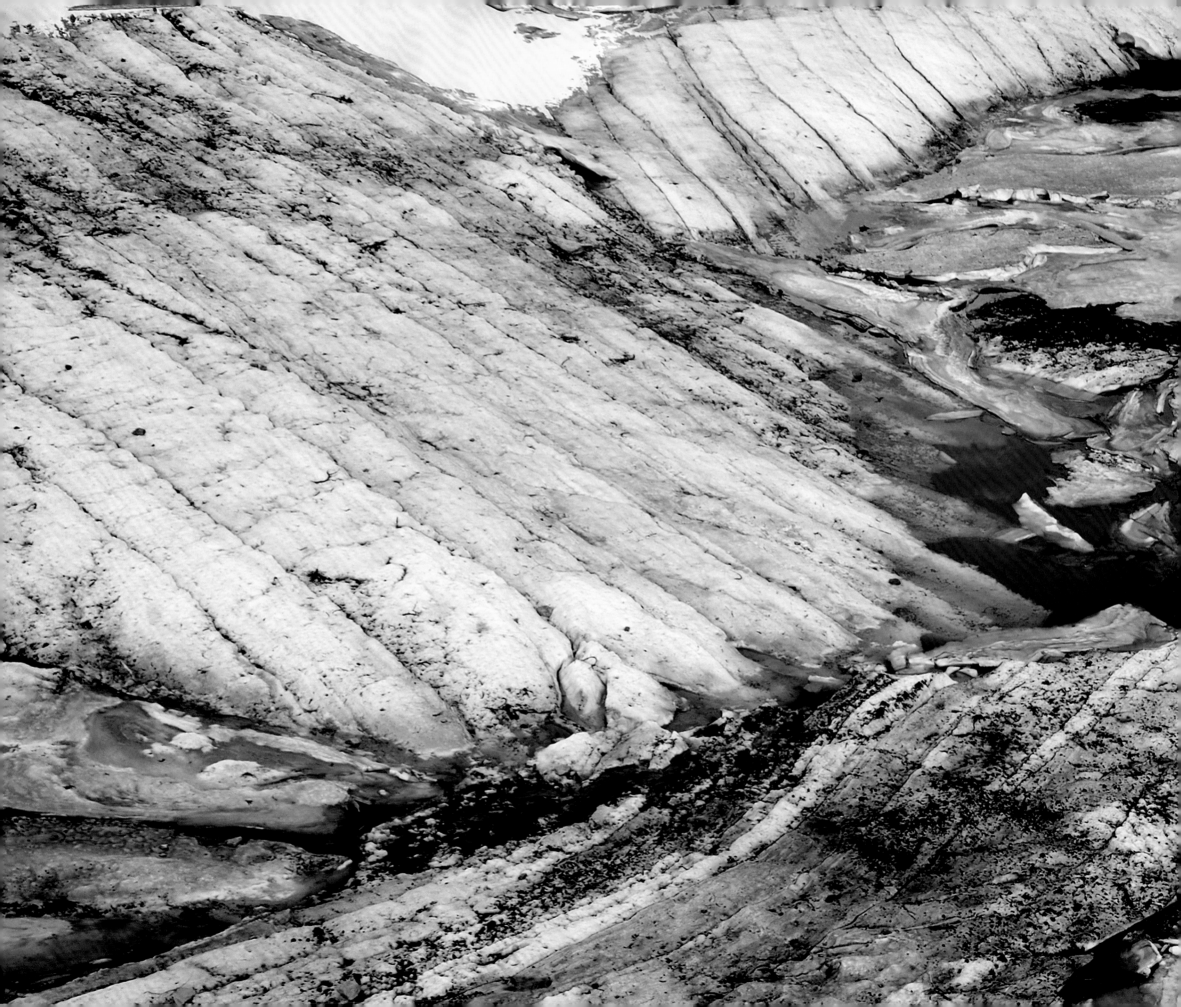

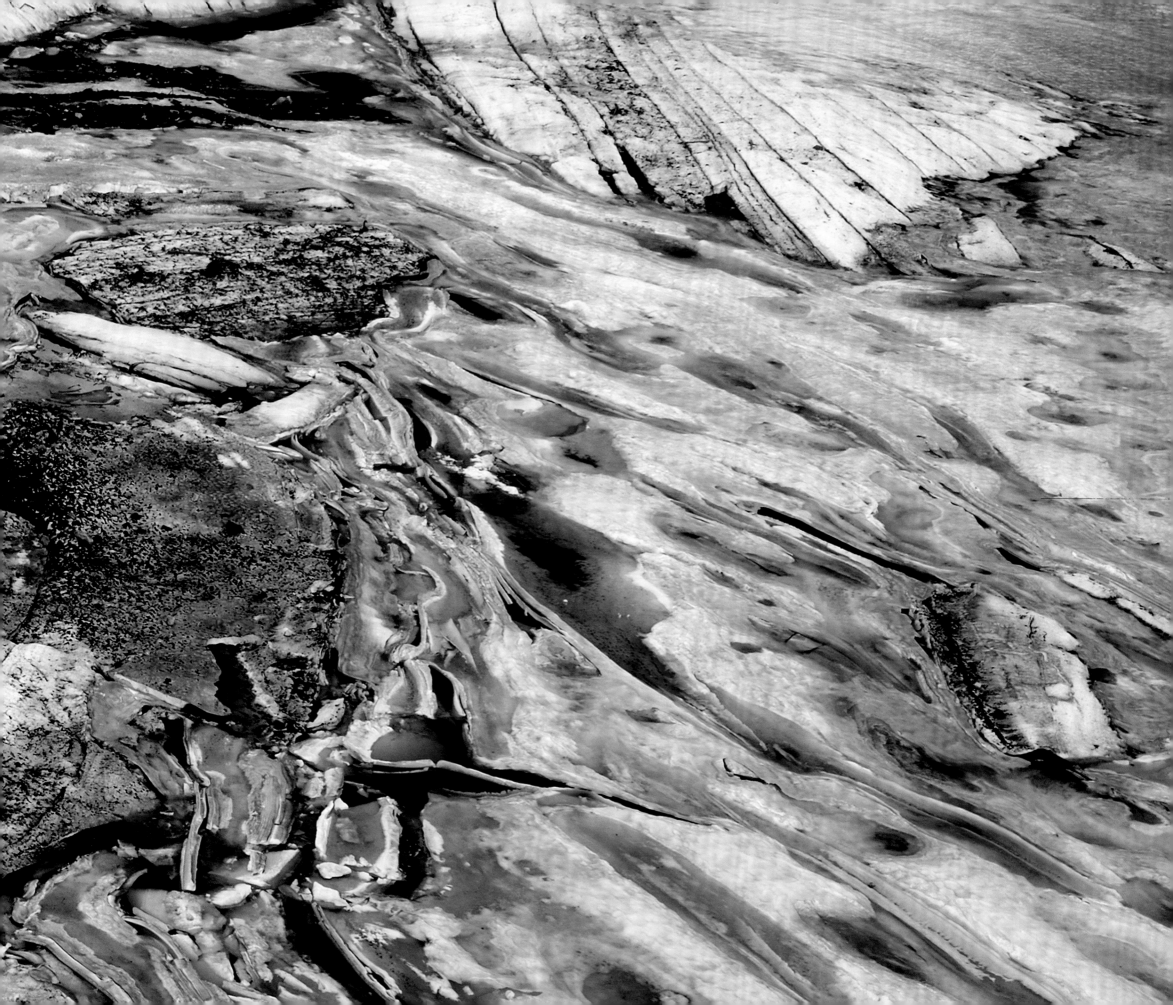

TIME NOW

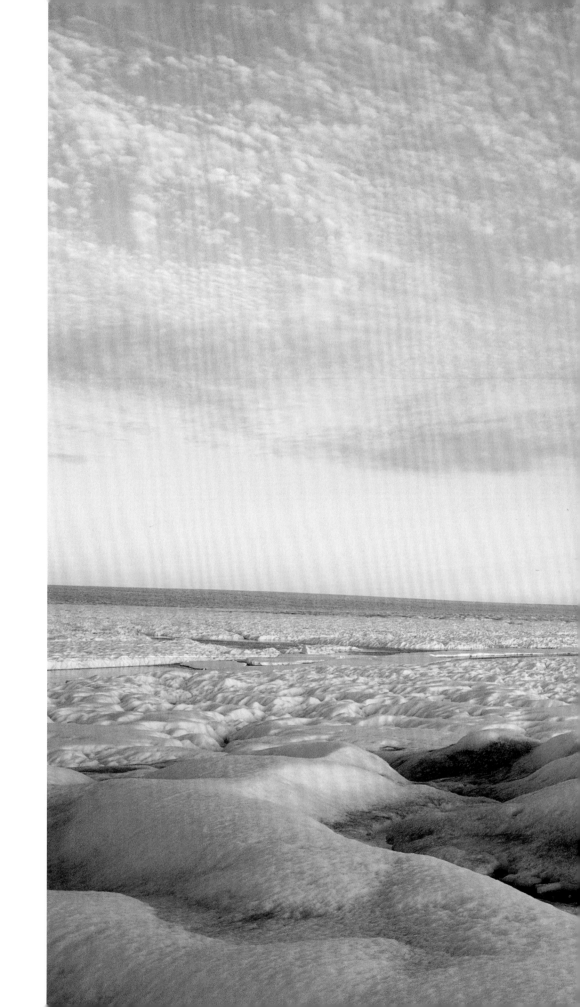

▶ Greenland Ice Sheet │ **Greenland** │ 9 July 2009

▼ Khumbu Glacier │ **Nepal** │ 8 May 2010 │ Cameras NP-4 and NP-5 at the foot of Mount Everest.

Snow falls.
If more snow falls in winter than melts in summer,
the snow grows deep.
Accumulating weight squeezes snow into ice.
Gravity pulls the ice river downhill.
A glacier is born.

Flowing ice
stresses and strains, cracks and collapses.
Flowing ice scours bedrock of ancient age.
Crevasses and moraines, seracs and icebergs,
come into being.

Warm the air or stop the snow: a glacier thins and retreats.
Cool the air or bring blizzards: a glacier advances.
Tickle a glacier's belly with warm seawater:
a glacier collapses.

Glacier ice holds the memory
of heat and cold and moving air.
It is both thermometer and barometer,
a "bermometer."

Air
and ocean are changing.
In most places, most glaciers
are retreating.

We hereby bear witness
to the art and architecture of ice,
as seen AD 2005 to 2011.

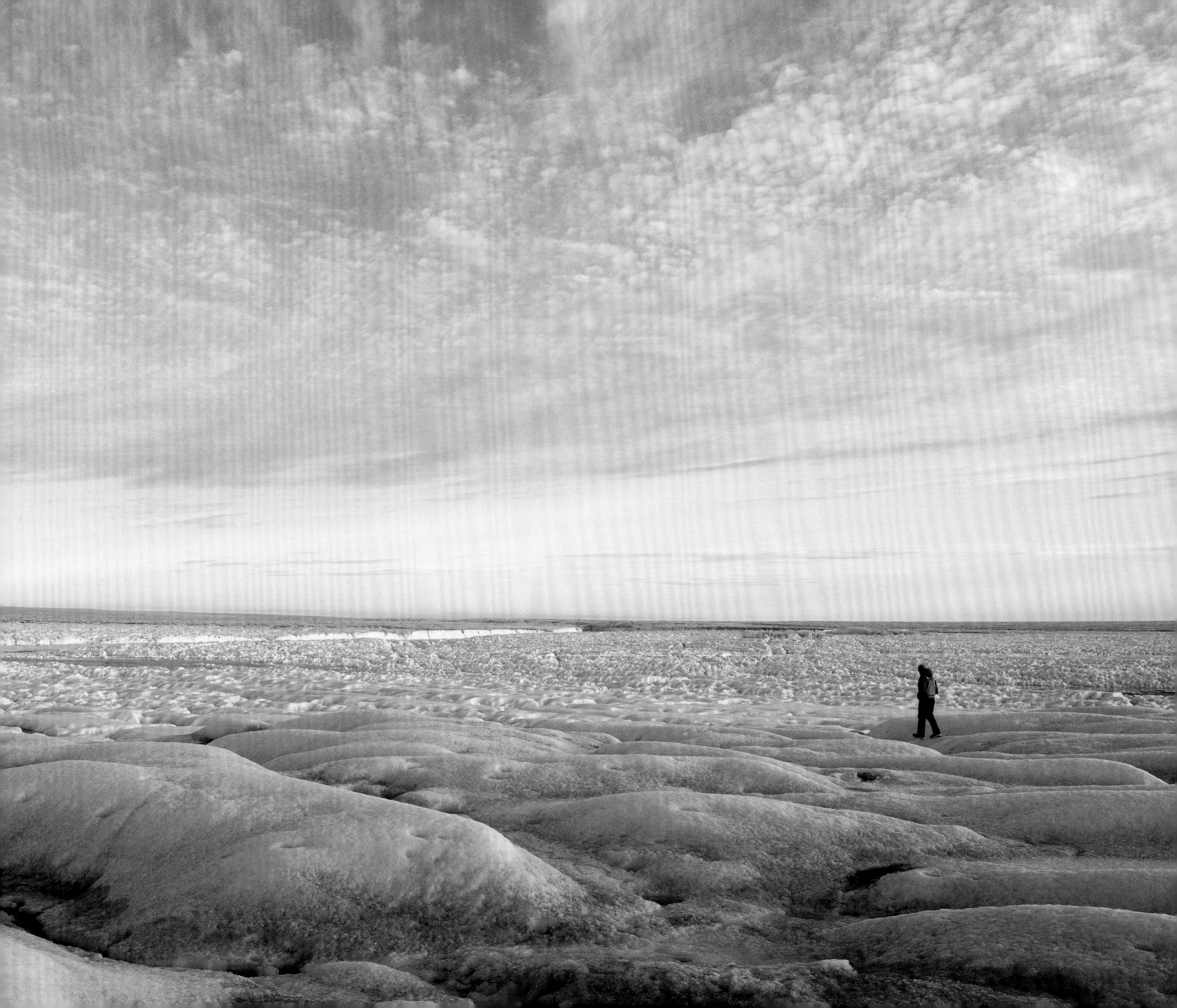

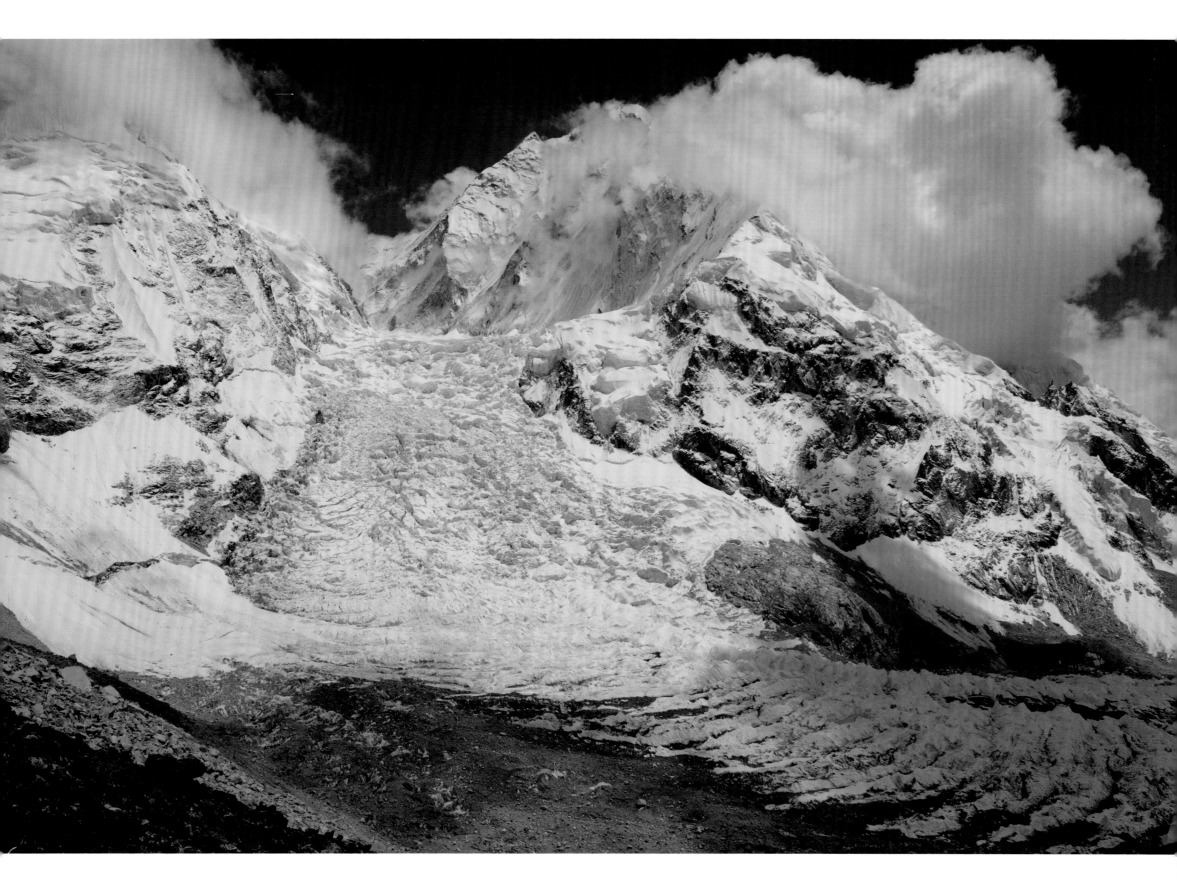

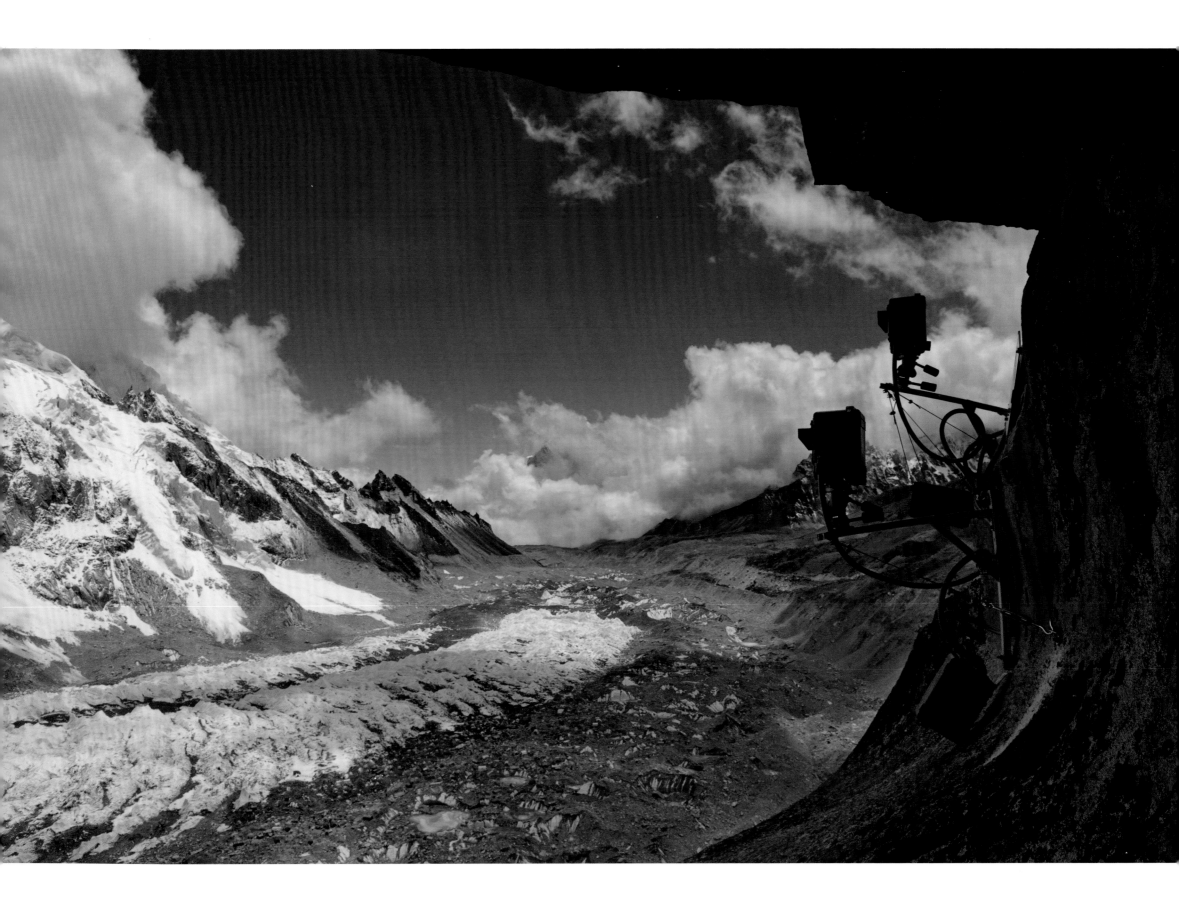

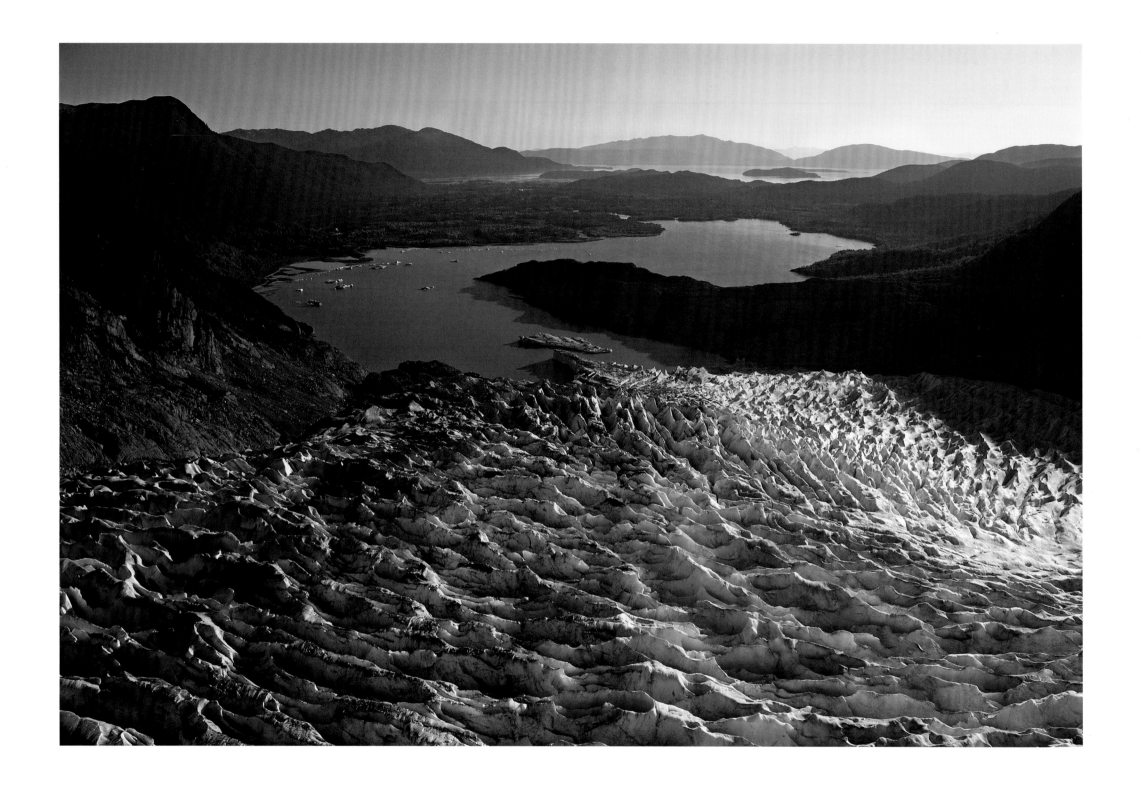

▲ ▶ Mendenhall Glacier | **Alaska, United States** | 15 September 2010 | Crevasses and icefall at the terminus. ▼ Aletsch Glacier | **Switzerland** | 22 September 2011

22

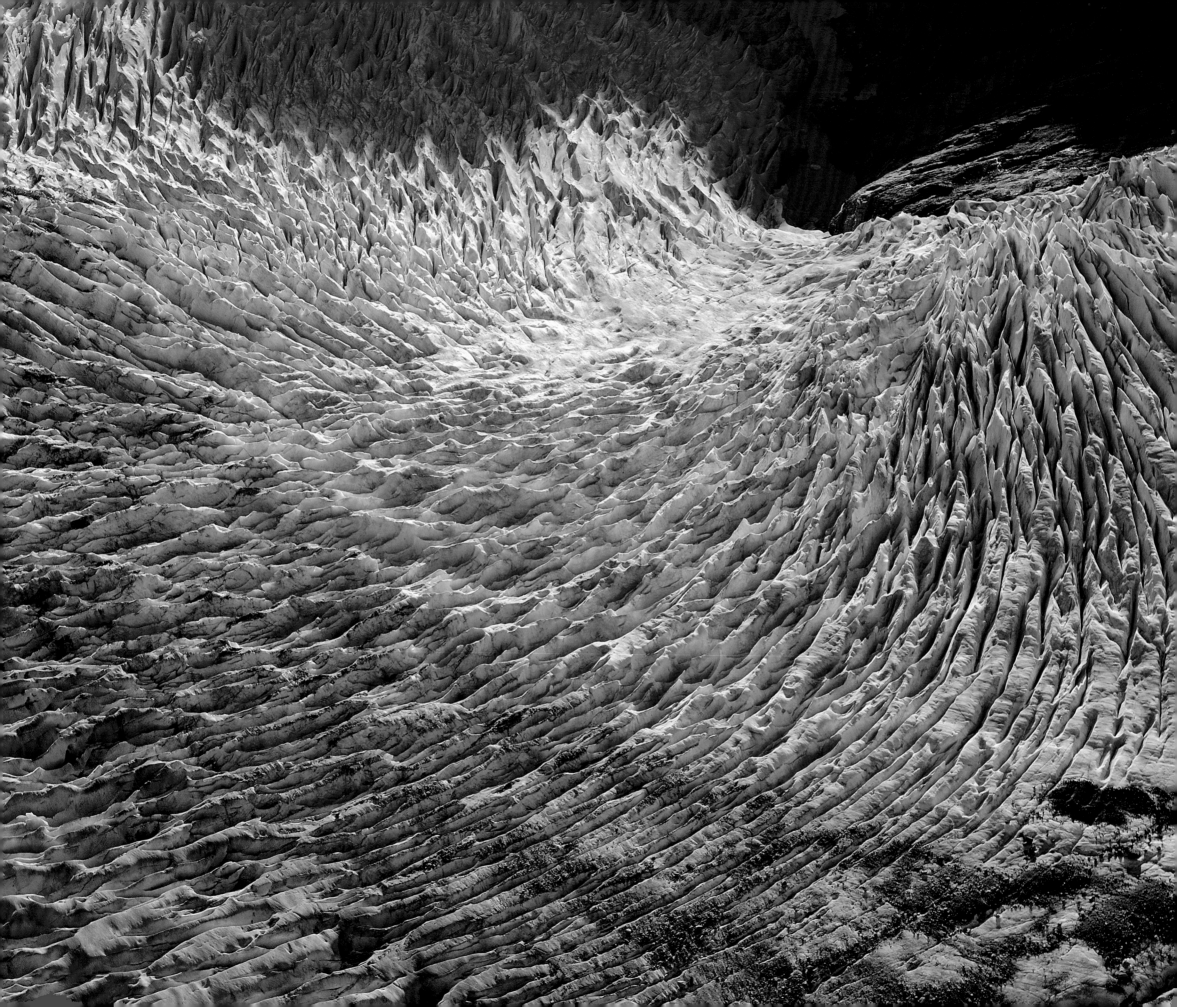

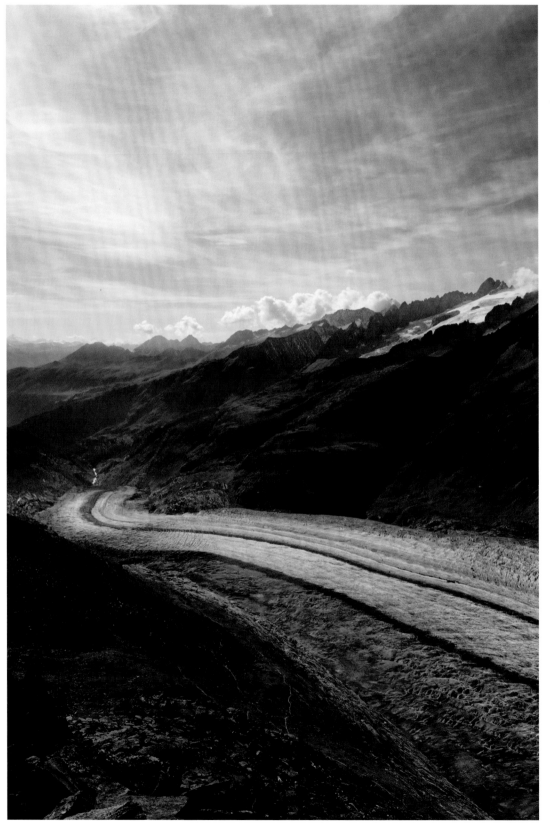
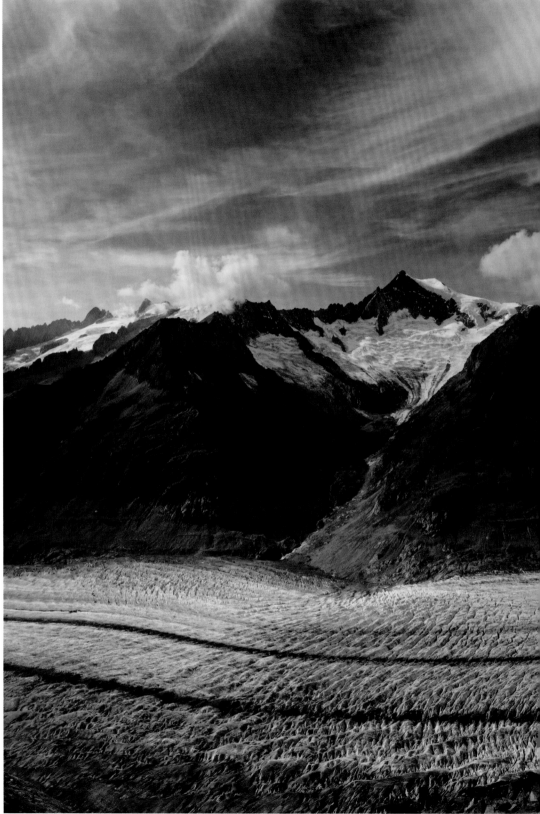

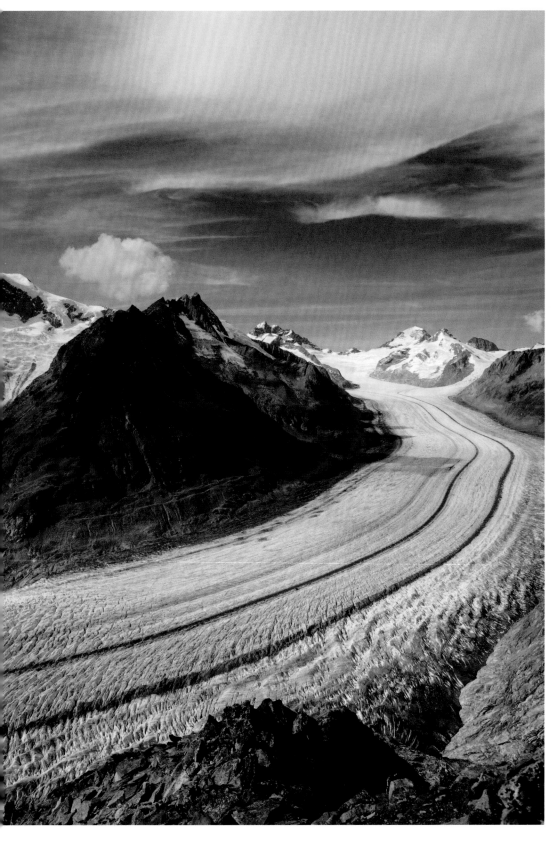
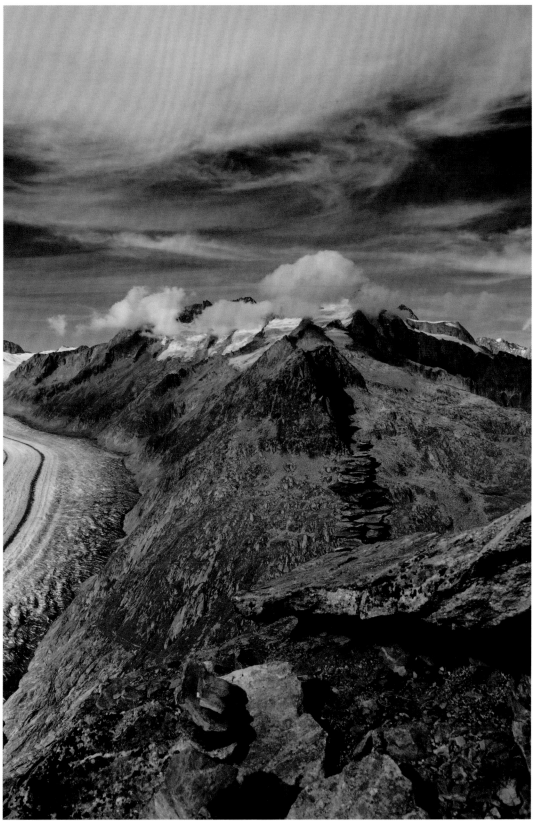

West branch Columbia Glacier | **Alaska, United States** | 26 August 2009 | Moraines—sediment eroded from surrounding mountains—stripe the ice.

Klinaklini Glacier | **British Columbia, Canada** | 1 September 2009 | Eight cubic kilometers of ice (1.9 cubic miles) have melted in recent decades.

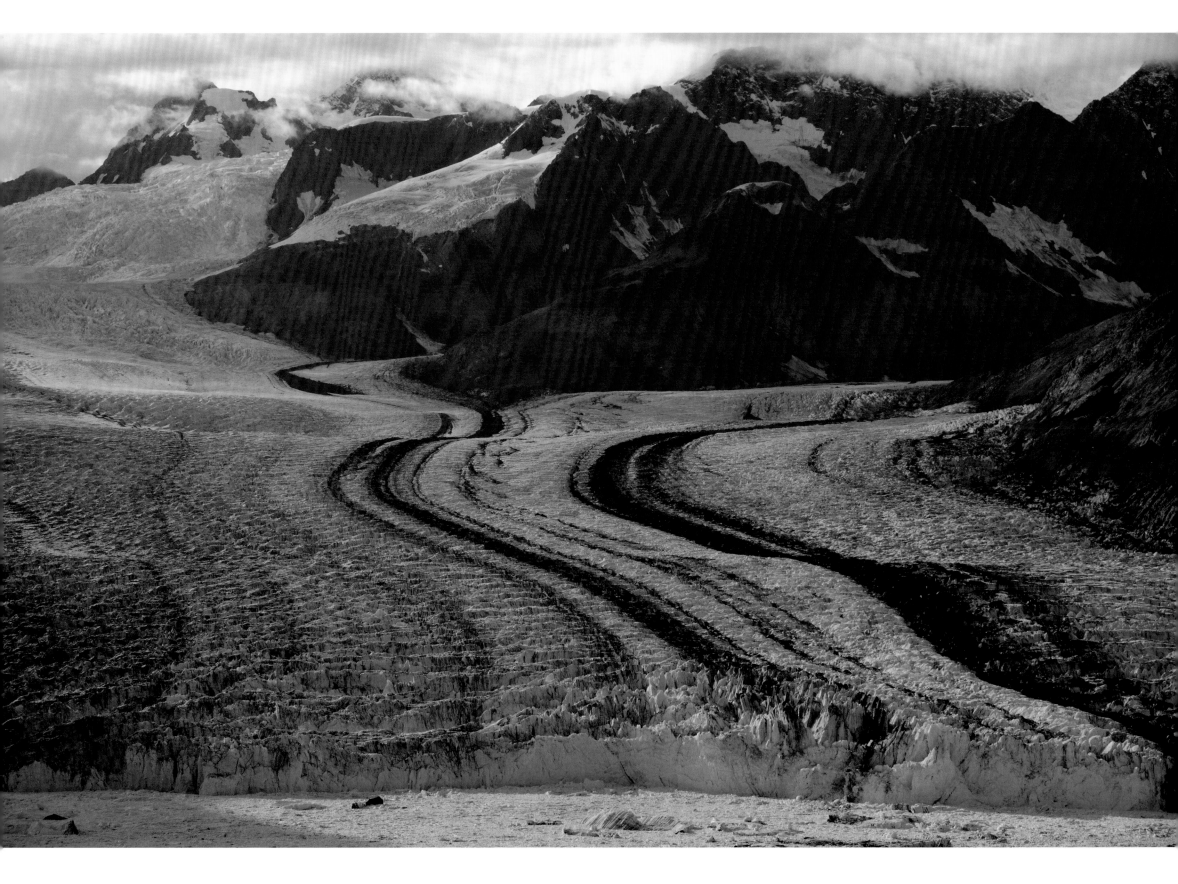

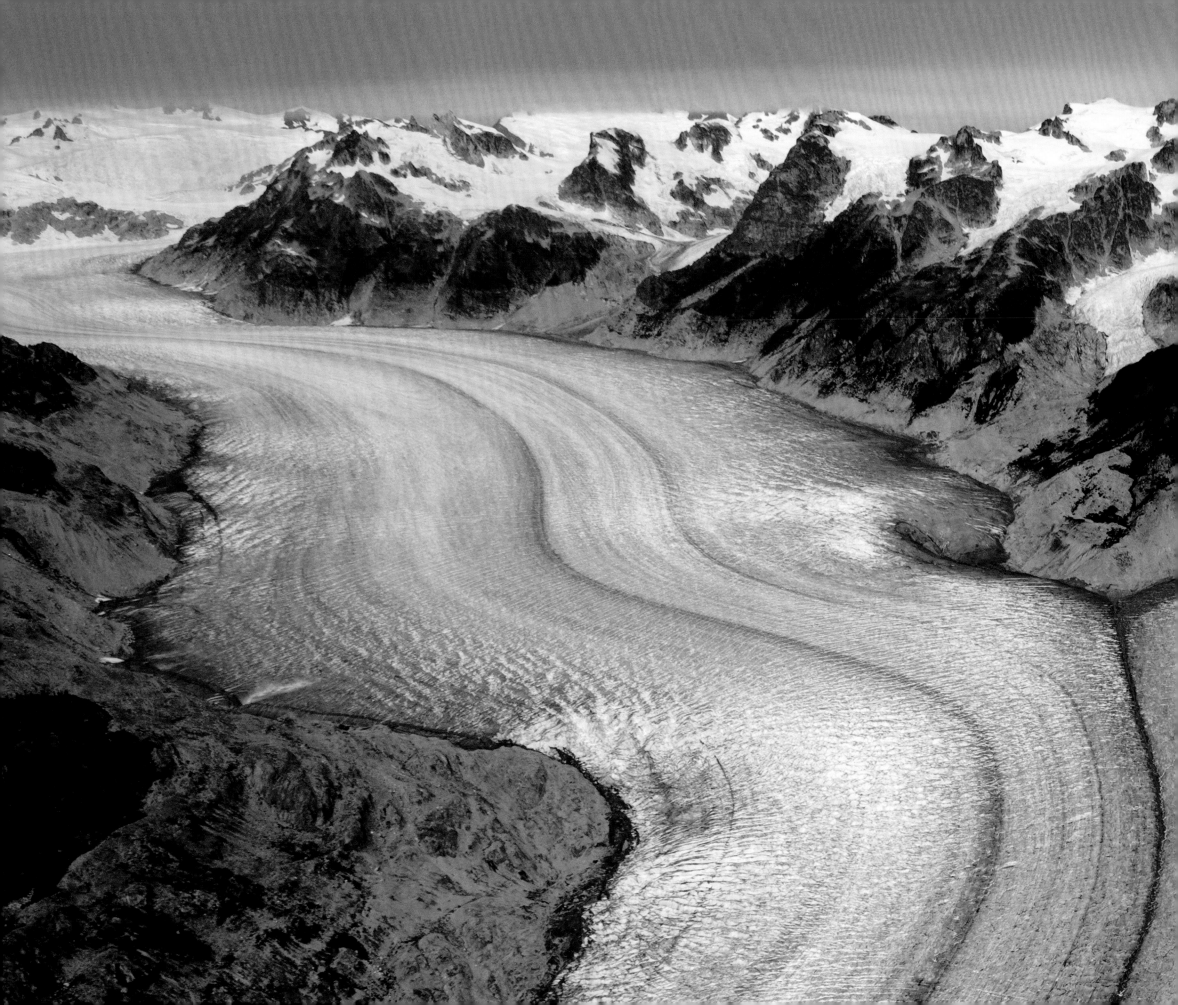

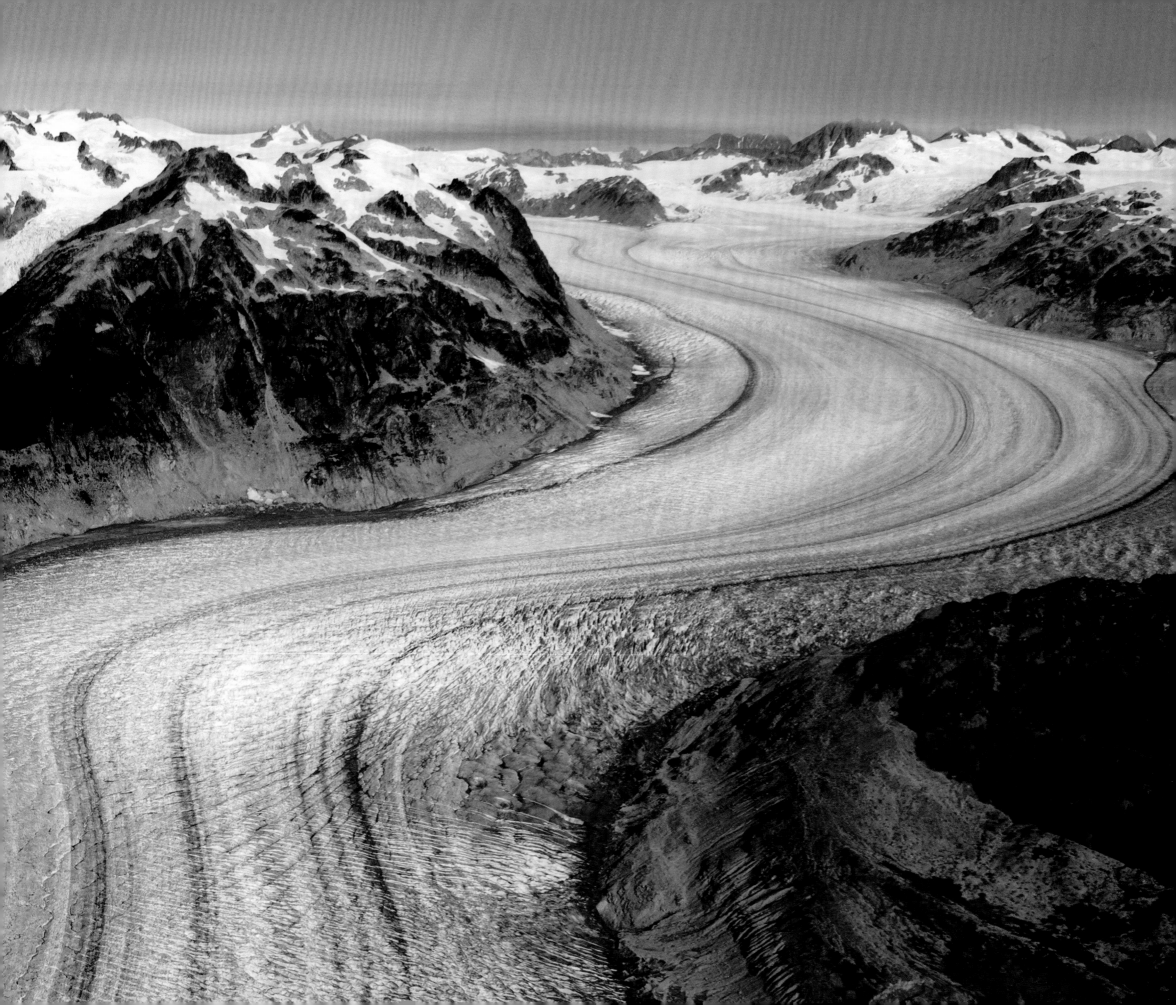

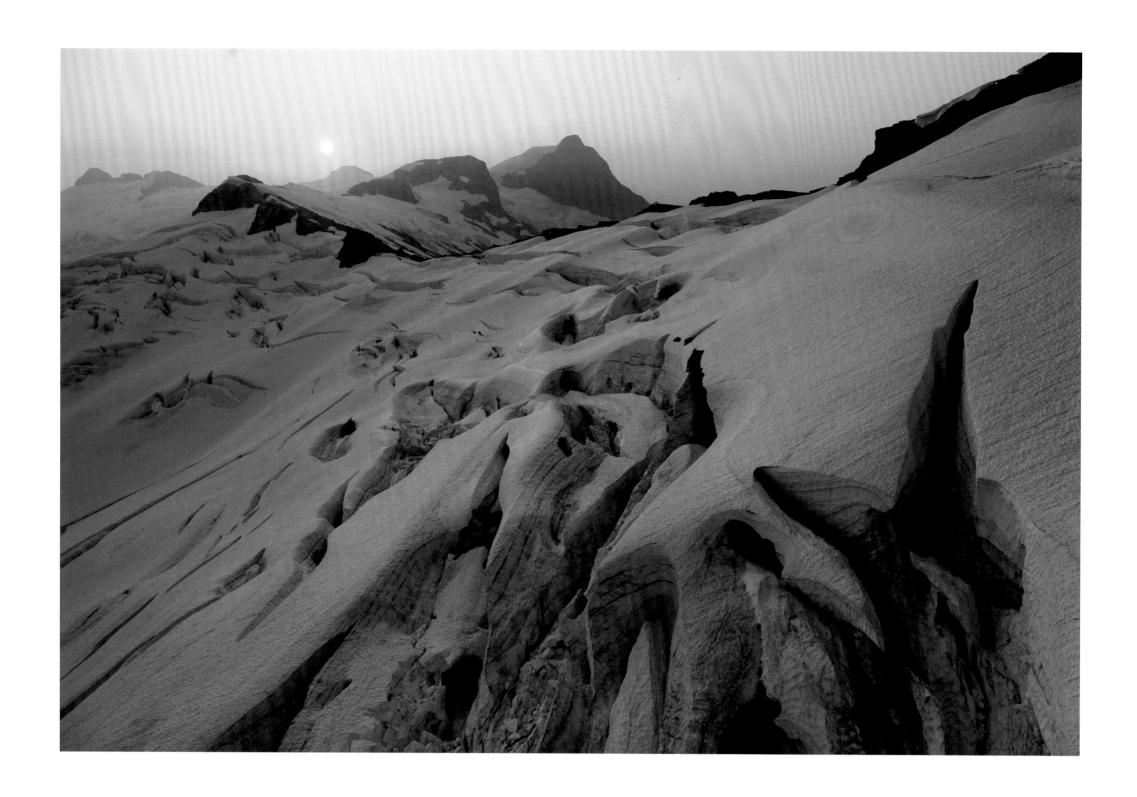

▲ ▶ Tahumming Glacier | **British Columbia, Canada** | 30 August 2009

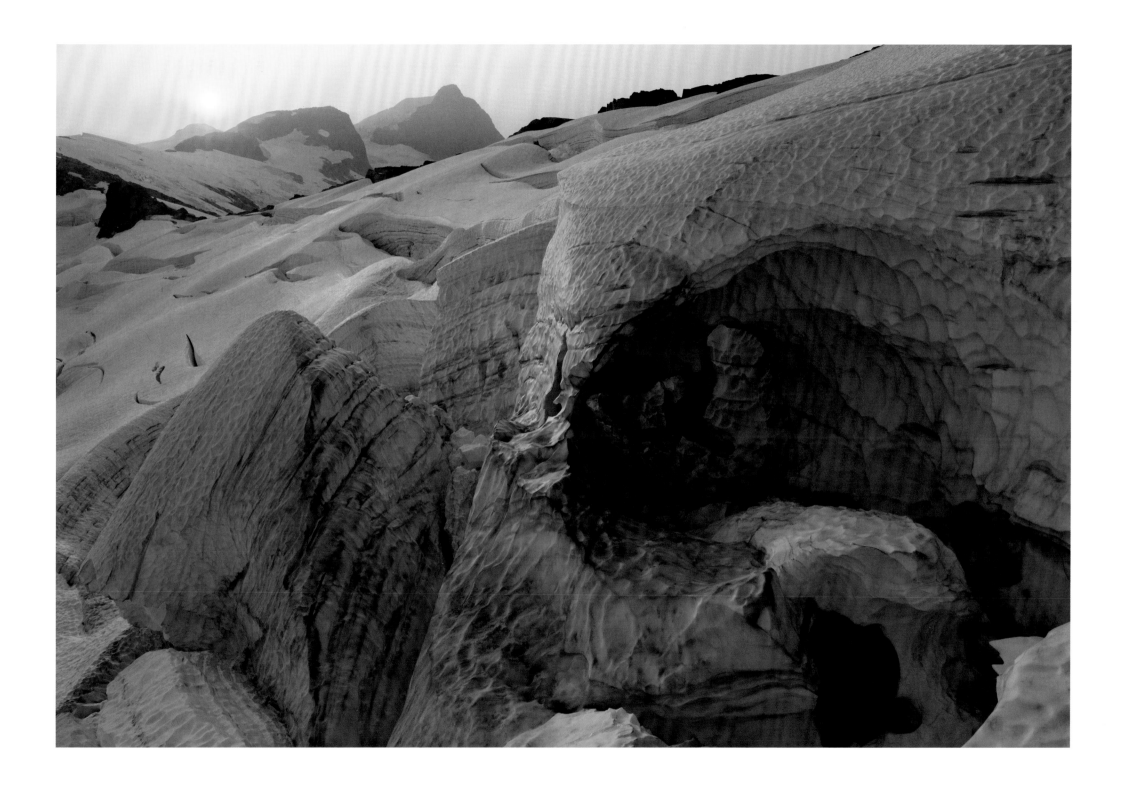

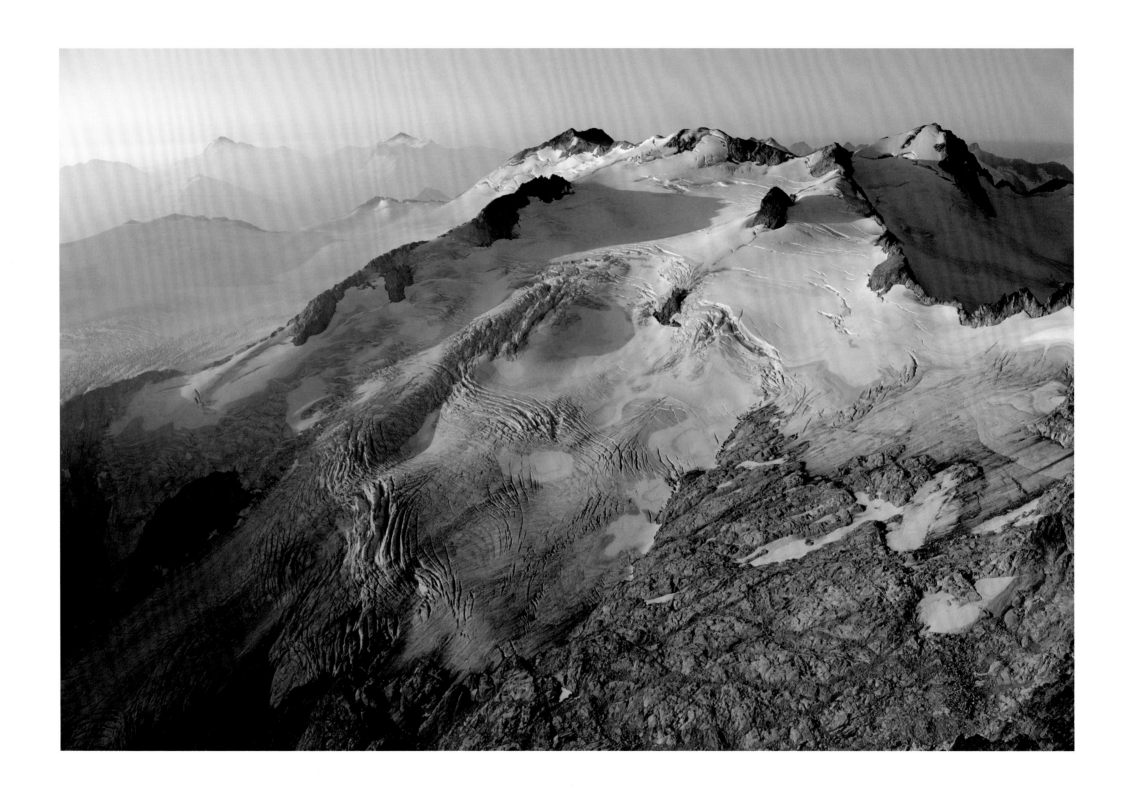

▲ Glacier north of Cheakamus Lake, Coast Mountains │ **British Columbia, Canada** │ 31 August 2009

▶ ▼ Bishop Glacier │ **British Columbia, Canada** │ 1 September 2008 │ Icebergs and lake are formed by glacial retreat.

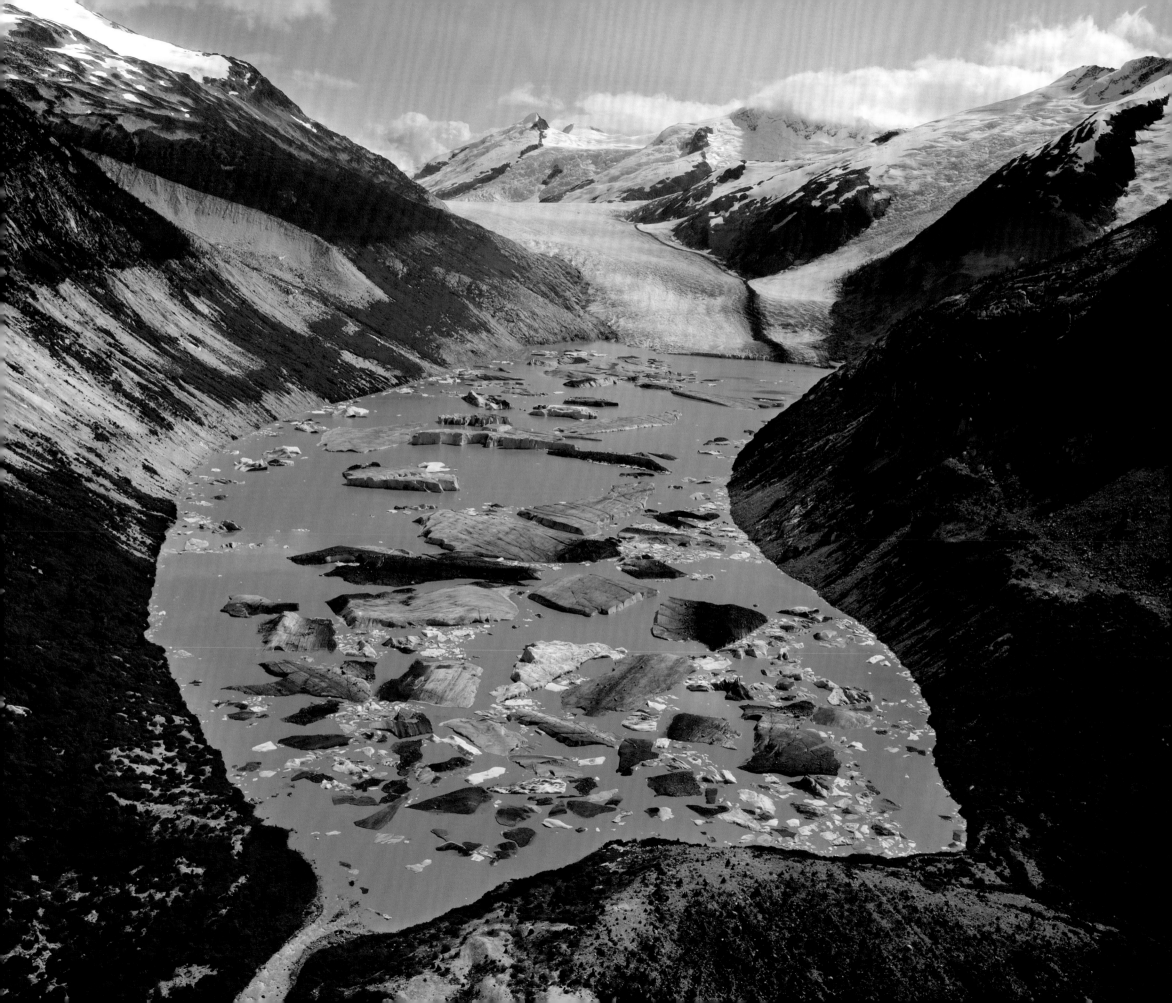

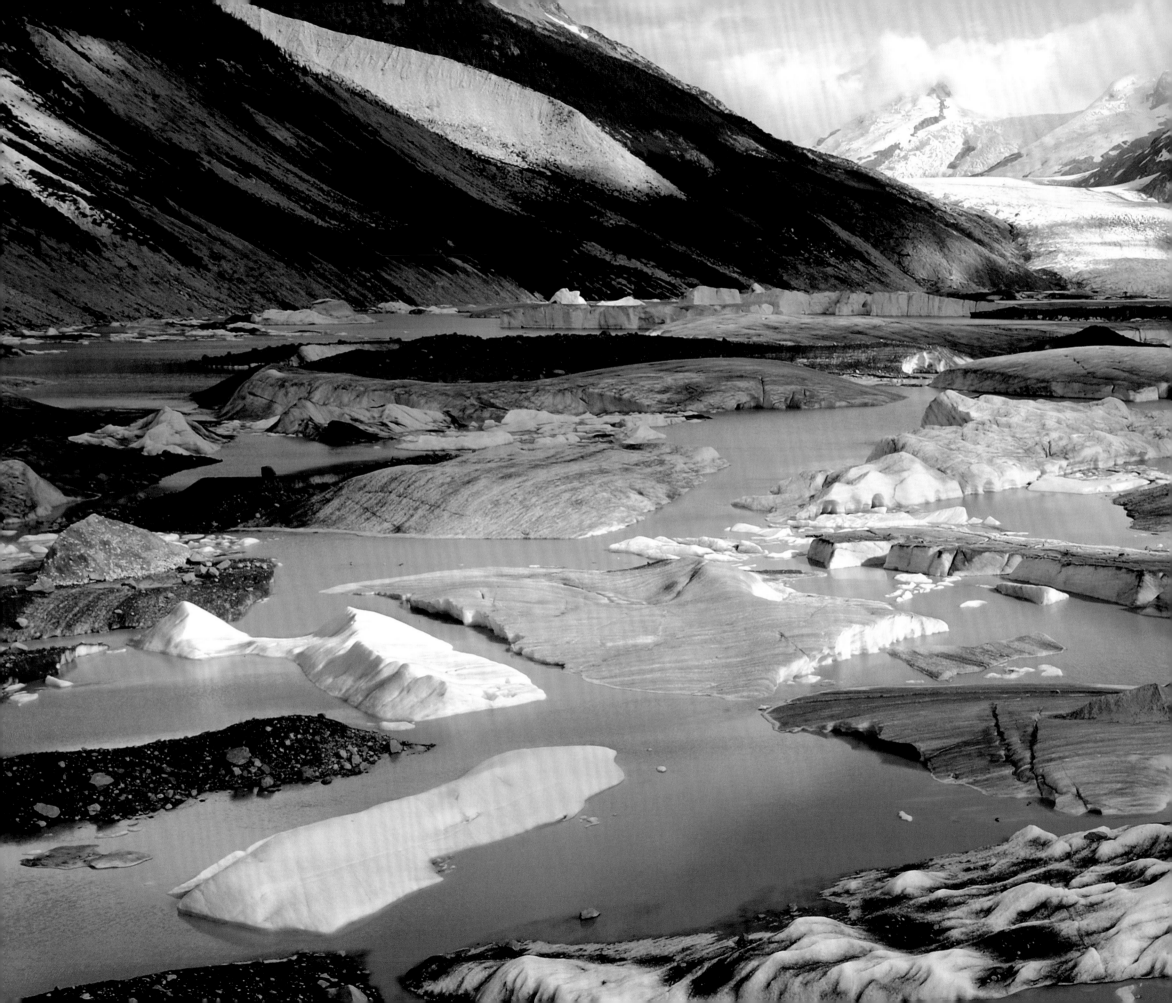

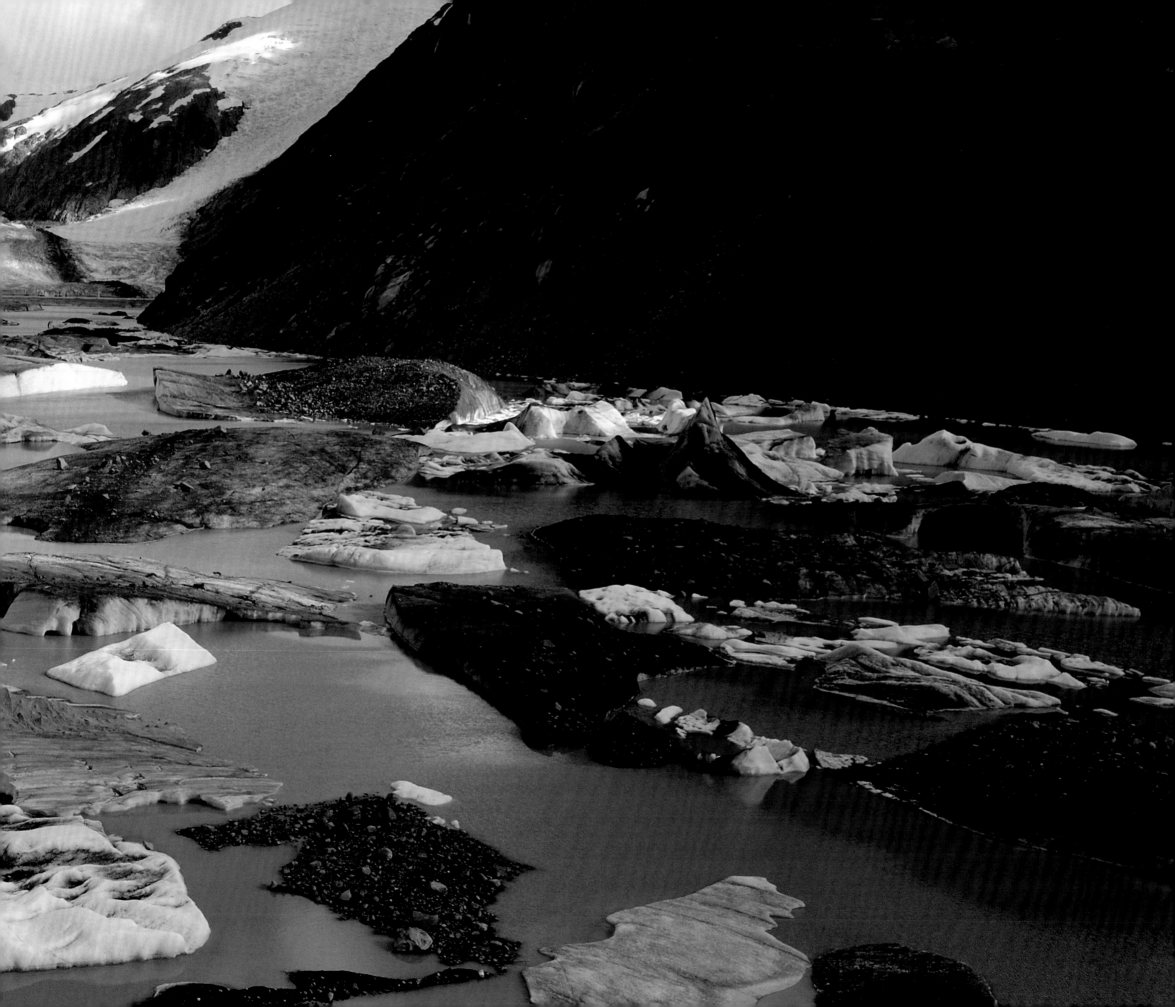

▶ Heakamie Glacier | **British Columbia, Canada** | 29 August 2009 | Crevasses form as ice flows over steep bedrock.

▼ Jökulsárlón | **Iceland** | 5 March 2005

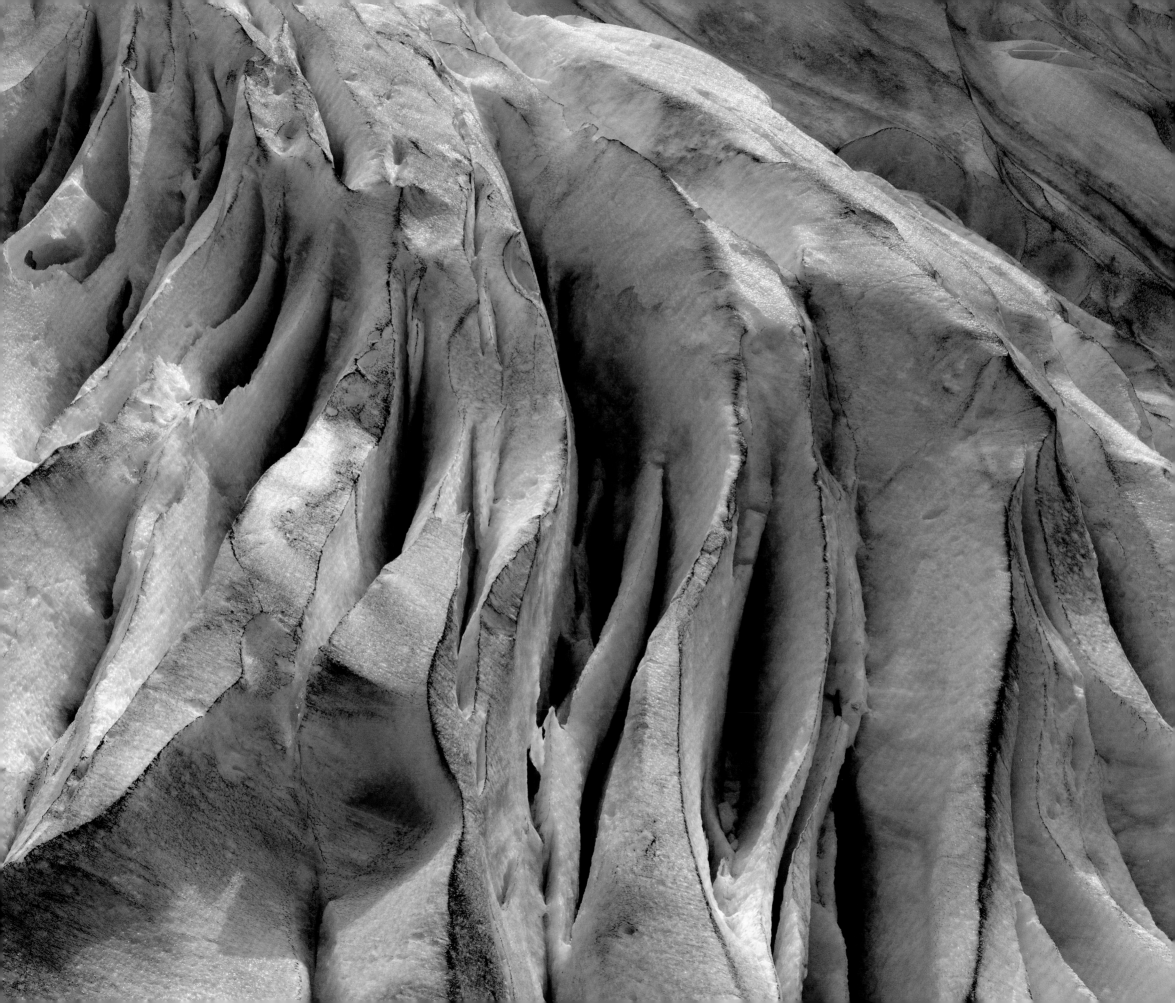

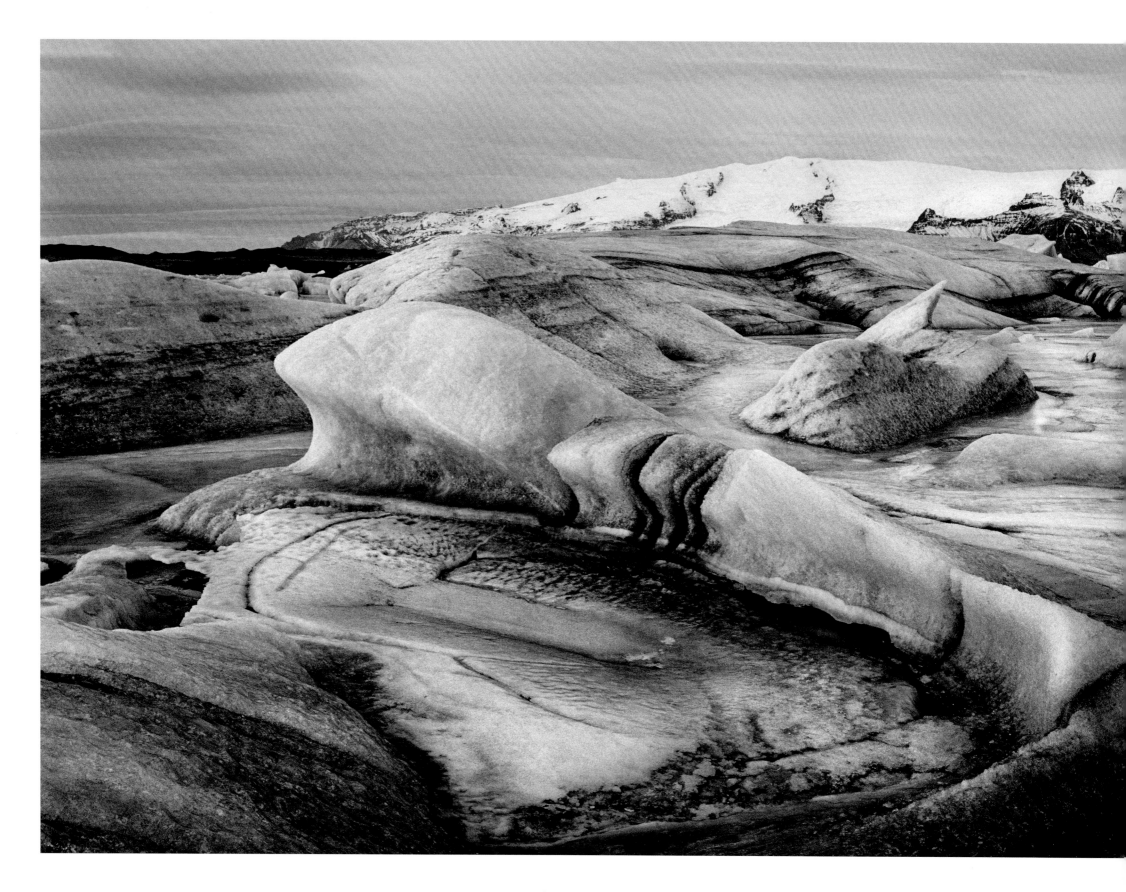

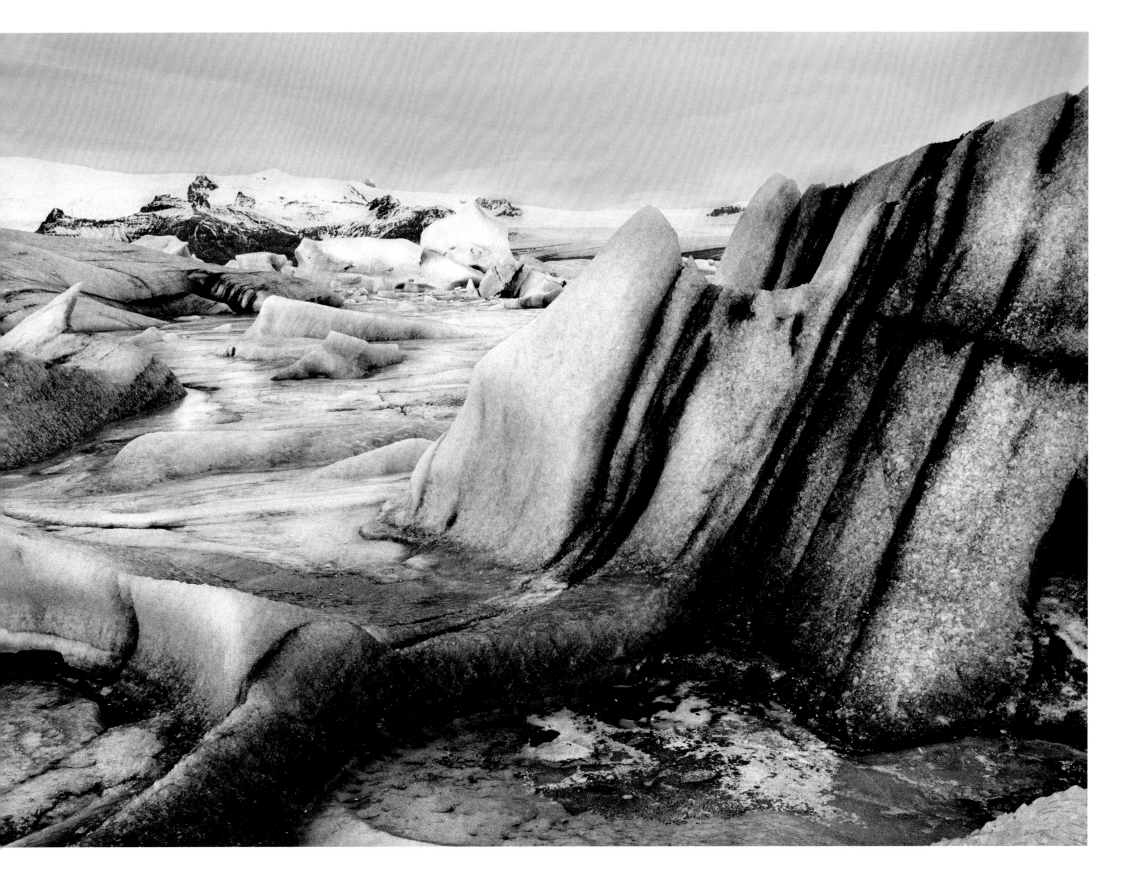

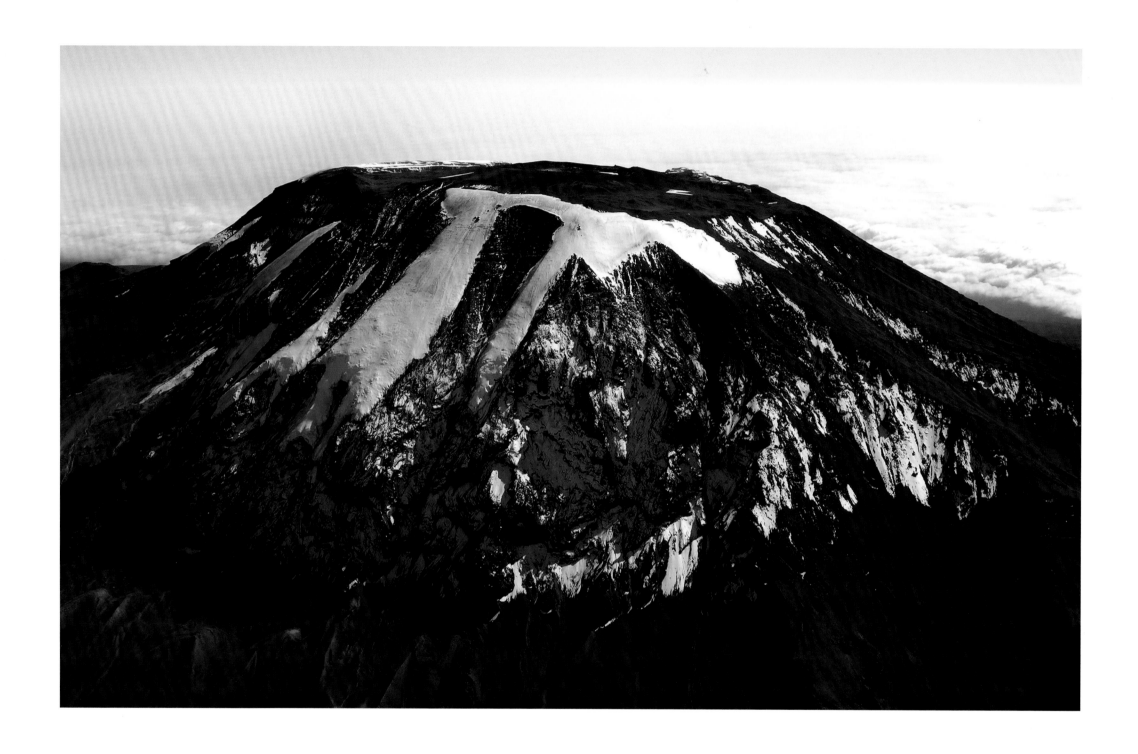

▲ Mount Kilimanjaro | **Tanzania** | 21 July 2005

▶ Mount Kilimanjaro | **Tanzania** | 27 July 2005 | A fast-melting face of the Furtwangler Glacier near the summit.

▼ Mont Blanc | **France** | 21 September 2006 | Ice on western Europe's highest peak is shrinking and thinning.

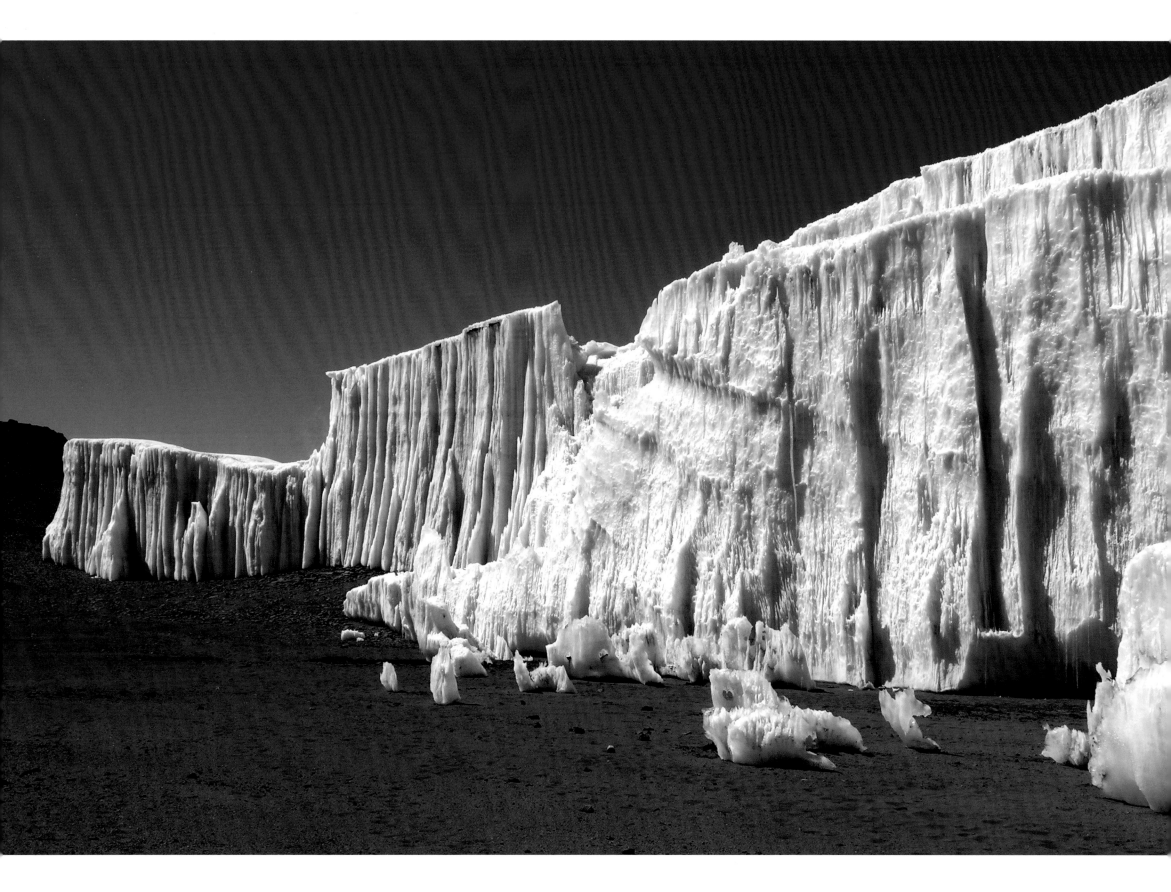

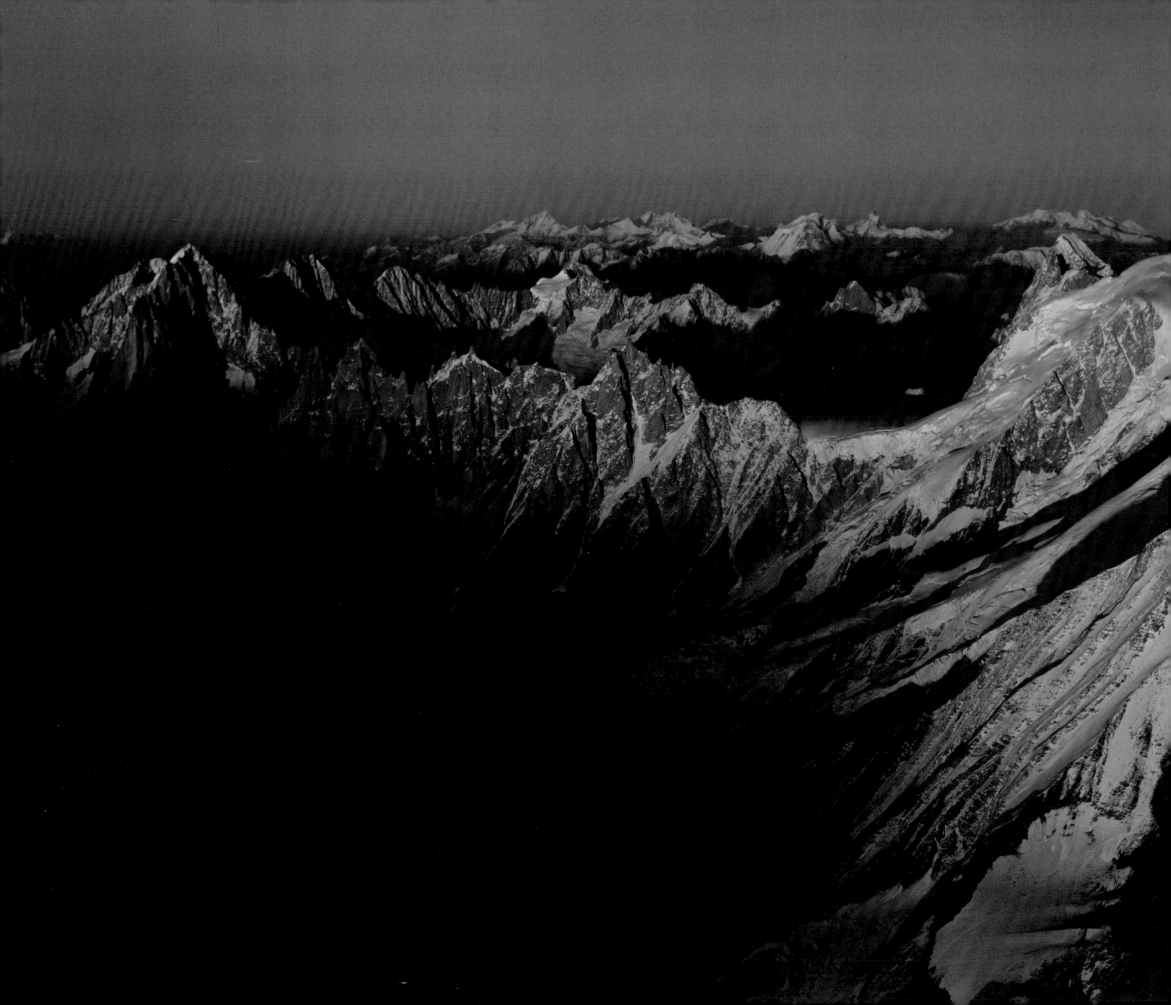

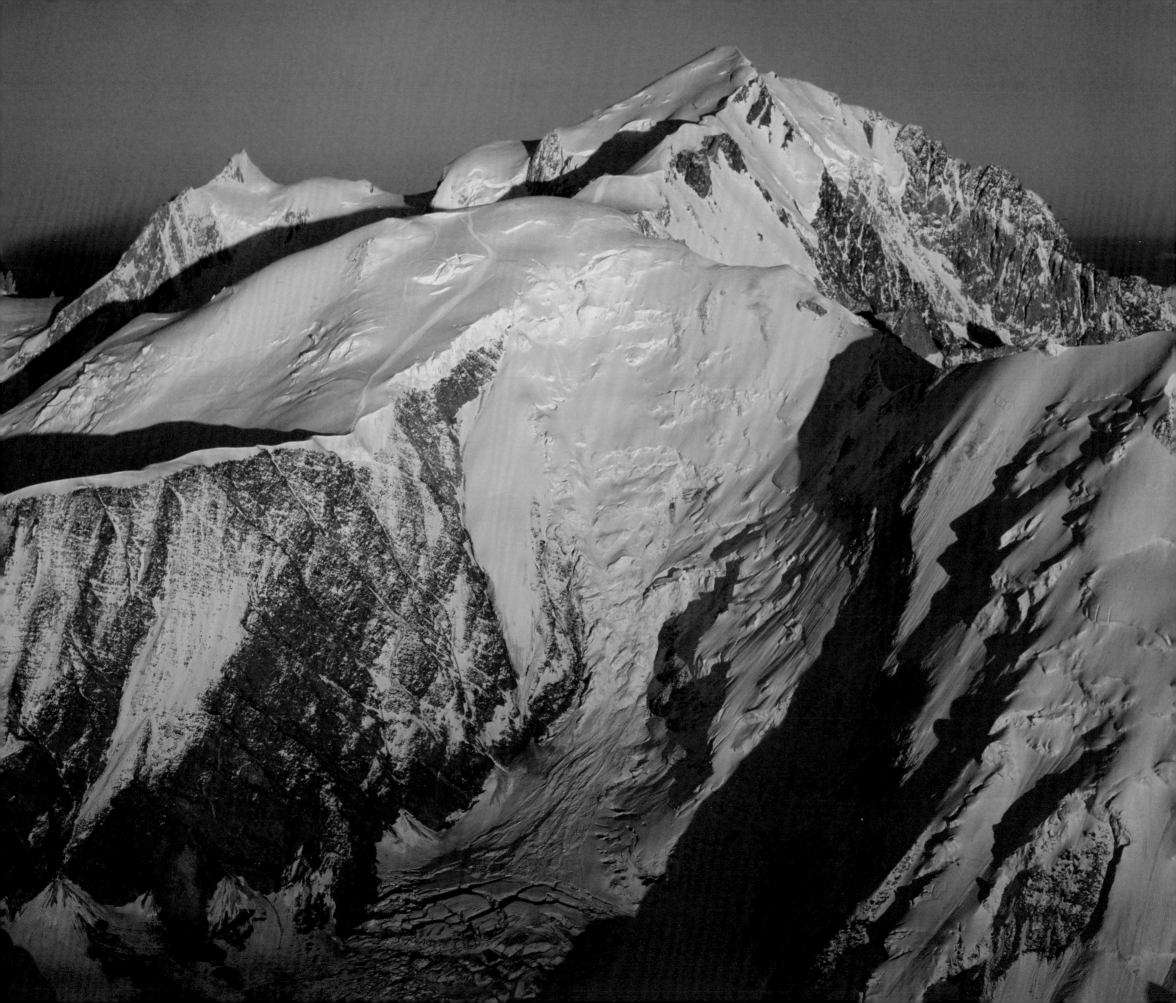

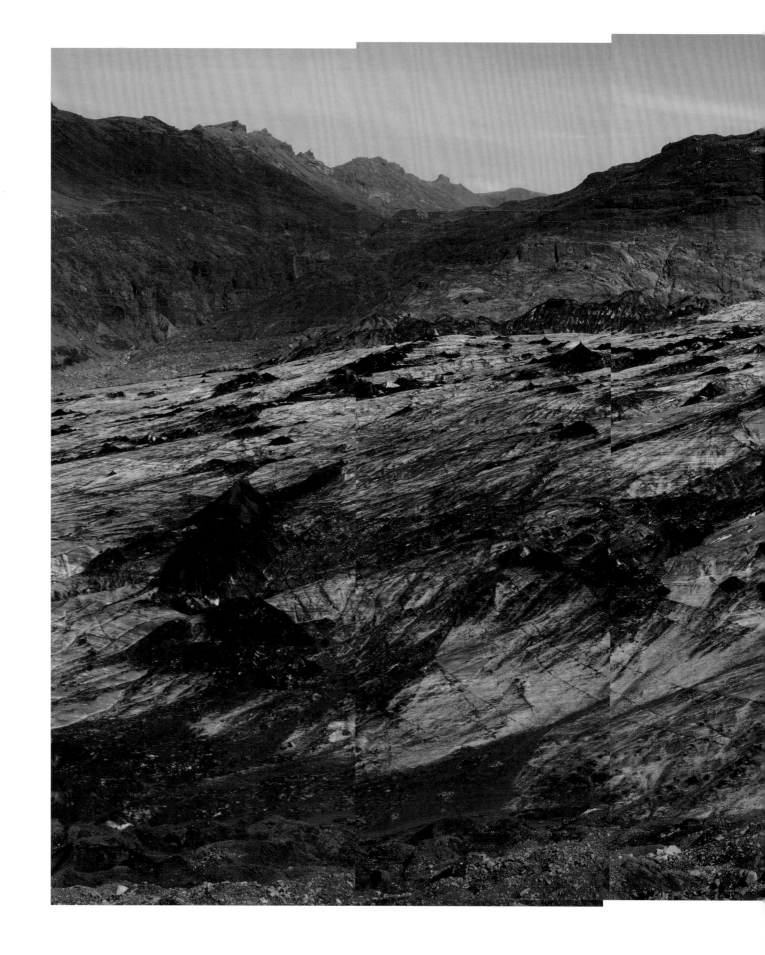

▶ Sólheimajökull │ **Iceland** │ 16 June 2011
From waypoint WP-2011-06-1.

▼ Skeiðarárjökull │ **Iceland** │ 24 July 2008
Ash layers from volcanic eruptions are embedded in the ice.

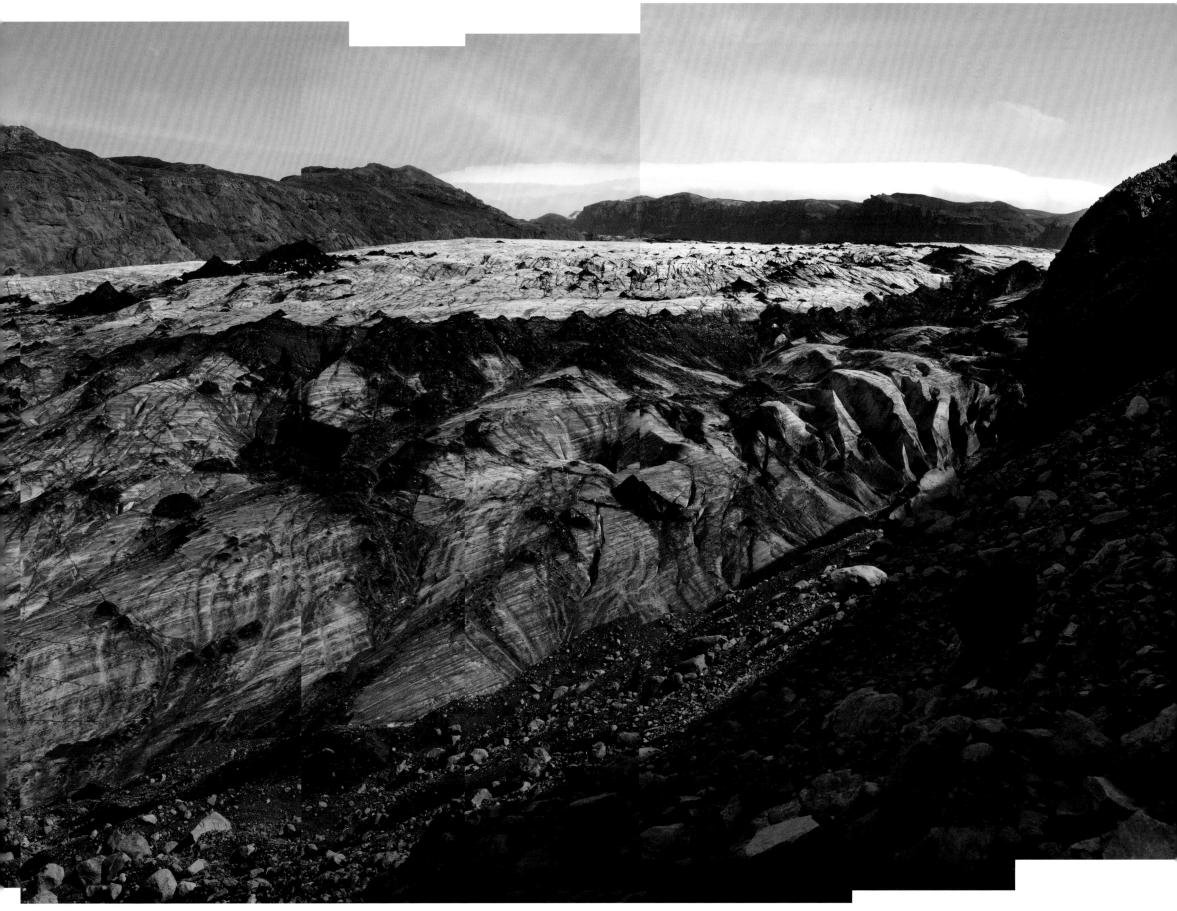

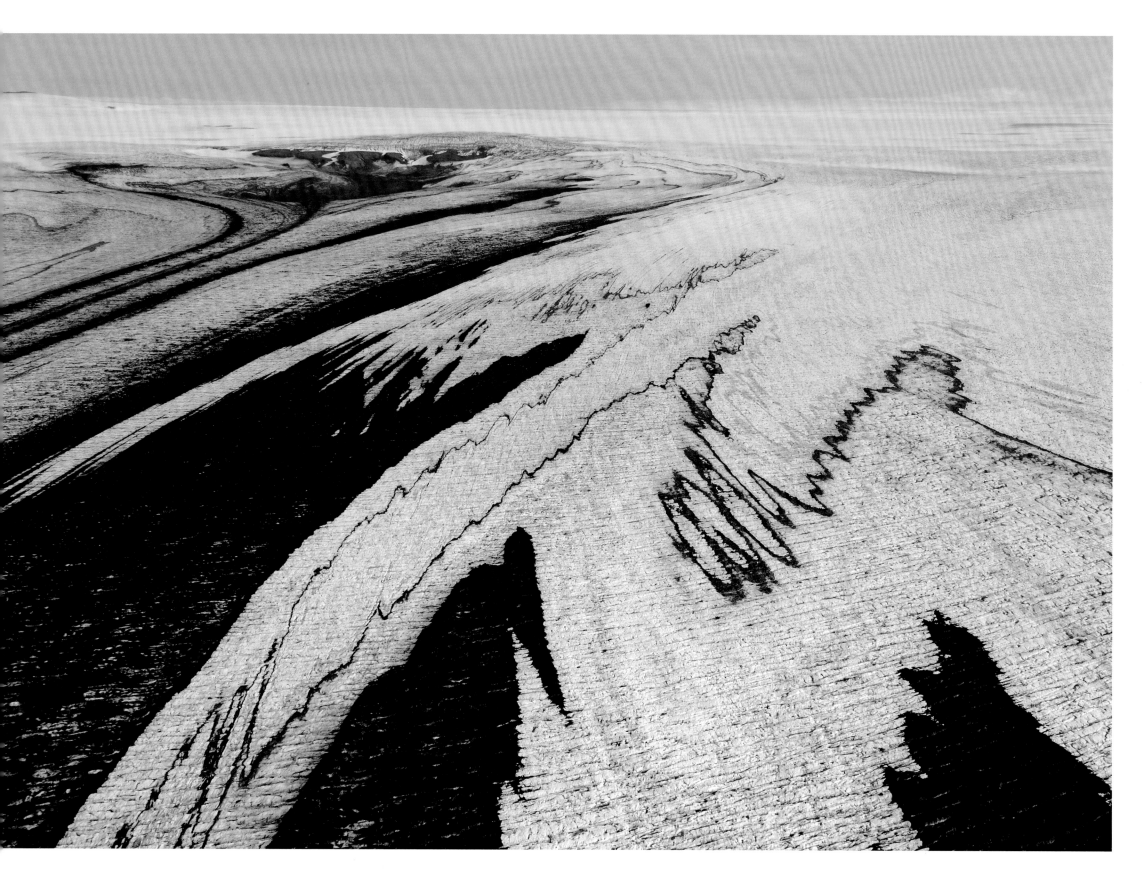

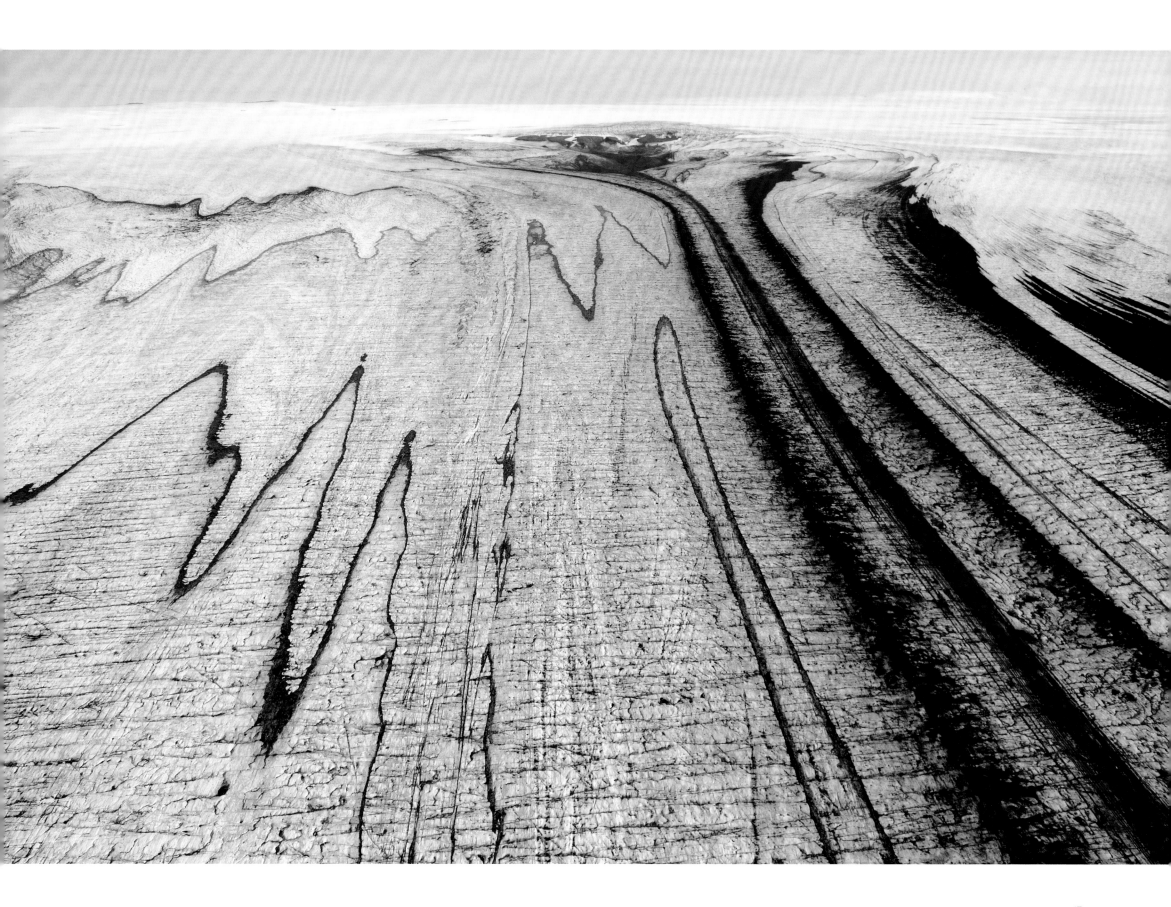

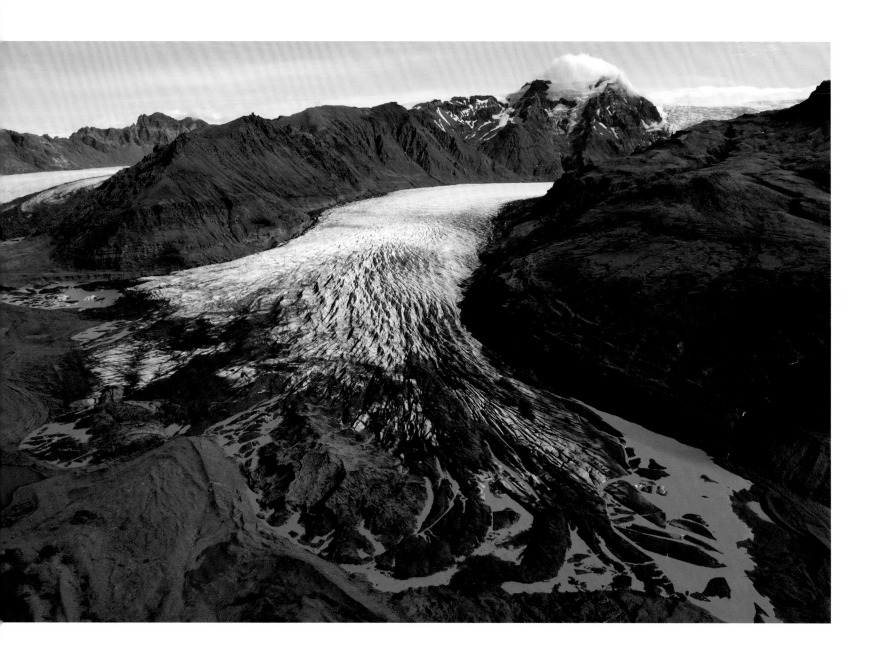

▲ Svínafellsjökull | **Iceland** | 24 July 2008 | With the retreat of the ice, a lake is born at the foot of Hvannadalshnúkur, Iceland's highest peak.

▶ Sólheimajökull | **Iceland** | 25 March 2011 | Ice filled this entire valley in 2005.

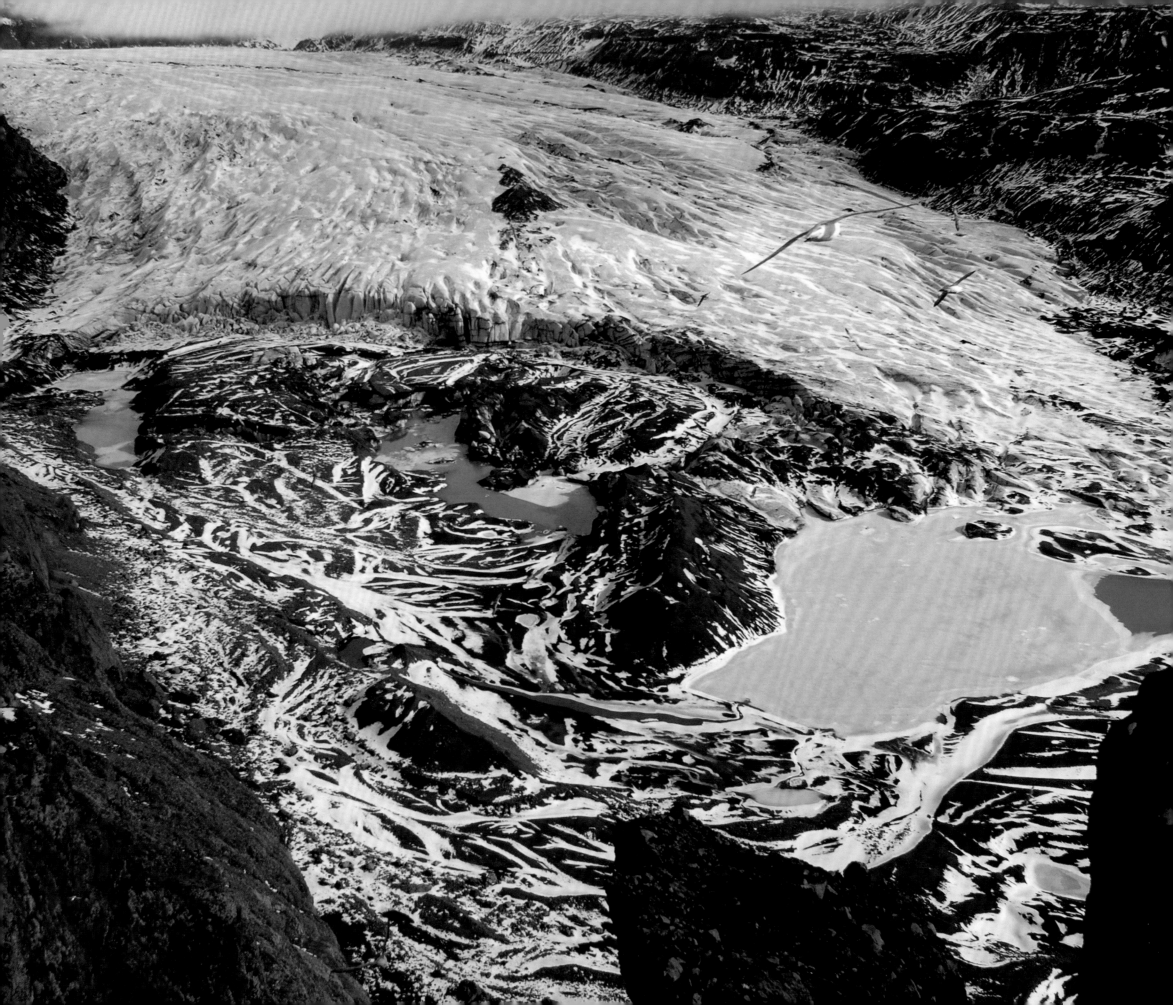

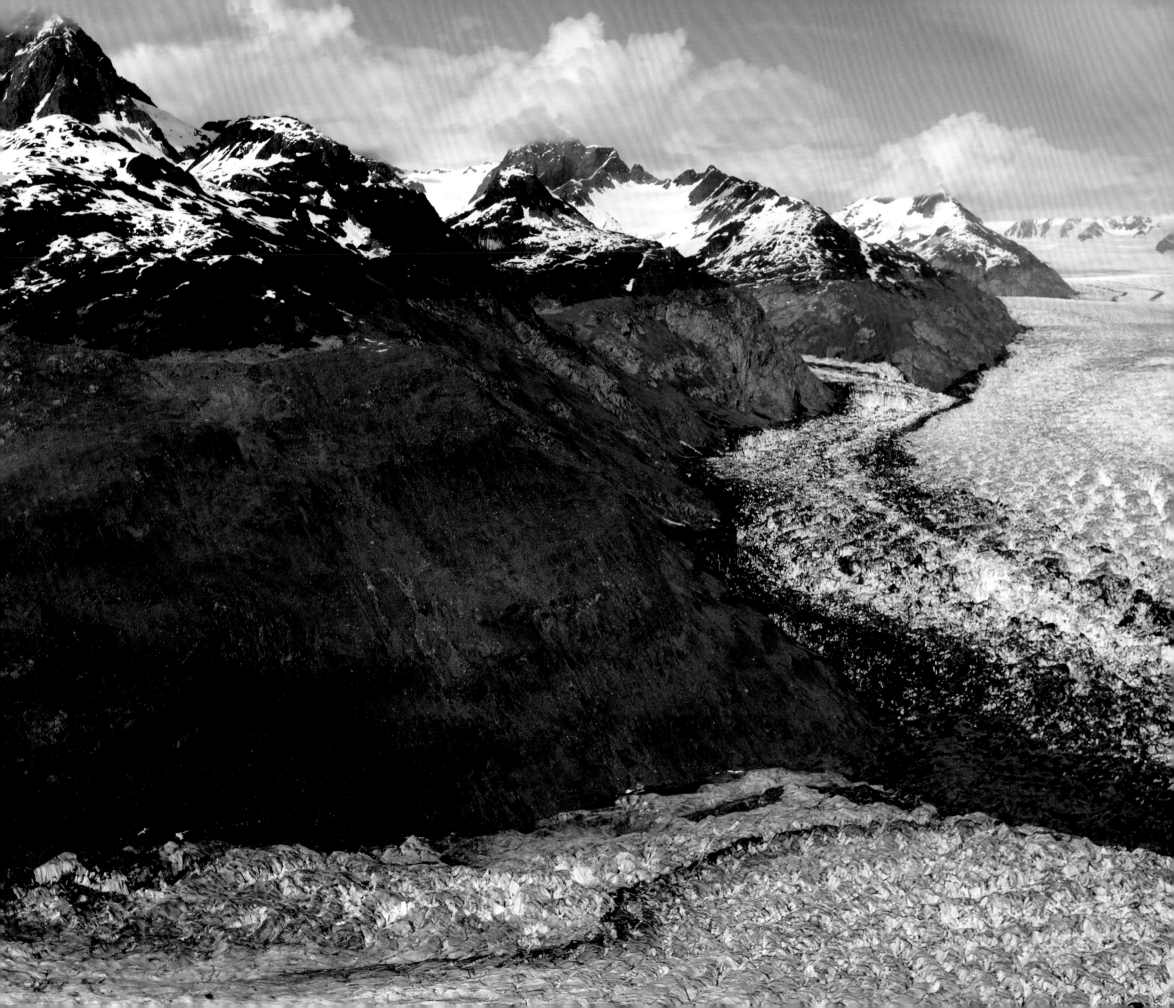

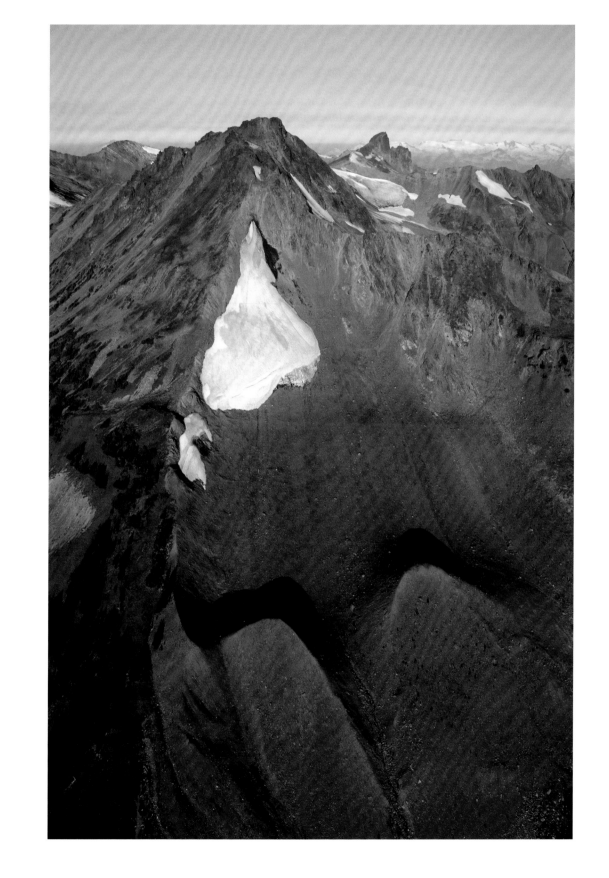

◀ Columbia Glacier | **Alaska, United States** | 23 June 2006
In the mid-1980s, ice filled this valley up to the lower edge of the dark band
of vegetation. Ice deflation since then is more than 1,200 vertical feet.

▶ Coast Mountains | **British Columbia, Canada** | 31 August 2009
The last fragment of a tiny, unnamed "pocket" glacier.

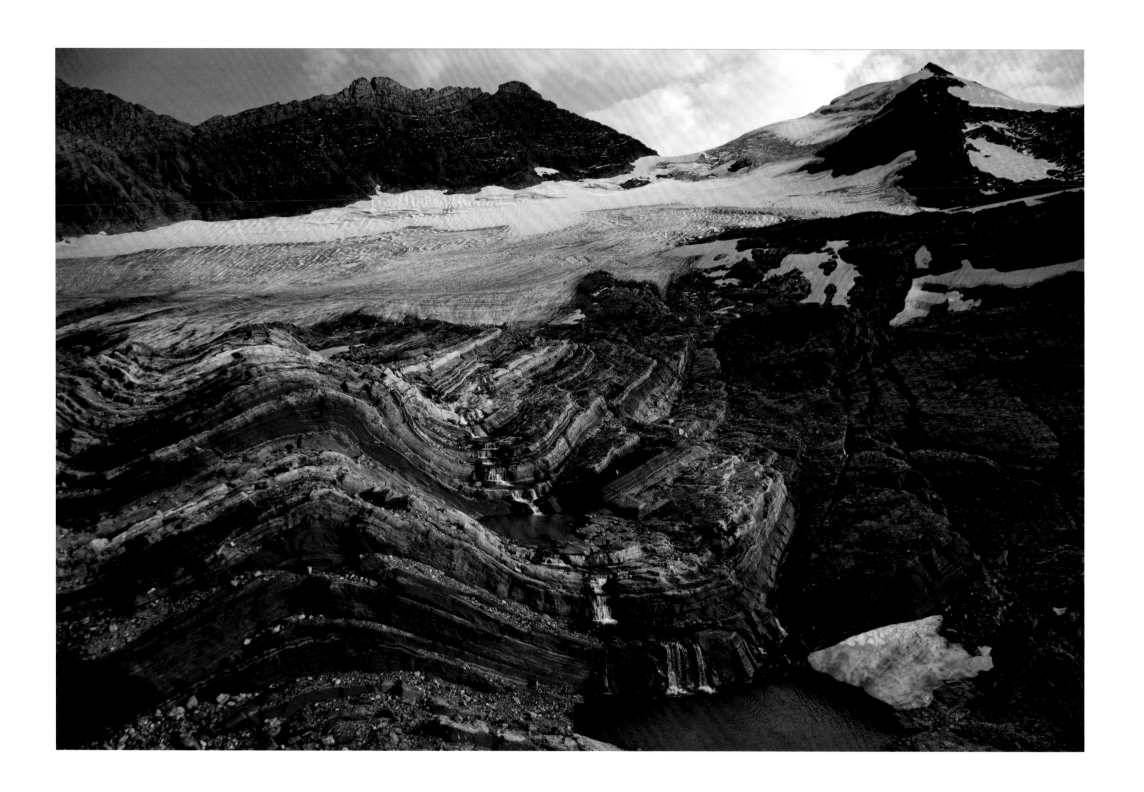

▲ Sperry Glacier, Glacier National Park | **Montana, United States** | 4 September 2006
Bedrock and a waterfall appeared as the glacier thinned and retreated. When all the park's ice is gone by mid-century, a glacier-less national treasure will need a new name.

▶ Oberer Grindelwald Glacier | **Switzerland** | 27 September 2006

▶ Mendenhall Glacier | **Alaska, United States** | 16 September 2010
Bedrock polished by flowing ice is now exposed by glacial retreat.

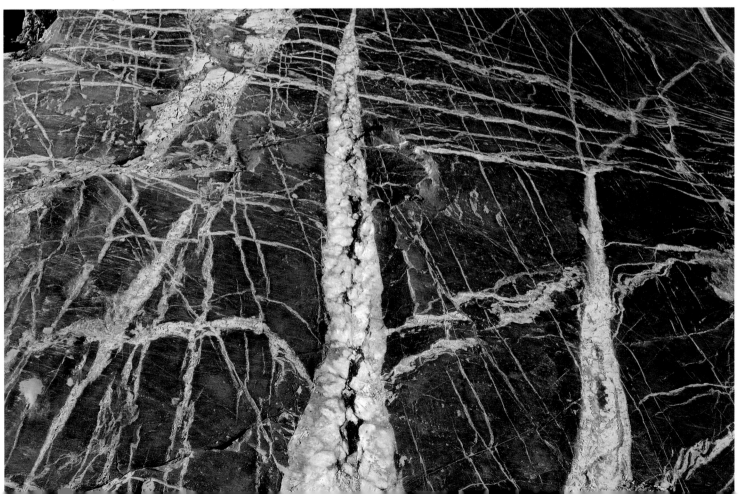

▶ Sólheimajökull | **Iceland** | 23 February 2009 | Snowdrift on bare ice, etched by volcanic ash.

▼ LEFT: Columbia Glacier | **Alaska, United States** | 8 June 2005 | Terminus of the glacier.

RIGHT: Columbia Glacier | **Alaska, United States** | 6 September 2010 | View from Digital Globe WorldView 1 satellite.

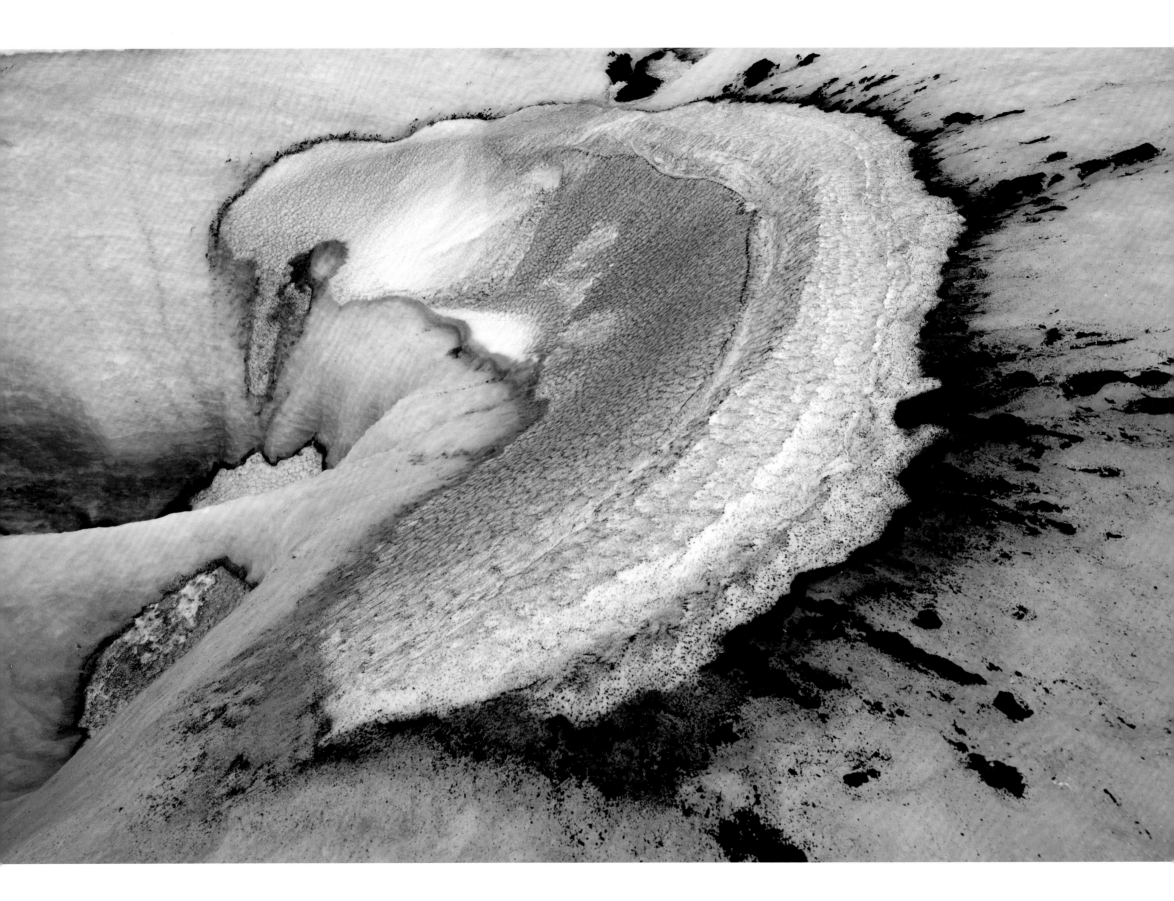

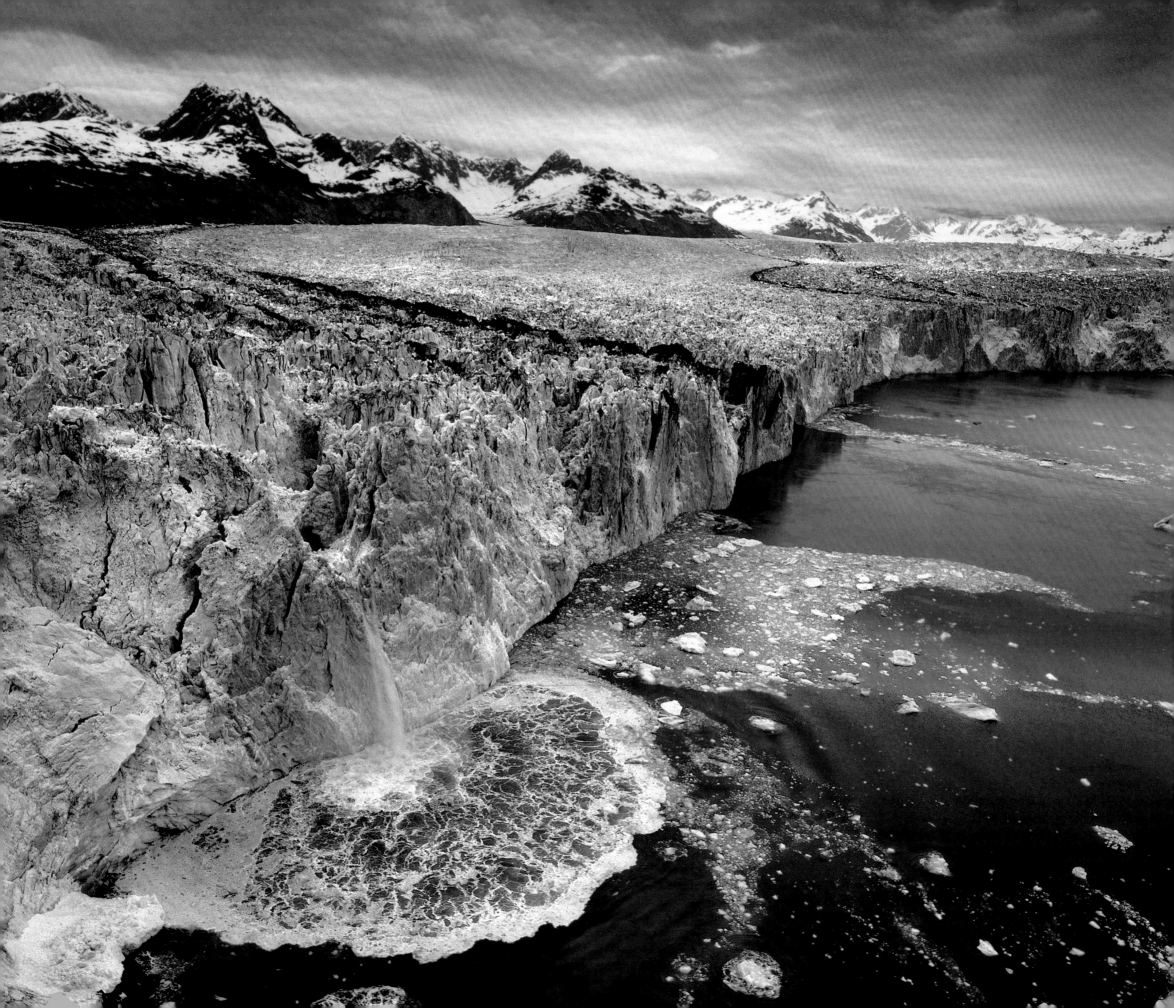

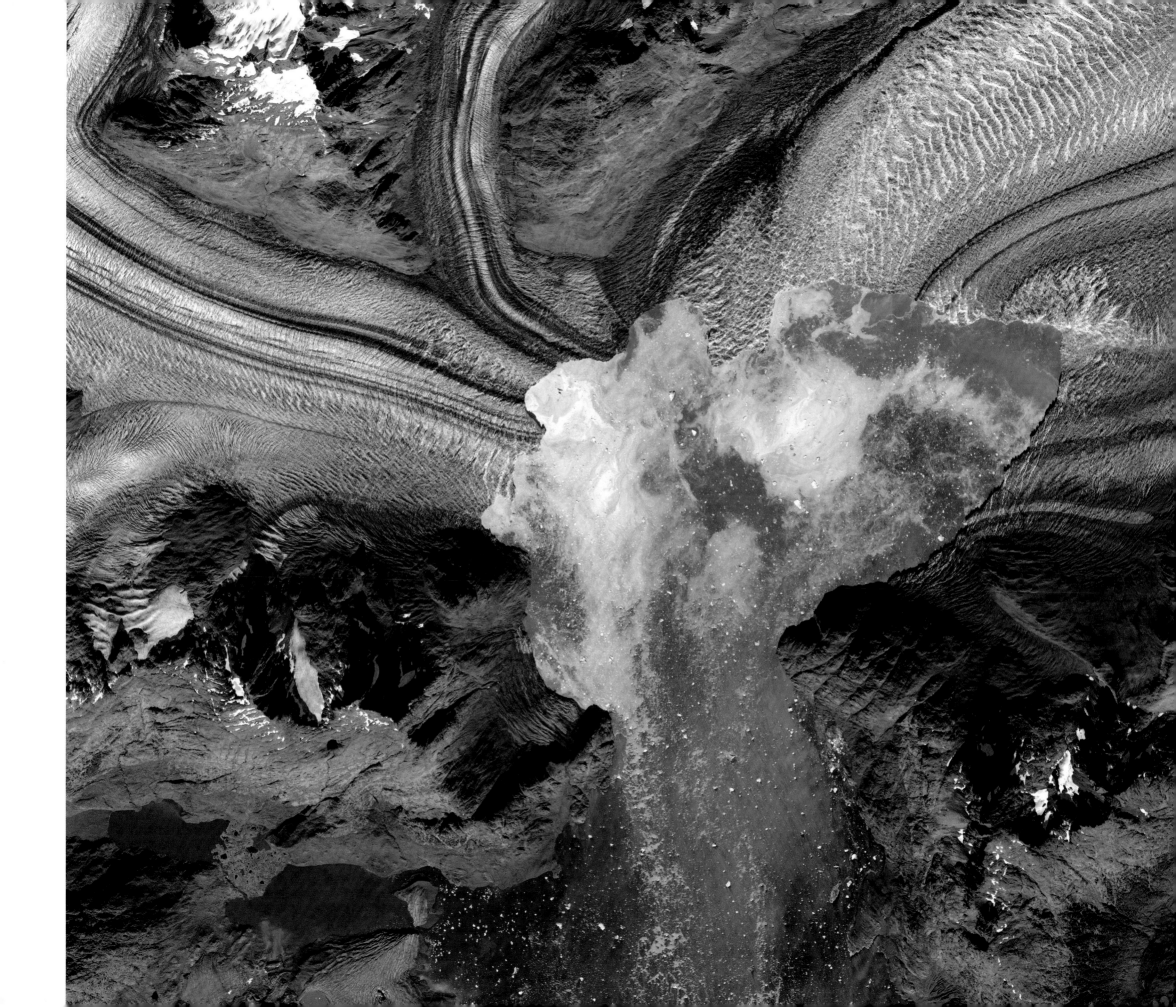

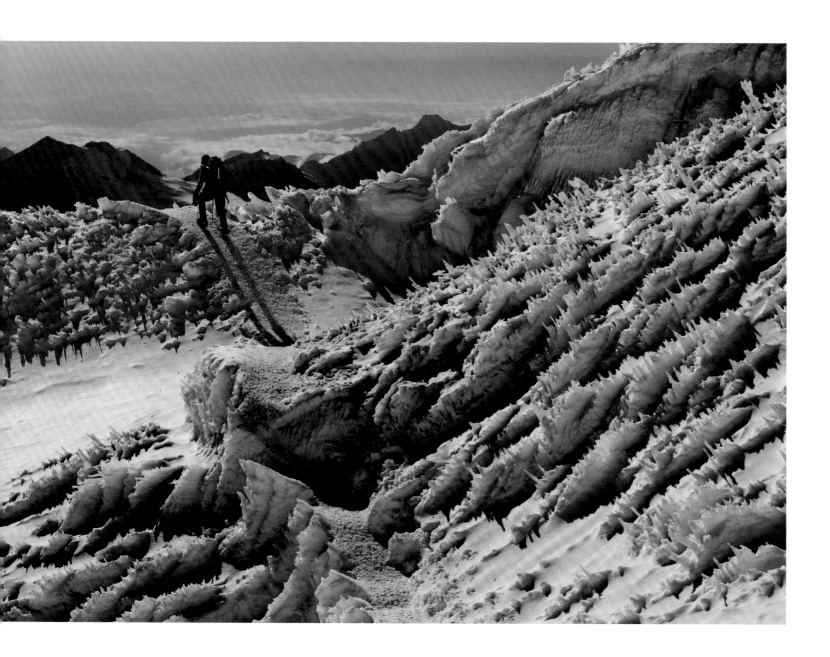

▲ Huayna Potosi | **Bolivia** | 20 August 2006 | High-altitude sun cooks the ice into small *neve penitentes*.

► Huayna Potosi | **Bolivia** | 20 August 2006

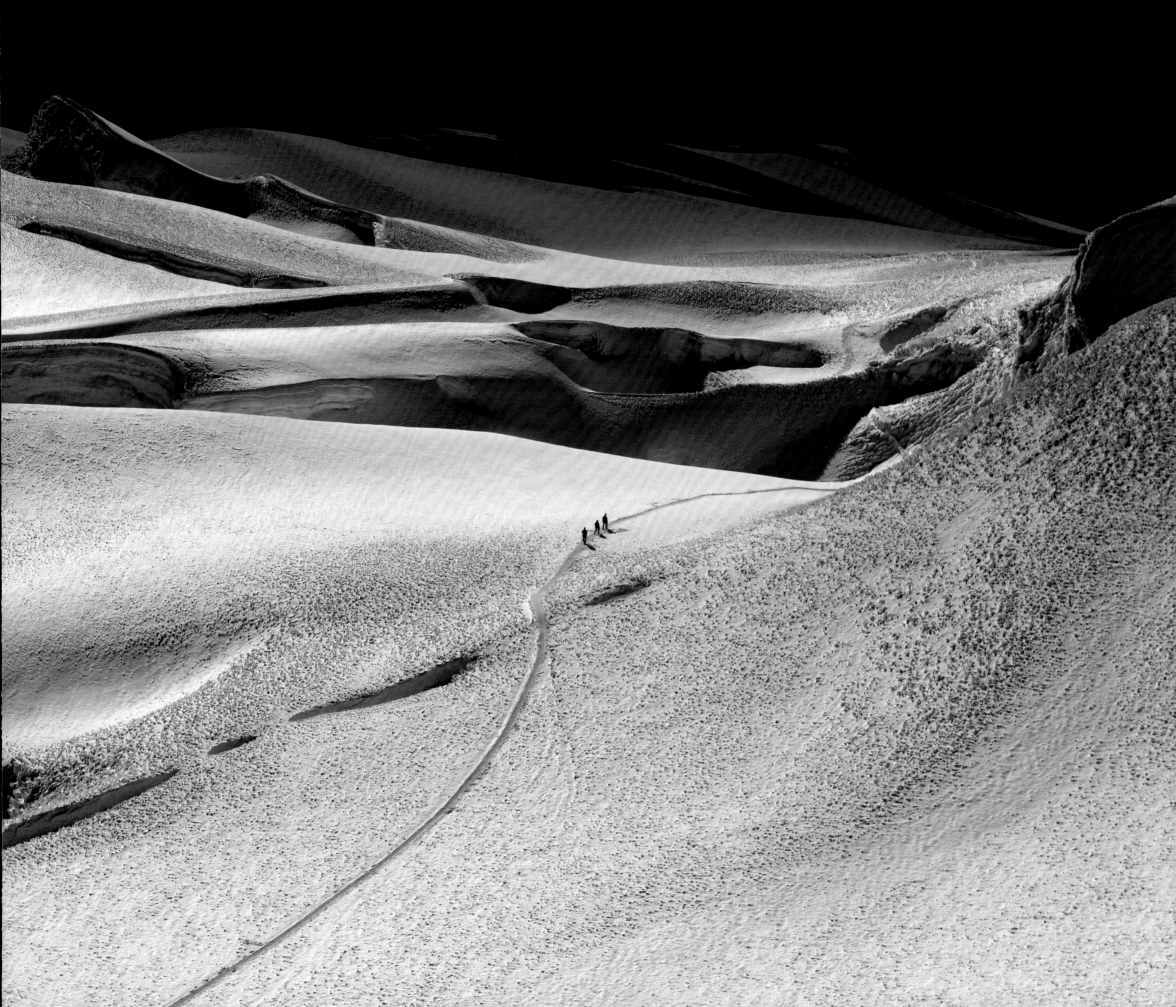

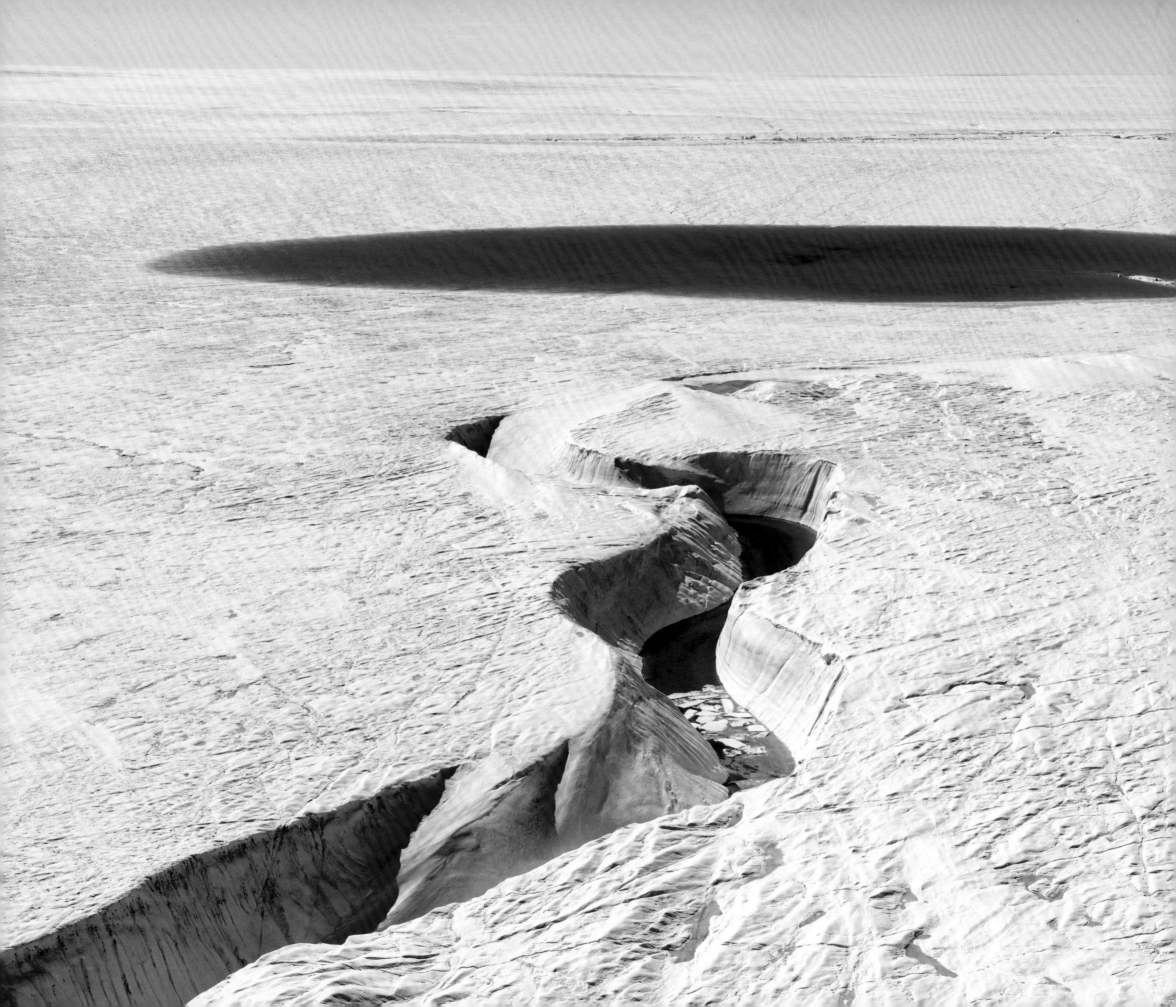

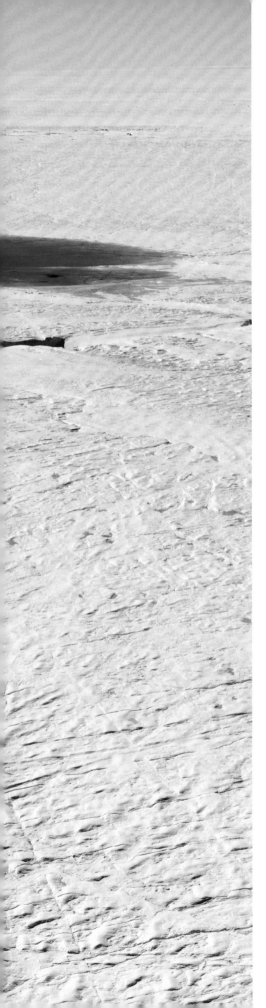

◀ Birthday Canyon and North-North Lake, Greenland Ice Sheet | **Greenland** | 28 June 2009 | When meltwater fills the lake, it overflows into the canyon.

▼ South Lake, Greenland Ice Sheet | **Greenland** | 20 July 2006

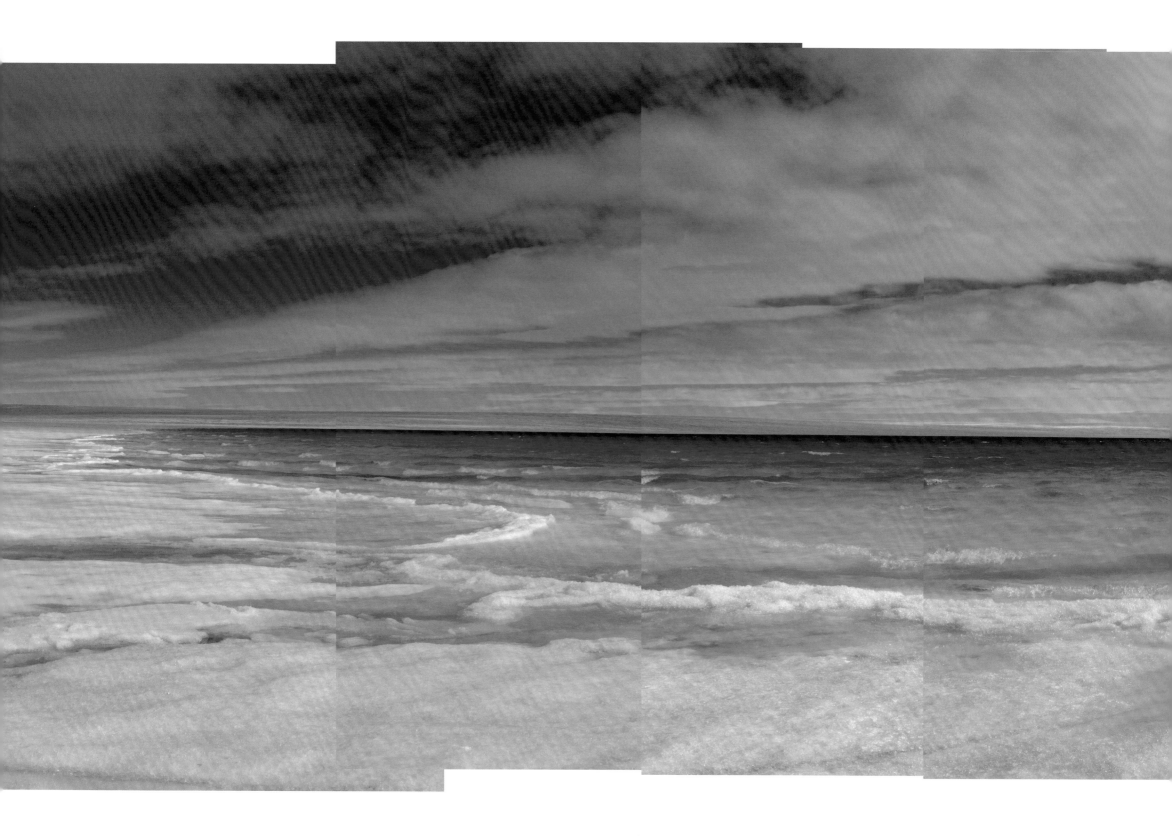

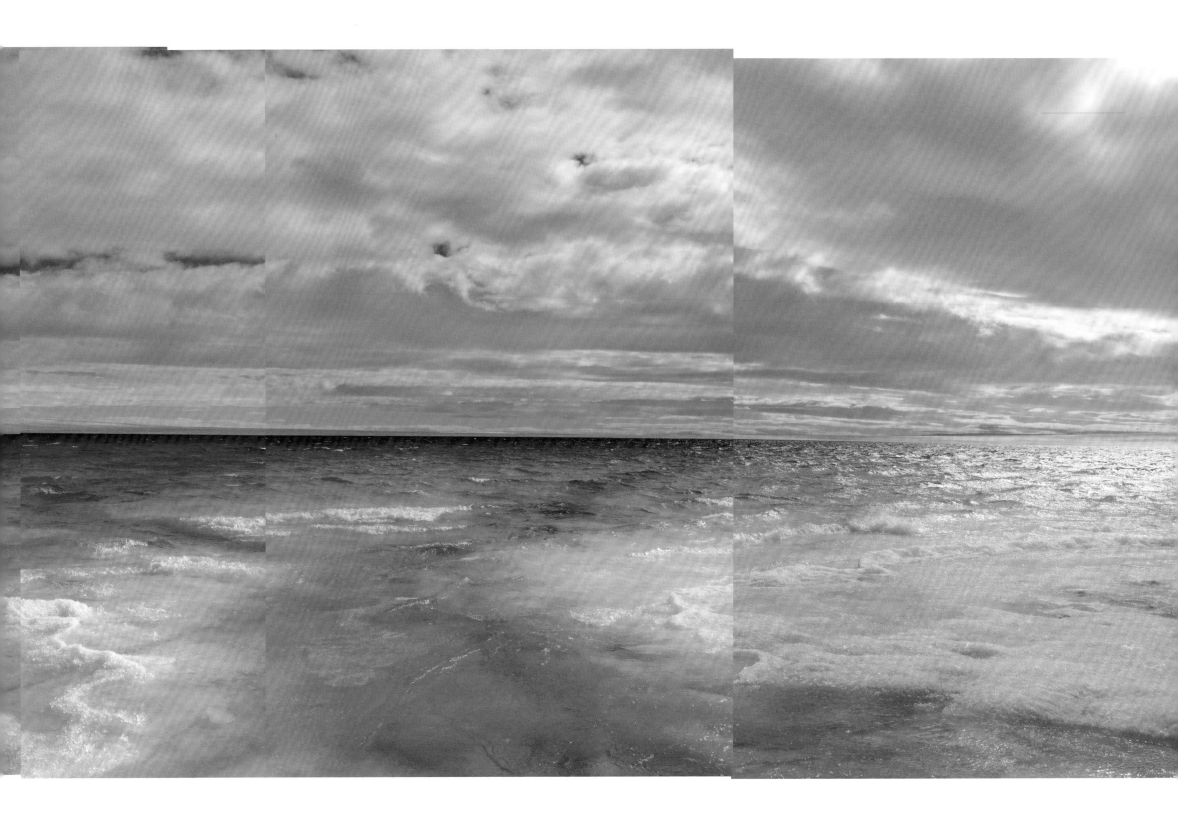

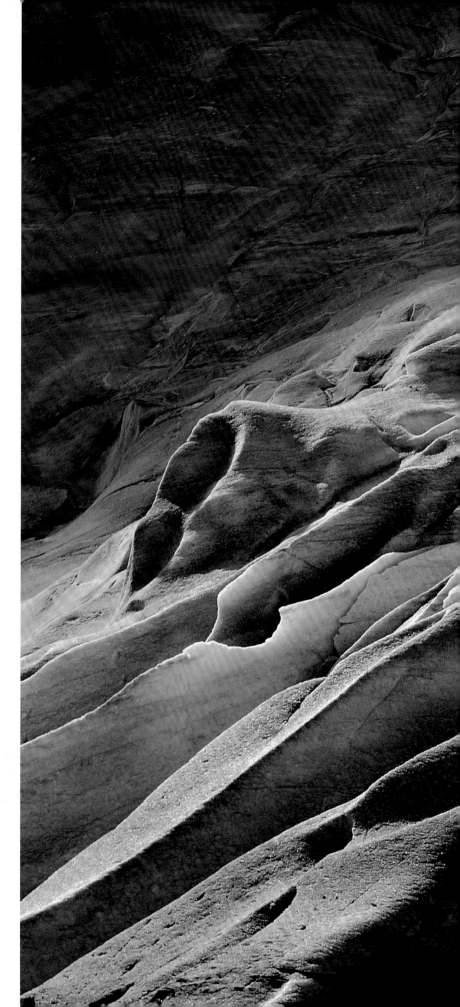

► Crevasses at Mendenhall Glacier │ **Alaska, United States** │ 15 September 2010

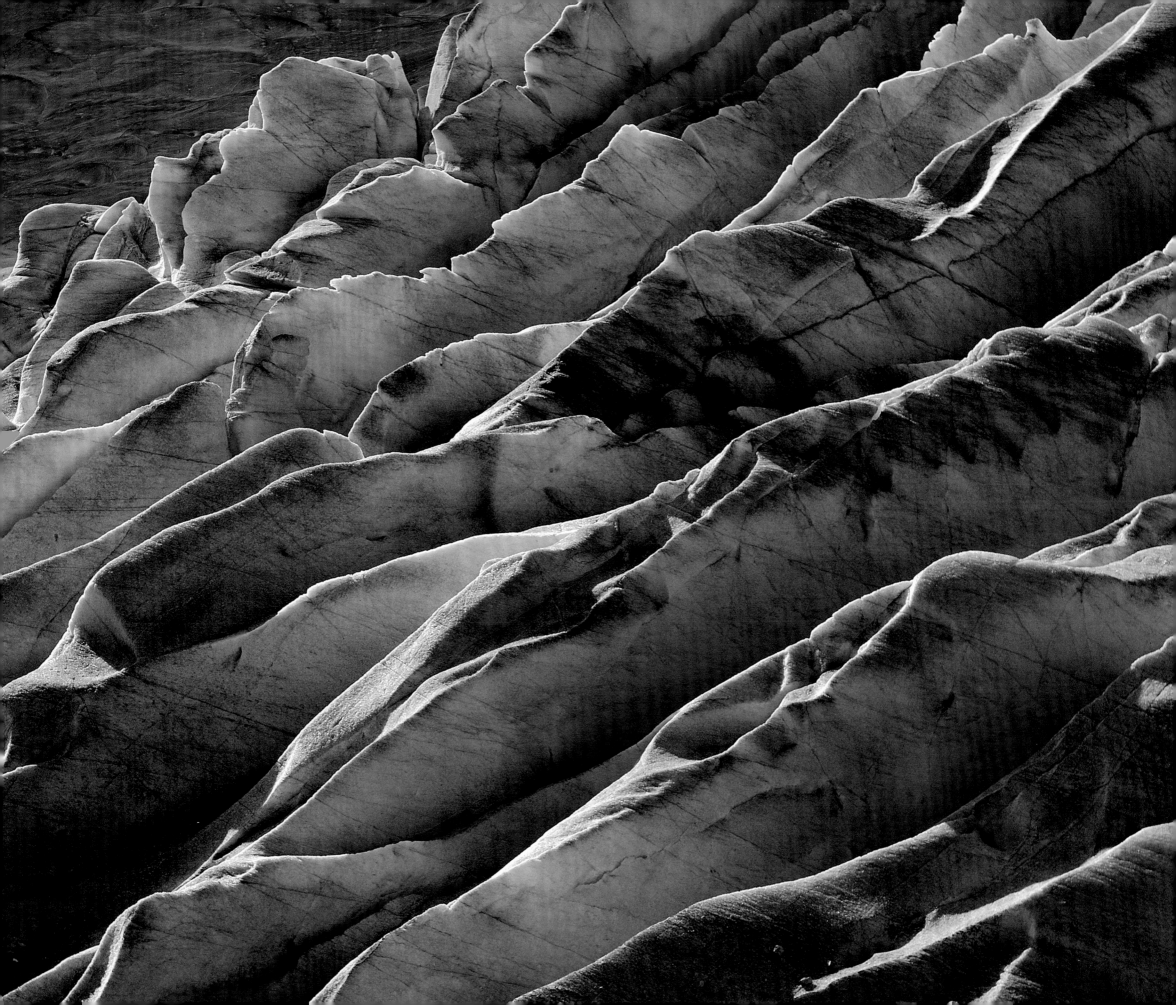

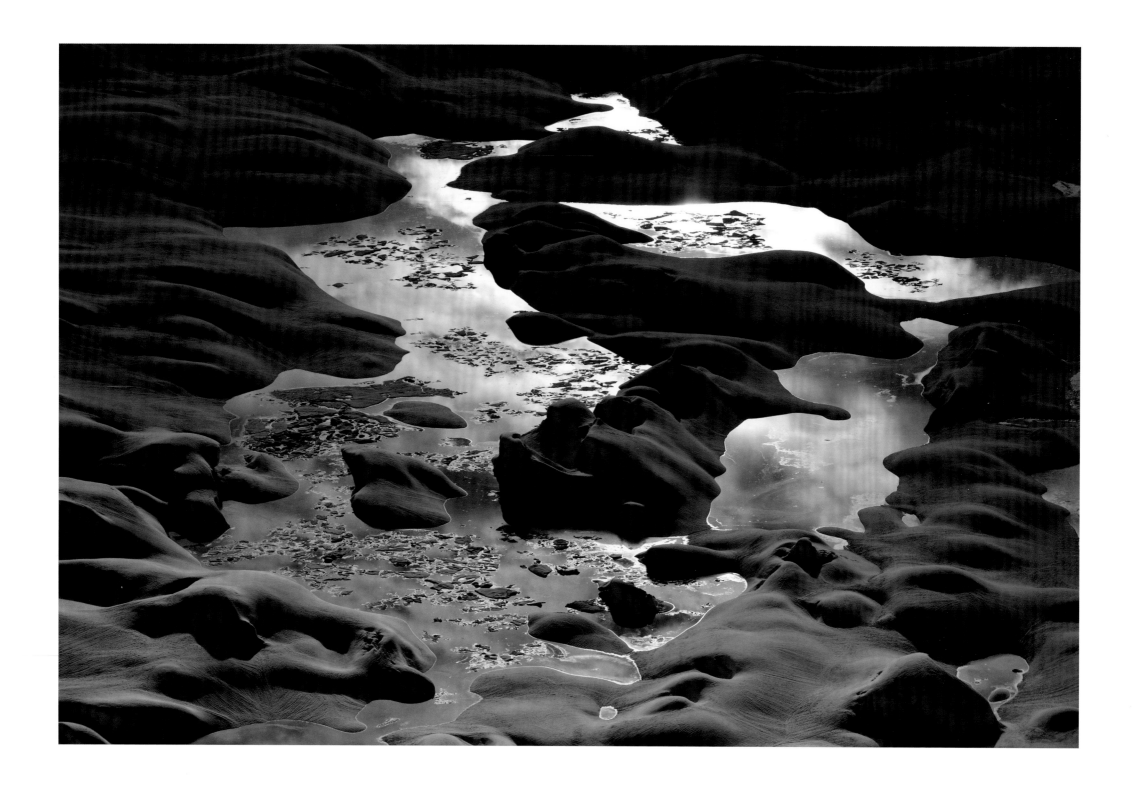

▲ Meltwater pool on Columbia Glacier | **Alaska, United States** | 20 June 2008 ▶ Grinnell Glacier, Glacier National Park | **Montana, United States** | 4 September 2006

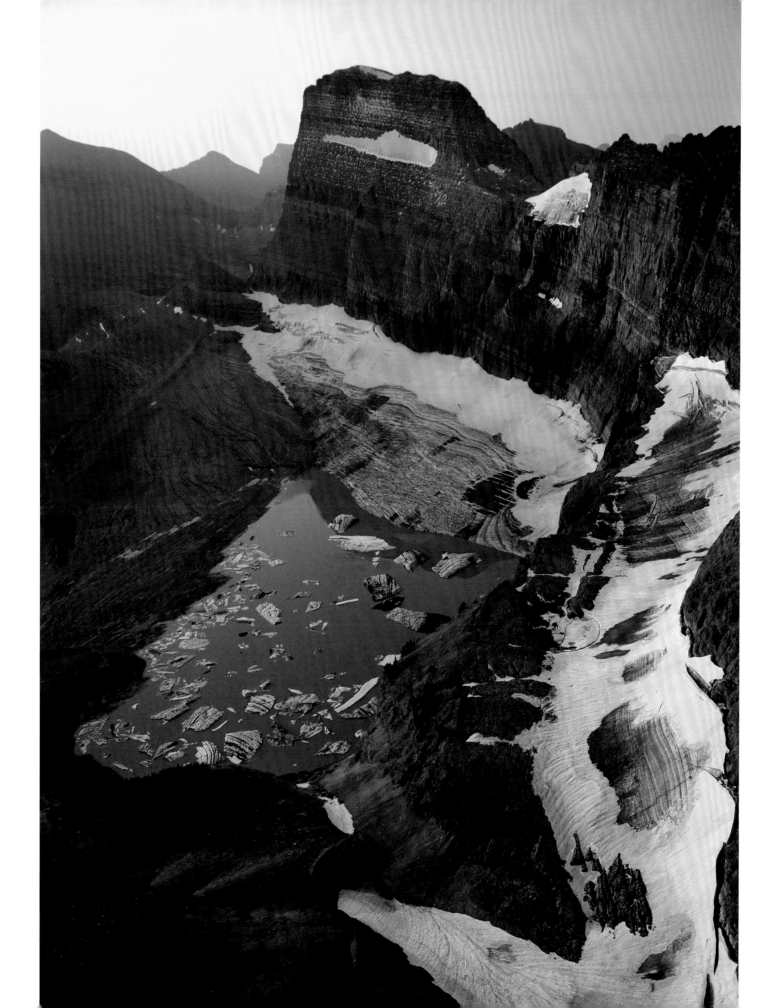

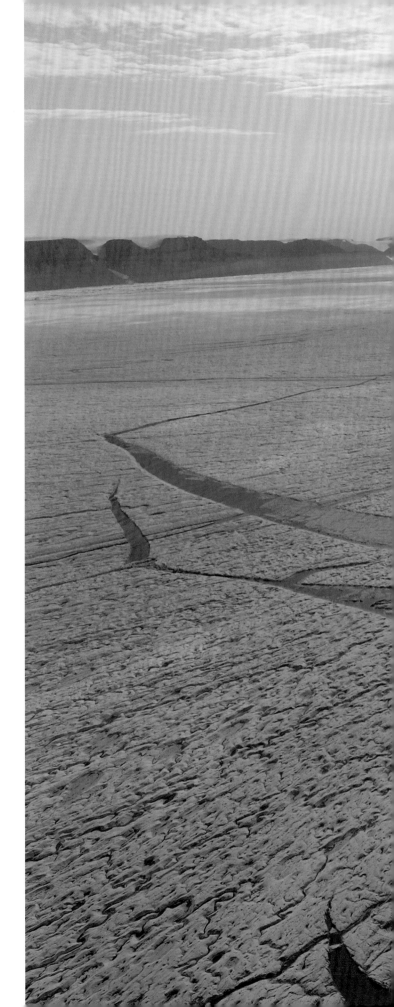

▶ Petermann Glacier and unnamed tributary | **Greenland** | 29 July 2009
Gigantic ice tongue flows into the sea in northwest Greenland.

▼ Columbia Glacier | **Alaska, United States** | 25 August 2009

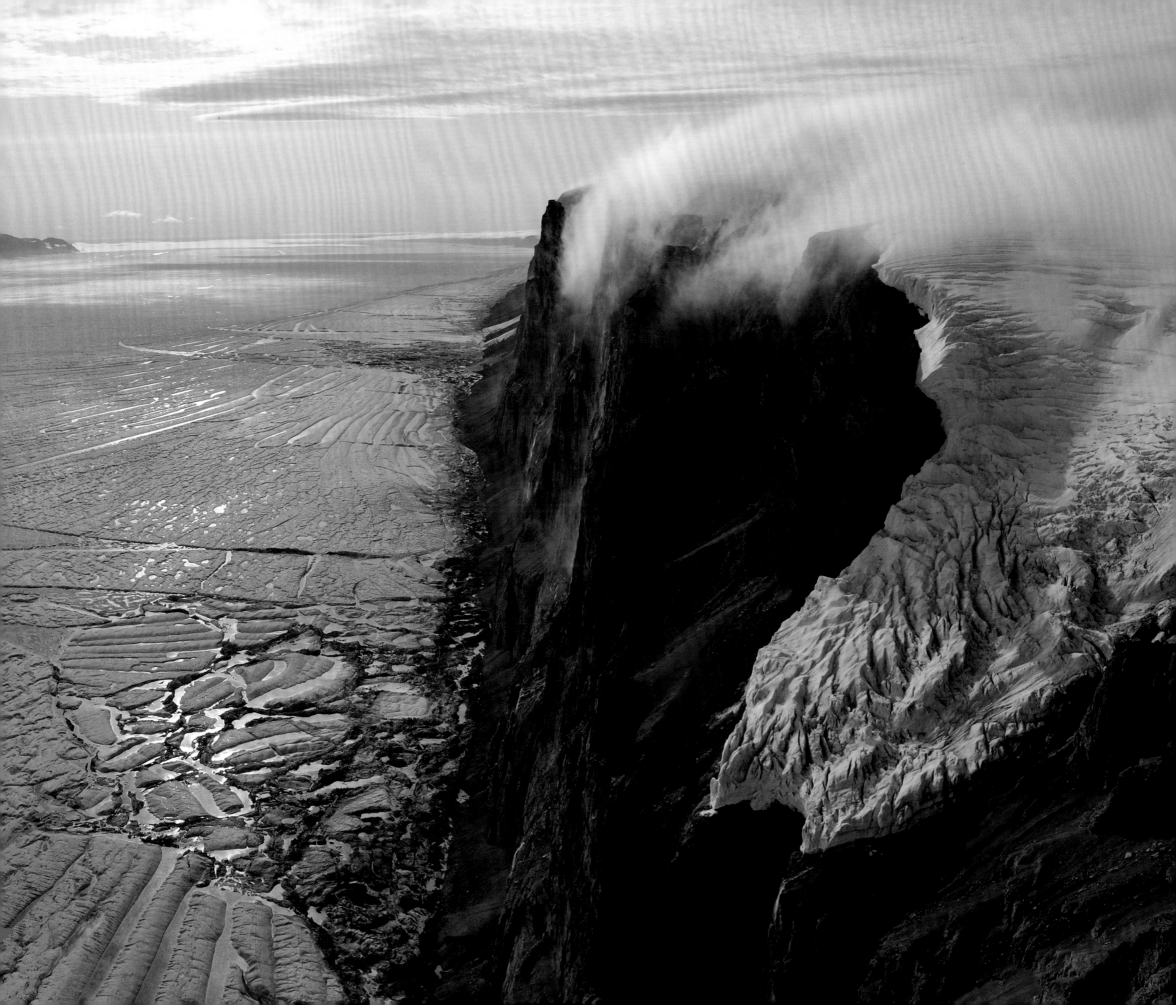

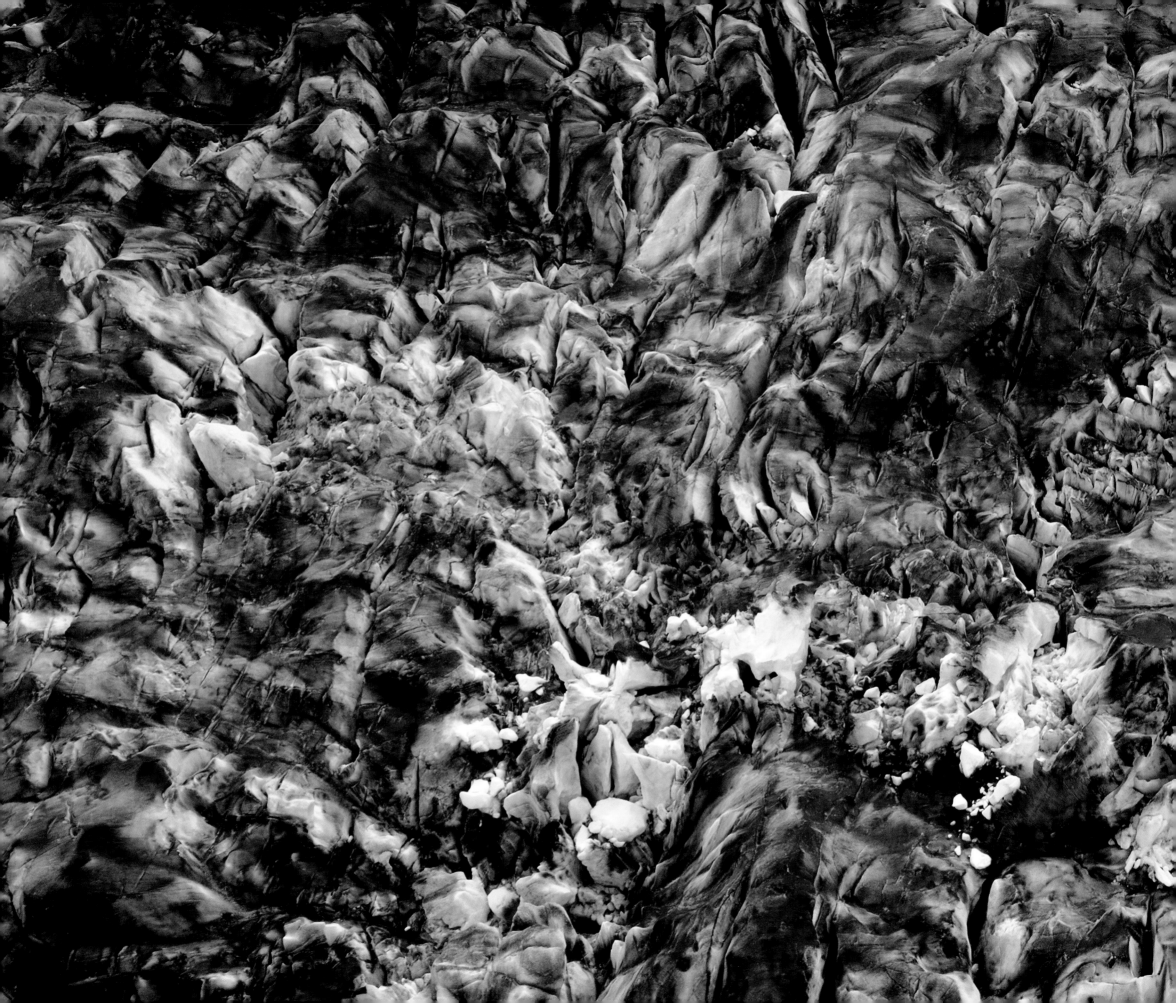

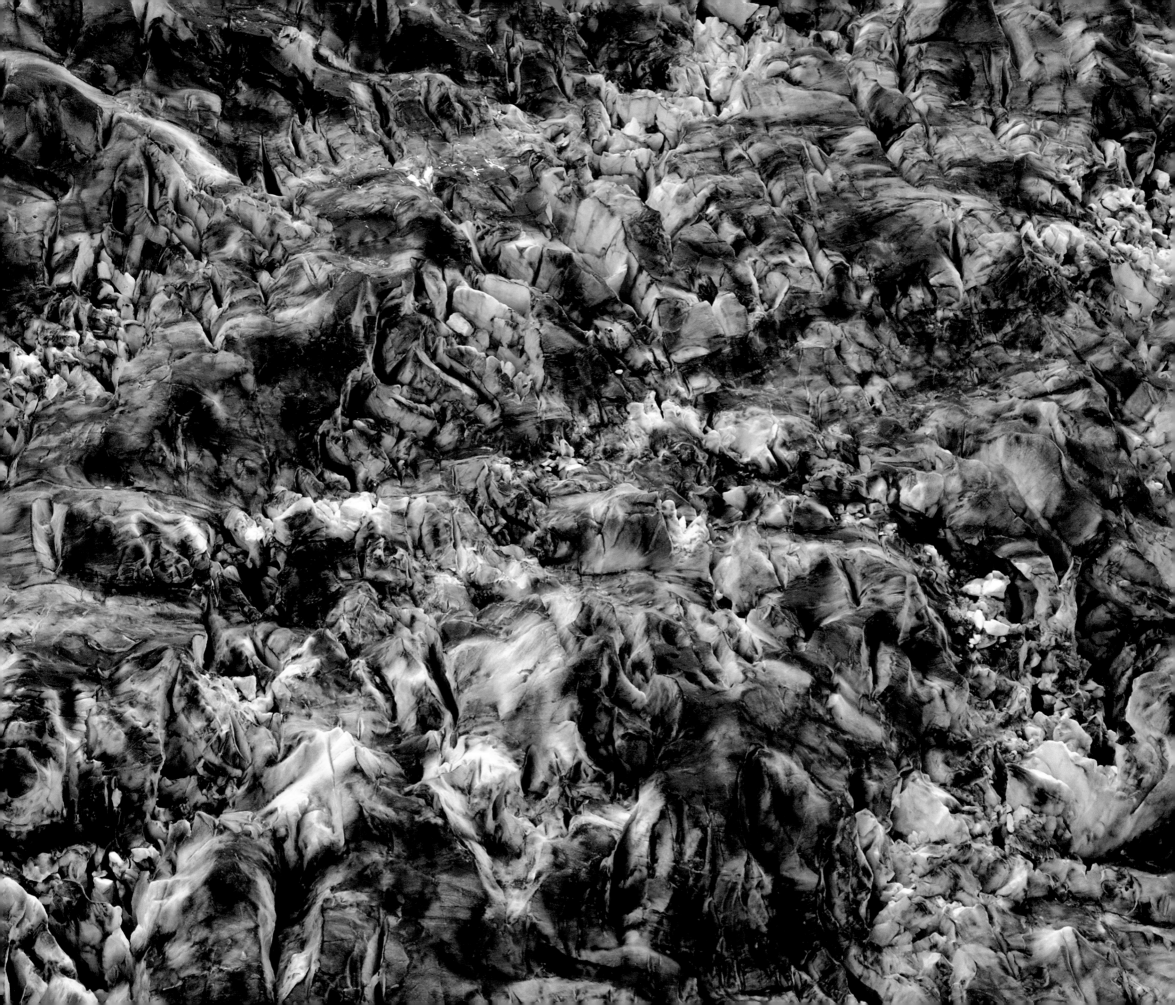

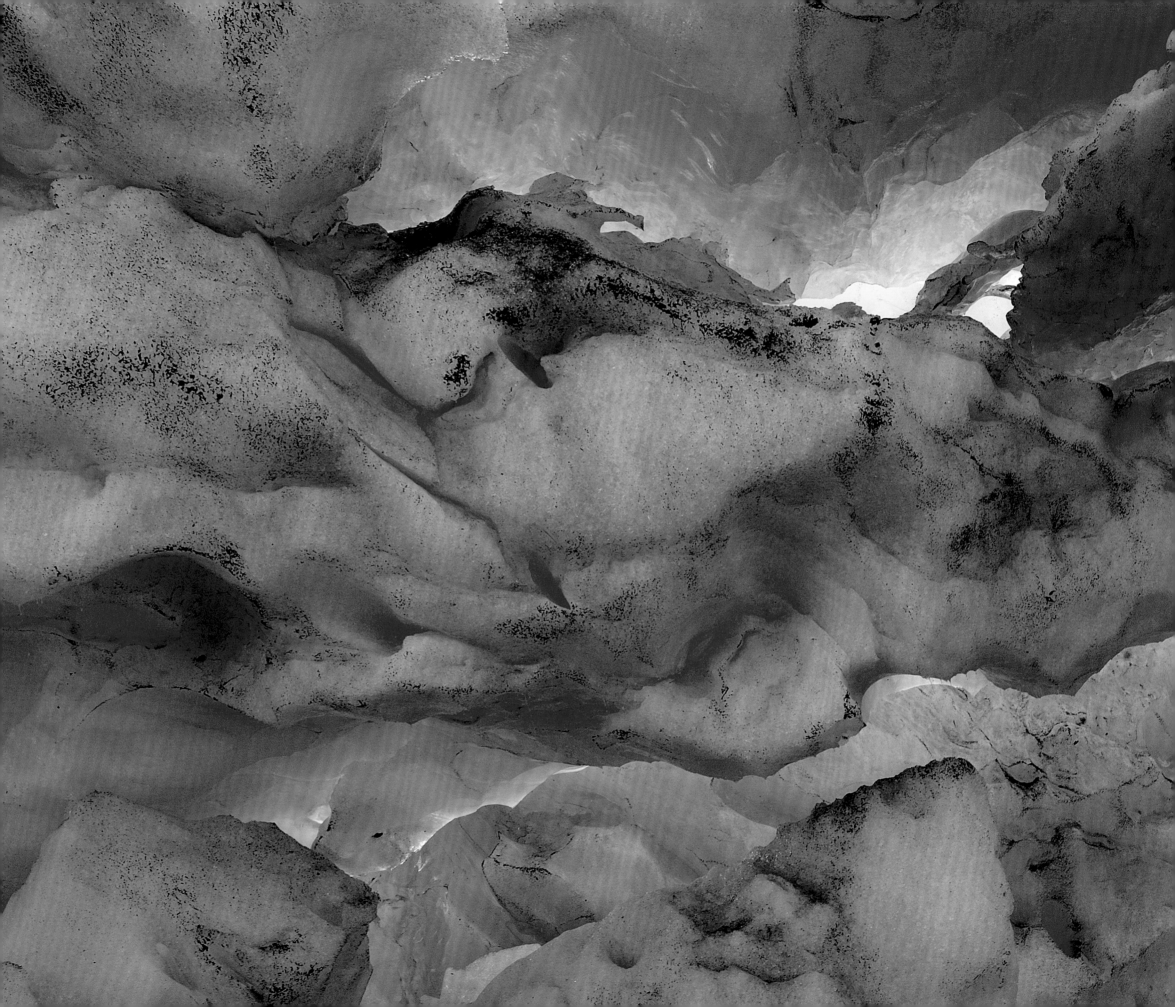

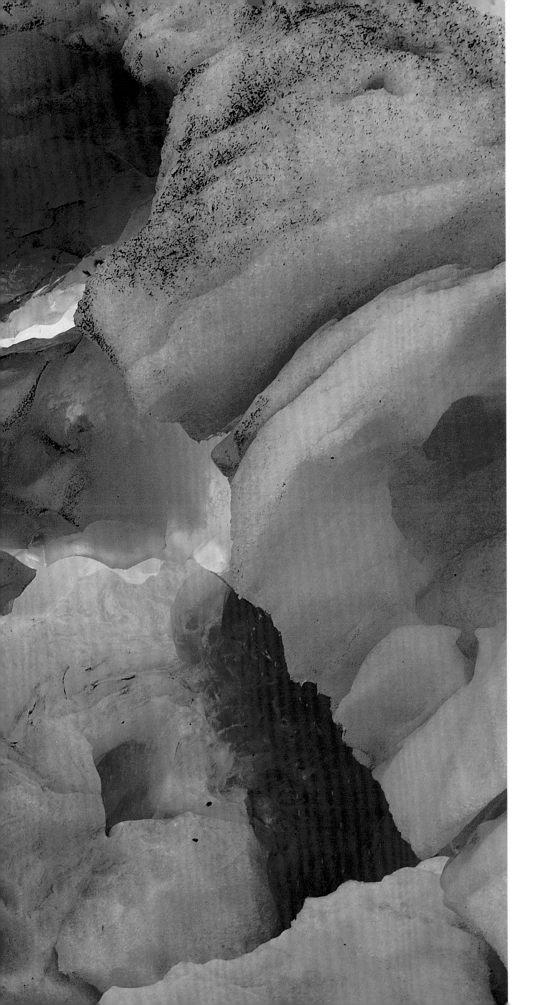

◀ Mendenhall Glacier | **Alaska, United States** | 14 September 2010

▼ Whiteout Glacier | **Alaska, United States** | 13 June 2008
Looking up through a crevasse from inside the glacier.

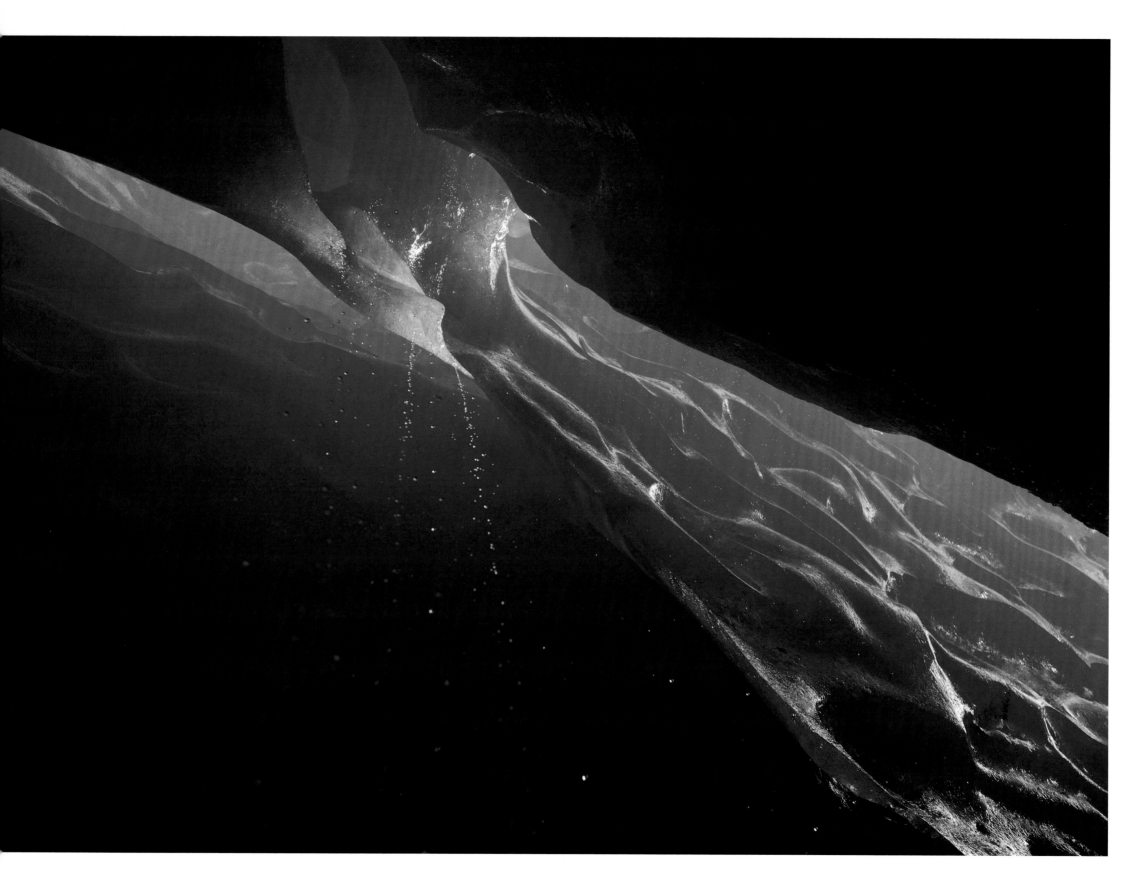

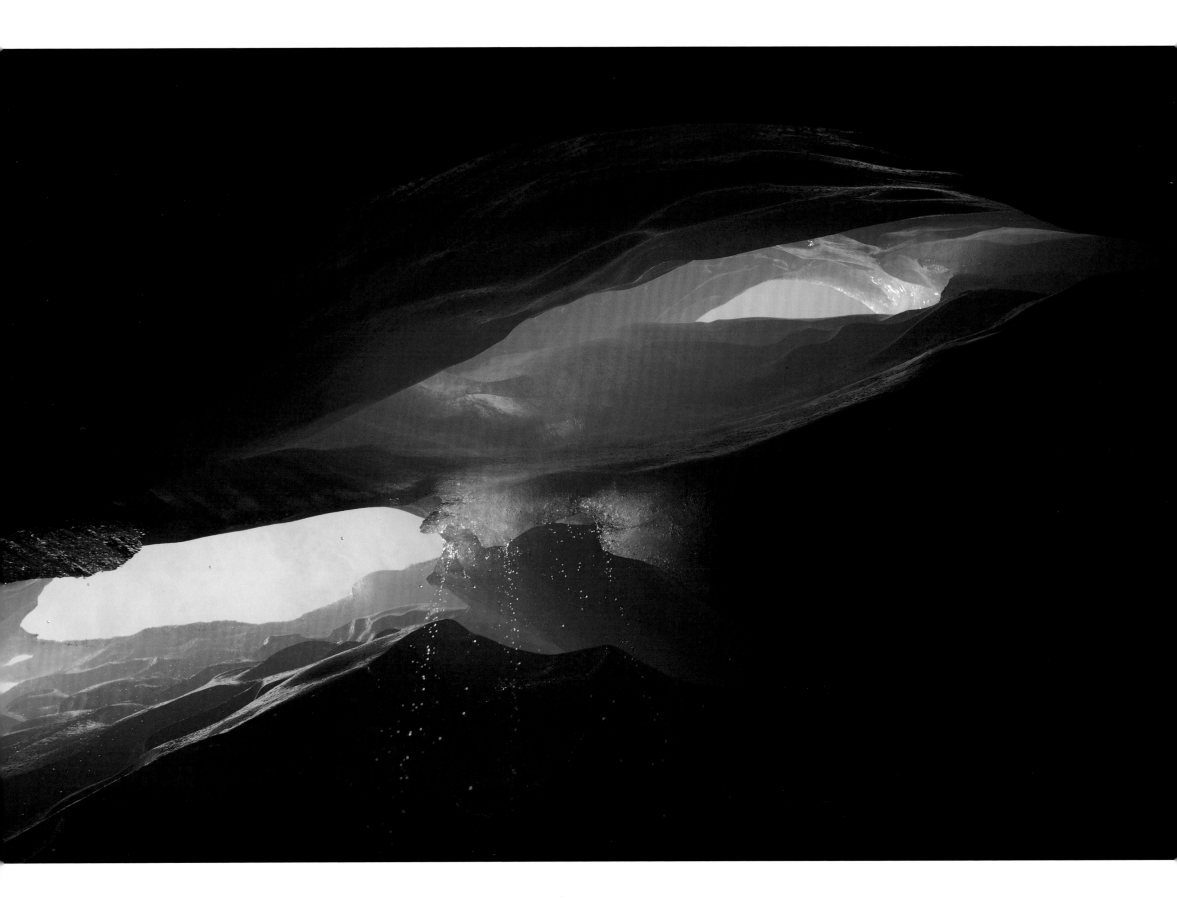

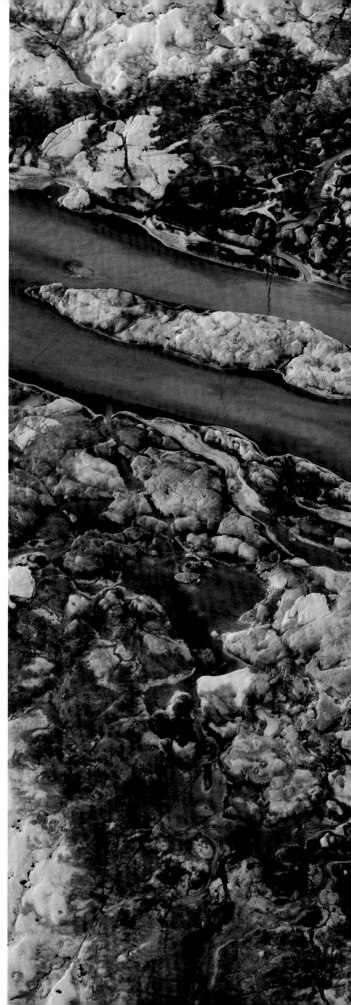

▶ Greenland Ice Sheet | **Greenland** | 15 July 2006 | Meltwater channel carves through silt and dust blown onto the ice.

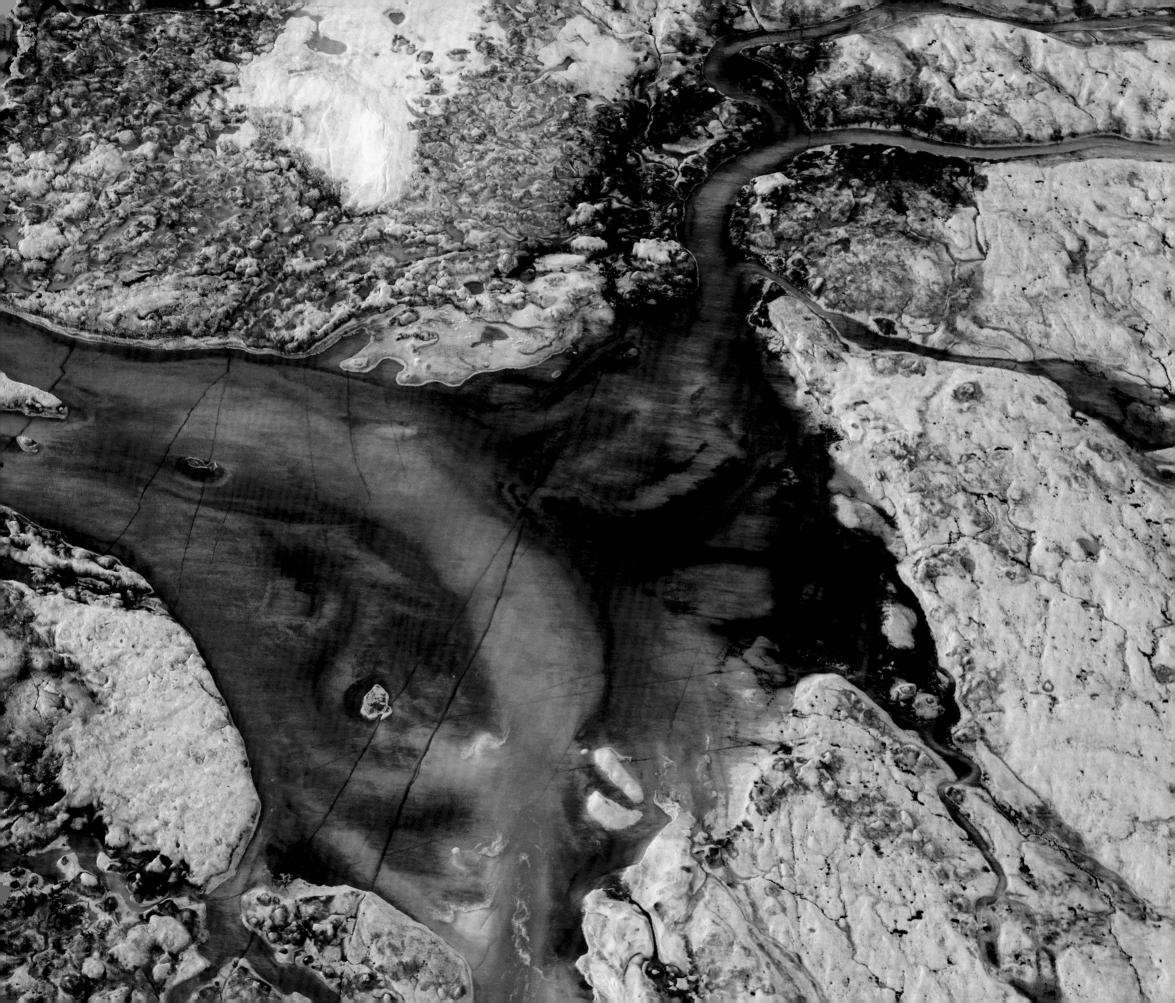

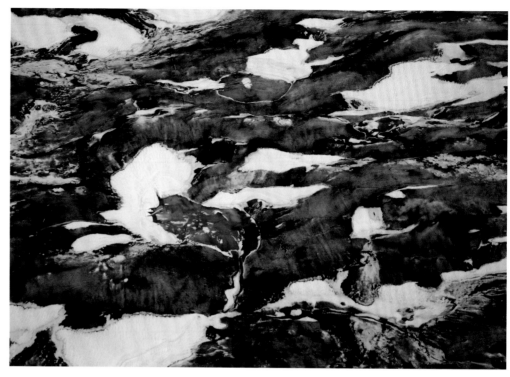

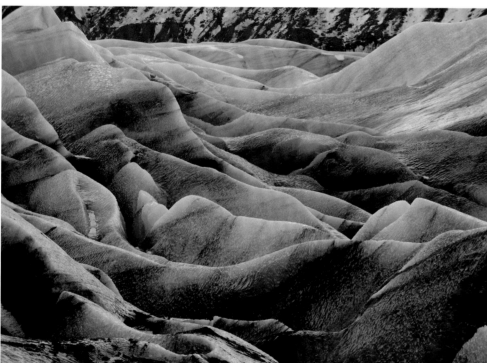

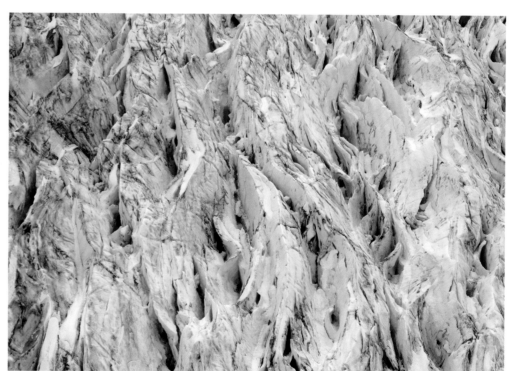

TOP: Knik Glacier | **Alaska, United States** | 13 May 2008

BOTTOM: Svínafellsjökull | **Iceland** | 12 February 2008

TOP: Columbia Glacier | **Alaska, United States** | 23 June 2006

BOTTOM: Knik Glacier | **Alaska, United States** | 13 May 2008

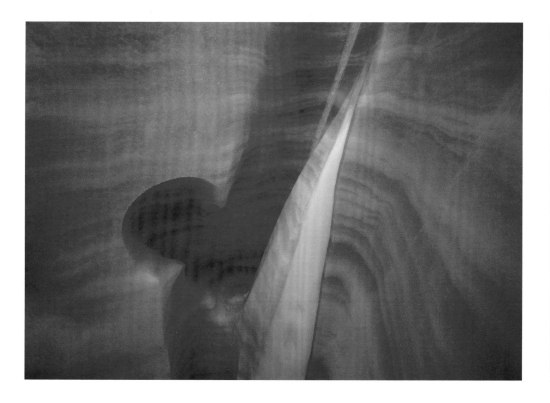

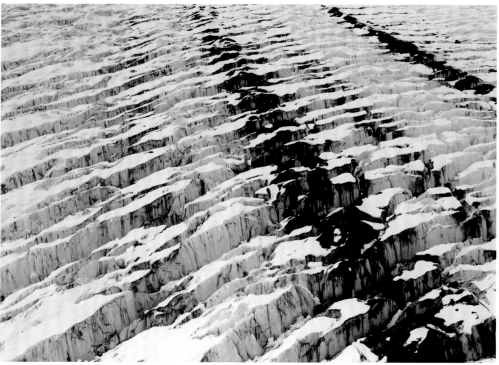

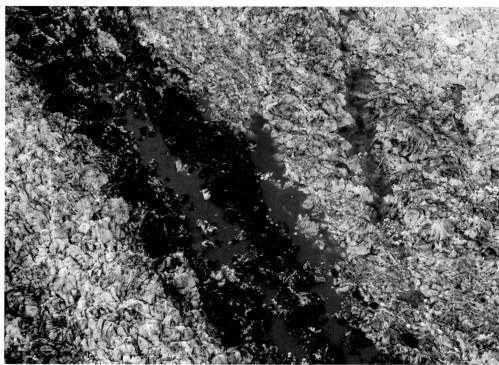

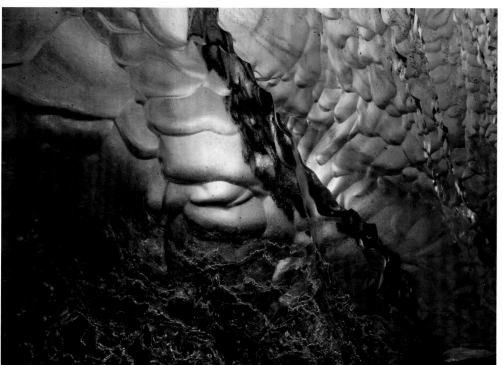

TOP: Nova Moulin, Greenland Ice Sheet | **Greenland** | 13 July 2008

BOTTOM: Columbia Glacier | **Alaska, United States** | 22 June 2006

TOP: West Branch Columbia Glacier | **Alaska, United States** | 17 June 2008

BOTTOM: Jökulsárlón | **Iceland** | 10 February 2008

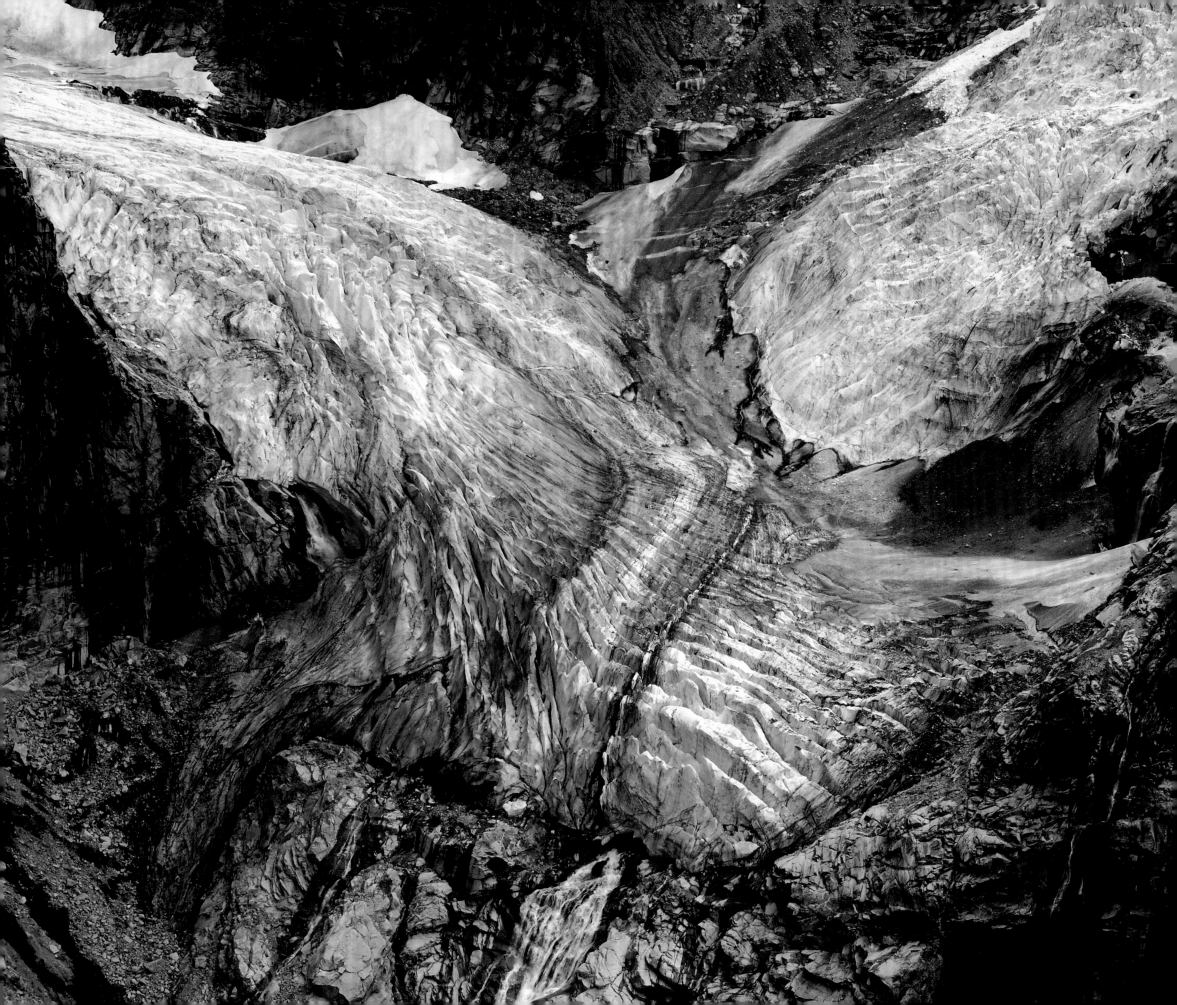

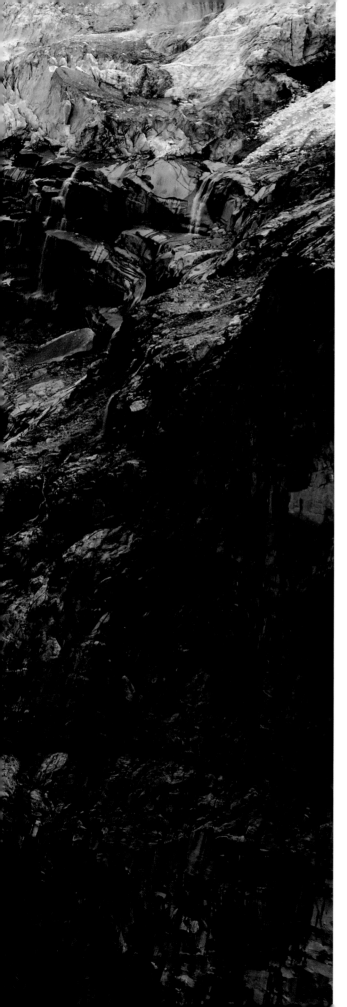

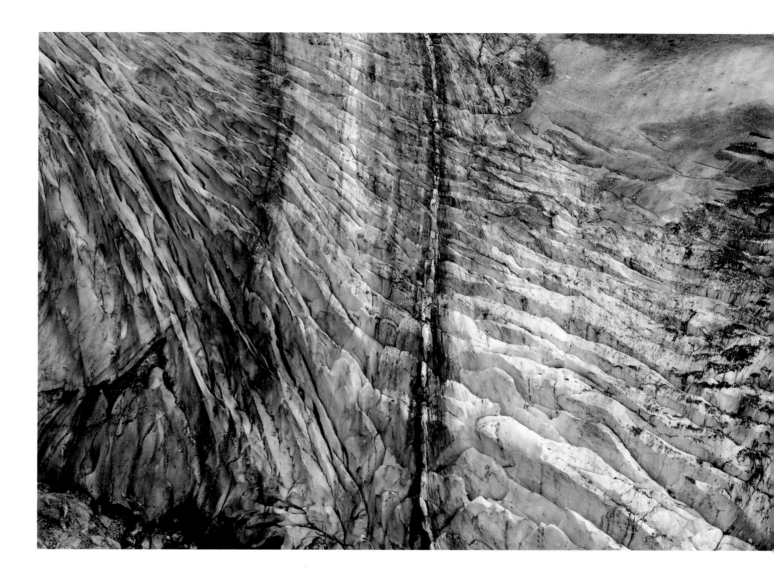

◀ ▲ Tahumming Glacier | **British Columbia, Canada** | 1 September 2008

► Coast Mountains | **British Columbia, Canada** | 2 September 2008 | Algae colors ice and meltwater on the surface of an unnamed lake.

▼ Umiamako Glacier | **Greenland** | 4 June 2008 | Mountain glaciers meet main stem of a tidewater glacier. Seen from Digital Globe WorldView 2 satellite.

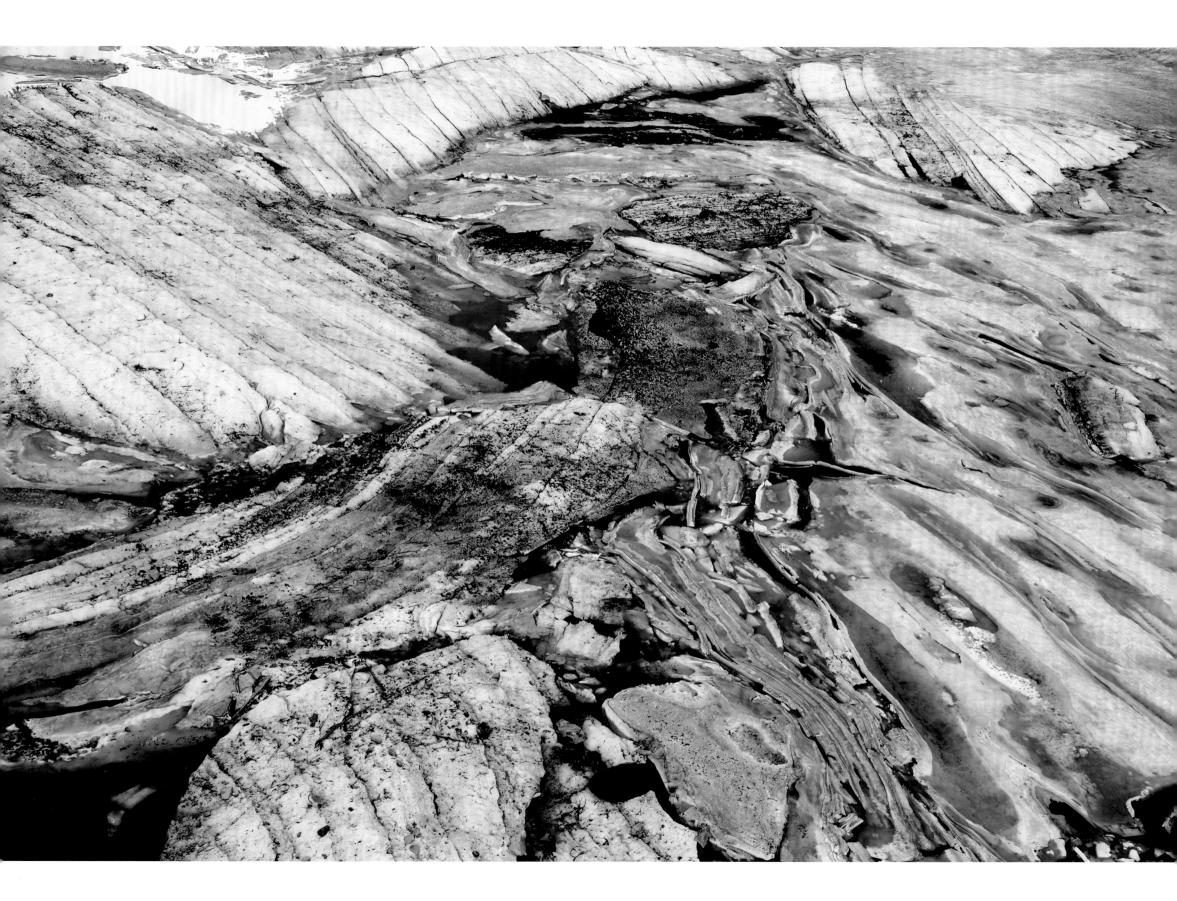

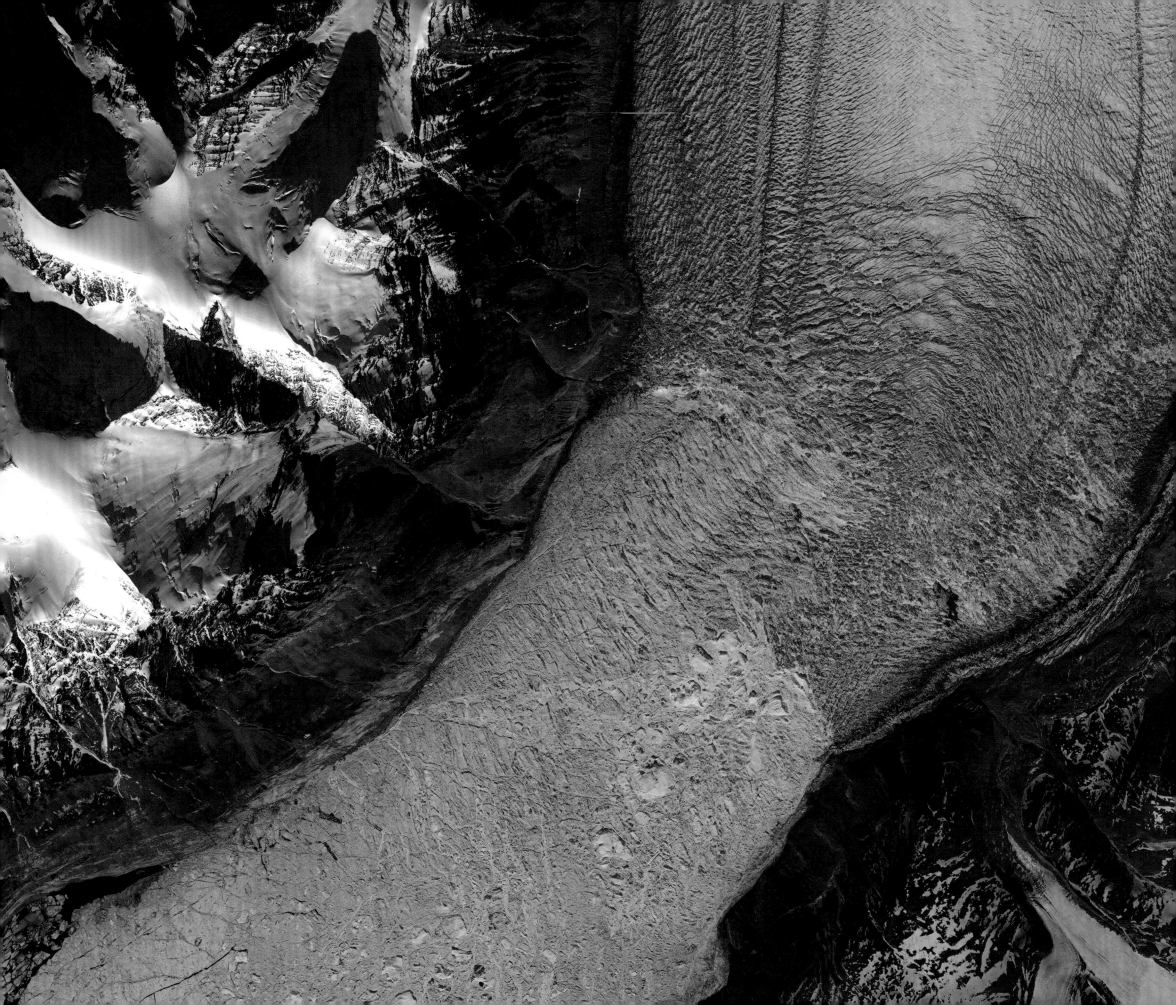

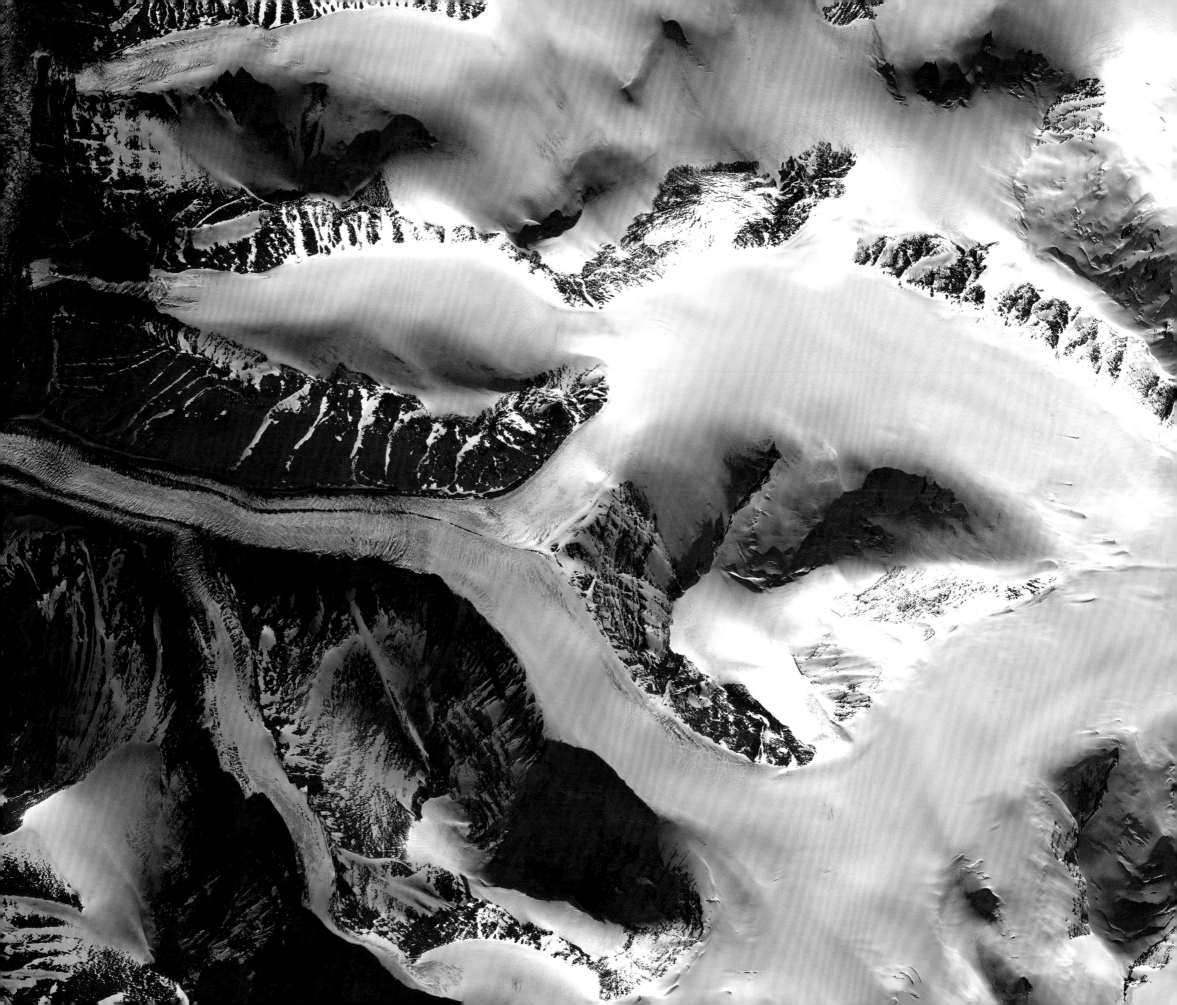

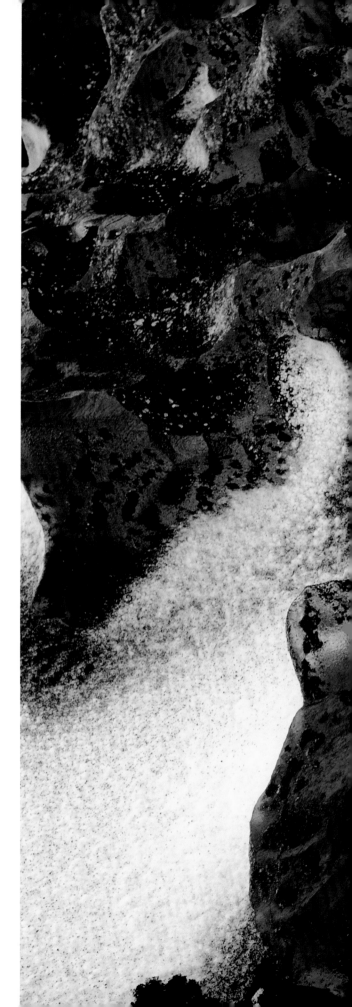

► Jökulsárlón | **Iceland** | 9 February 2008 | Texture of sand, snow and ice on a bergy bit.

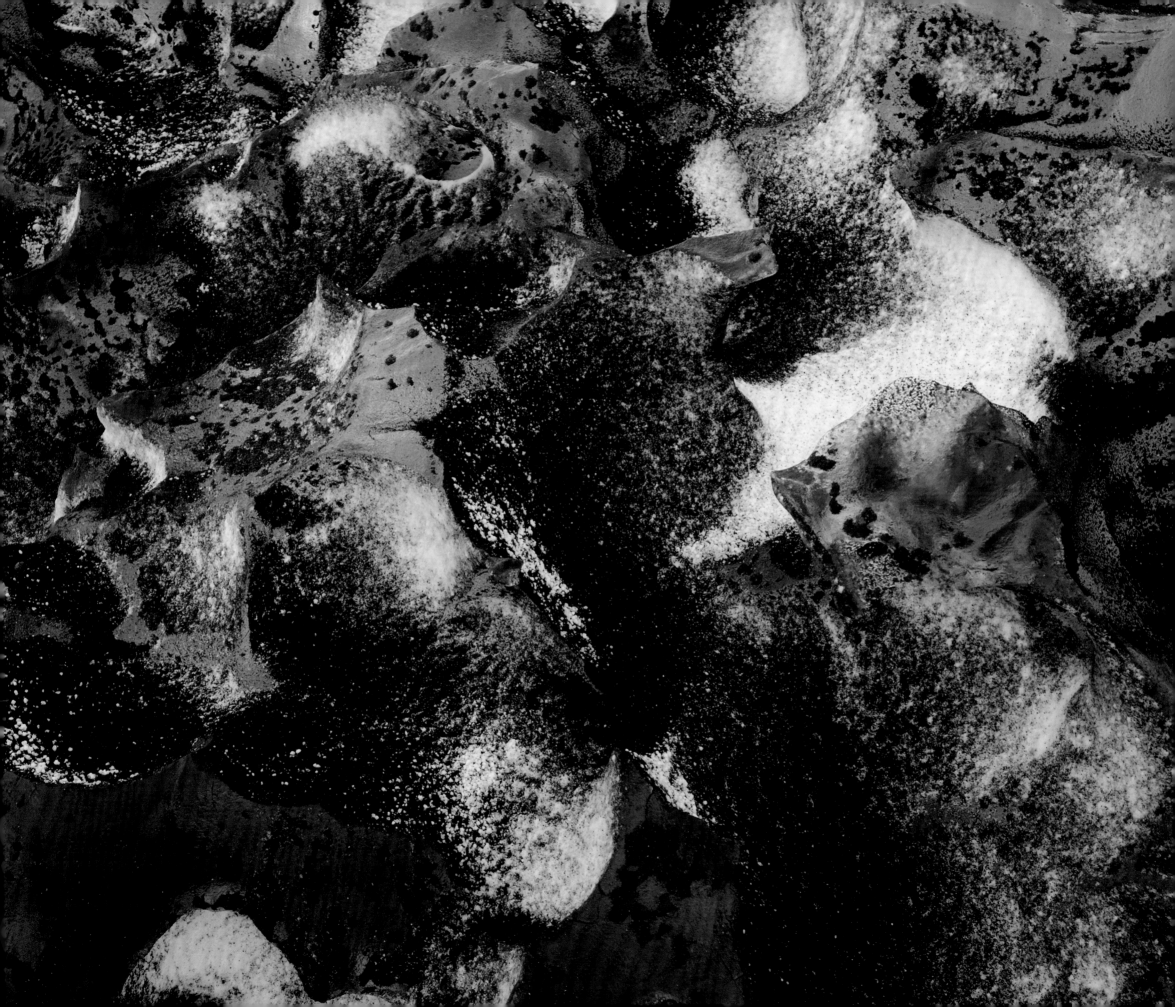

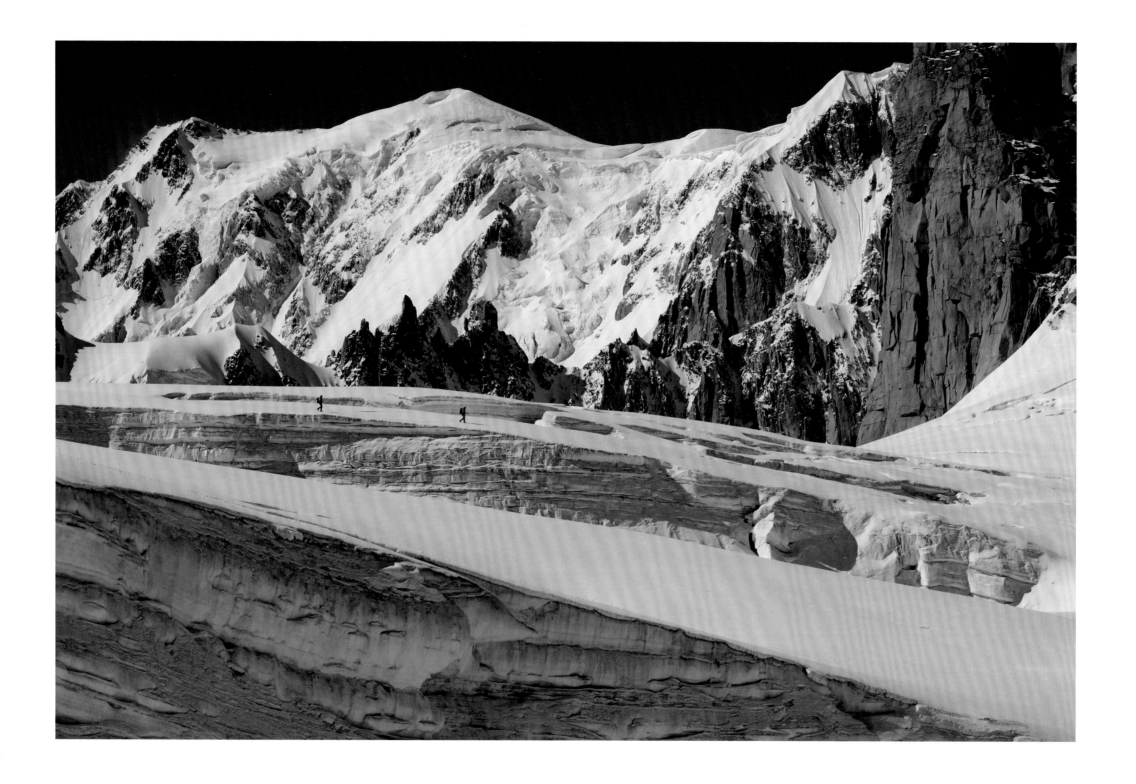

◀ Vallée Blanche | **France** | 16 September 2008 | Summit of Mont Blanc in background.　　▶ Chamonix valley | **France** | 21 September 2006 | Retreating ice and the Aiguille du Midi.

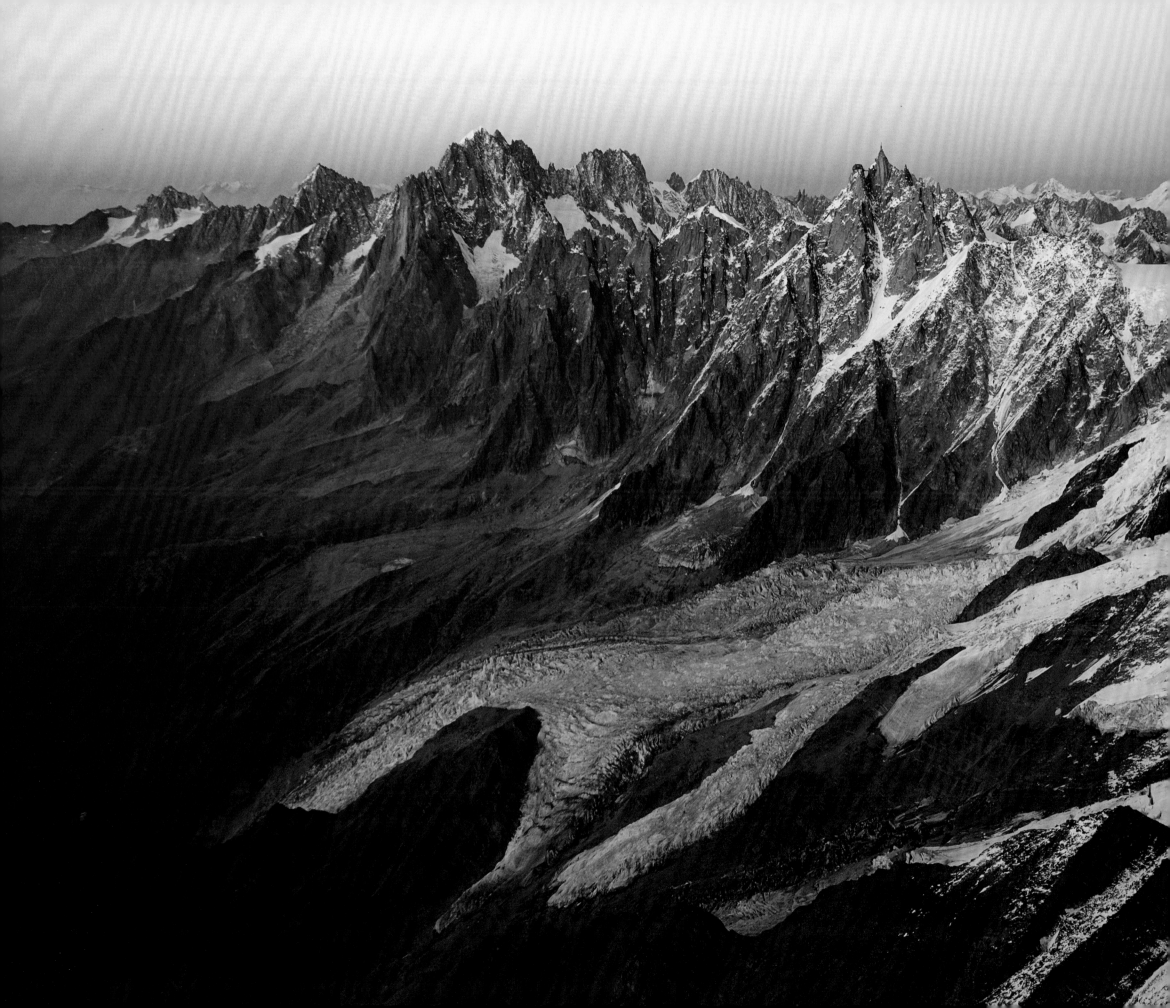

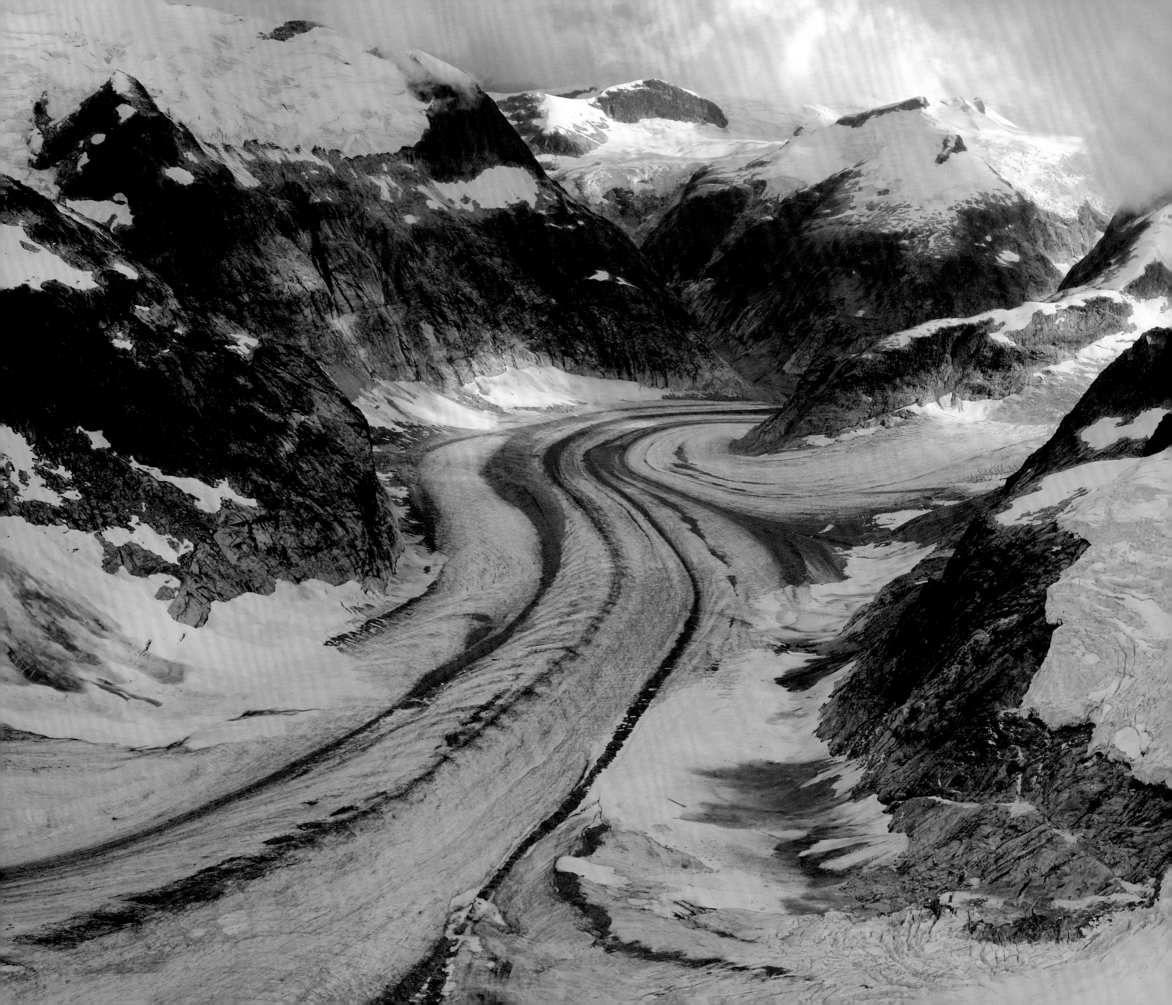

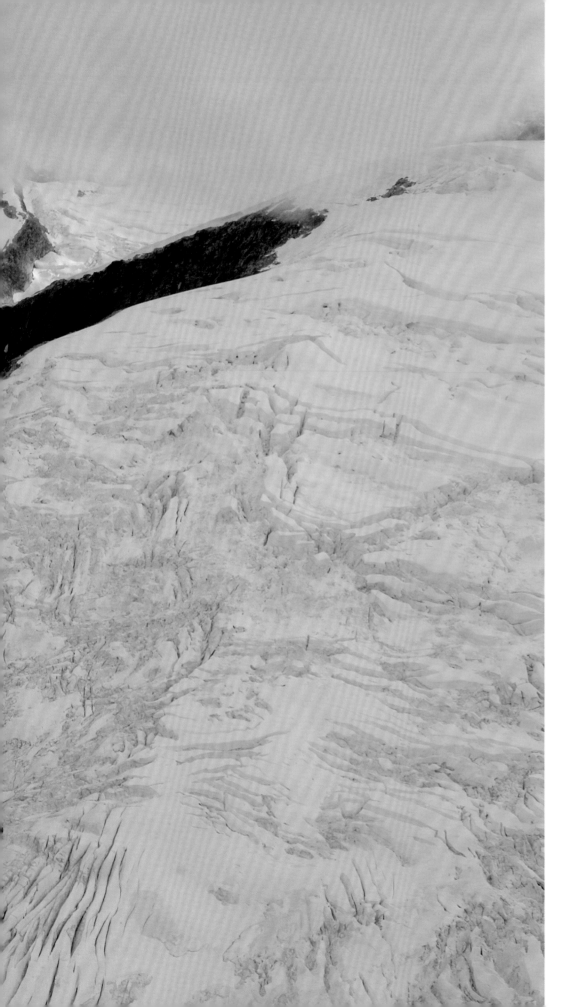

◄ Filer Glacier │ **British Columbia, Canada** │ 2 September 2008

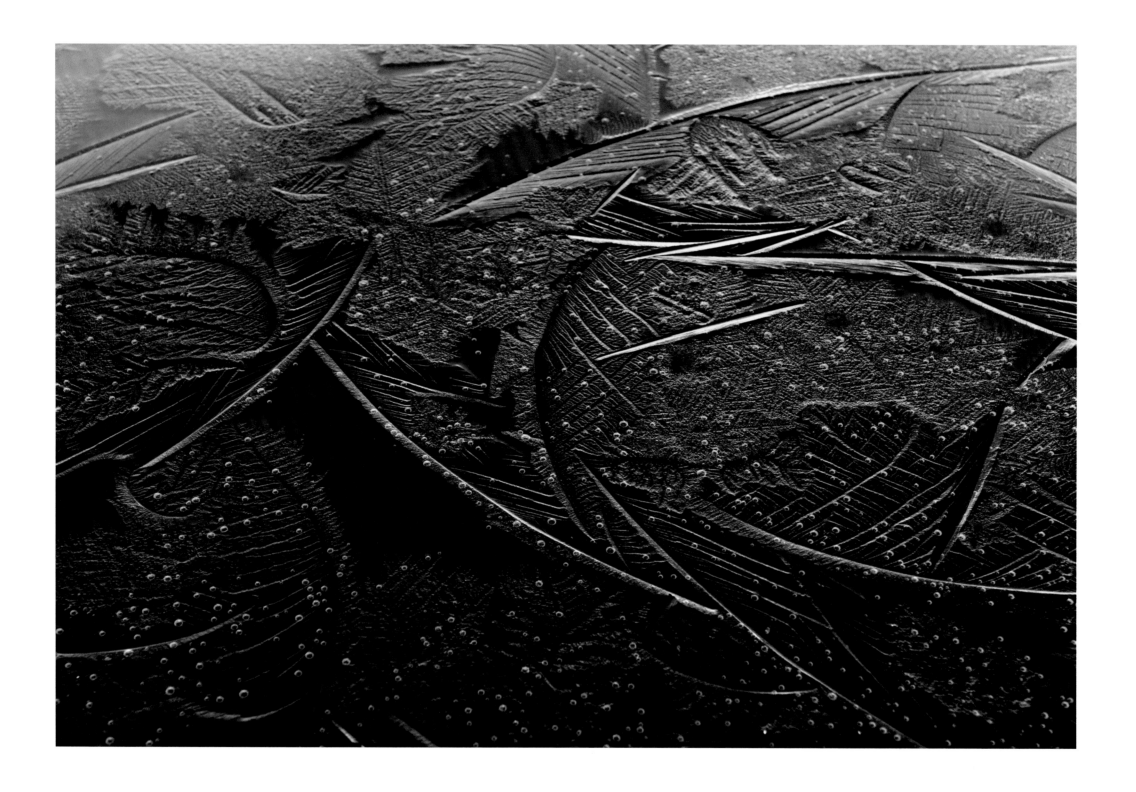

Greenland Ice Sheet | **Greenland** | ABOVE: 9 July 2009 | OPPOSITE: 16 July 2008 | On the surface of a meltwater pool, crystals are formed by cold air at midnight.

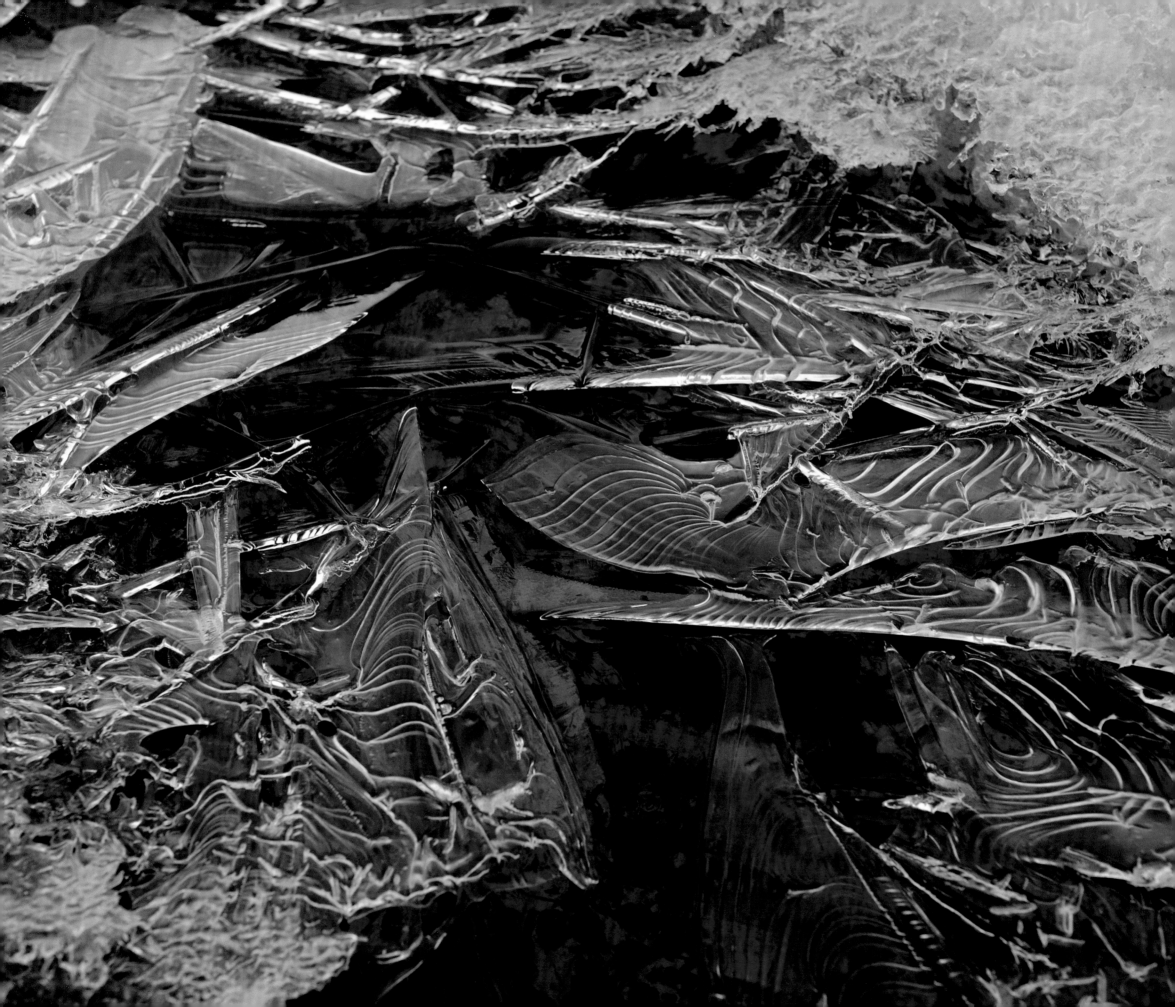

TIME PASSING

Glaciers are alive, evolving, bestial.
Glaciers respond hourly, daily, monthly, yearly
to air and water around them.
There's no such thing as "glacial pace."

Human eyes can't record change.
Cameras can.

Our cameras wait.
Dozens of cameras,
patient robots.
Their eyes blink open every 30 minutes,
150,000 blinks each year,
startled to see the world changing so fast:
time-lapse photography.

Sometimes we kick the stones
of places where we stood years before,
to see the changed world for ourselves:
repeat photography.

Gone, gone, now, all of it a dream.
Without the camera-memory
a tree falls in the forest,
ice melts in the mountains,
collapses in the Arctic,
but no one hears
the sound.

Monumental change does not belong
to the dim past or vague future
of an abstraction called
geology.
Monumental change is happening now.
Monumental change is us,
the human race,
living our history.

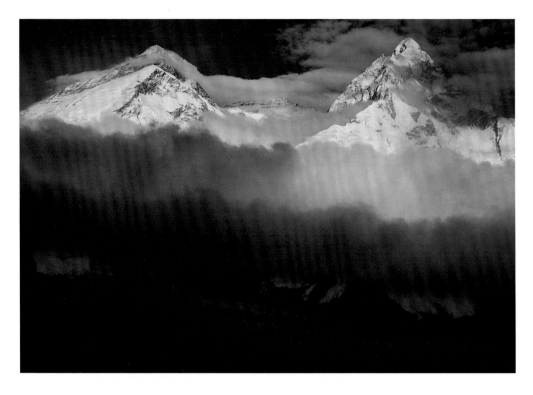

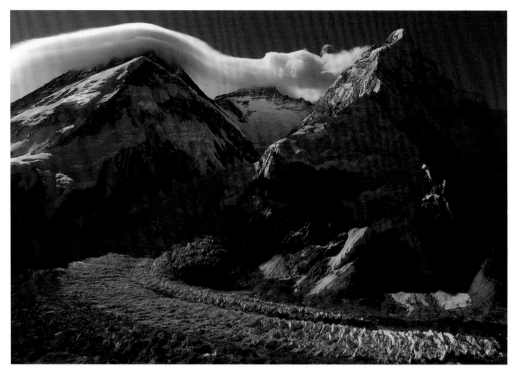

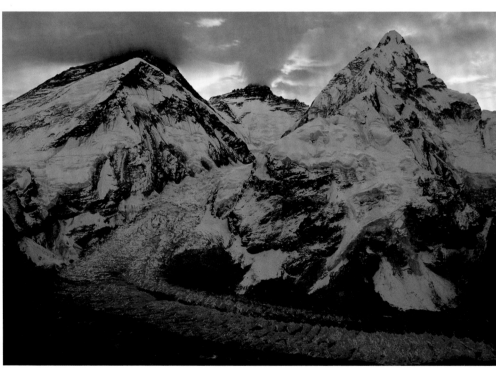

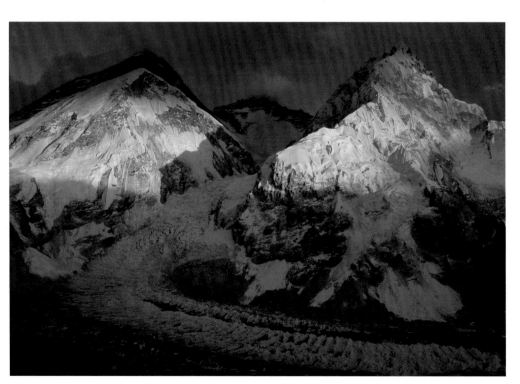

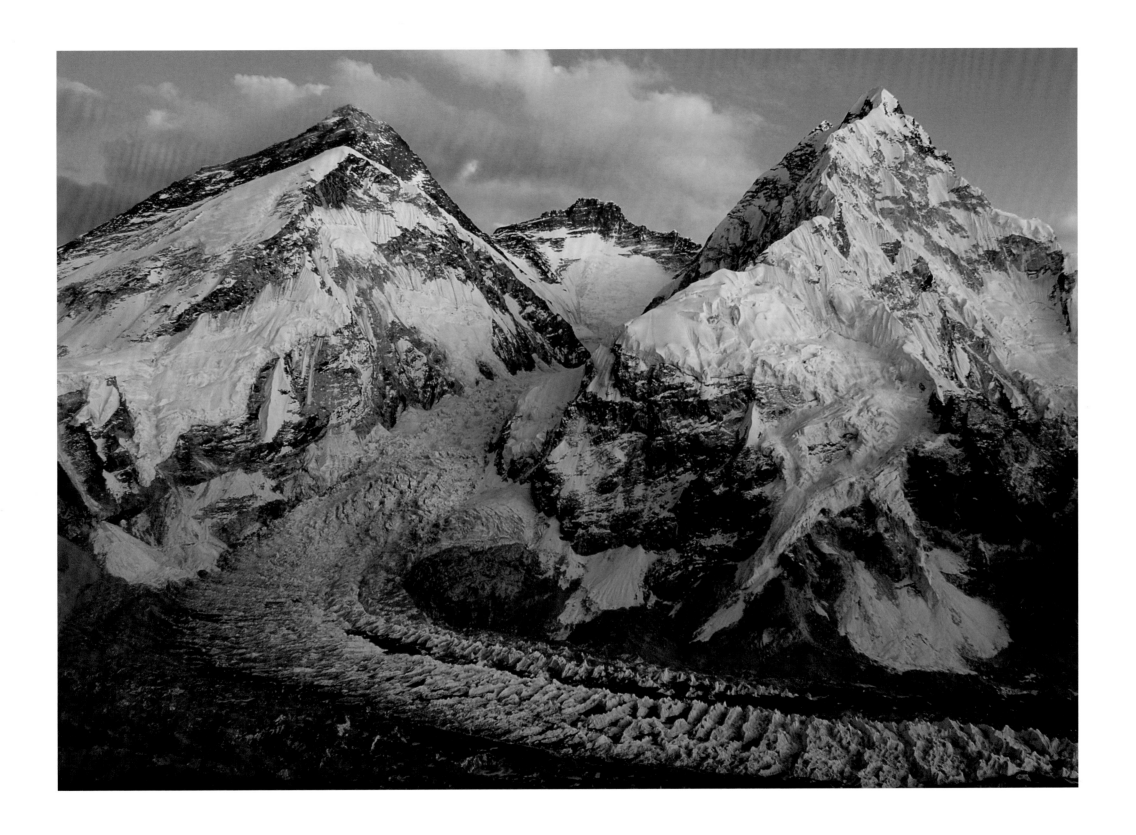

◀ ▲ Khumbu Glacier and Mount Everest | **Nepal** | Light and weather seen by EIS camera NP-3, May 2010–January 2011.

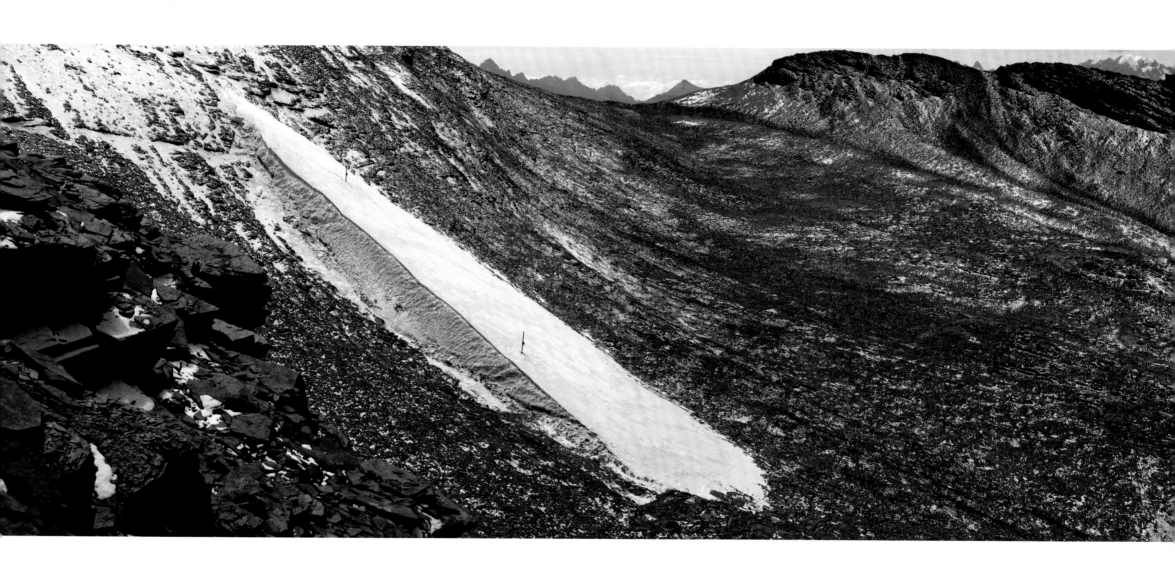

▲ Chacaltaya Glacier | **Bolivia** | 11 August 2006 | Last portrait of a glacier that once was home to the world's highest ski area.

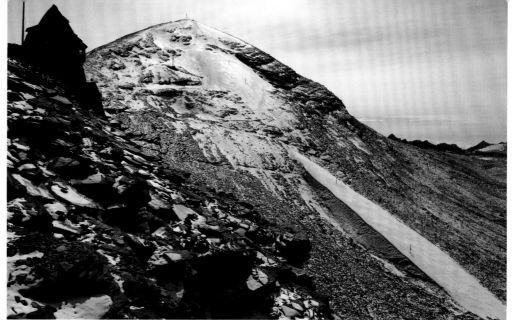

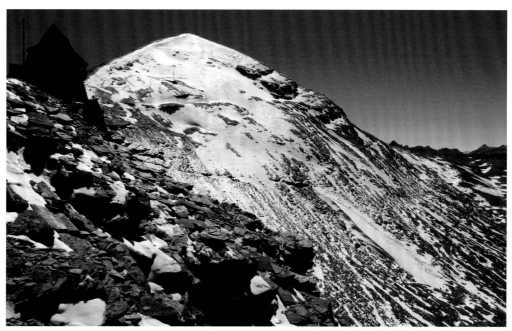

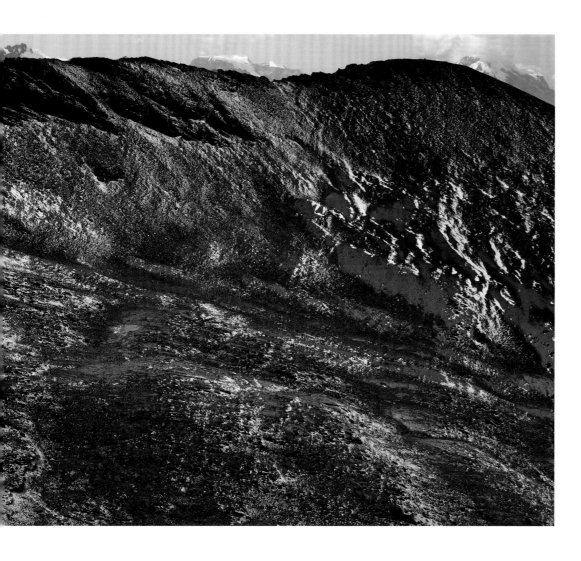

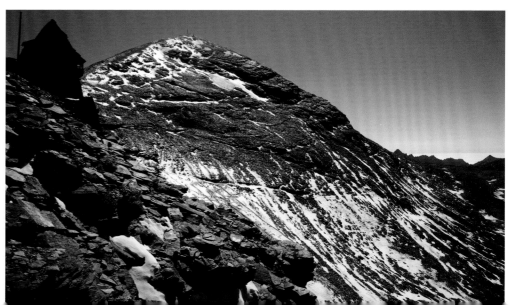

▶ TOP TO BOTTOM: 11 August 2006 | 11 August 2008 | 11 August 2009

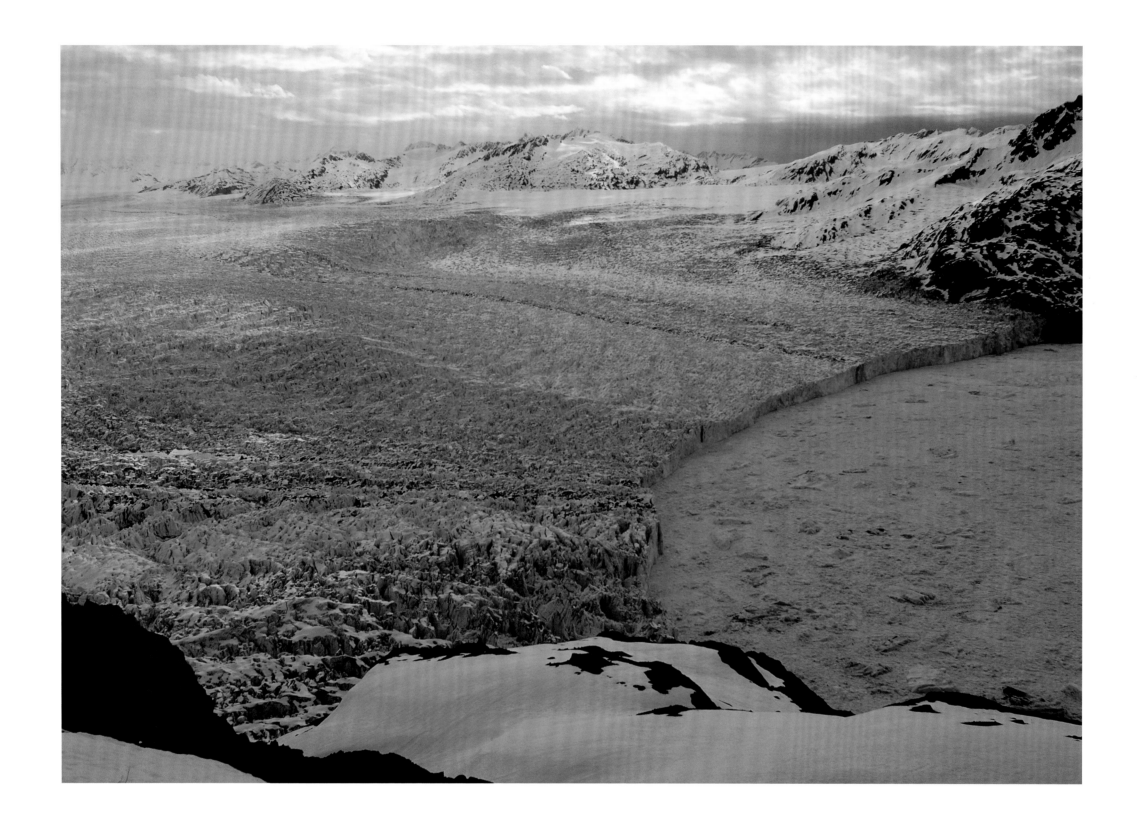

ABOVE: 15 May 2007

▲ ▶ Columbia Glacier │ **Alaska, United States** │ Seen by EIS camera AK-01.

100

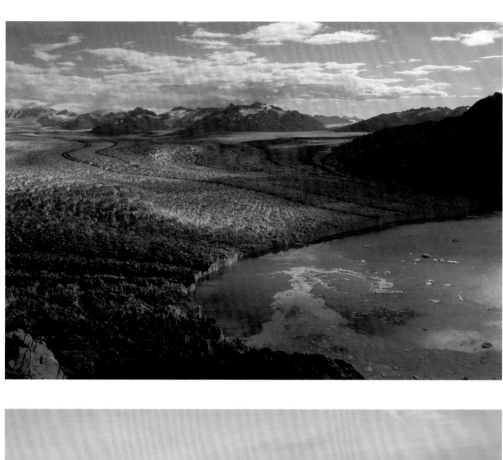
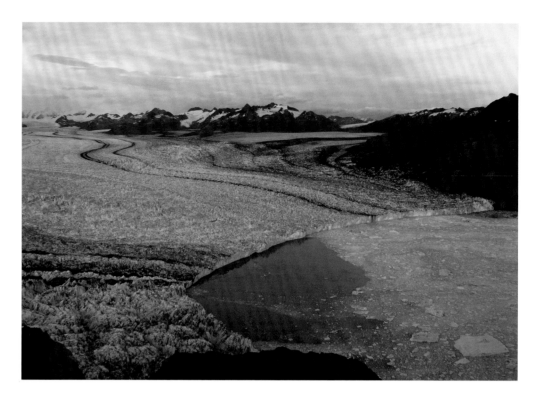
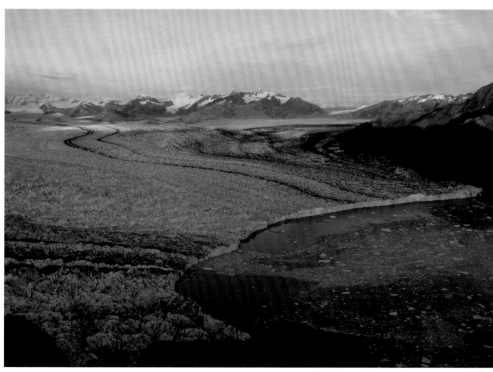
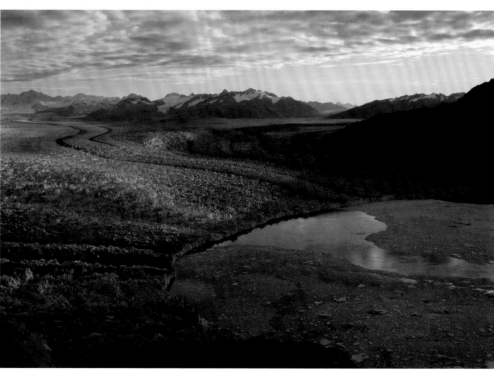

TOP ROW: 25 August 2007 | 16 September 2007 BOTTOM ROW: 26 September 2007 | 29 September 2007

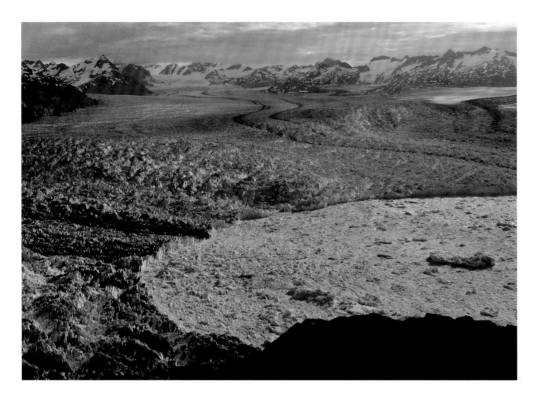

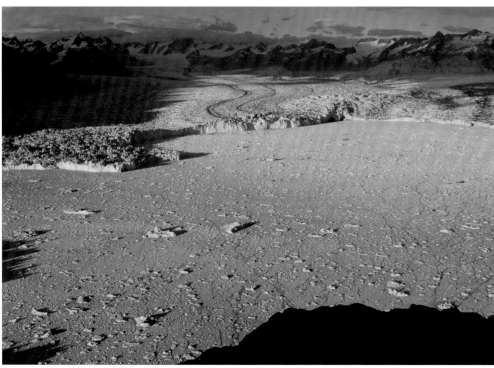
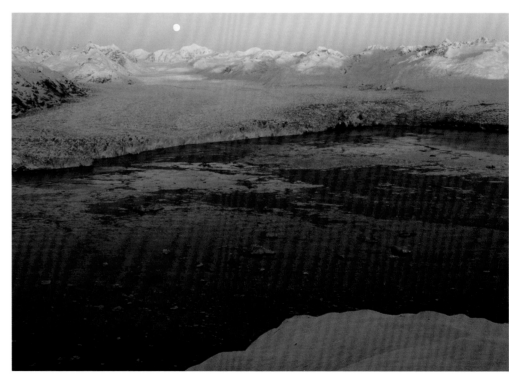

TOP ROW: 9 August 2008 | 10 May 2009 BOTTOM ROW: 24 August 2010 | 19 January 2011

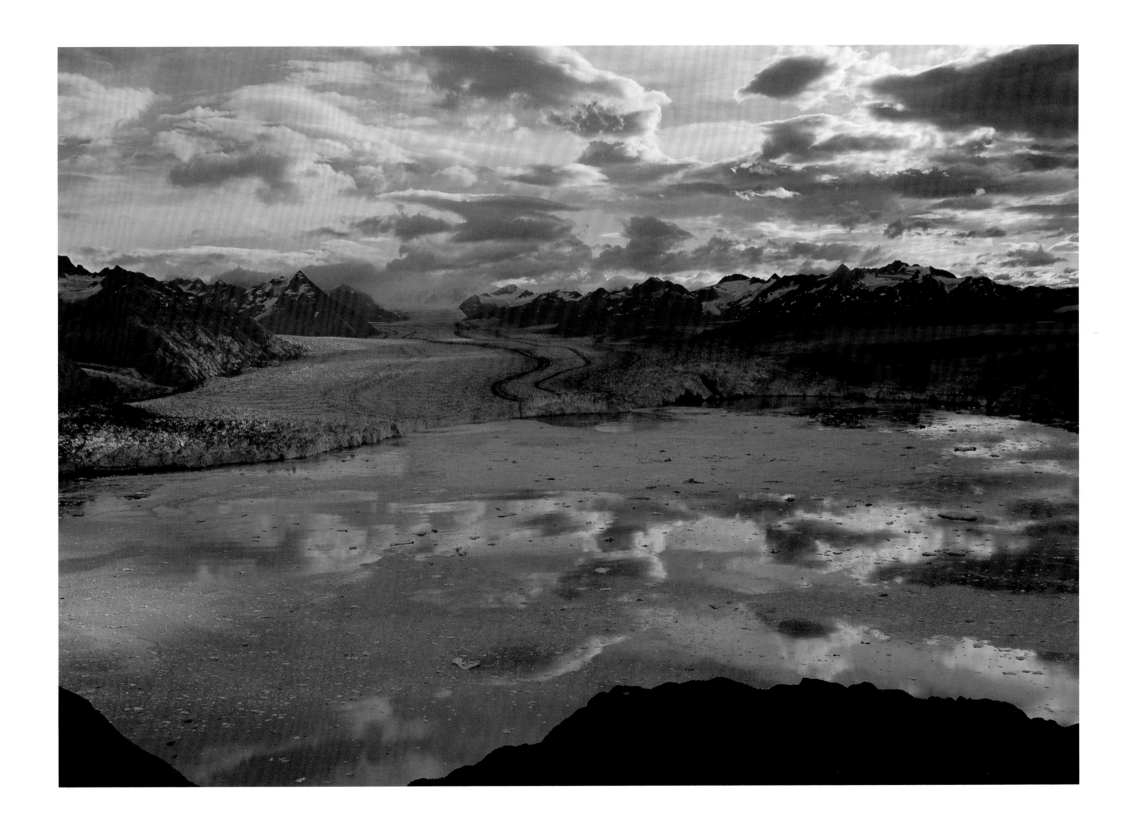

Columbia Glacier | **Alaska, United States** | Seen by EIS camera AK-01b.

ABOVE: 16 August 2011

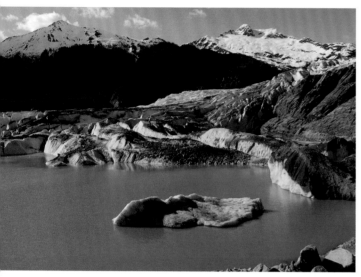

20 May 2007

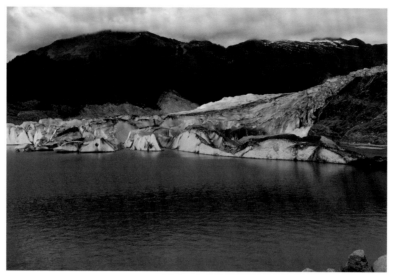

17 August 2007

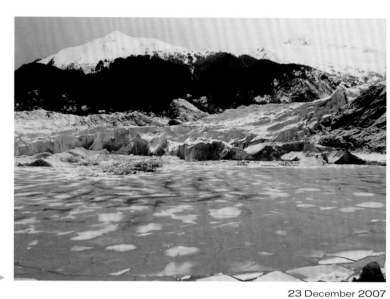

23 December 2007

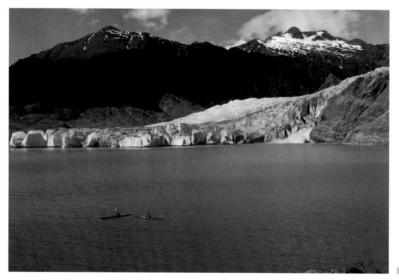

25 July 2009

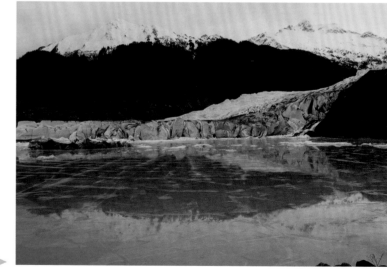

28 February 2010

Mendenhall Glacier | **Alaska, United States** | Seen by EIS camera AK-05.

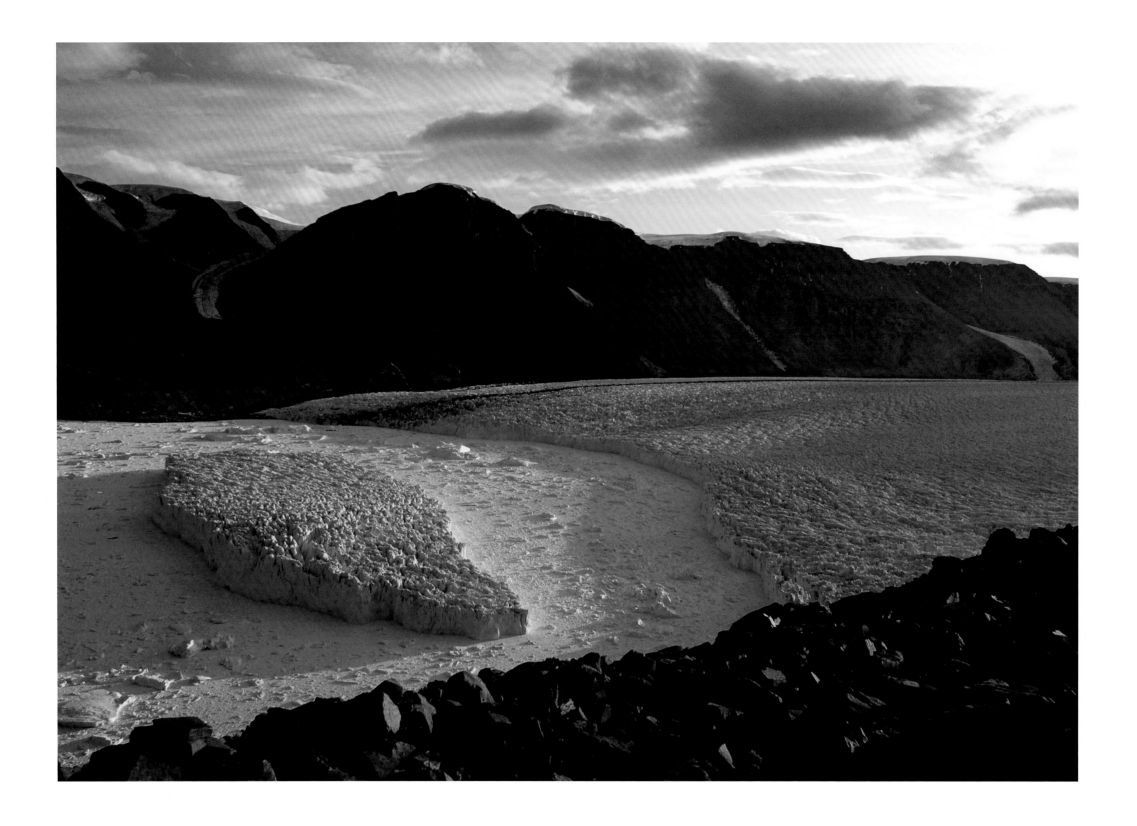

▲ Rink Glacier │ **Greenland** │ Seen by EIS camera GLA2.

ABOVE: 22 July 2011

▲ Ilulissat Glacier | **Greenland** | Massive icebergs continually calve into the ocean. Seen by EIS cameras GL-04 and GL-05.

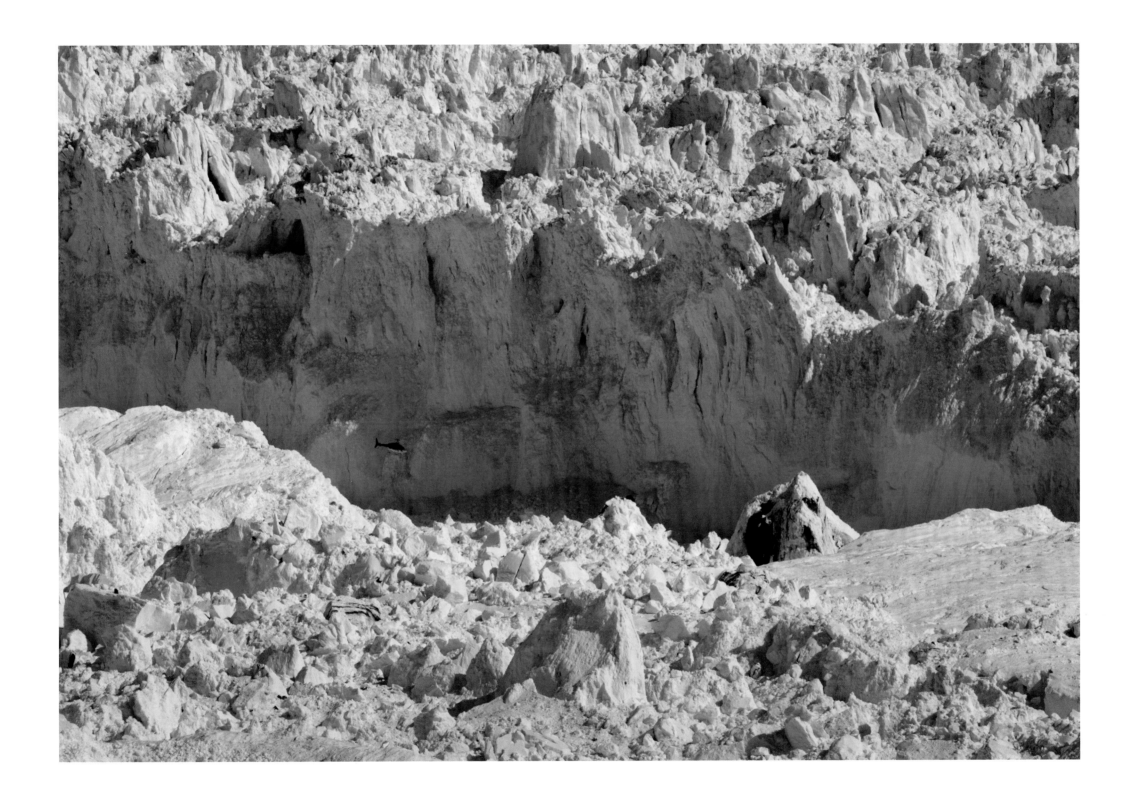

▲ Ilulissat Glacier | **Greenland** | 7 June 2007 | Helicopter gives scale to calving face three- to four-hundred feet high. Sea surface in foreground is filled with densely packed icebergs.

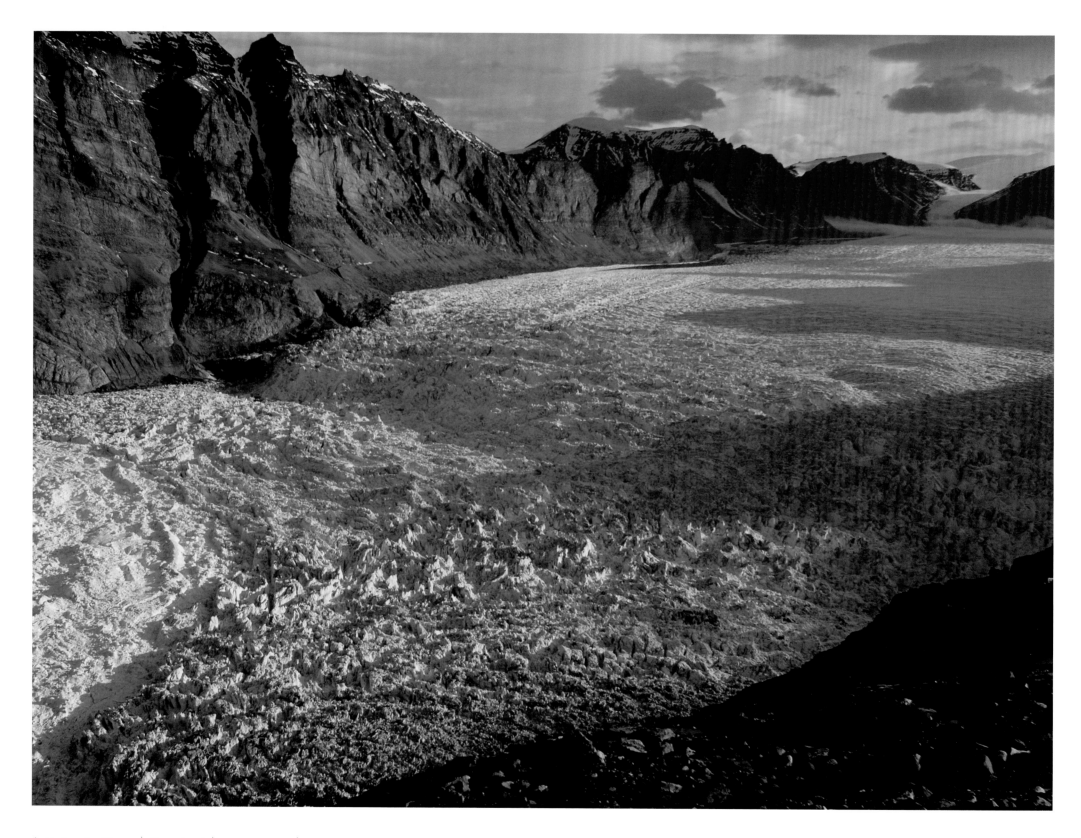

▲ Umiamako Glacier | **Greenland** | 17 June 2007 | Seen by EIS camera GL-06.

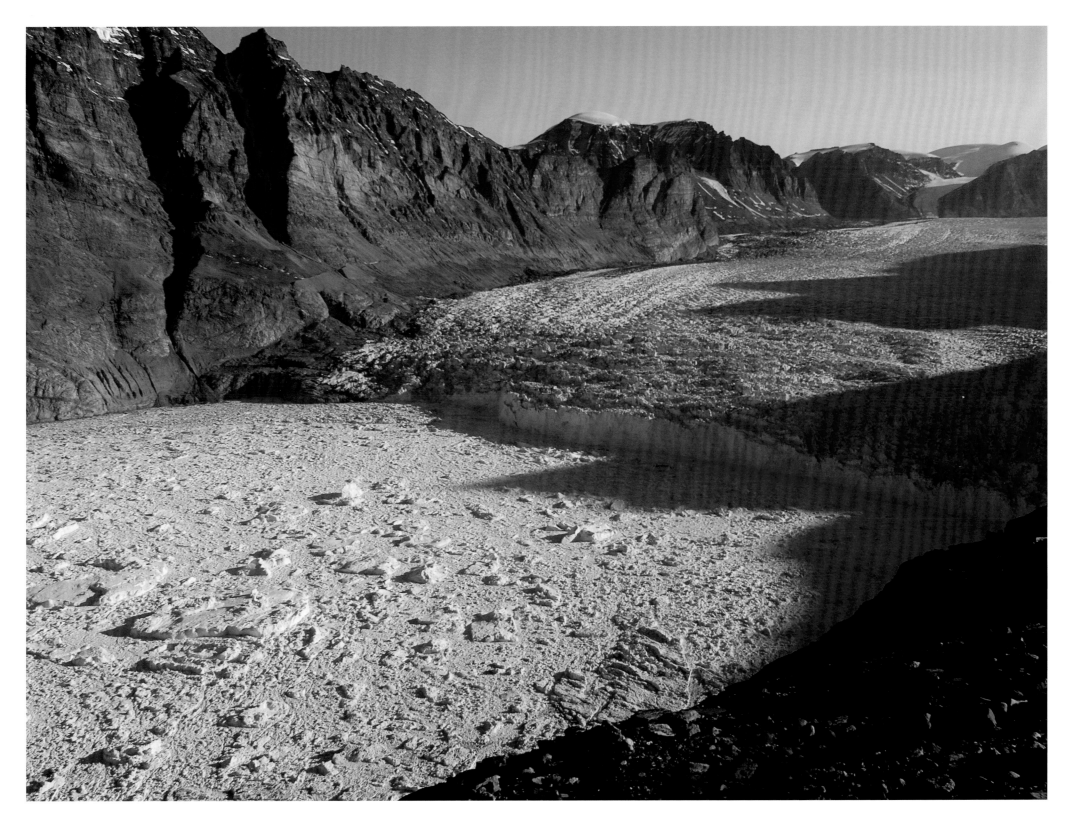

▲ Umiamako Glacier | **Greenland** | 16 June 2011 | Seen by EIS camera GL-06.

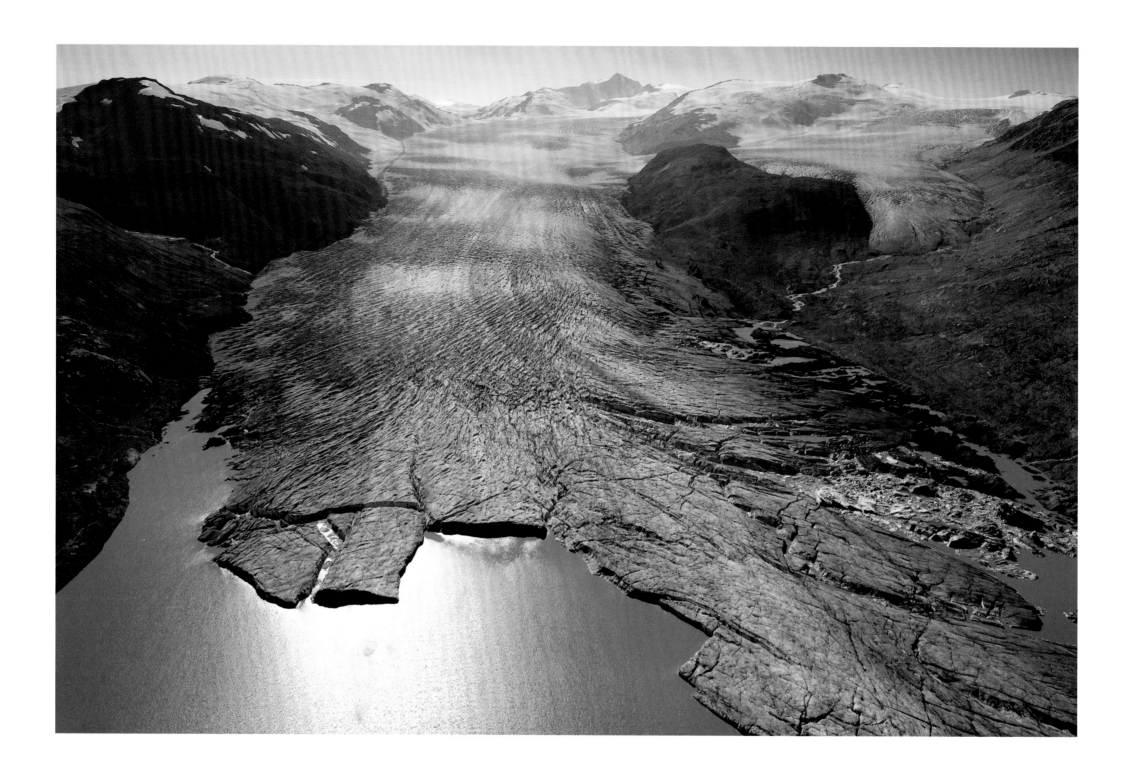

▲ Bridge Glacier | **British Columbia, Canada** | 1 September 2009

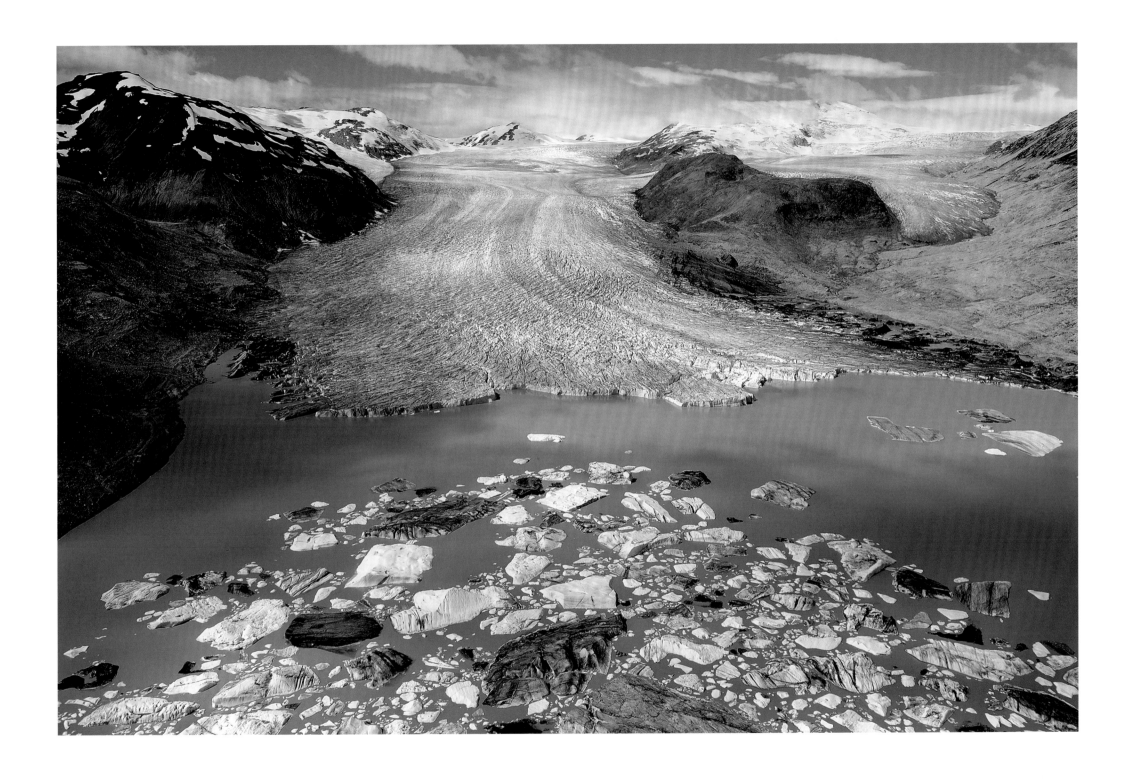

▲ Bridge Glacier | **British Columbia, Canada** | 23 August 2010

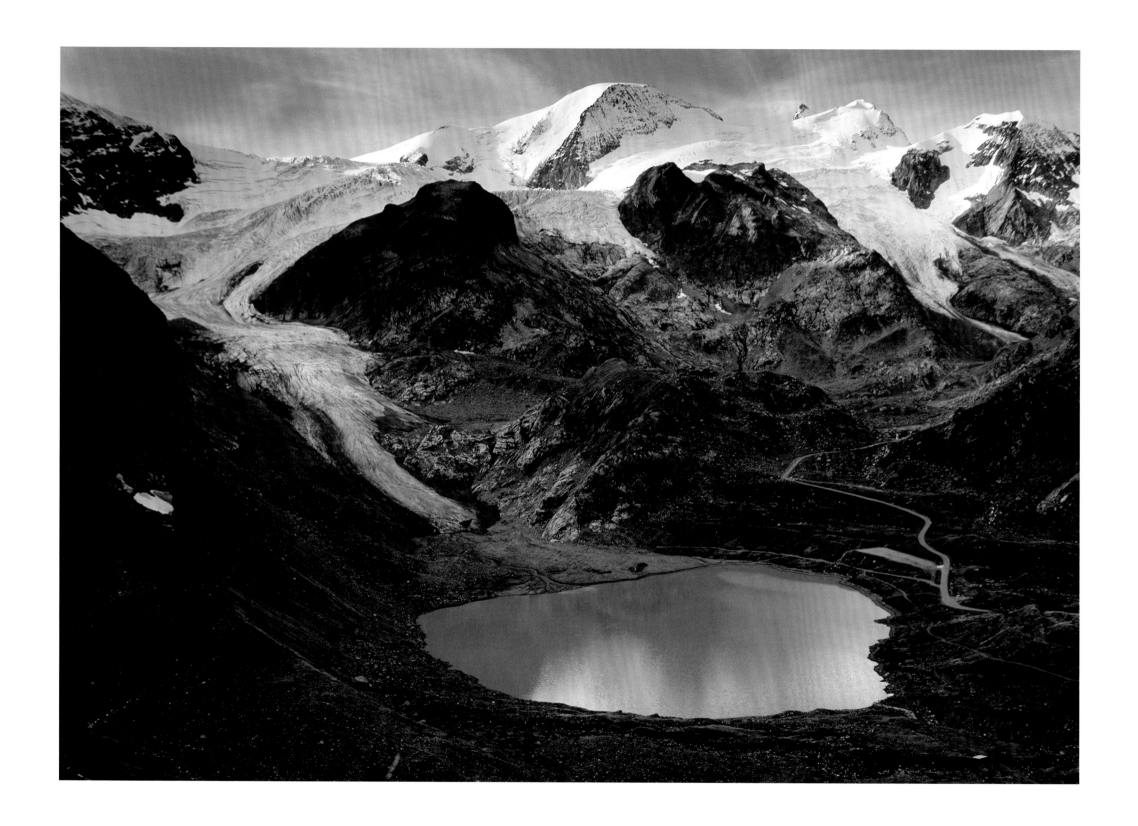

▲ Stein Glacier | **Switzerland** | 25 September 2006

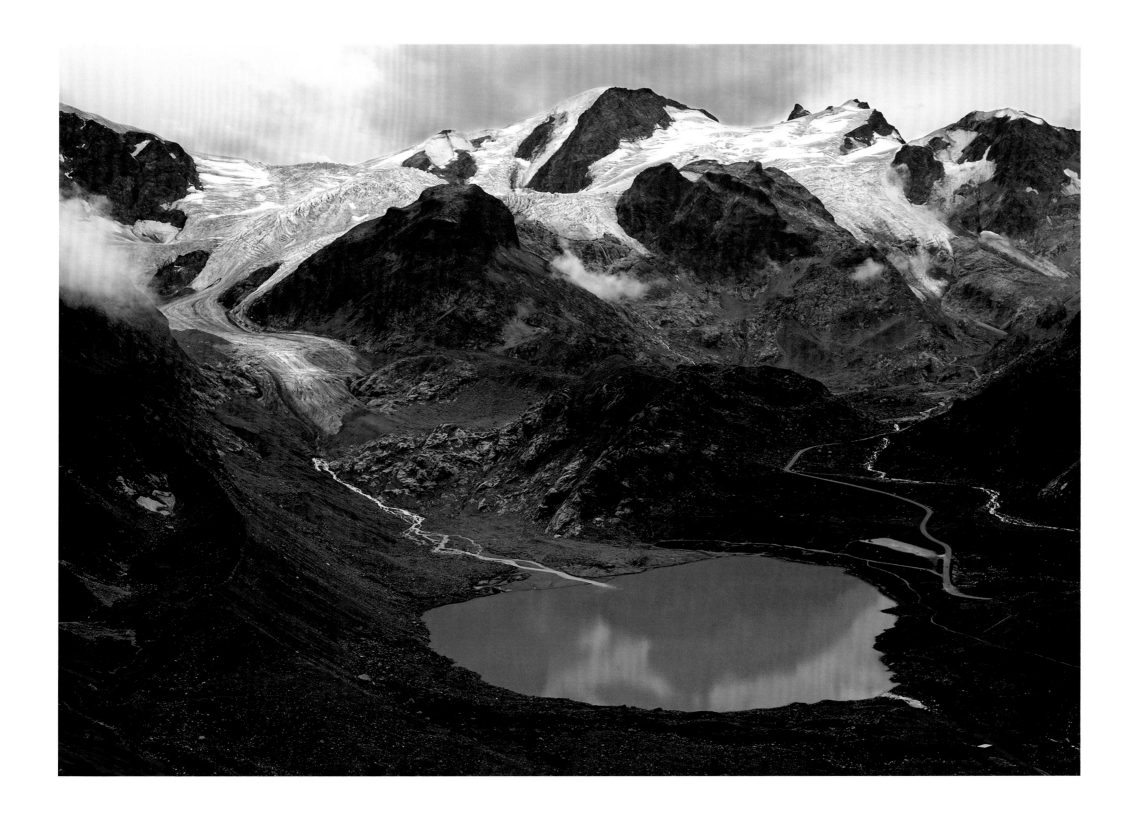

▲ Stein Glacier | **Switzerland** | 17 September 2011

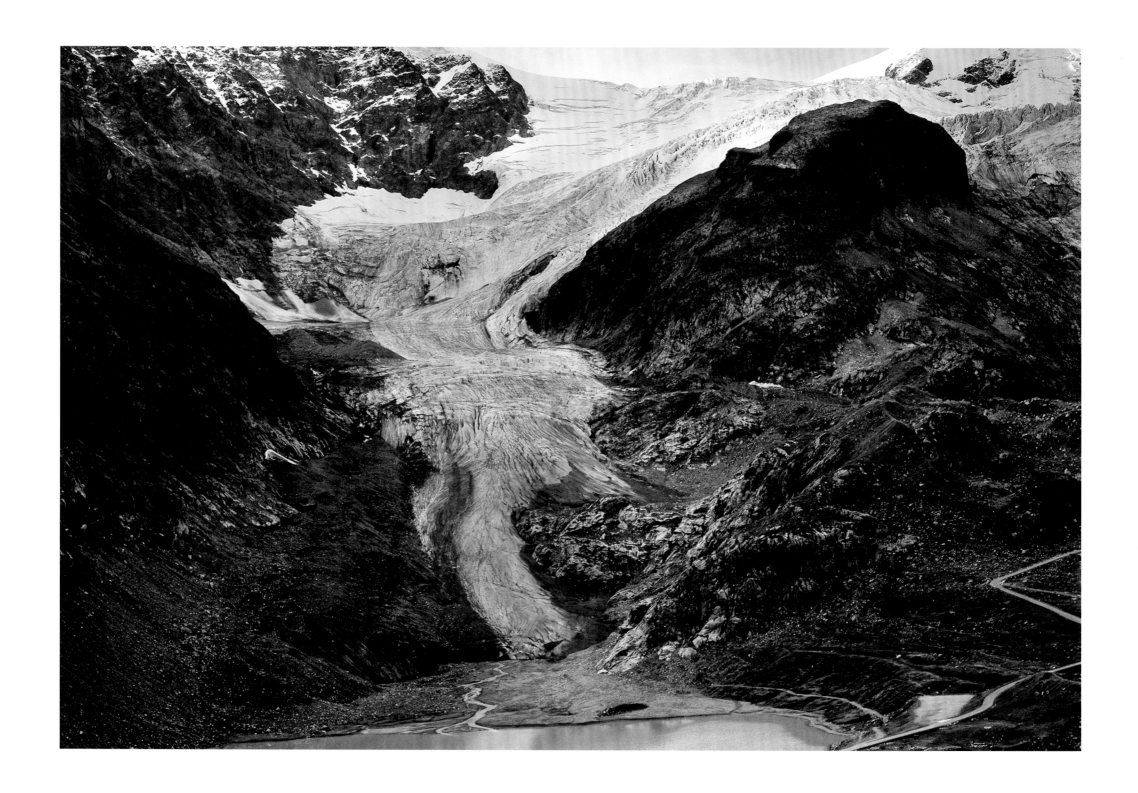

▲ Stein Glacier | **Switzerland** | 25 September 2006

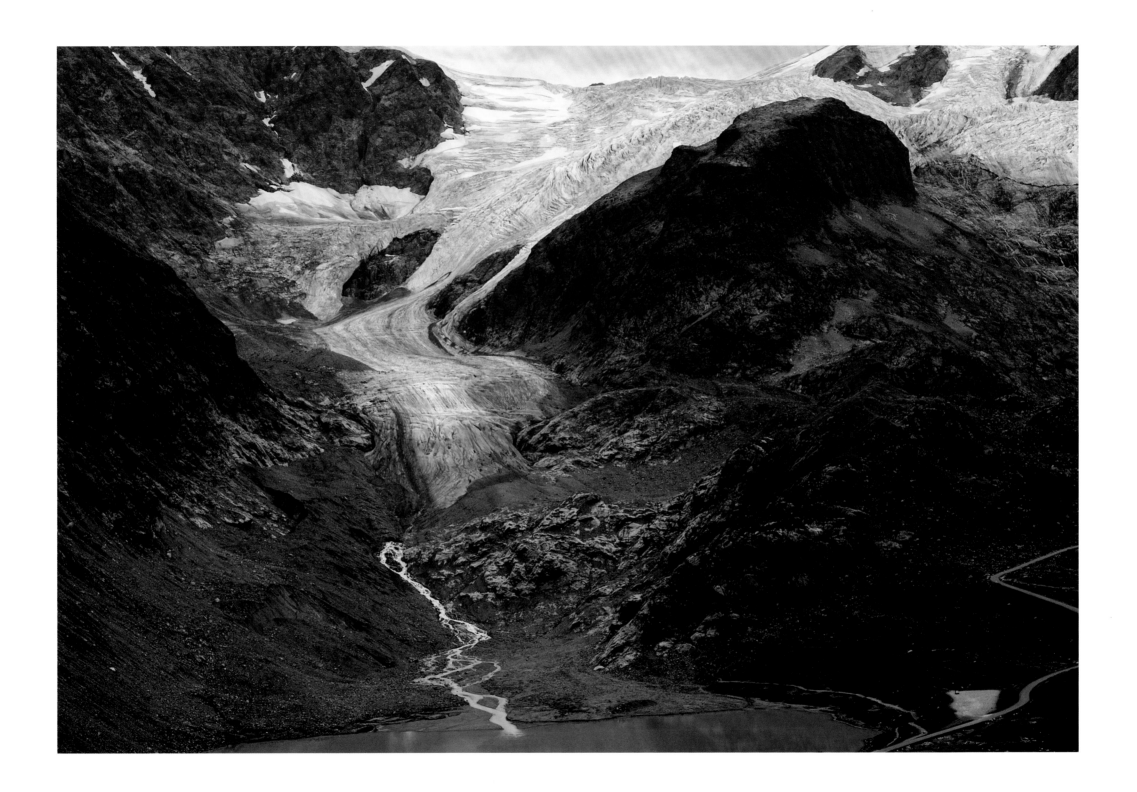

▲ Stein Glacier │ **Switzerland** │ 17 September 2011

▼ Eiger Glacier │ **Switzerland** │ 24 September 2006

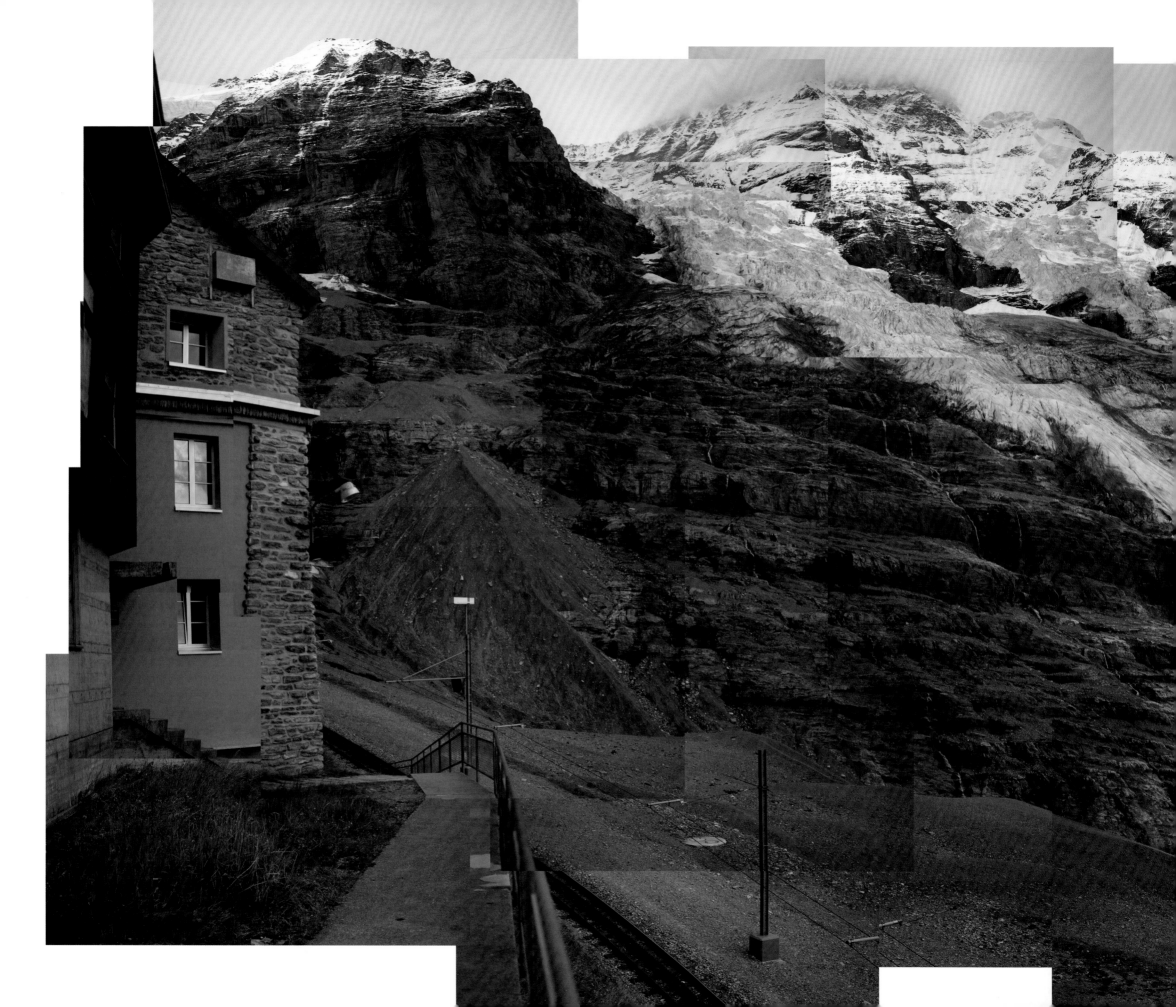

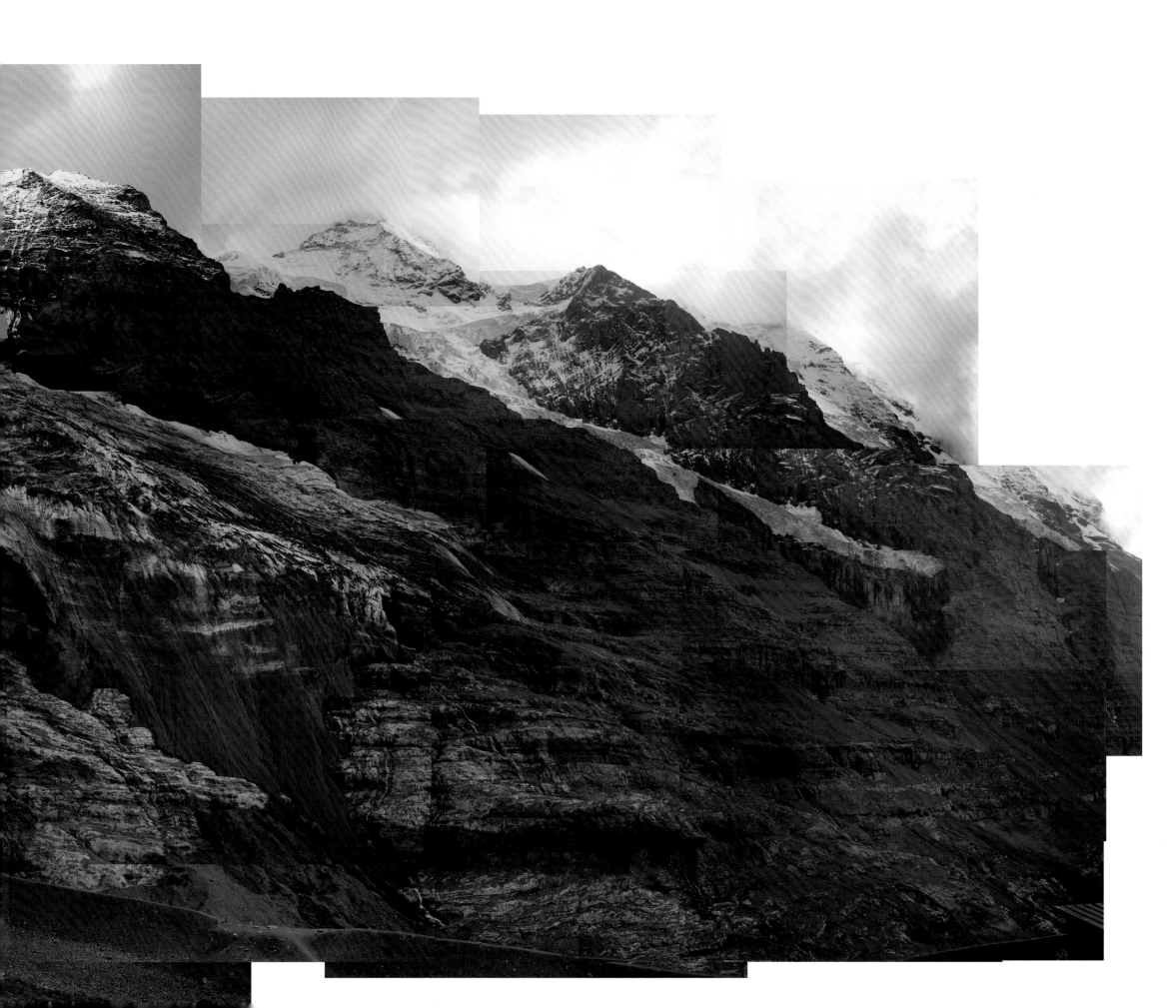

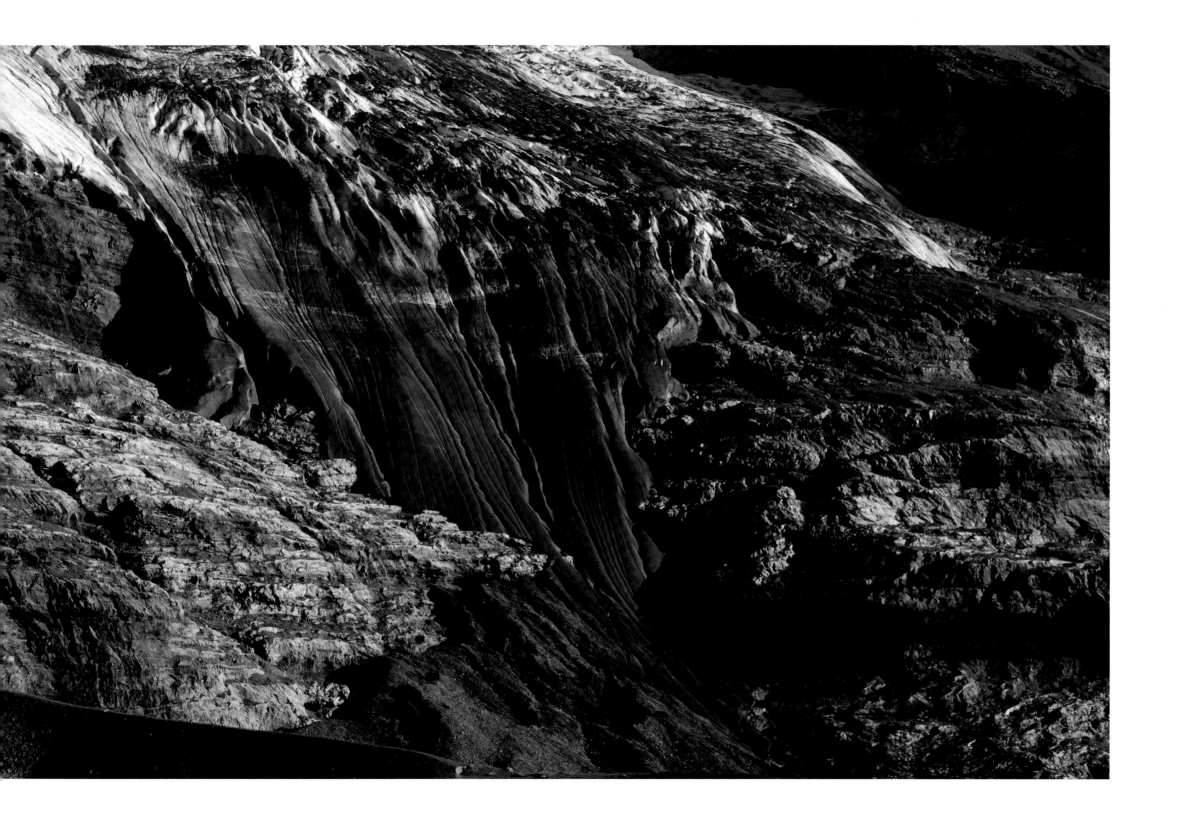

▲ Eiger Glacier | **Switzerland** | 24 September 2006

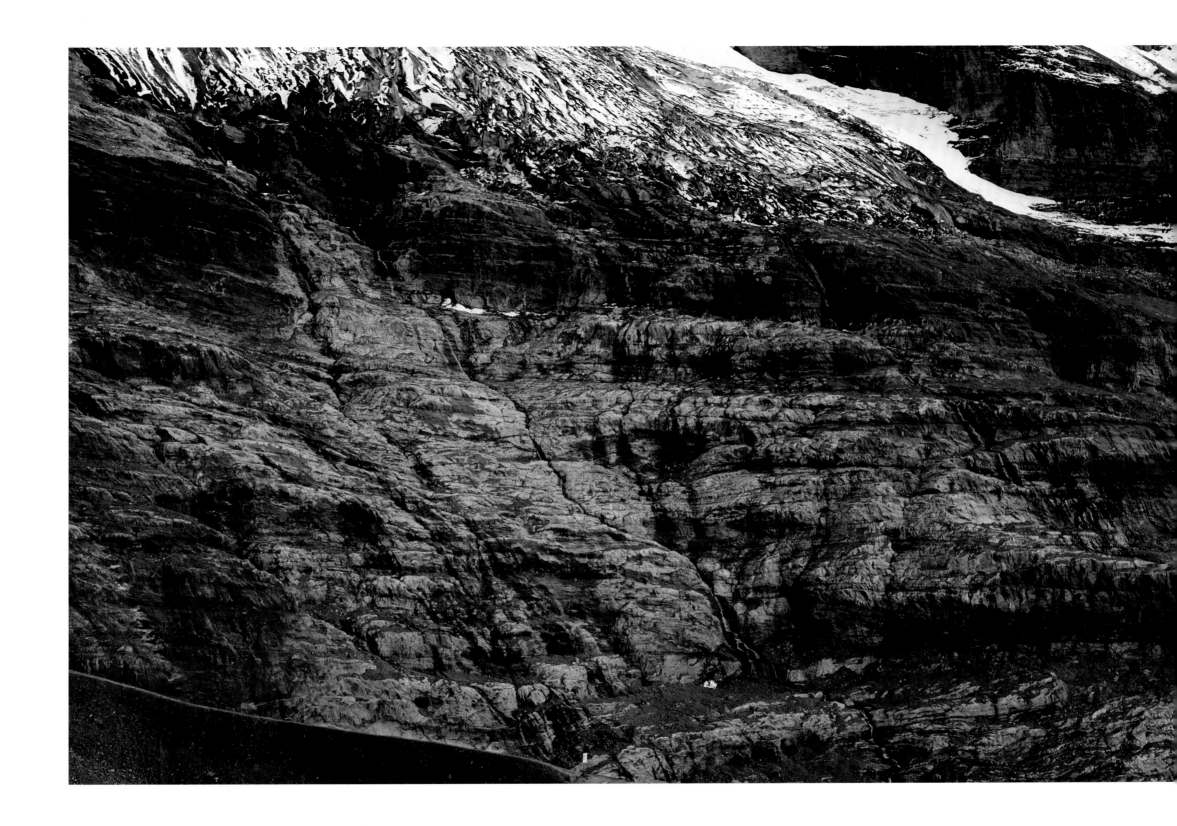

▲ Eiger Glacier | **Switzerland** | 25 September 2011

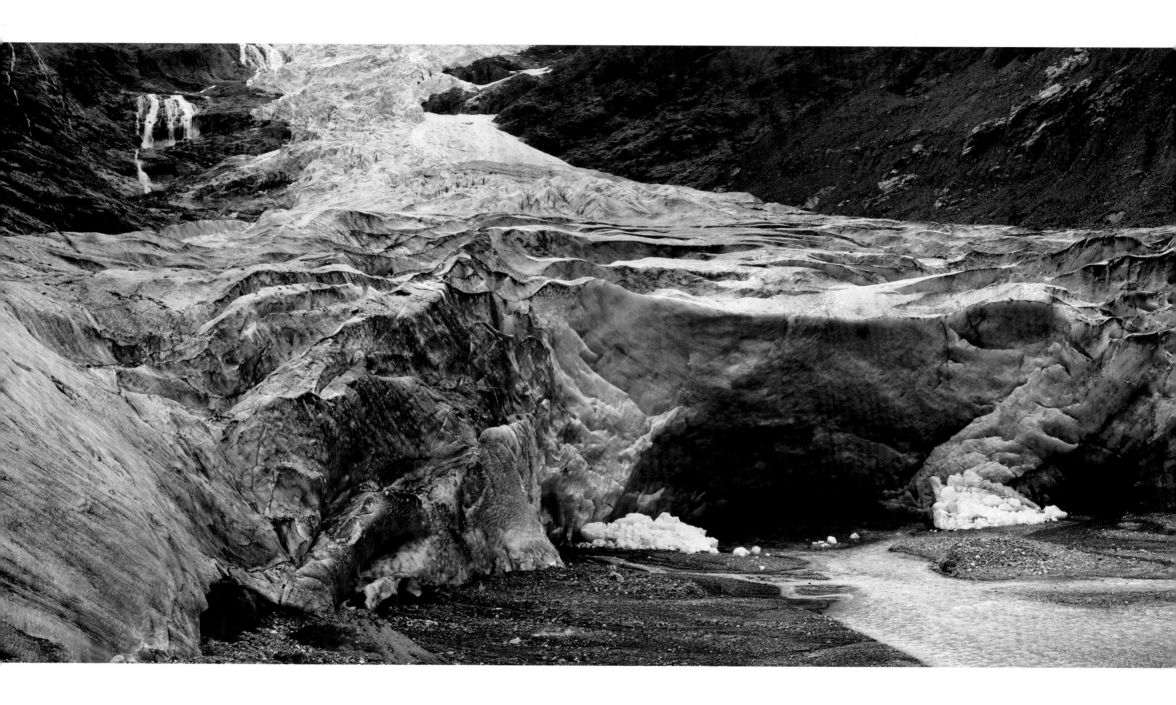

▲ Trift Glacier | **Switzerland** | 25 September 2006

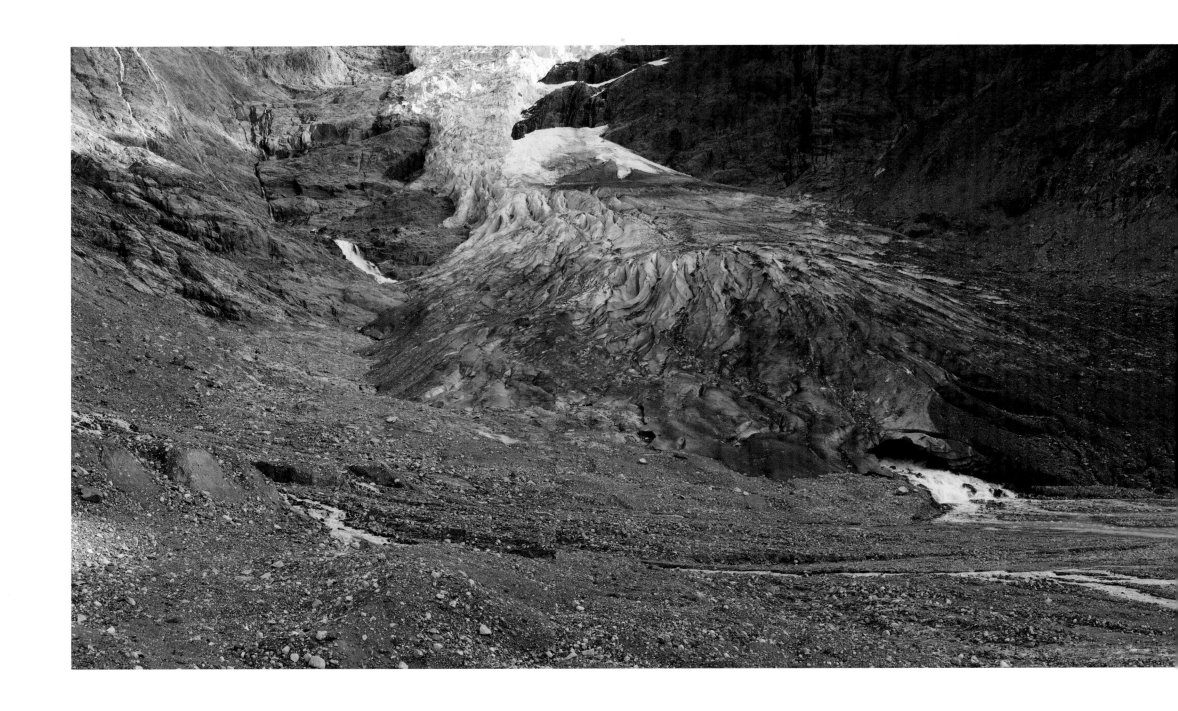

▲ Trift Glacier │ **Switzerland** │ 16 September 2011

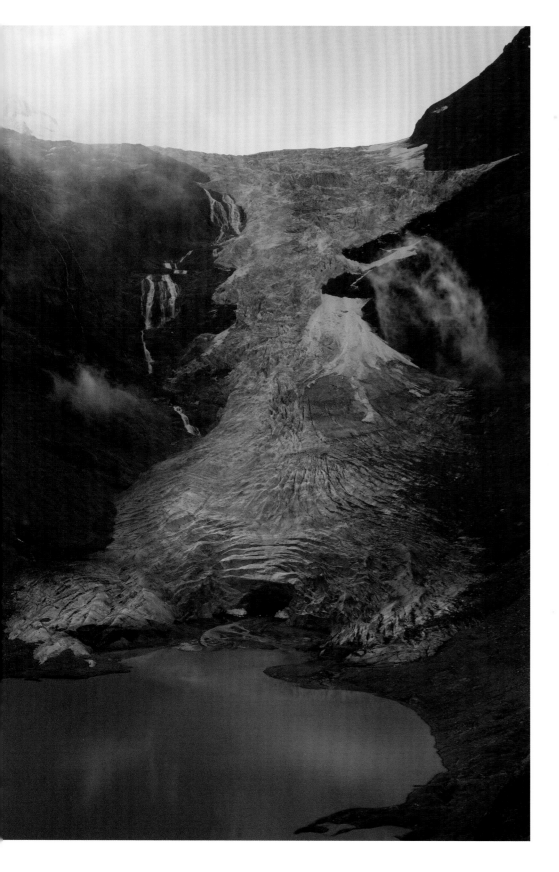
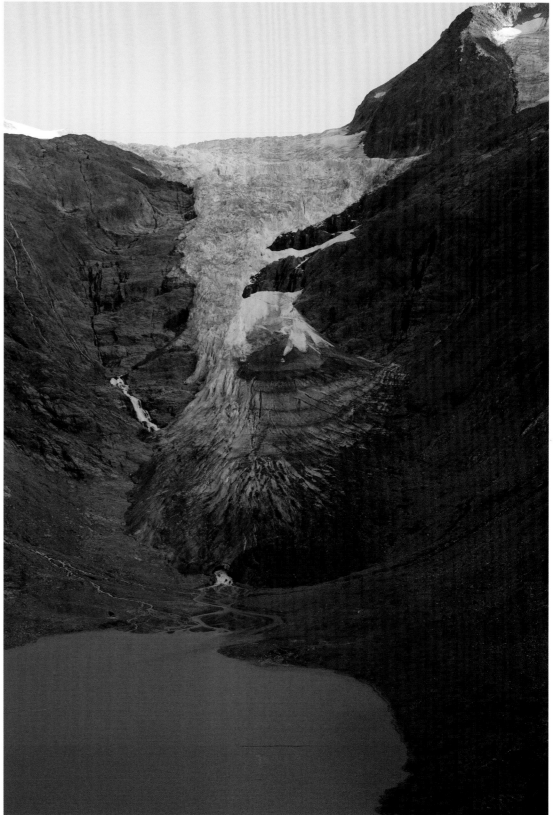

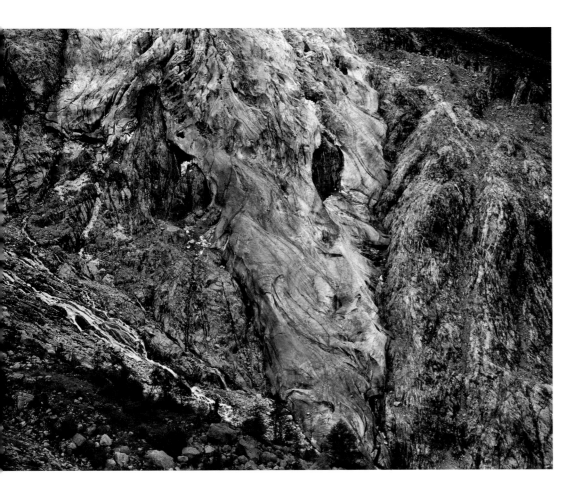

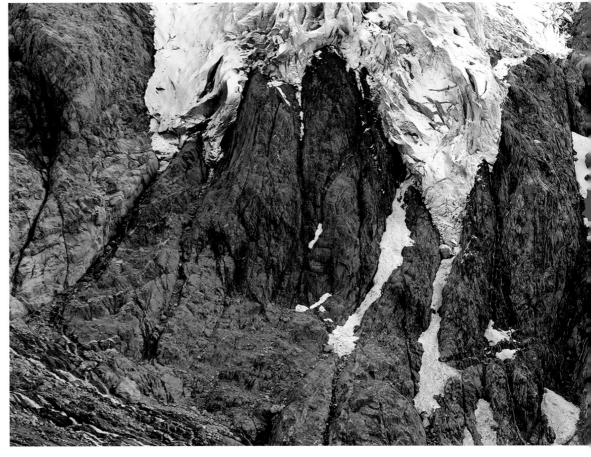

◄ Trift Glacier │ **Switzerland** │ LEFT: 25 September 2006 │ RIGHT: 16 September 2011

▲ Trient Glacier │ **Switzerland** │ LEFT: 18 September 2006 │ RIGHT: 20 September 2011

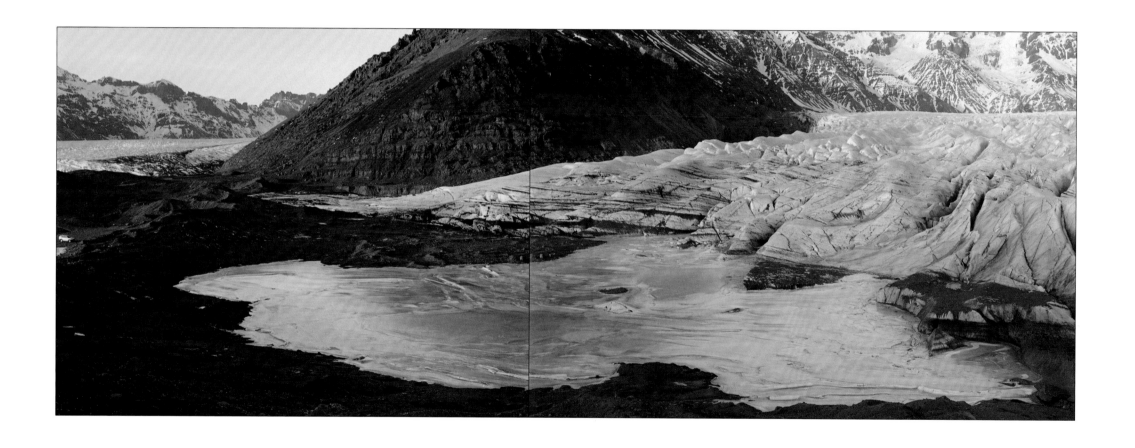

Svínafellsjökull | **Iceland** | 5 March 2005

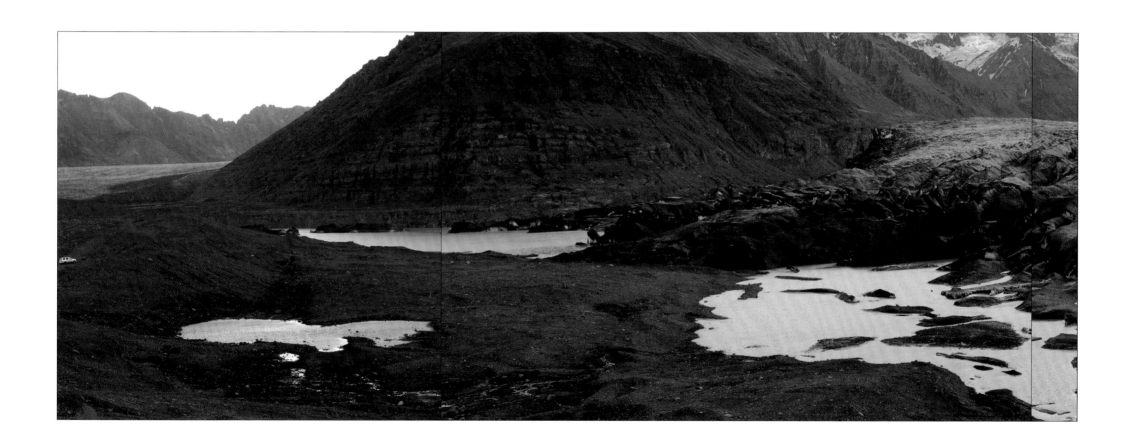

▲ Svínafellsjökull | **Iceland** | 17 June 2011

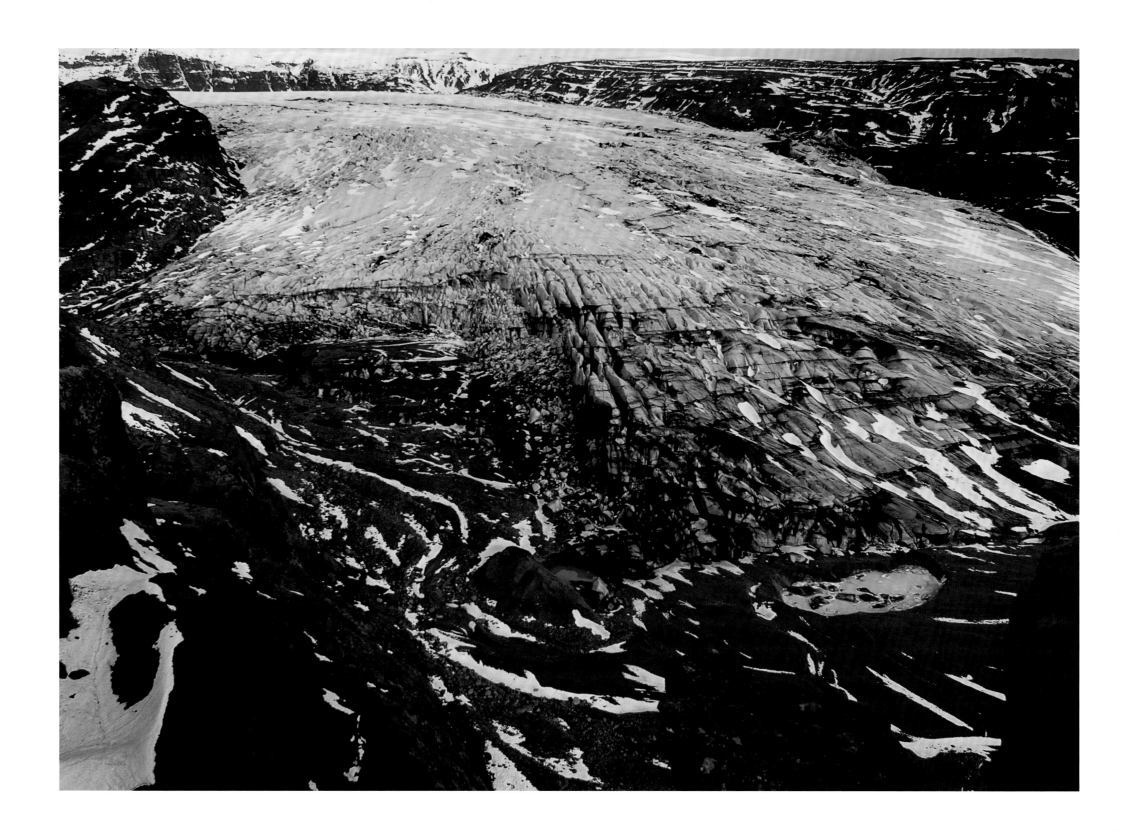

▲ ▶ Sólheimajökull | **Iceland** | Seen by EIS camera IL-05.

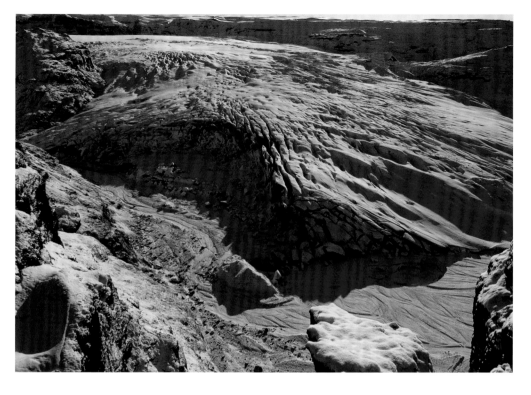

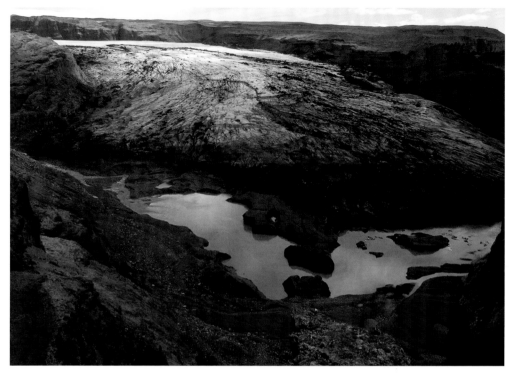

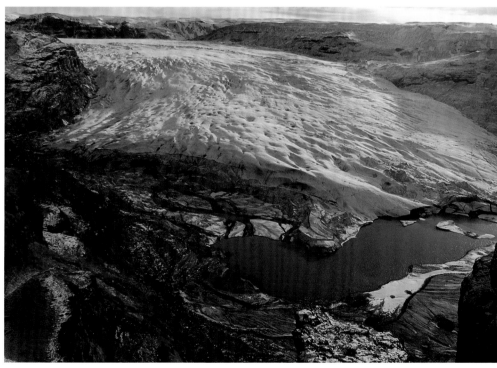

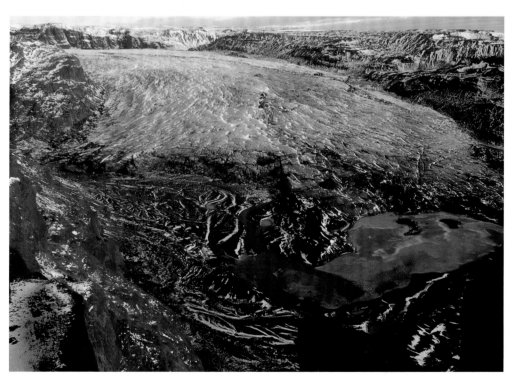

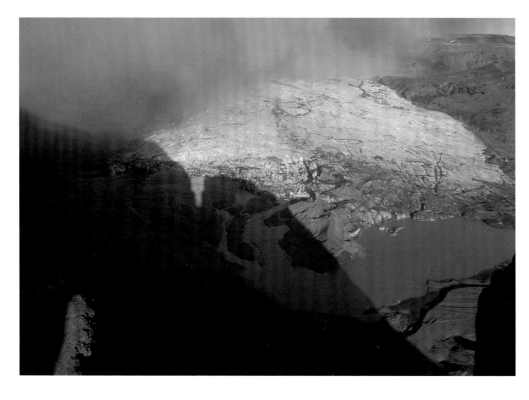

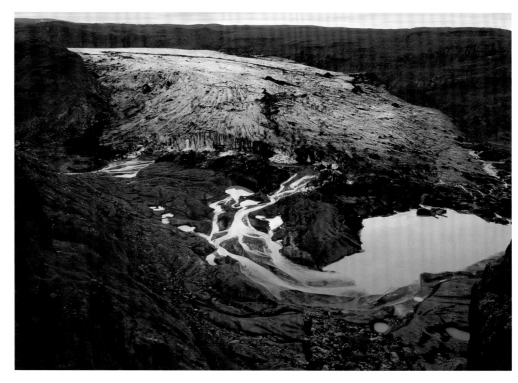

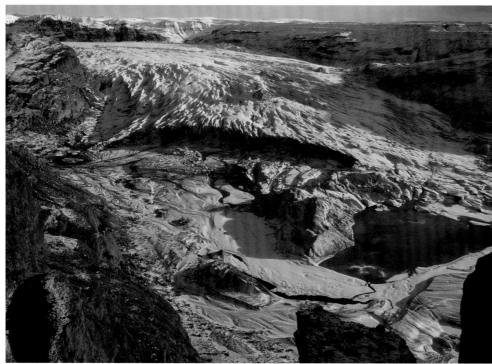

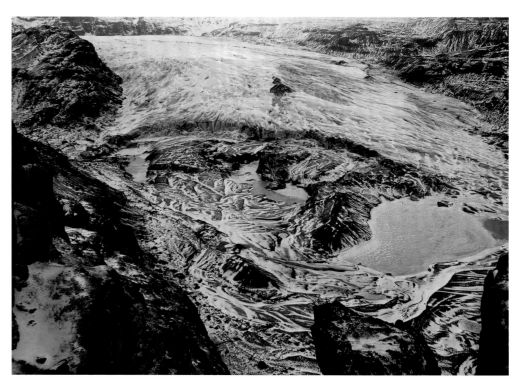

TOP ROW: 16 April 2010 | 29 August 2010 BOTTOM ROW: 10 November 2010 | 21 March 2011

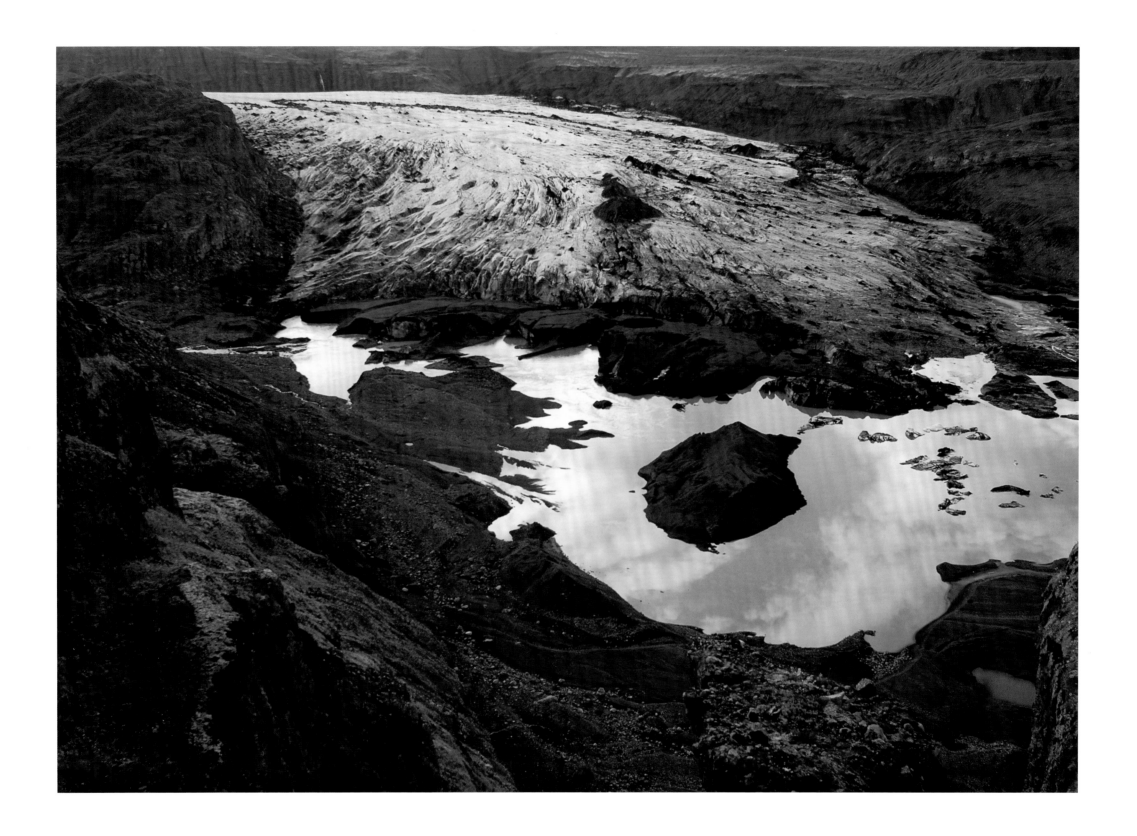

◄ ▲ Sólheimajökull | **Iceland** | Seen by EIS camera IL-05.

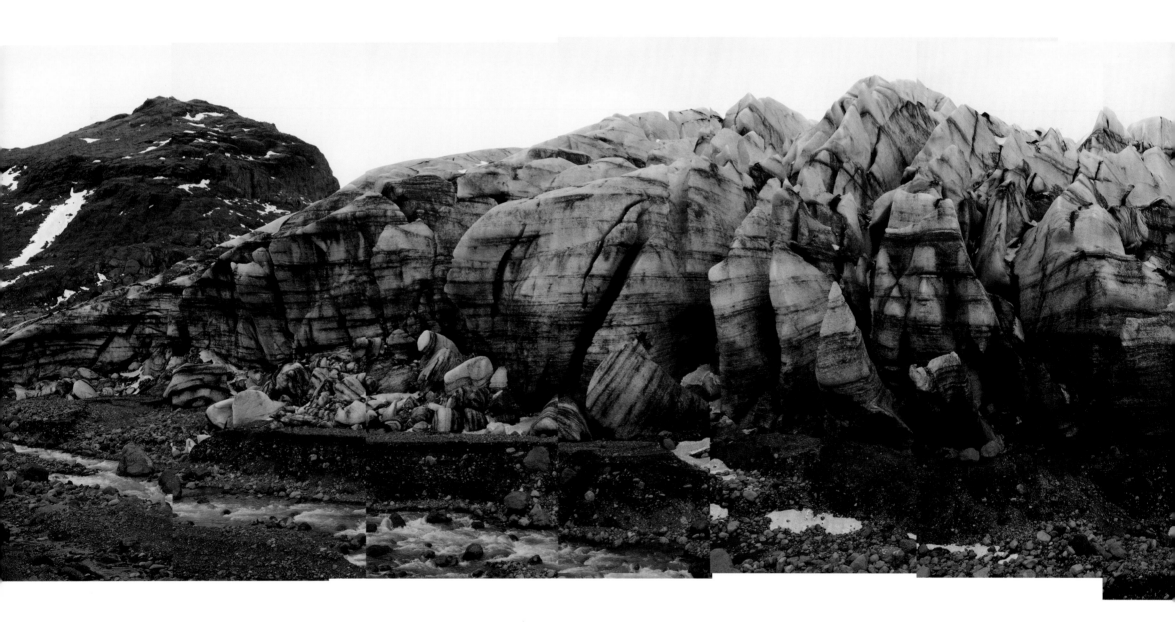

▲ Sólheimajökull │ **Iceland** │ 26 March 2007 │ Seen from WP-2.

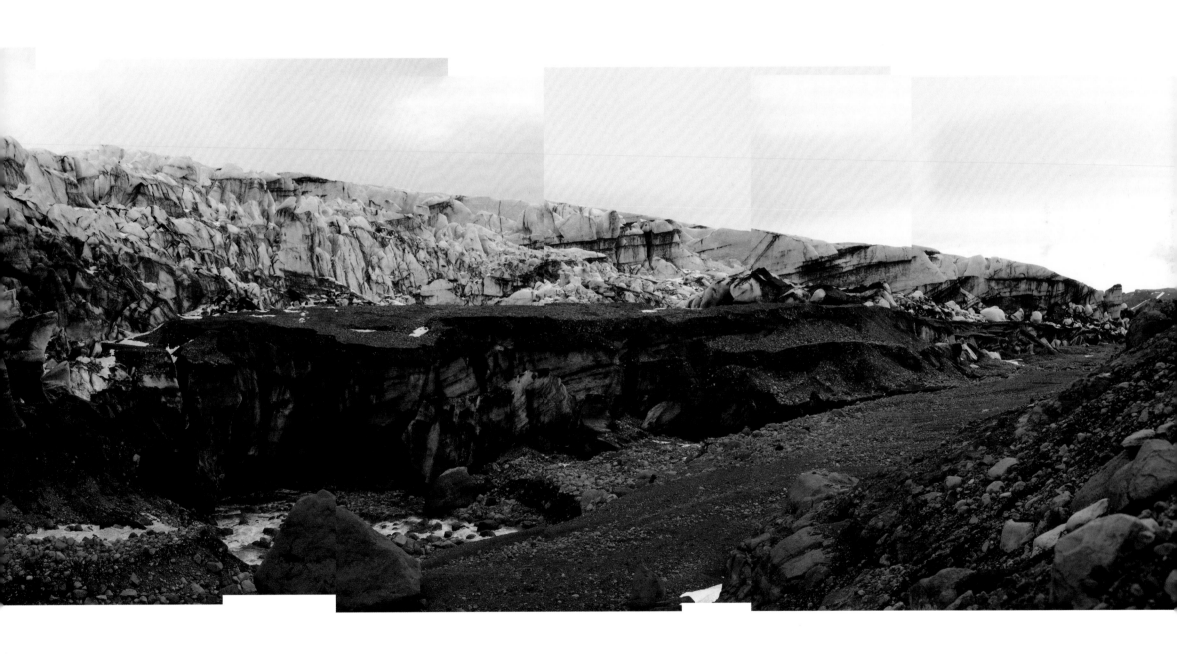

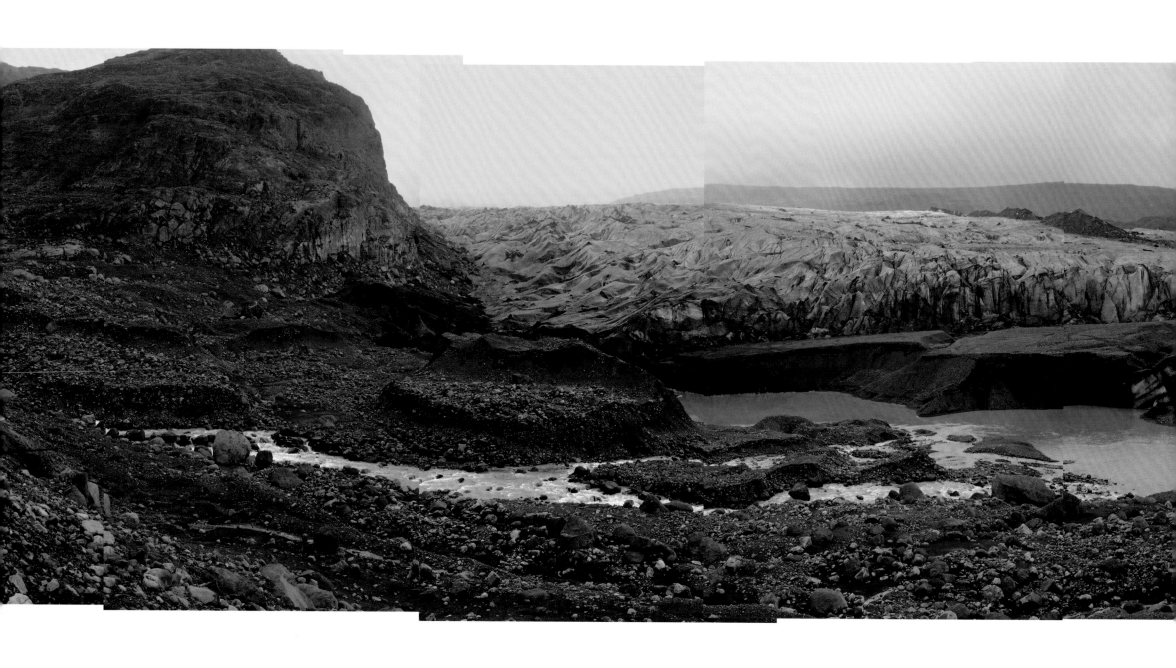

▲ Sólheimajökull | **Iceland** | 15 June 2011 | Seen from WP-2b.

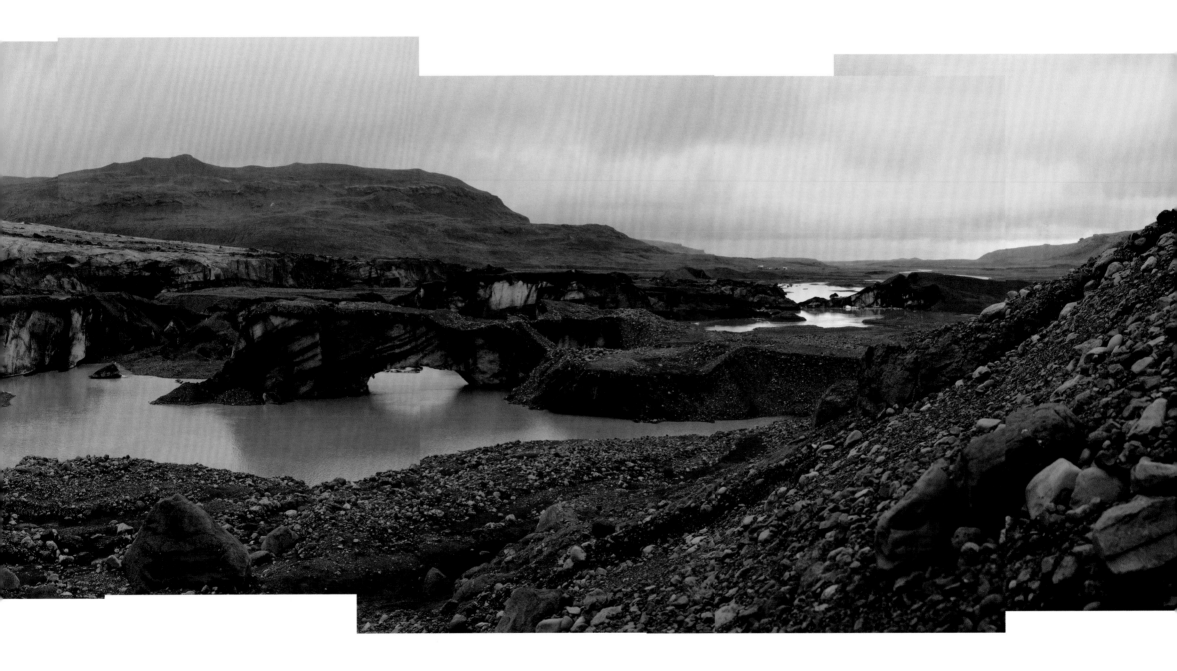

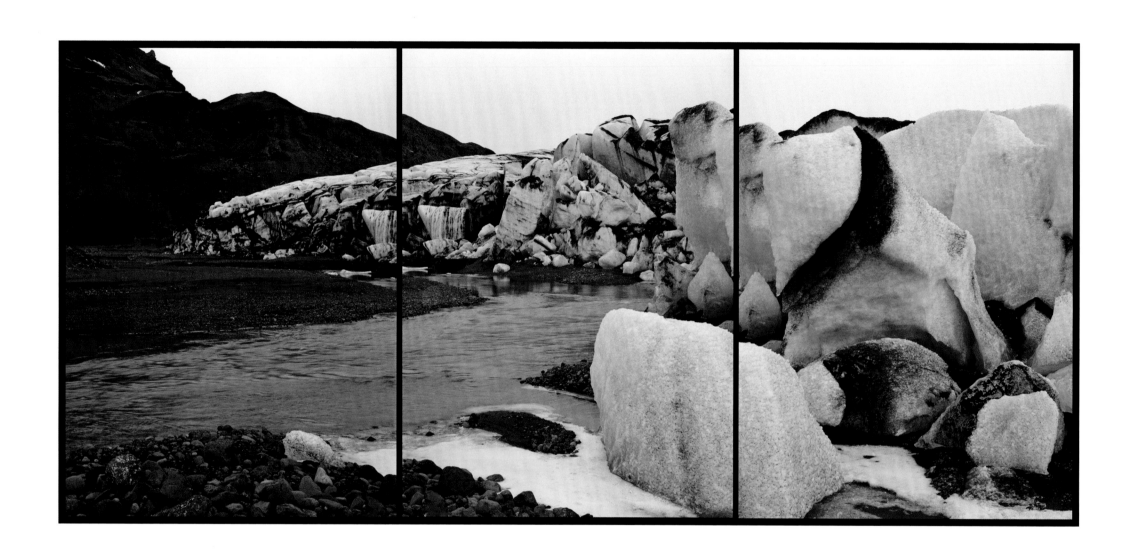

▲ Terminus of Sólheimajökull | **Iceland** | March 2005

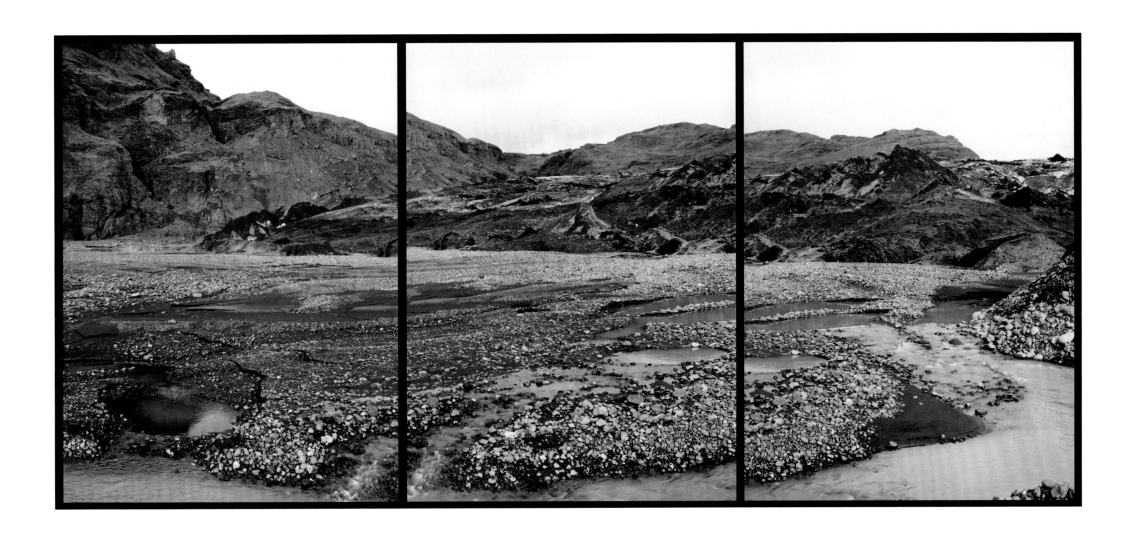

▲ Terminus of Sólheimajökull │ **Iceland** │ 1 October 2006

TRANSFORMATION

The frozen lattice
of one oxygen and two hydrogen atoms
is impermanent.
Its structures seem colossal,
yet are friable.

The sun beats down.
Crystal turns to purest water.
The taste is perfect.

Rivers of melt
snake across the glacier surface.
In months,
meltwater carves a canyon
that would take ten million years
to cut in stone.

Lakes sponge up melt
until their beds crack from sapphire weight.
Moulins open hungry jaws
and slurp meltwater
to a netherworld below the ice.
Always, the water finds
its path
to the immortal ocean.

At the borderland
between glacier and not-glacier
is the terminus.
The terminus of a glacier
flowing into water is called its calving face
(though no cows are nearby).
Its calves are icebergs of a trillion forms,
none alike.

Out to sea they go,
breaking, melting, collapsing.

The land is de-glaciated.

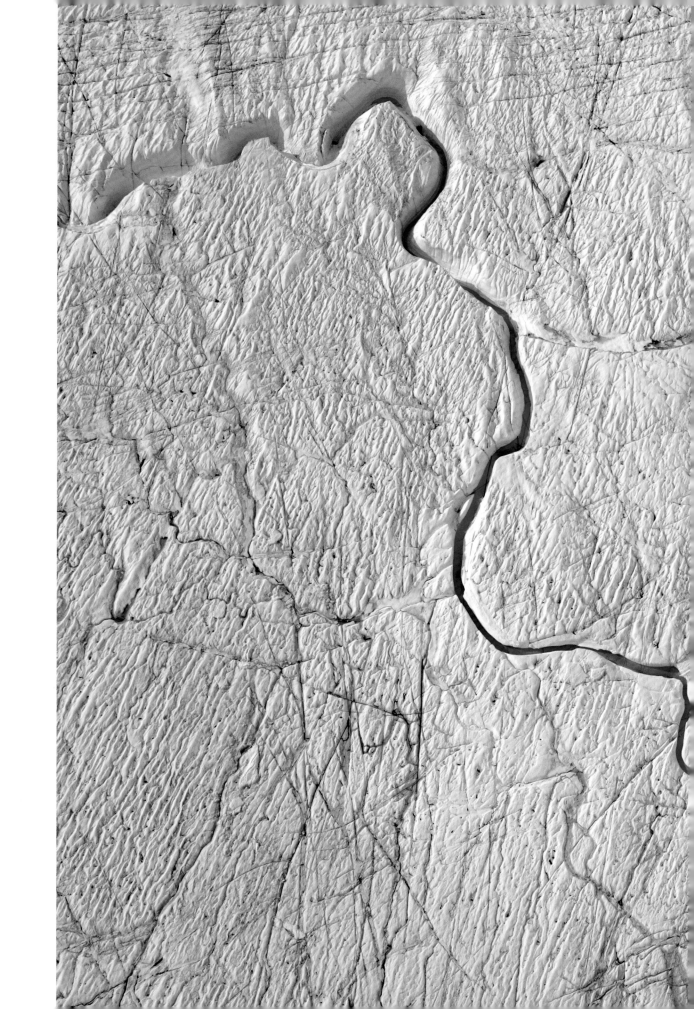

► Lake Meighan and Survey Canyon | **Greenland** | 6 July 2009
Ablated surface of the ice sheet shows abandoned meltwater channels
from an earlier time.

▼ Disko Bay | **Greenland** | 20 July 2006

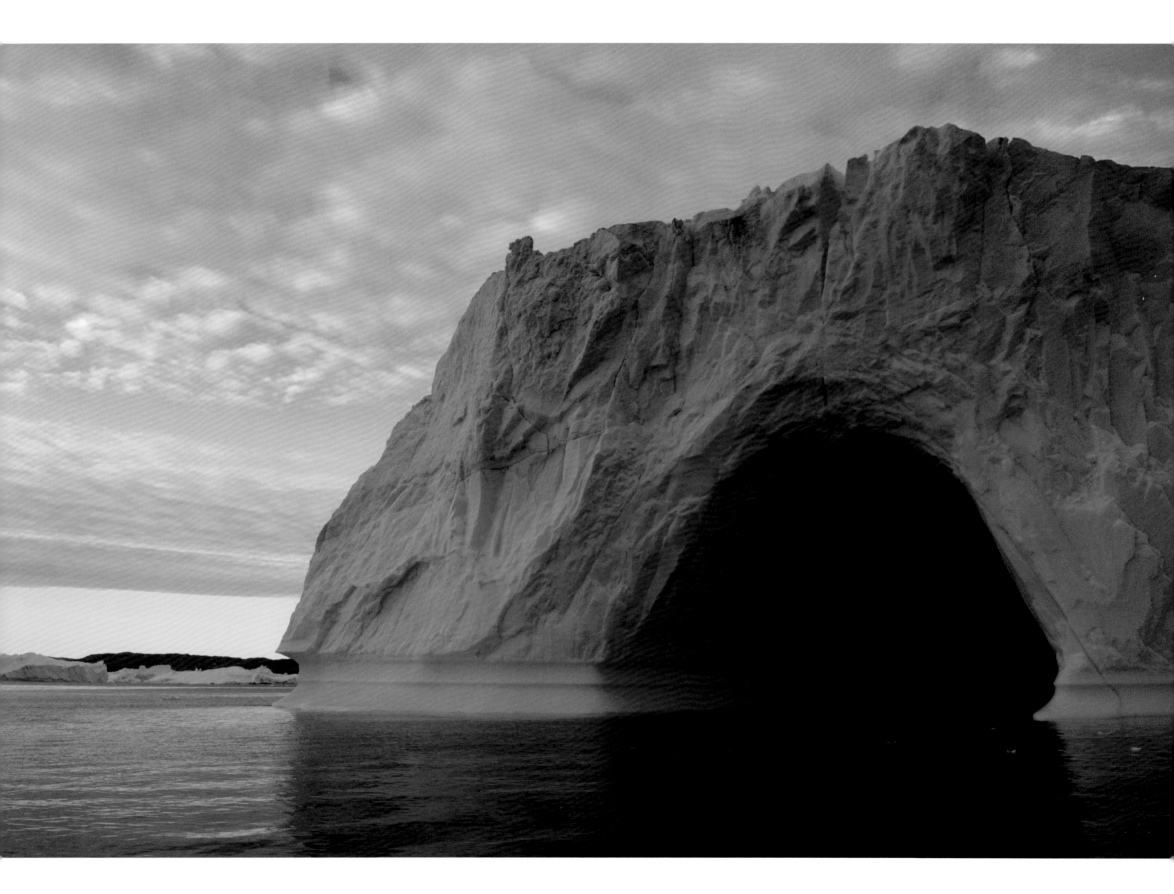

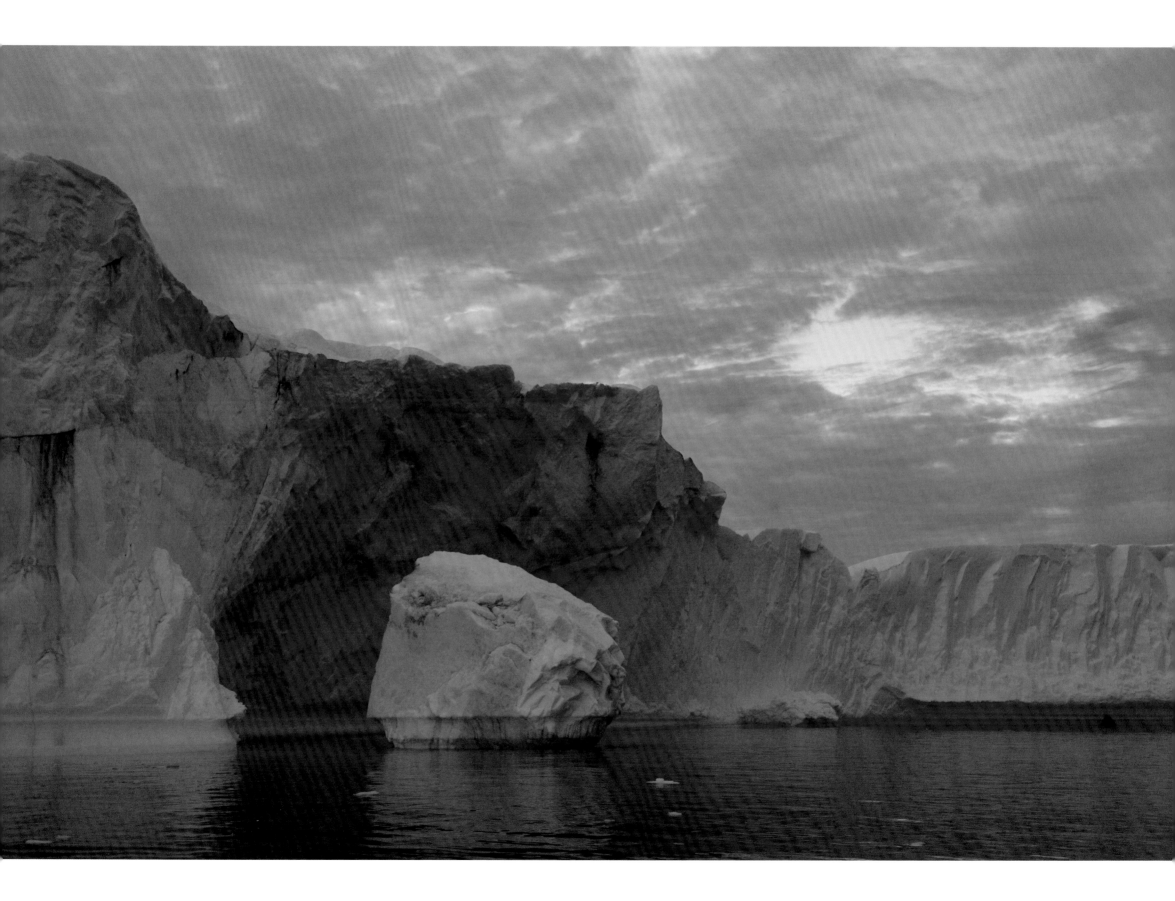

► Mendenhall Glacier | **Alaska, United States** | 16 September 2010

▼ Russell Glacier sector of Greenland Ice Sheet | **Greenland** | 12 July 2006

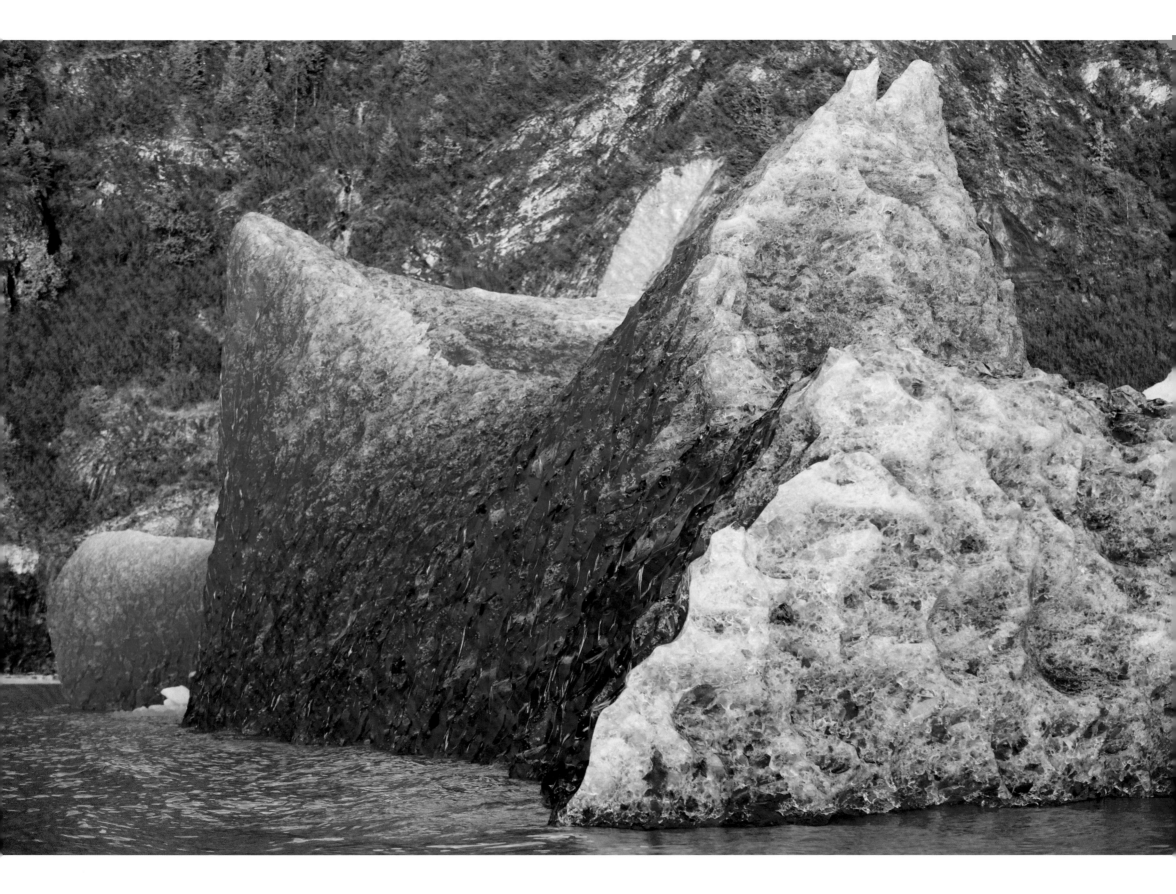

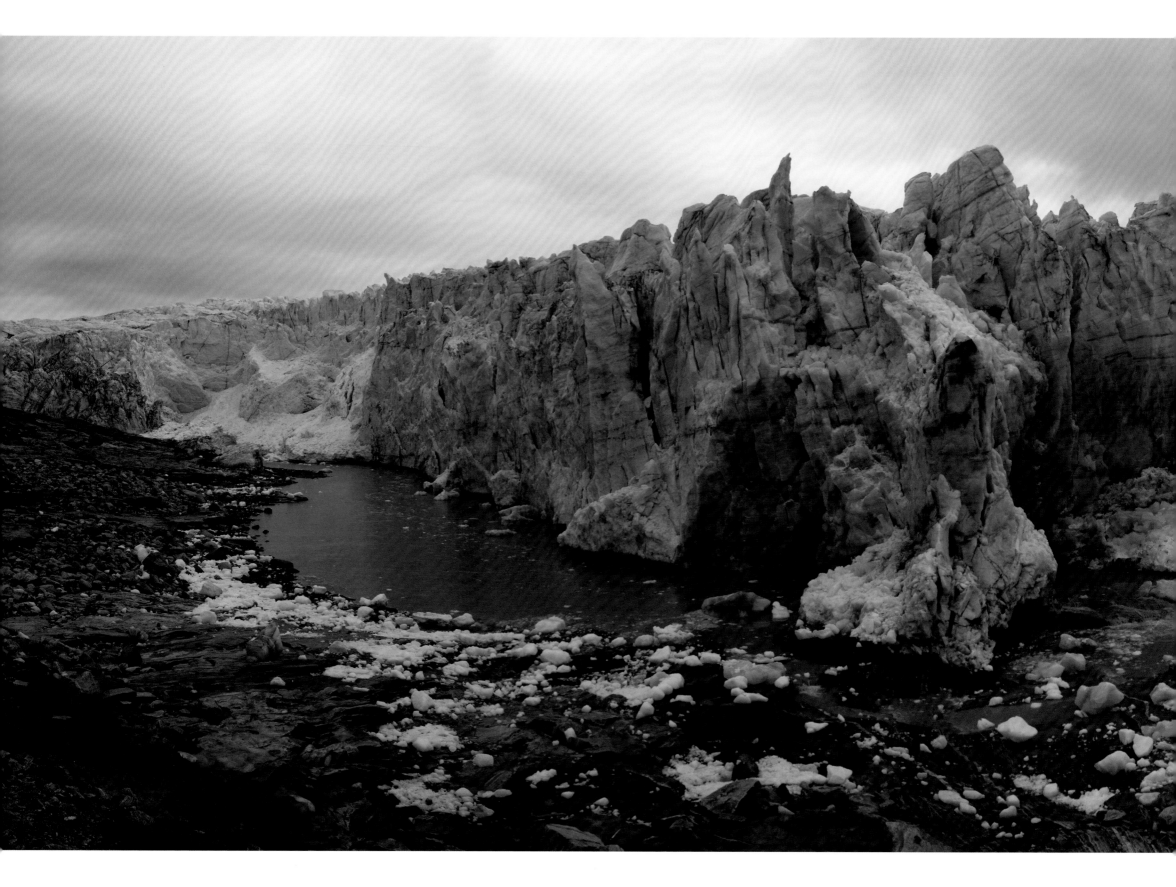

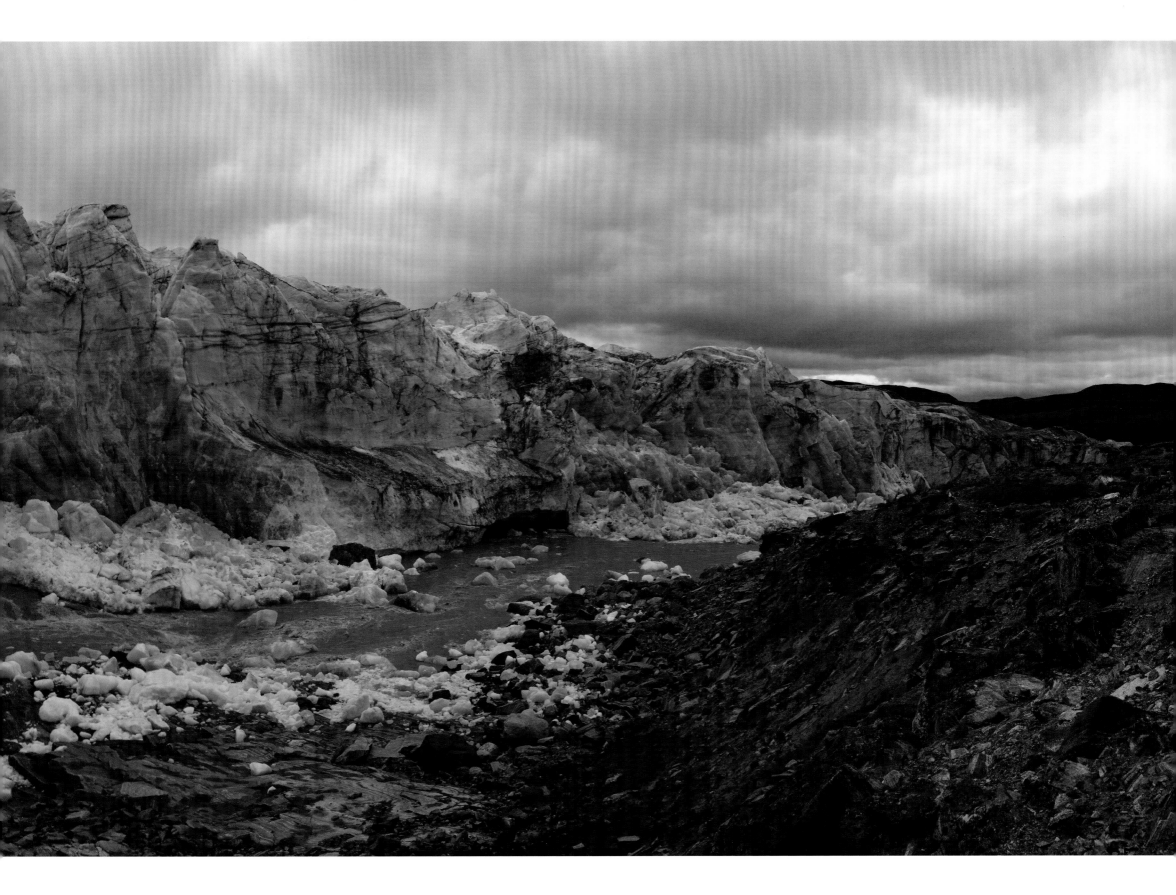

▶ Mendenhall Glacier | **Alaska, United States** | 16 September 2010

▼ Columbia Bay | **Alaska, United States** | 25 August 2009

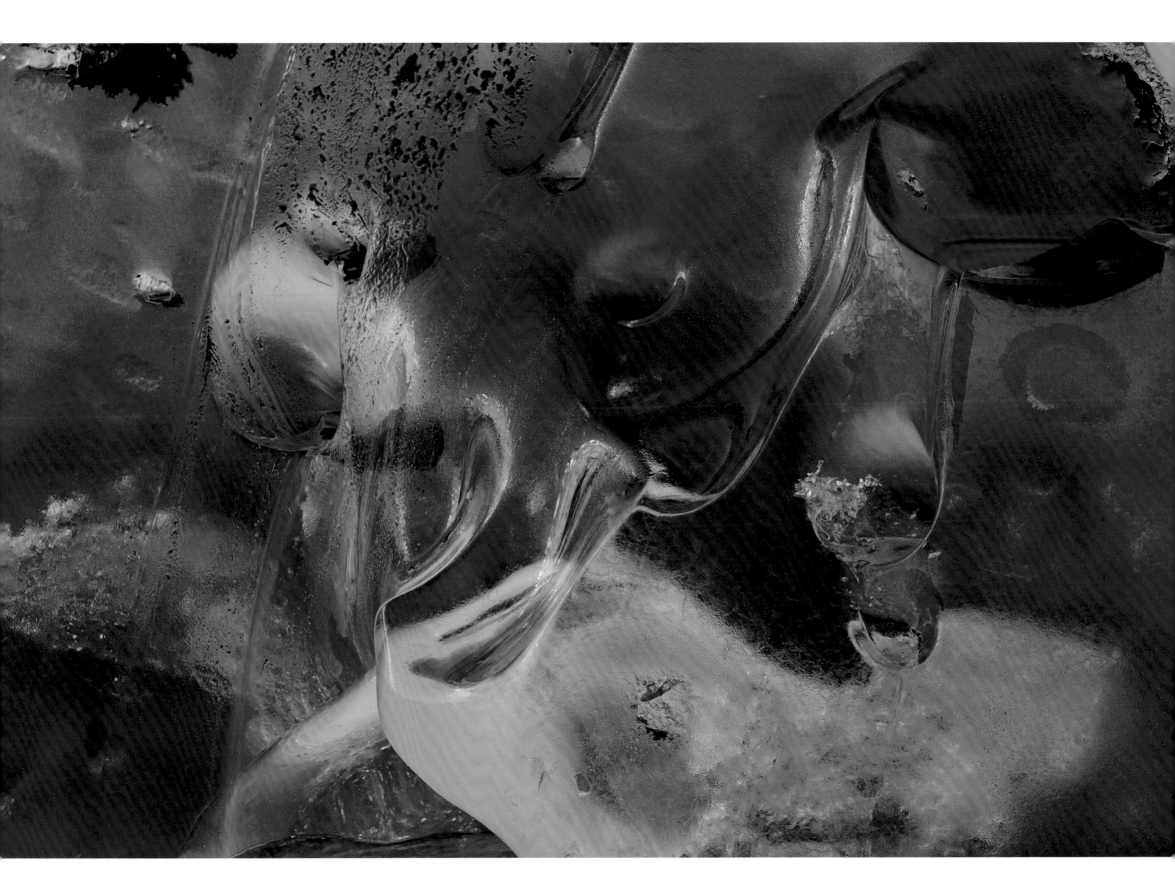

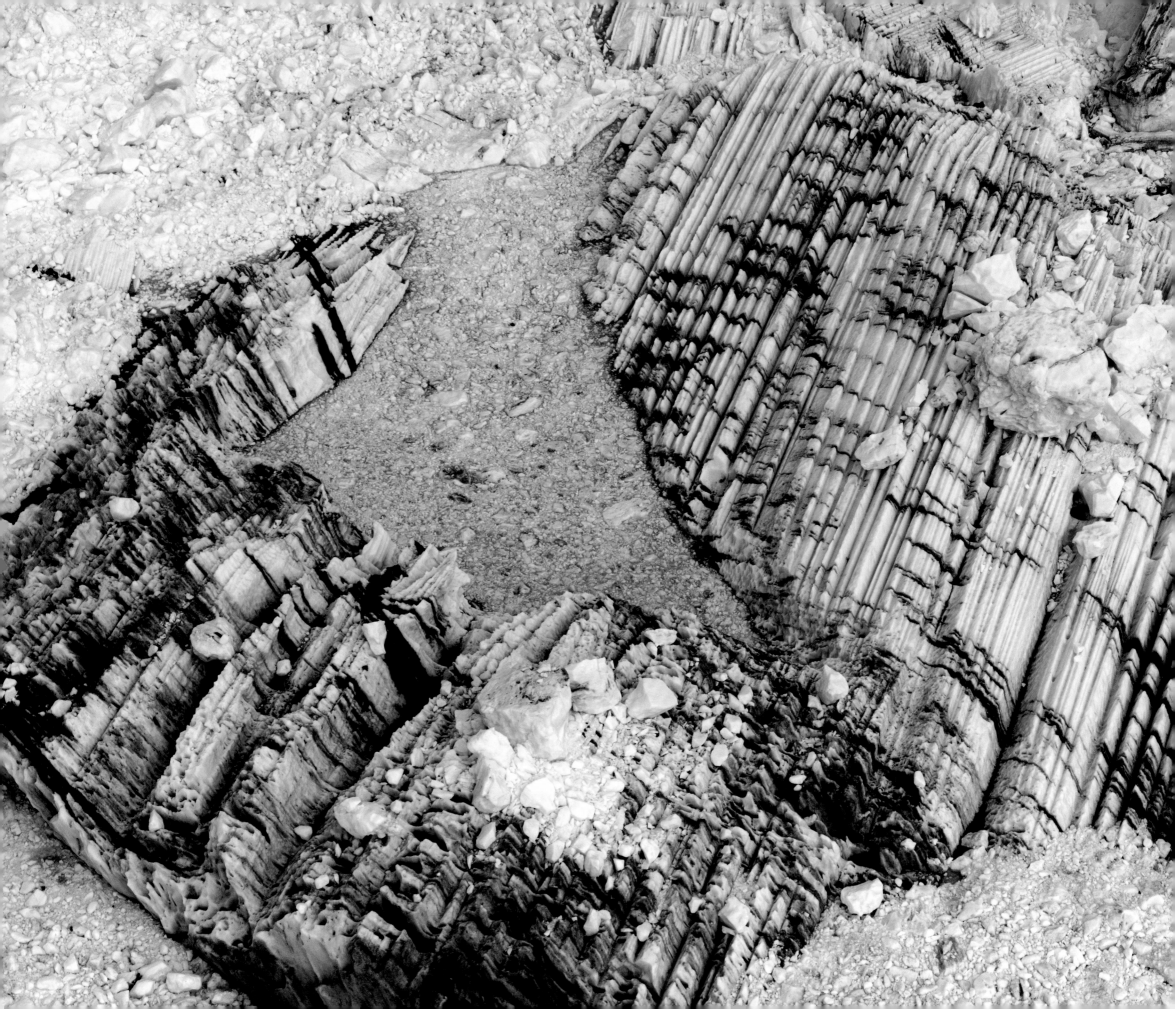

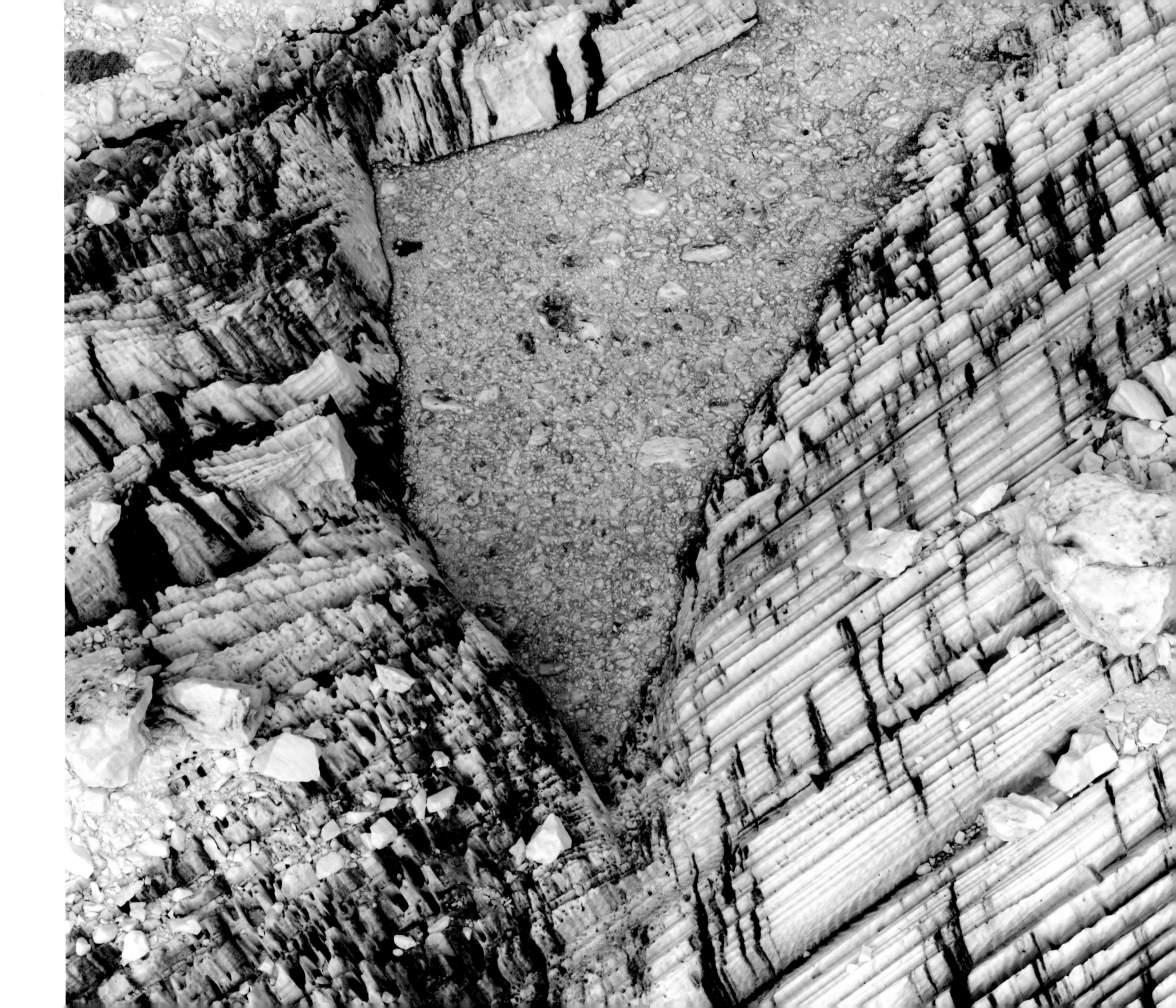

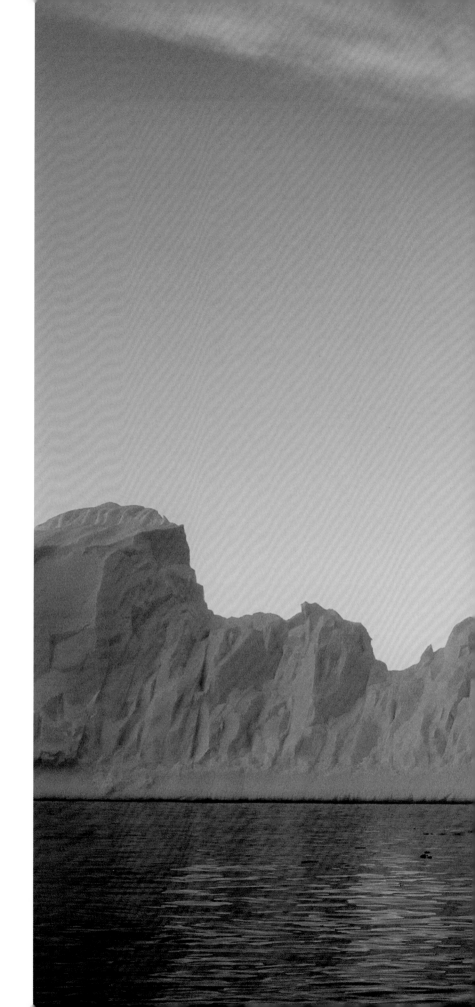

▶ Lindblad Cove, Antarctic Peninsula │ **Antarctica** │ 11 January 2011

▼ Disko Bay │ **Greenland** │ 16 July 2006
 Old ice fragments have re-frozen into a melange, seen here in the cross section of an iceberg.

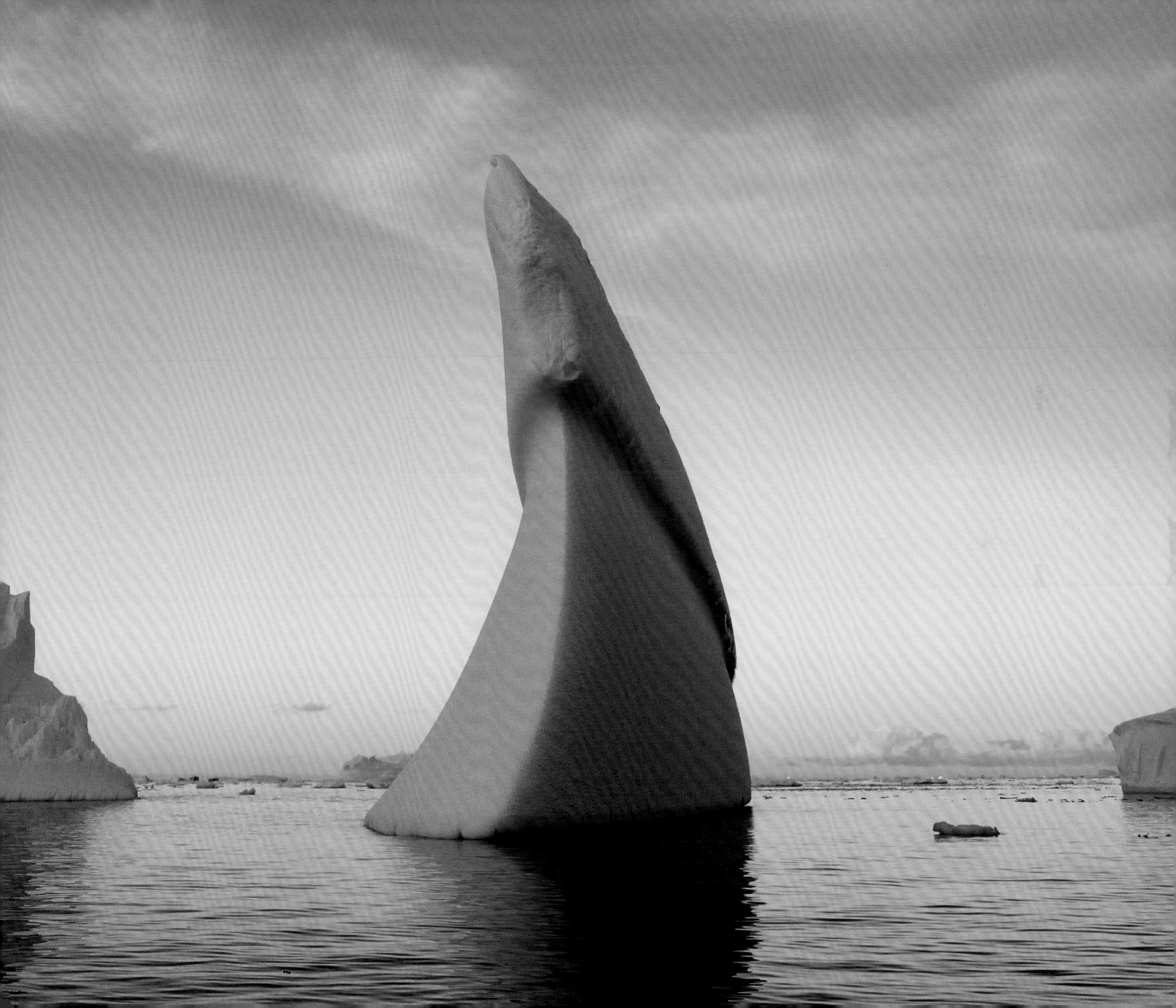

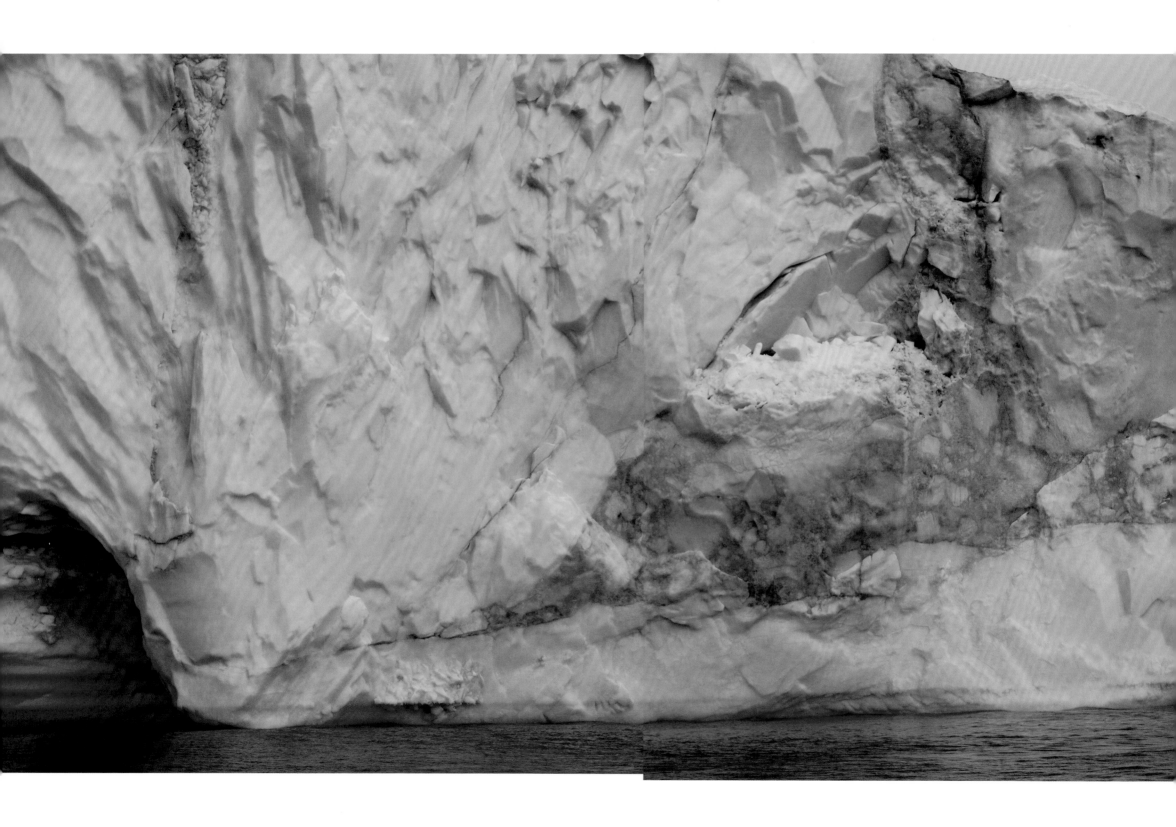

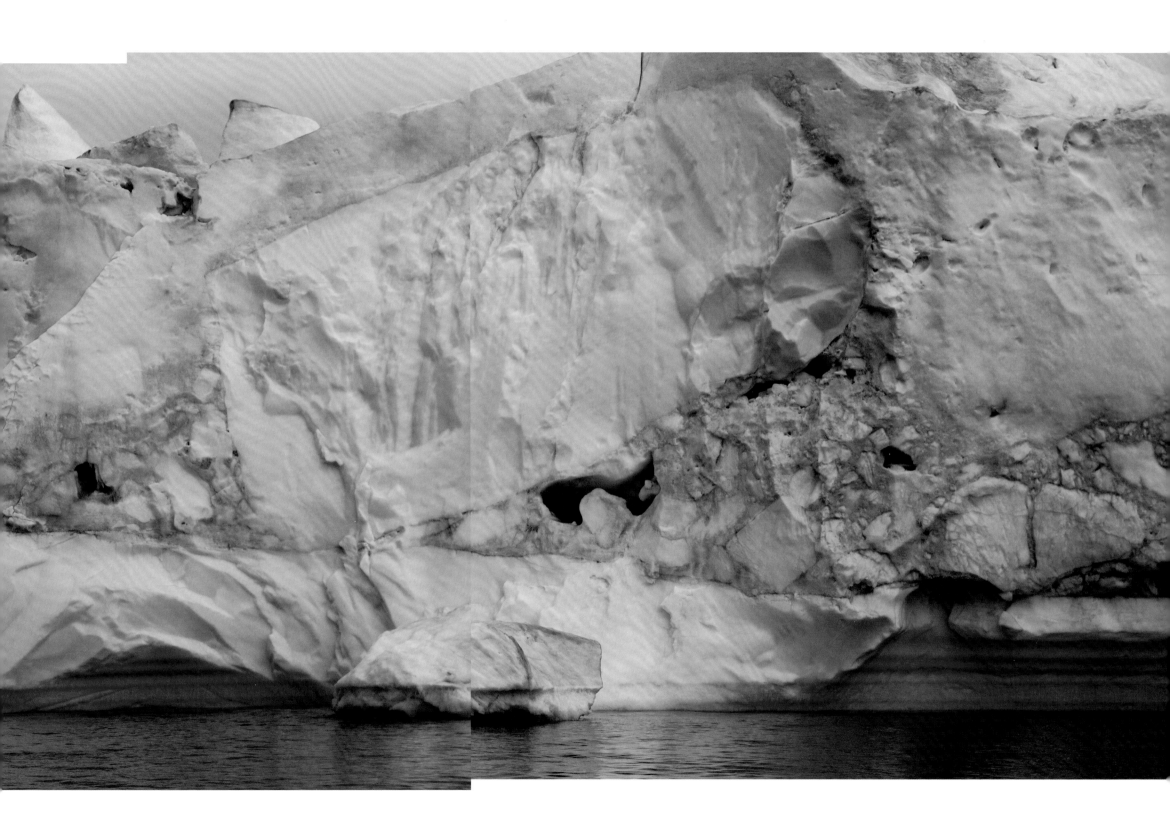

▶ Mendenhall Glacier │ **Alaska, United States** │ 16 September 2010

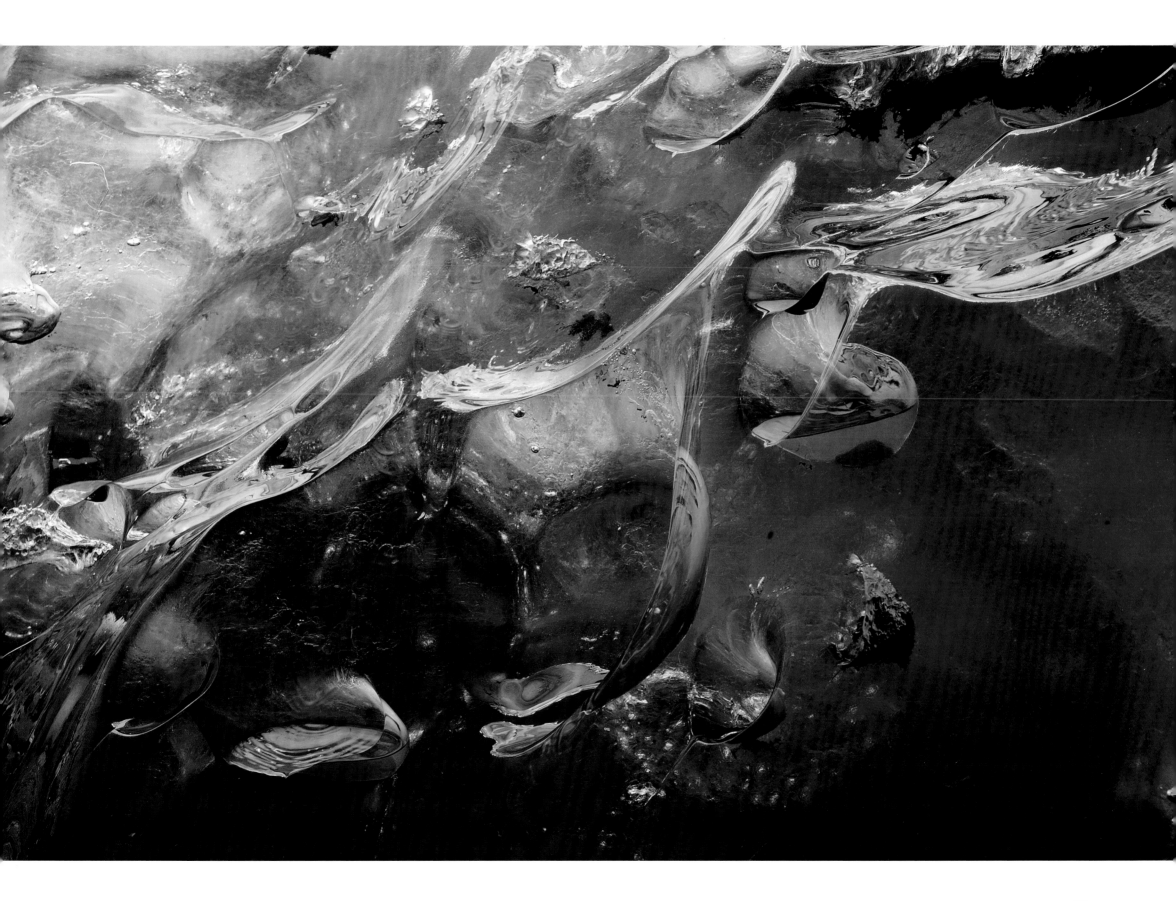

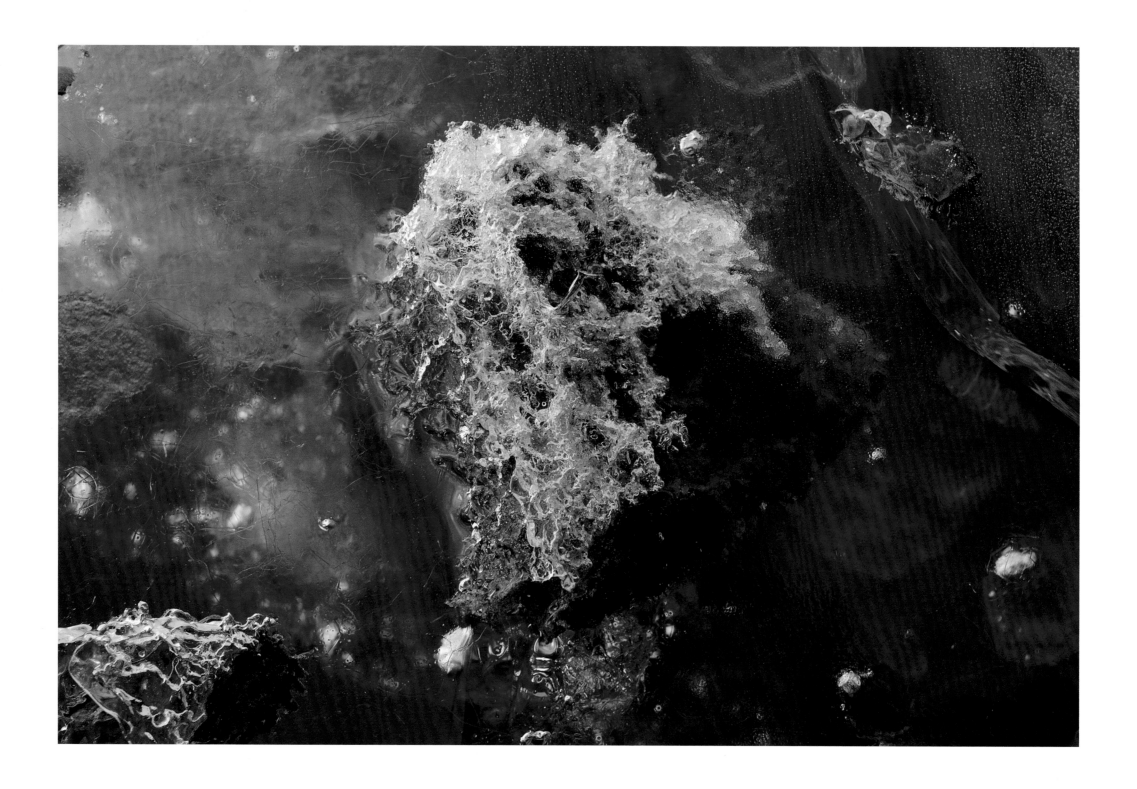

Mendenhall Glacier │ **Alaska, United States** │ 16 September 2010

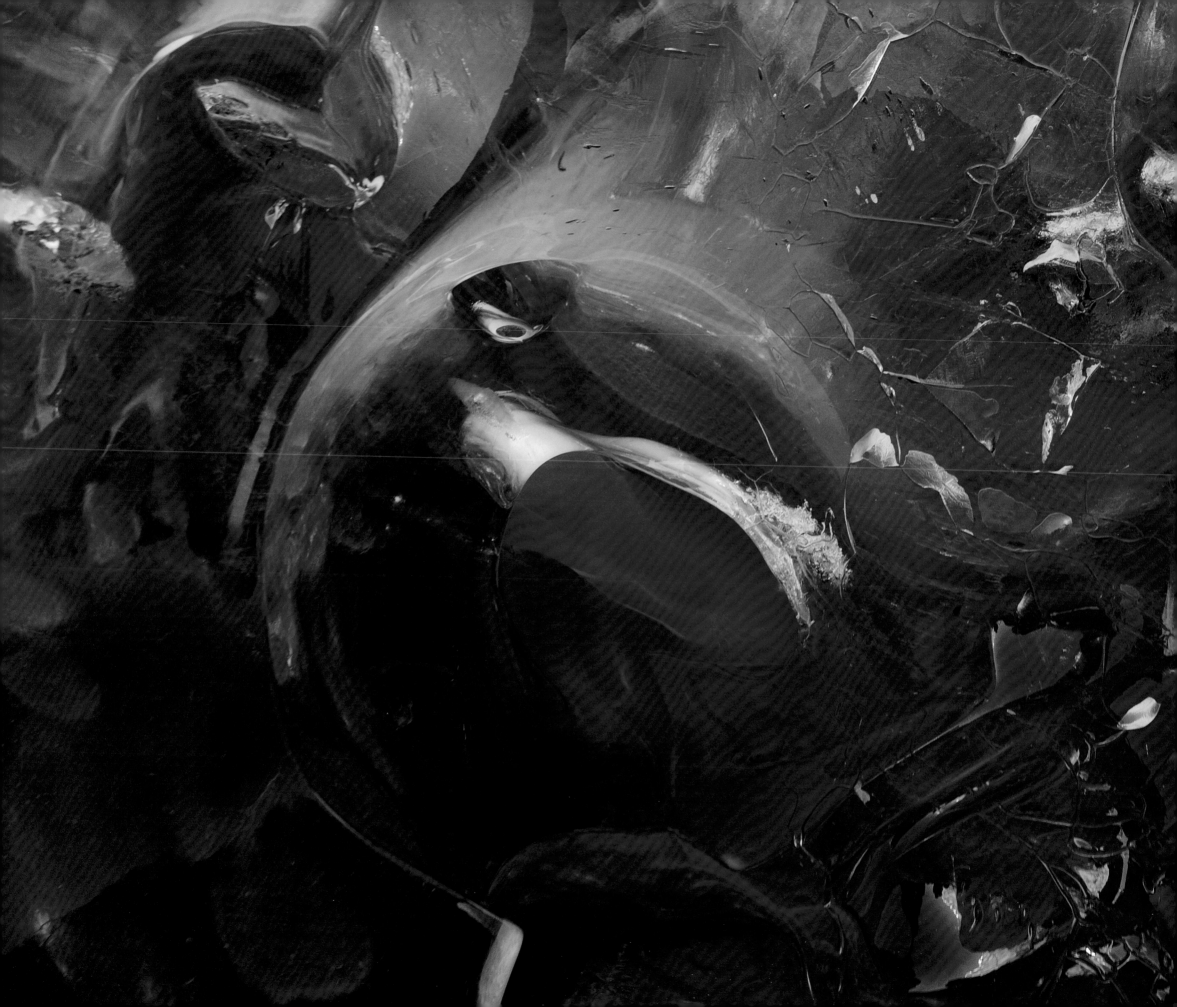

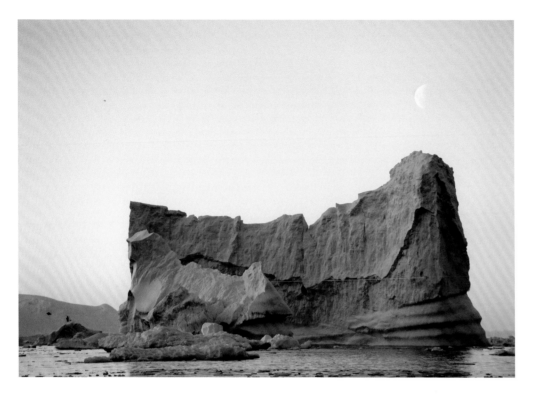

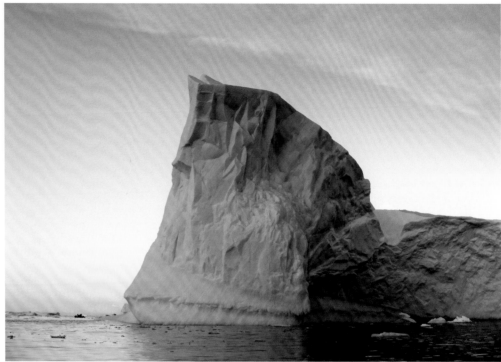

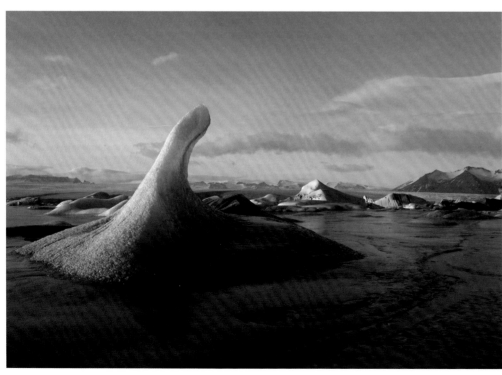

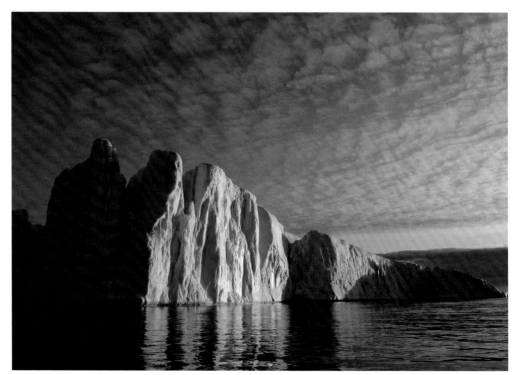

▲ TOP: Lindblad Cove | **Antarctica** | 11 January 2011

BOTTOM: Jökulsárlón | **Iceland** | 4 March 2005

▲ TOP: Lindblad Cove | **Antarctica** | 11 January 2011

BOTTOM: Disko Bay | **Greenland** | 24 August 2007

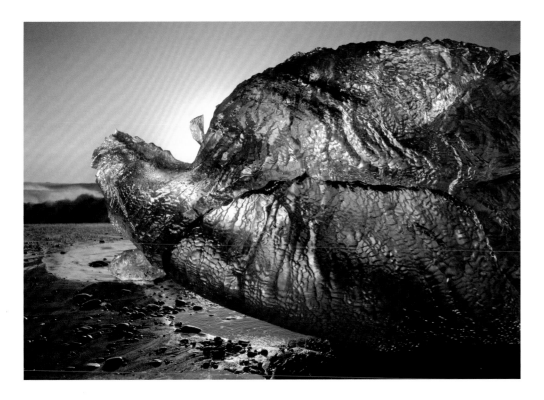

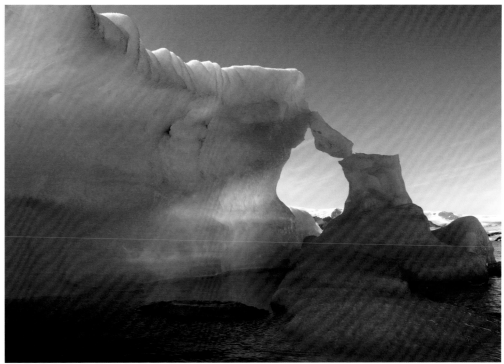

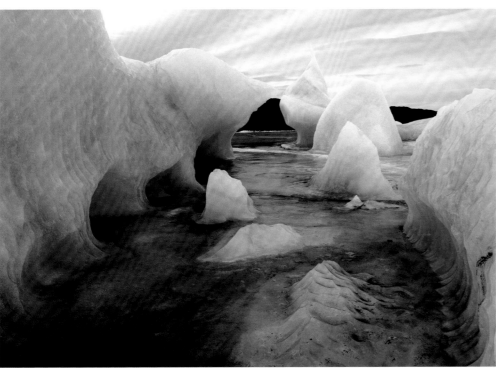

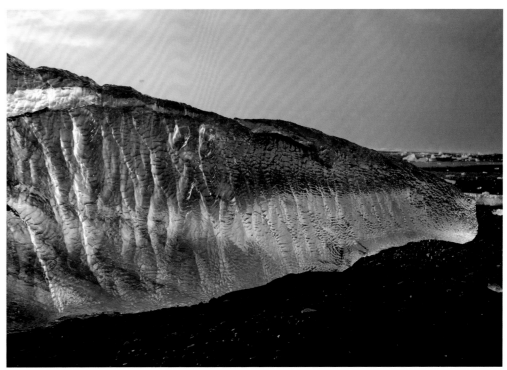

▲ TOP: Jökulsárlón │ **Iceland** │ 10 February 2008

BOTTOM: Jökulsárlón │ **Iceland** │ 4 March 2005

▲ TOP: Jökulsárlón │ **Iceland** │ 14 September 2007

BOTTOM: Jökulsárlón │ **Iceland** │ 10 February 2008

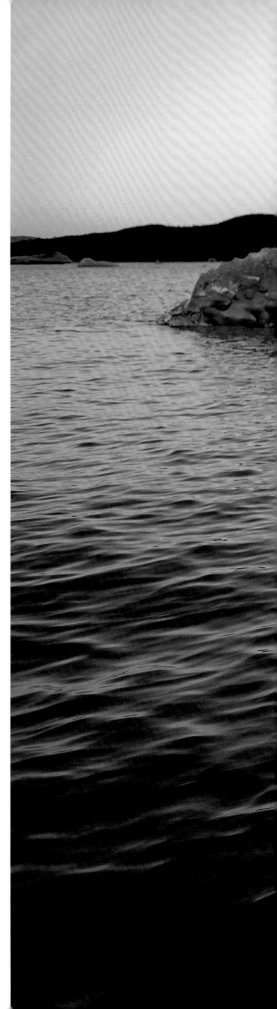

► Mendenhall Glacier │ **Alaska, United States** │ 16 September 2010

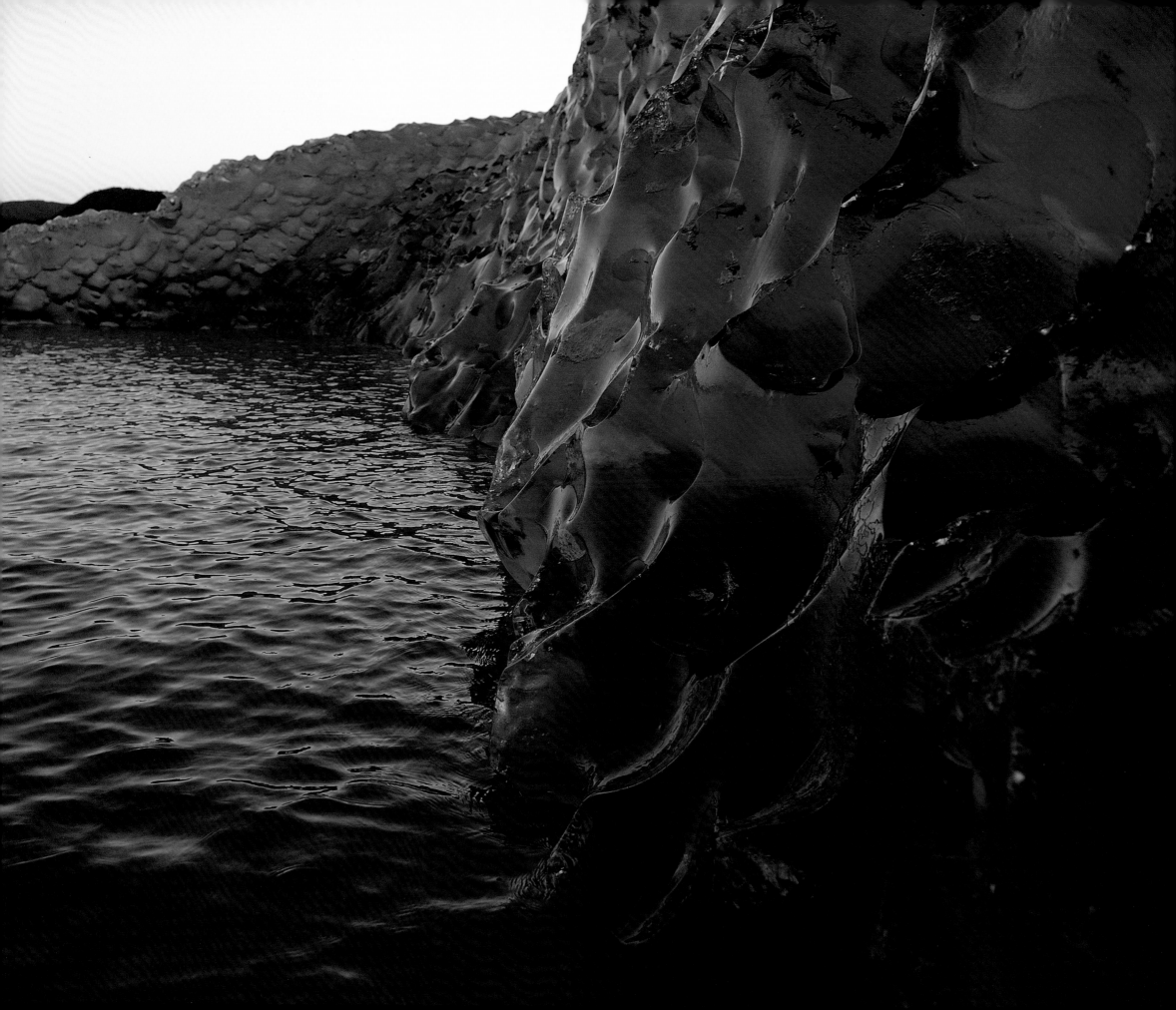

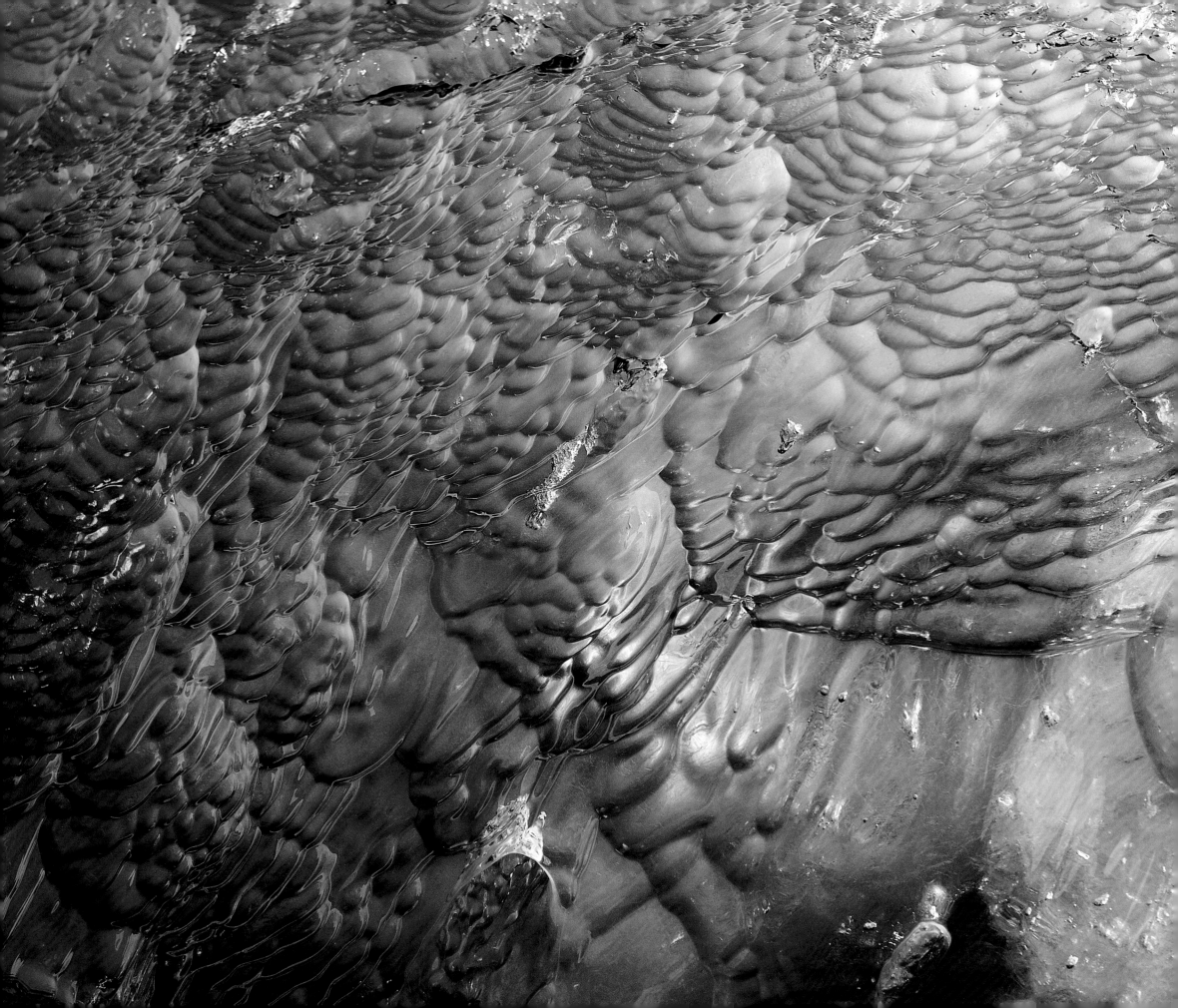

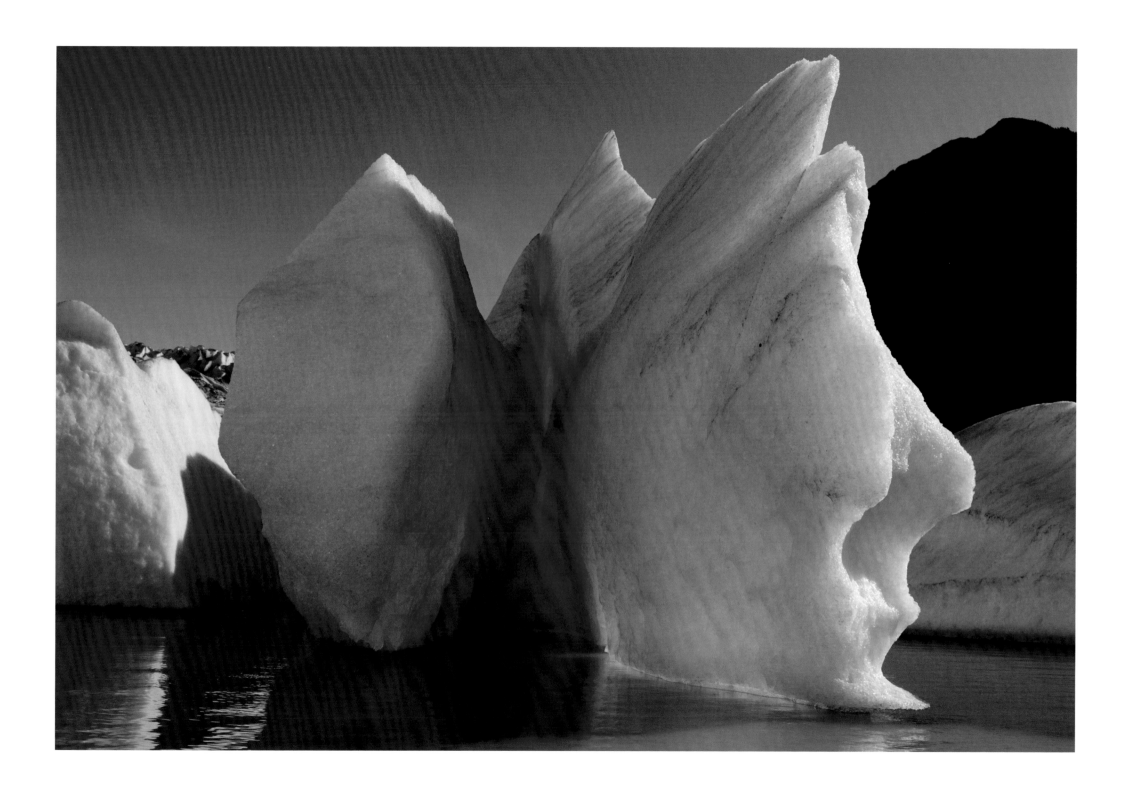

◀ ▲ Mendenhall Glacier │ **Alaska, United States** │ OPPOSITE: 16 September 2010 │ ABOVE: 14 September 2010

▶ Jökulsárlón | **Iceland** | 4 March 2005

▽ Sólheimajökull | **Iceland** | 17 September 2007 | Southwest edge of terminus.

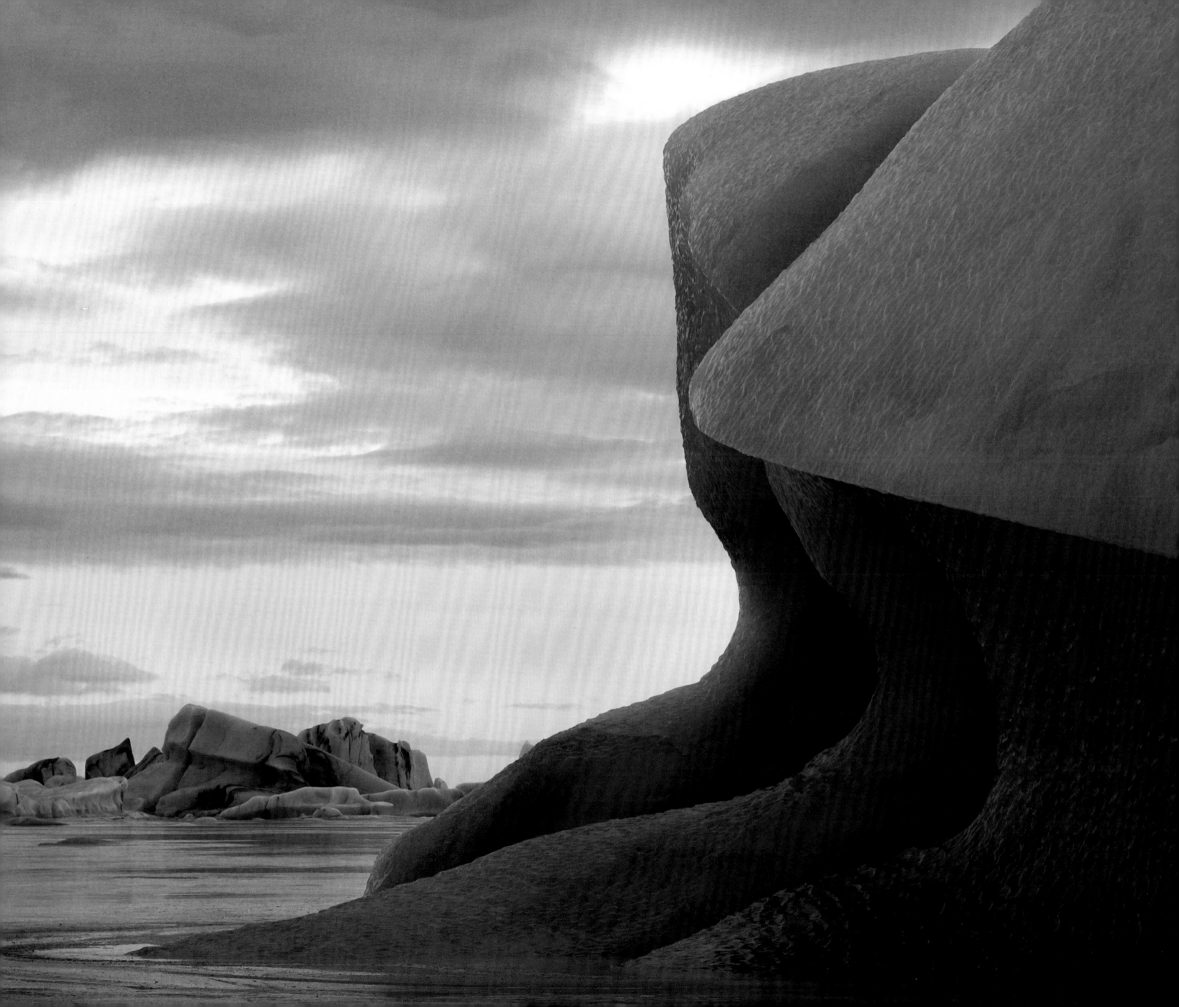

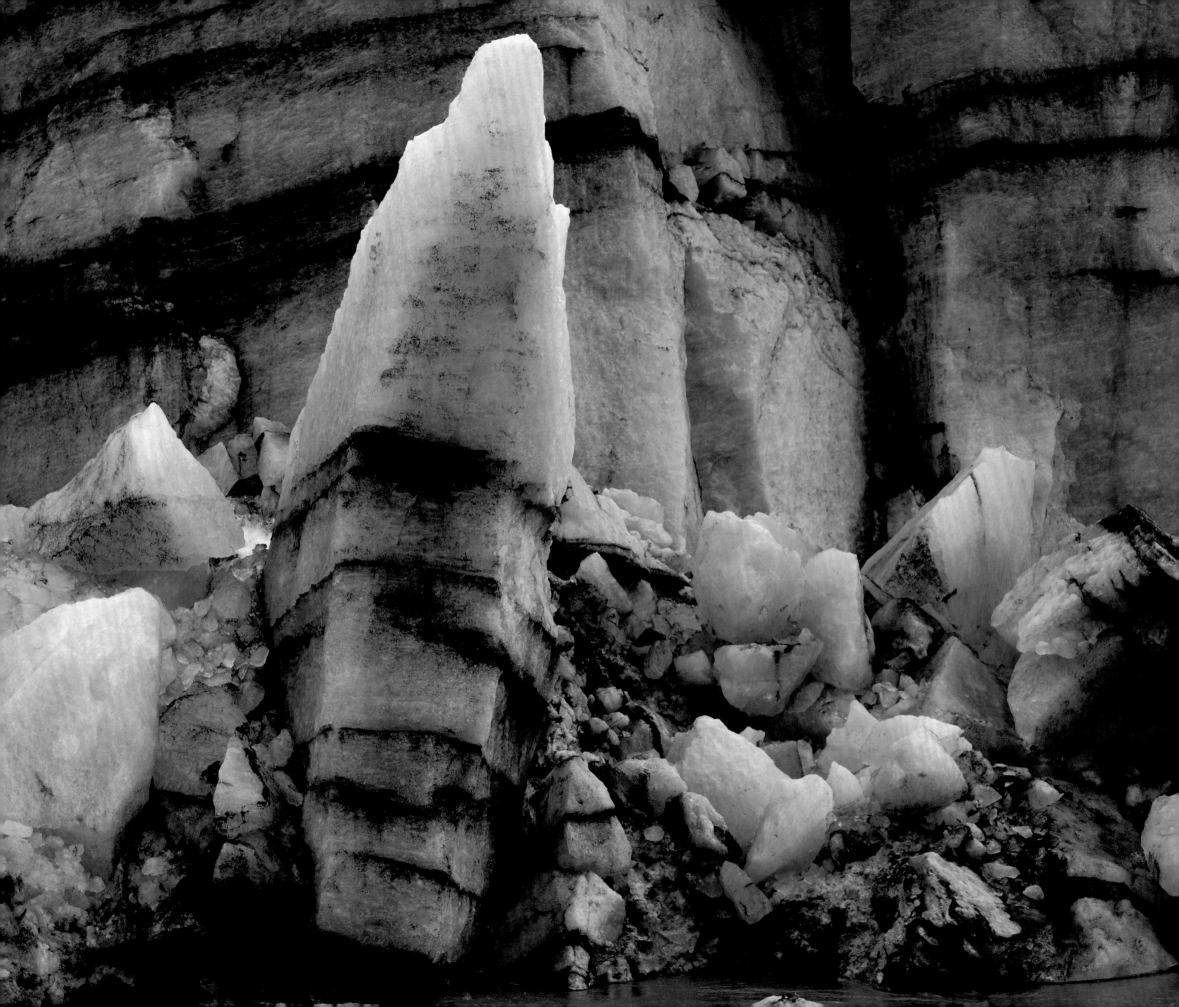

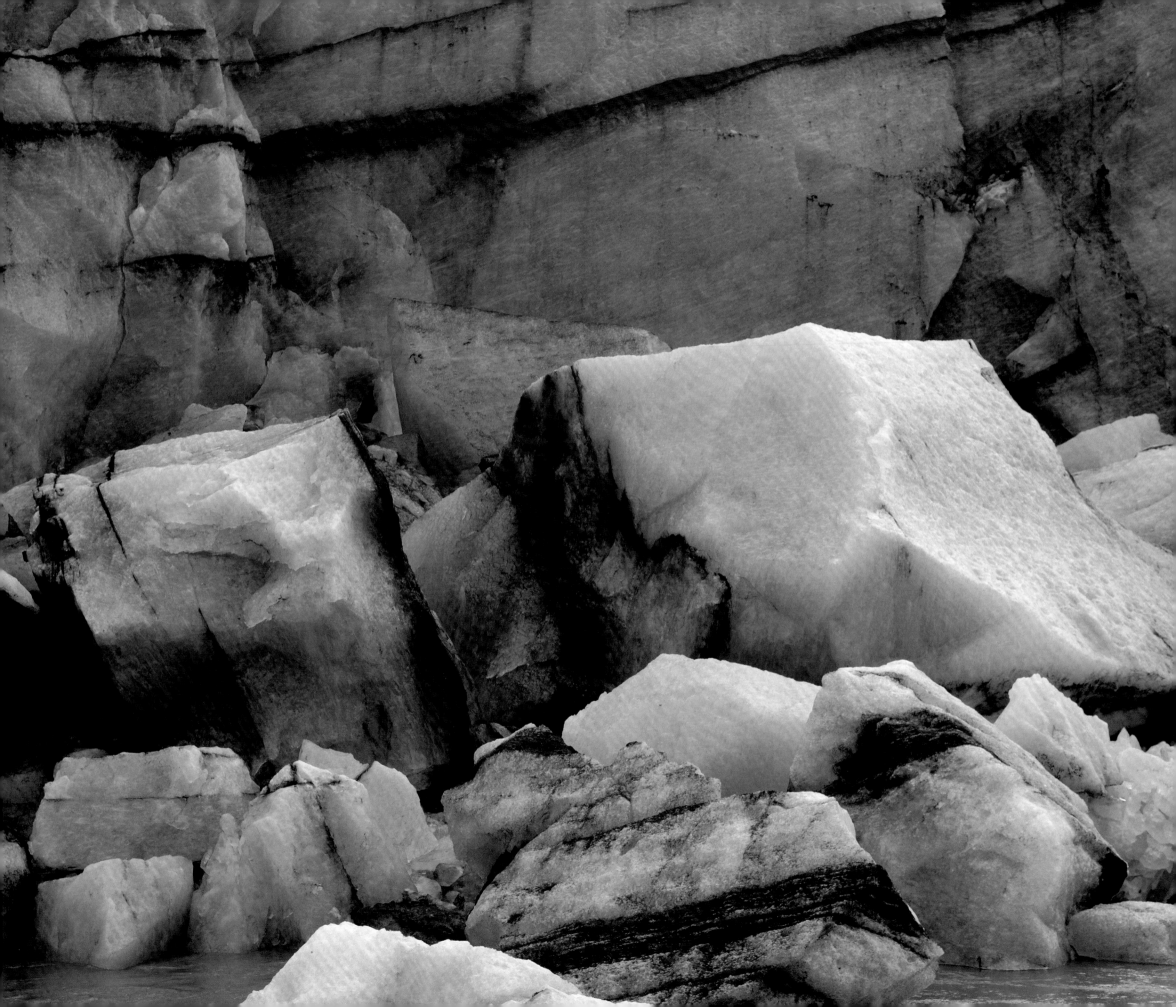

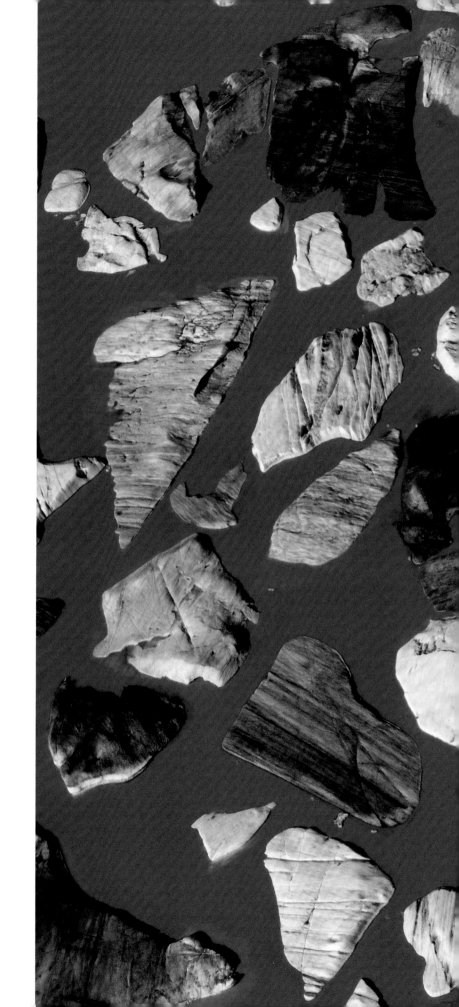

▶ Bridge Glacier | **British Columbia, Canada** | 1 September 2009

▼ LEFT: Breiðamerkurjökull and Jökulsárlón | **Iceland** | 30 August 2010 | Seen from Digital Globe WorldView 2 satellite.

RIGHT: Store Glacier | **Greenland** | 16 June 2008 | Seen from Digital Globe WorldView 2 satellite.

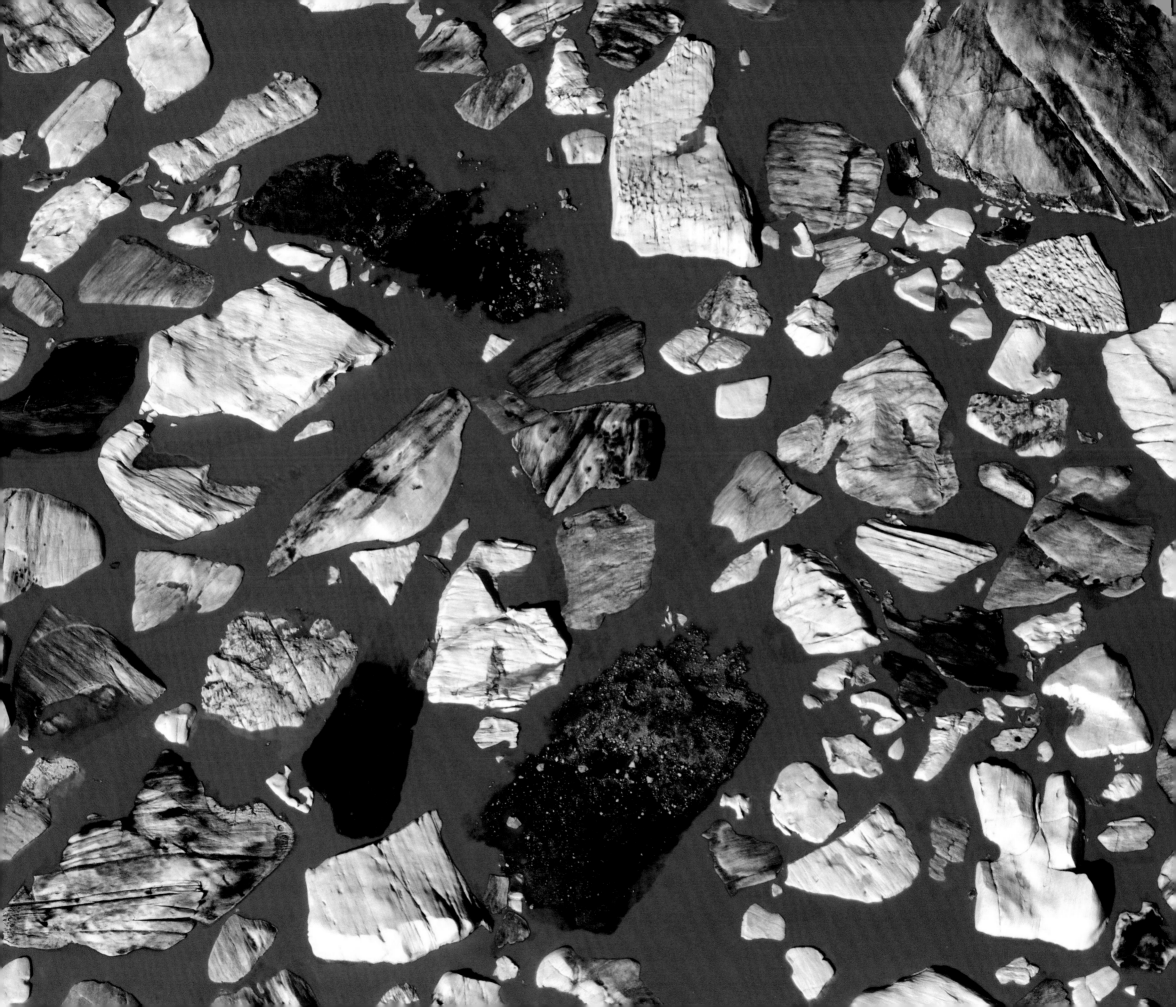

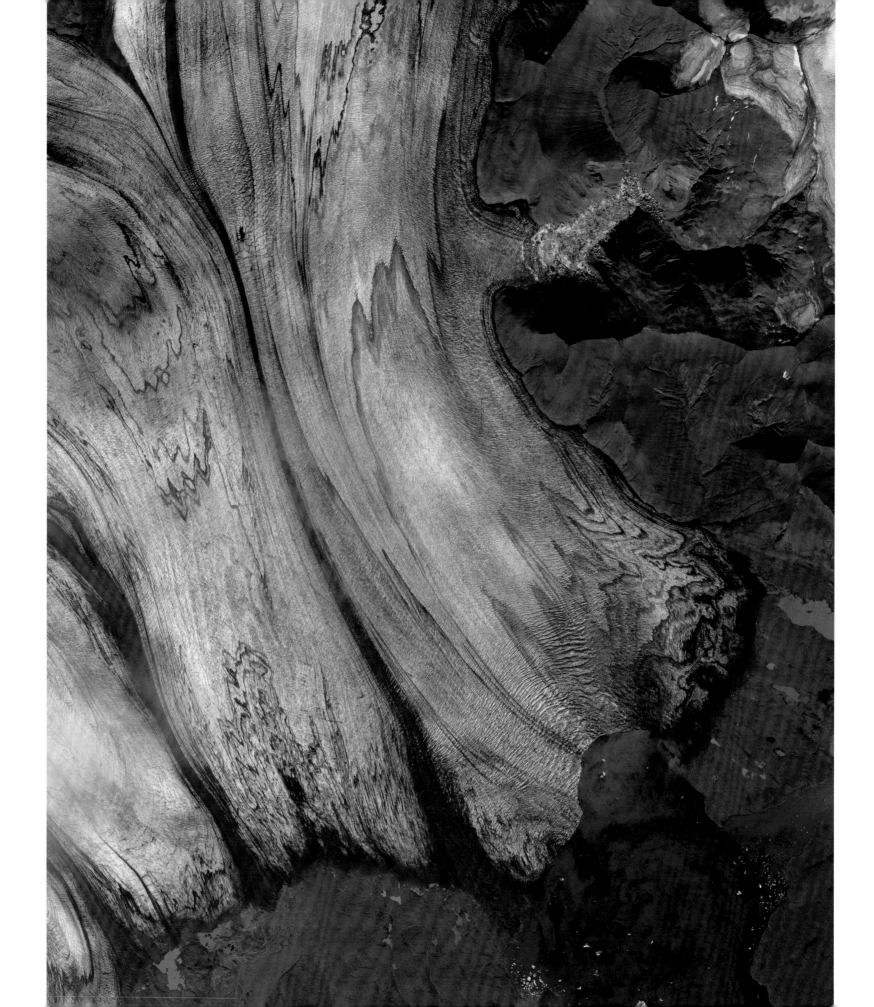

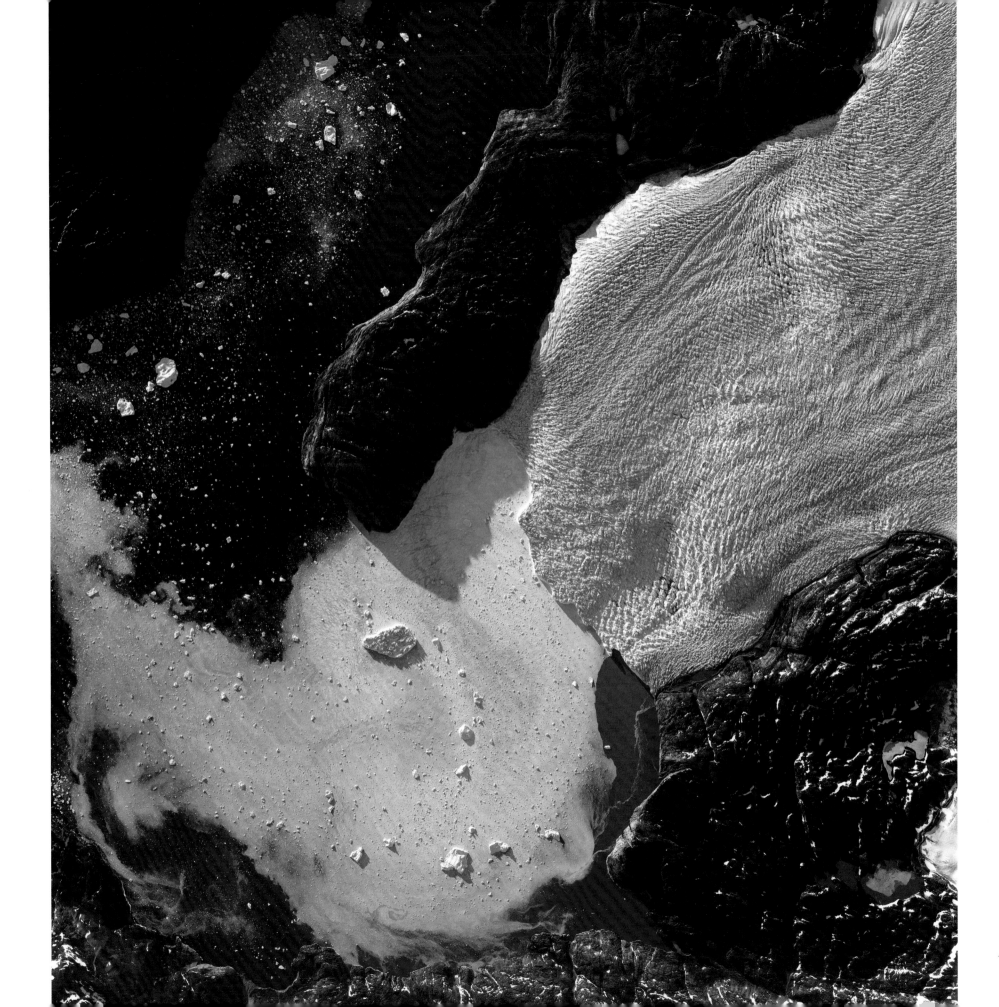

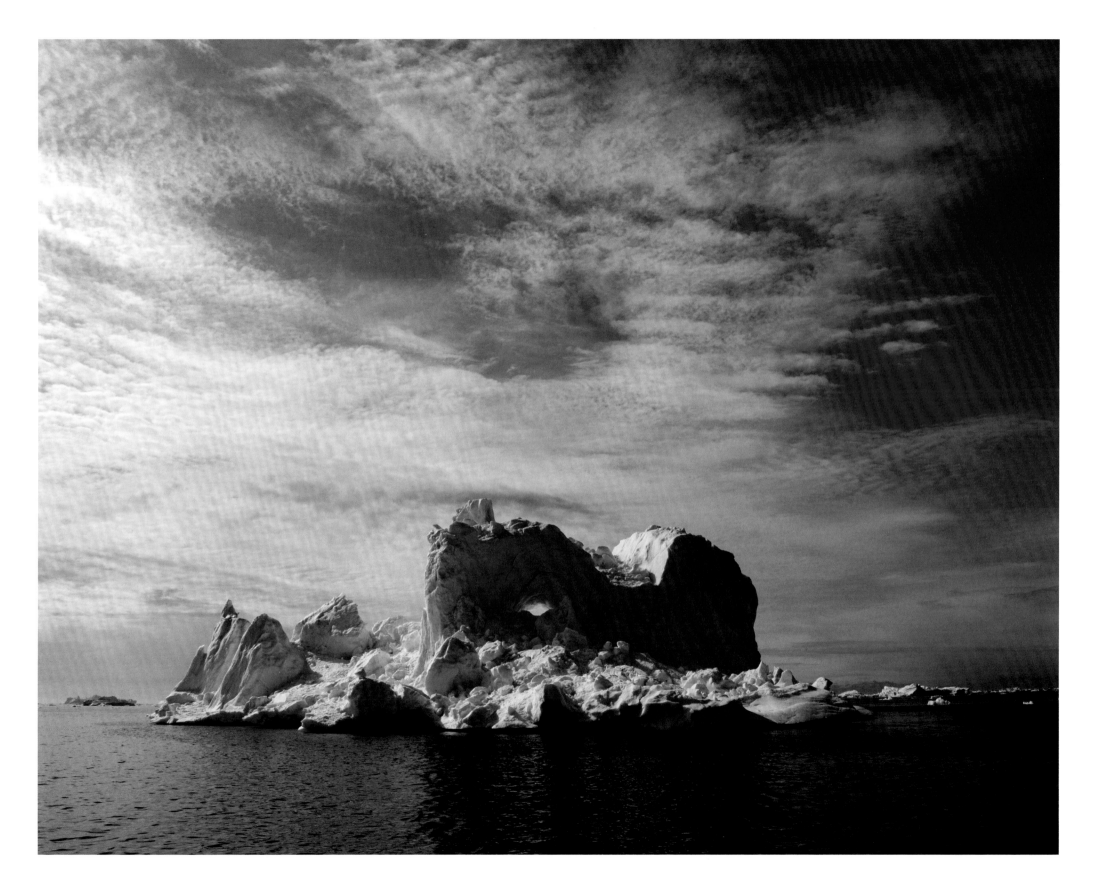

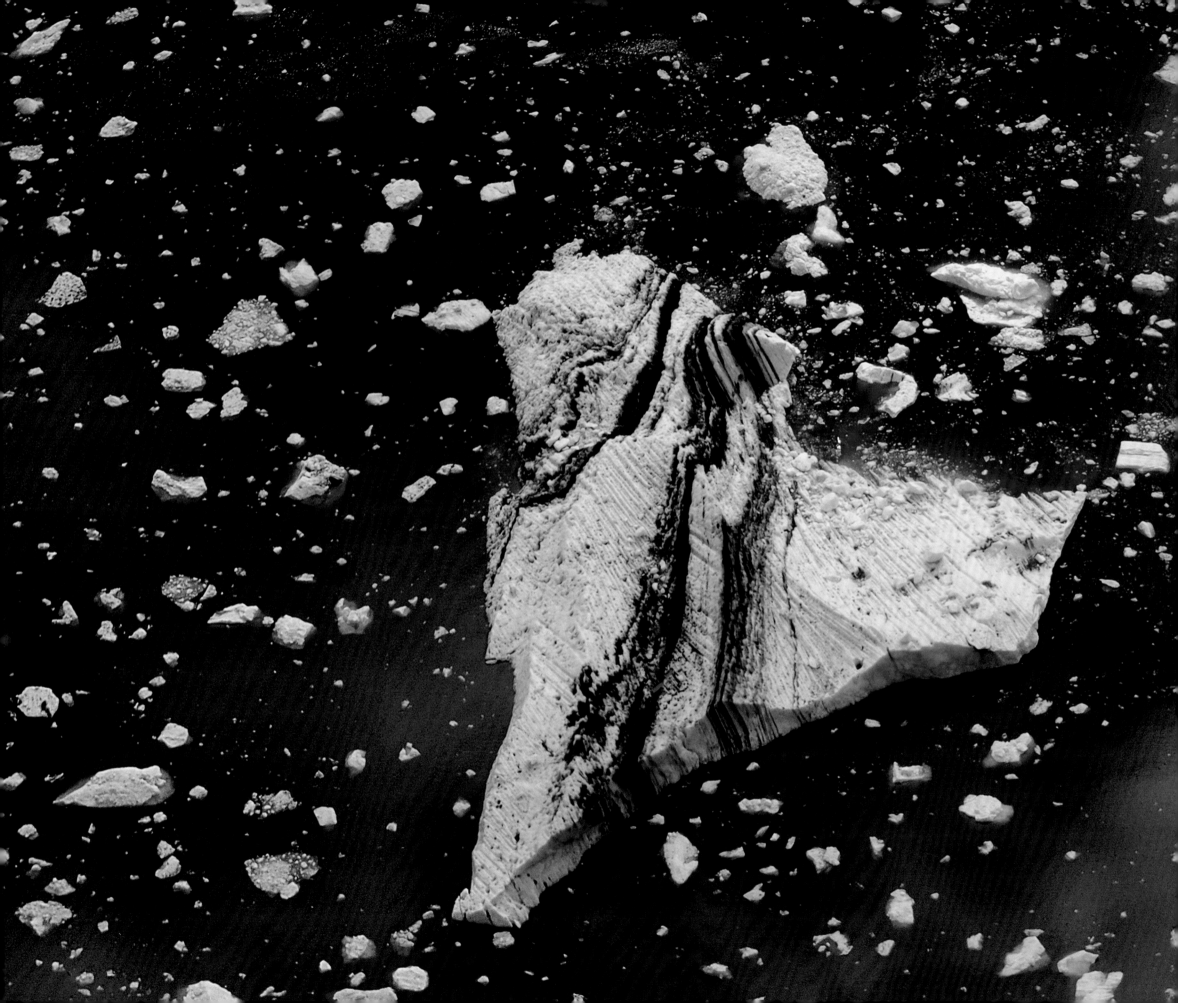

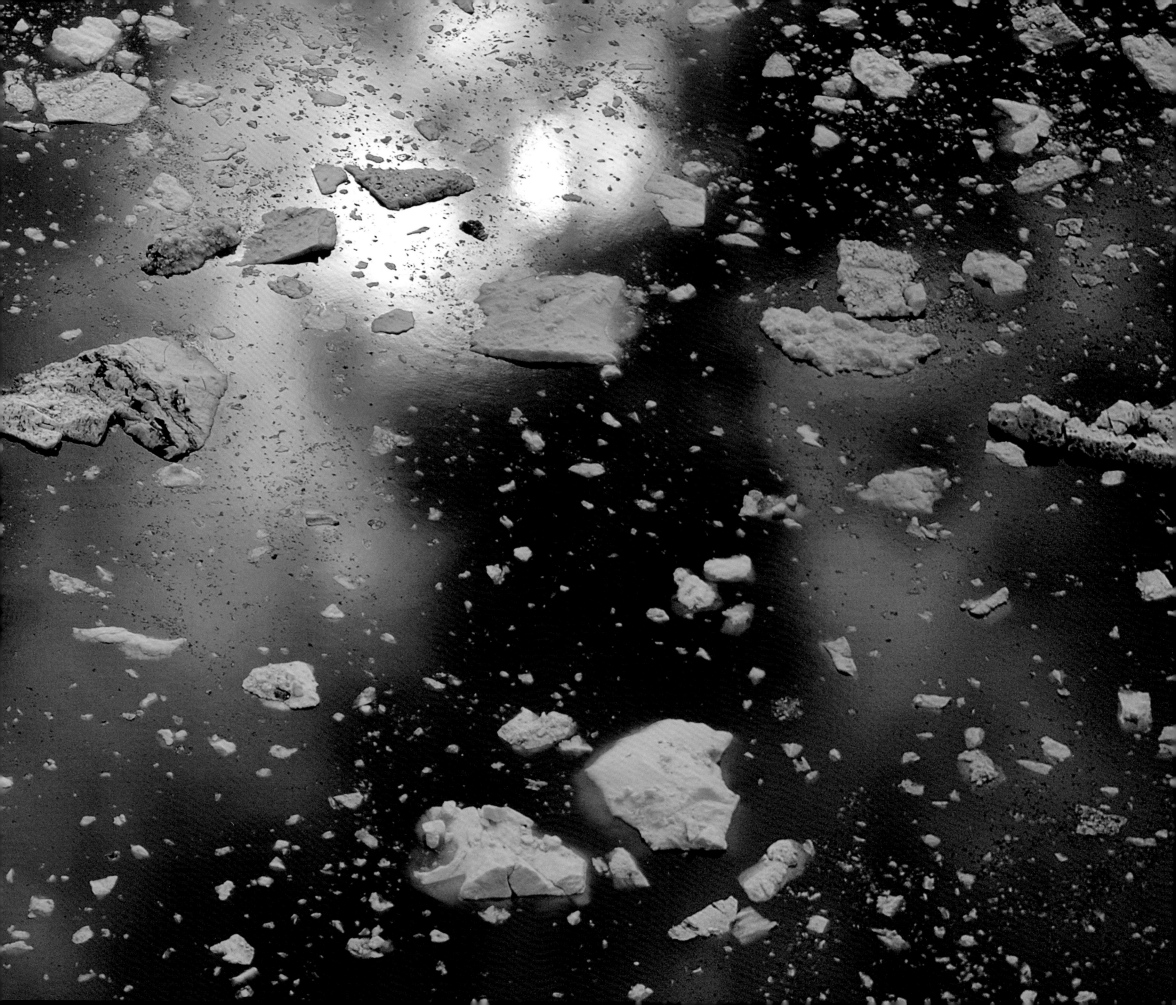

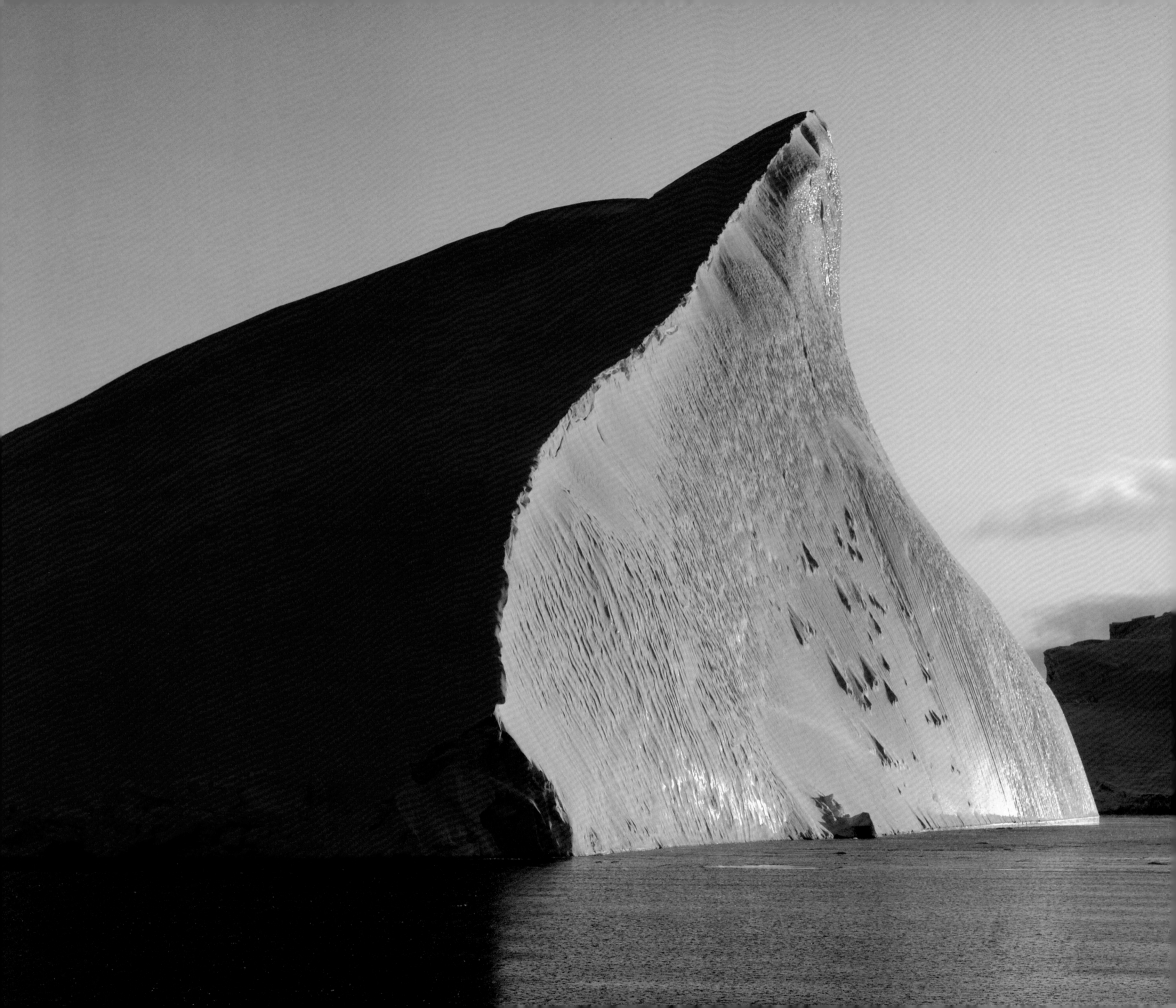

◀ Disko Bay │ **Greenland** │ 8 March 2008 │ In winter, the sea's surface is frozen to a leathery finish.

▼ Columbia Glacier │ **Alaska, United States** │ 17 June 2008

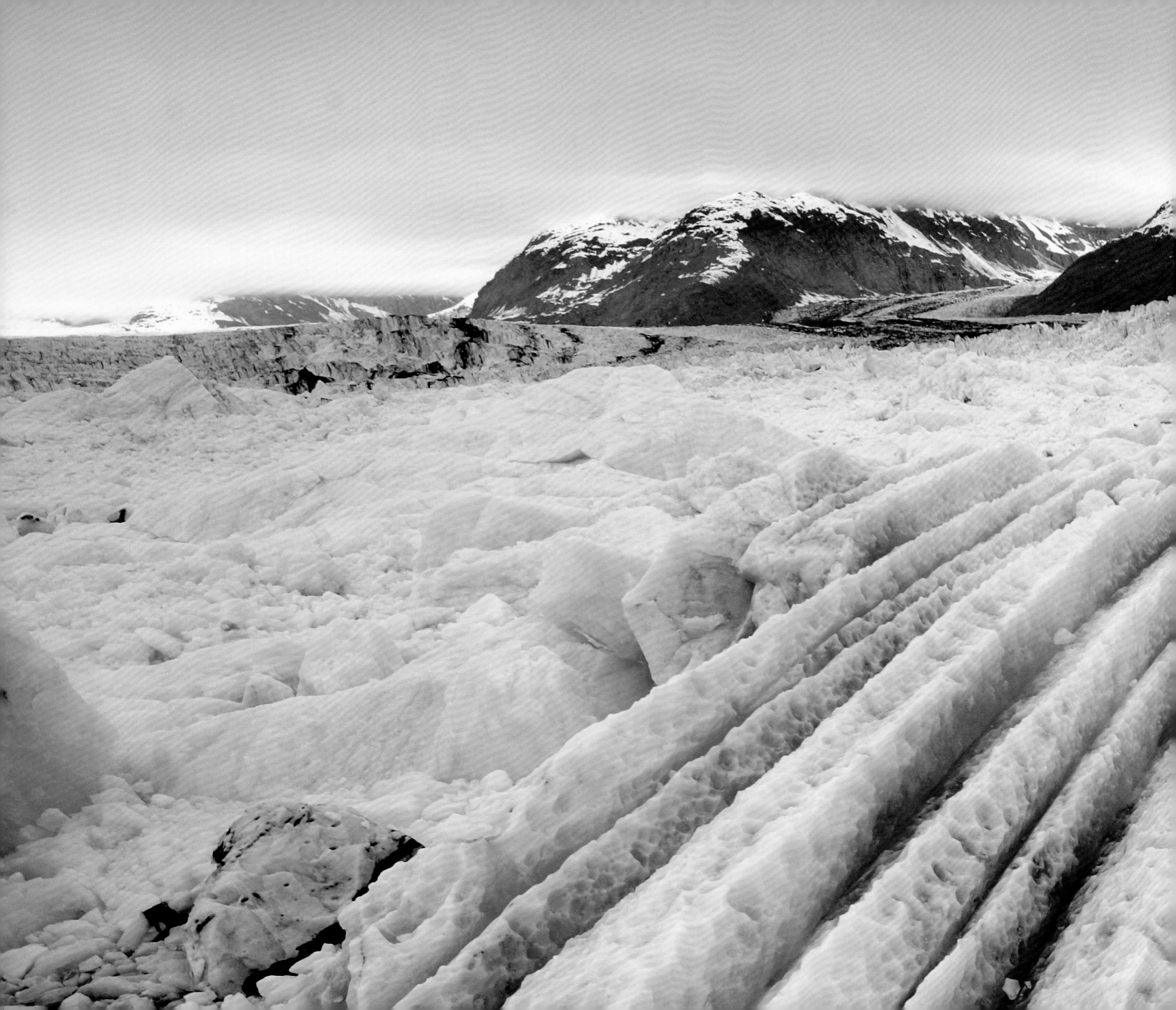

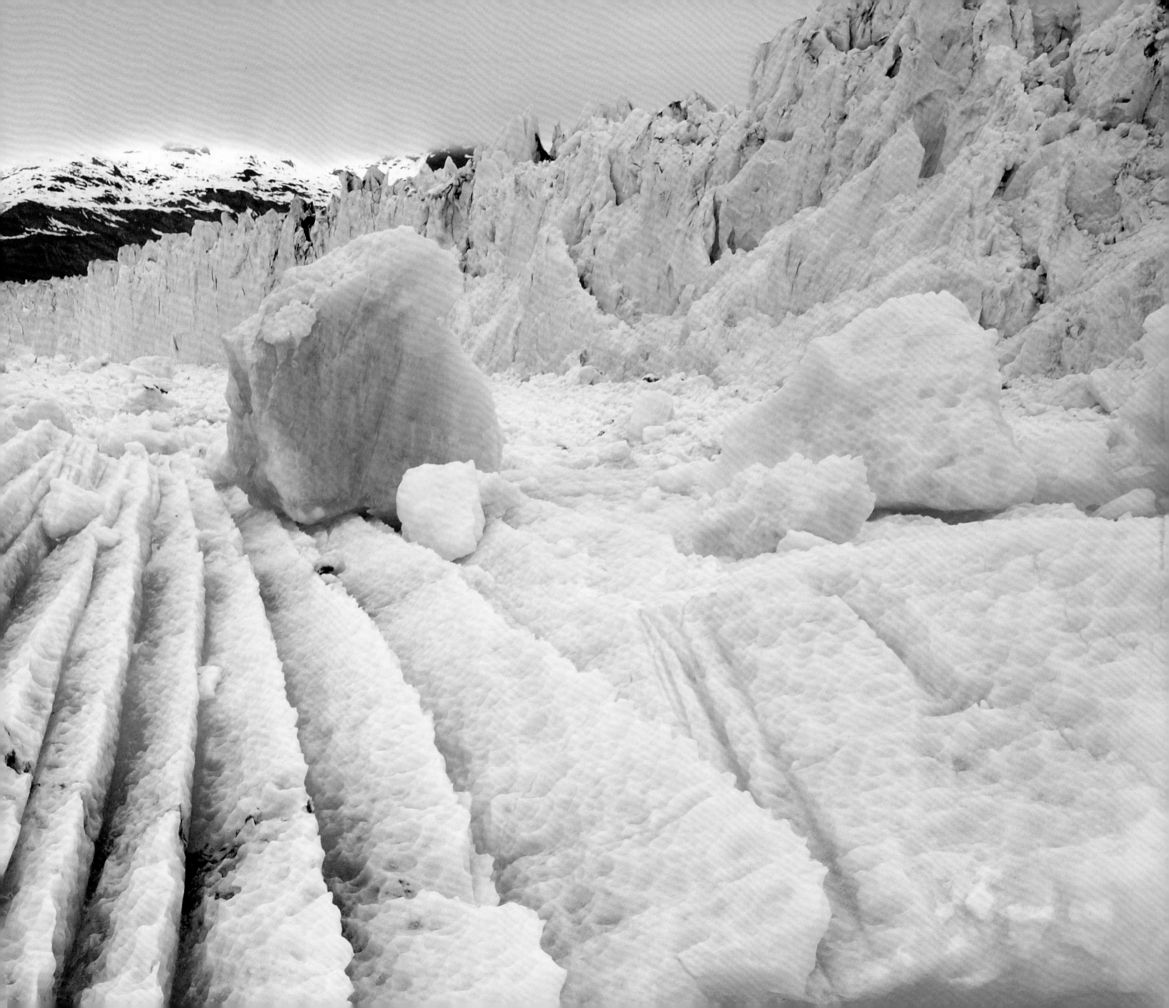

▶ Ilulissat Isfjord │ **Greenland** │ 15 March 2008 │ Pancake ice.

▼ Disko Bay │ **Greenland** │ 7 June 2010 │ Icebergs broken from the Ilulissat Glacier enter the northern reaches of the Atlantic Ocean.

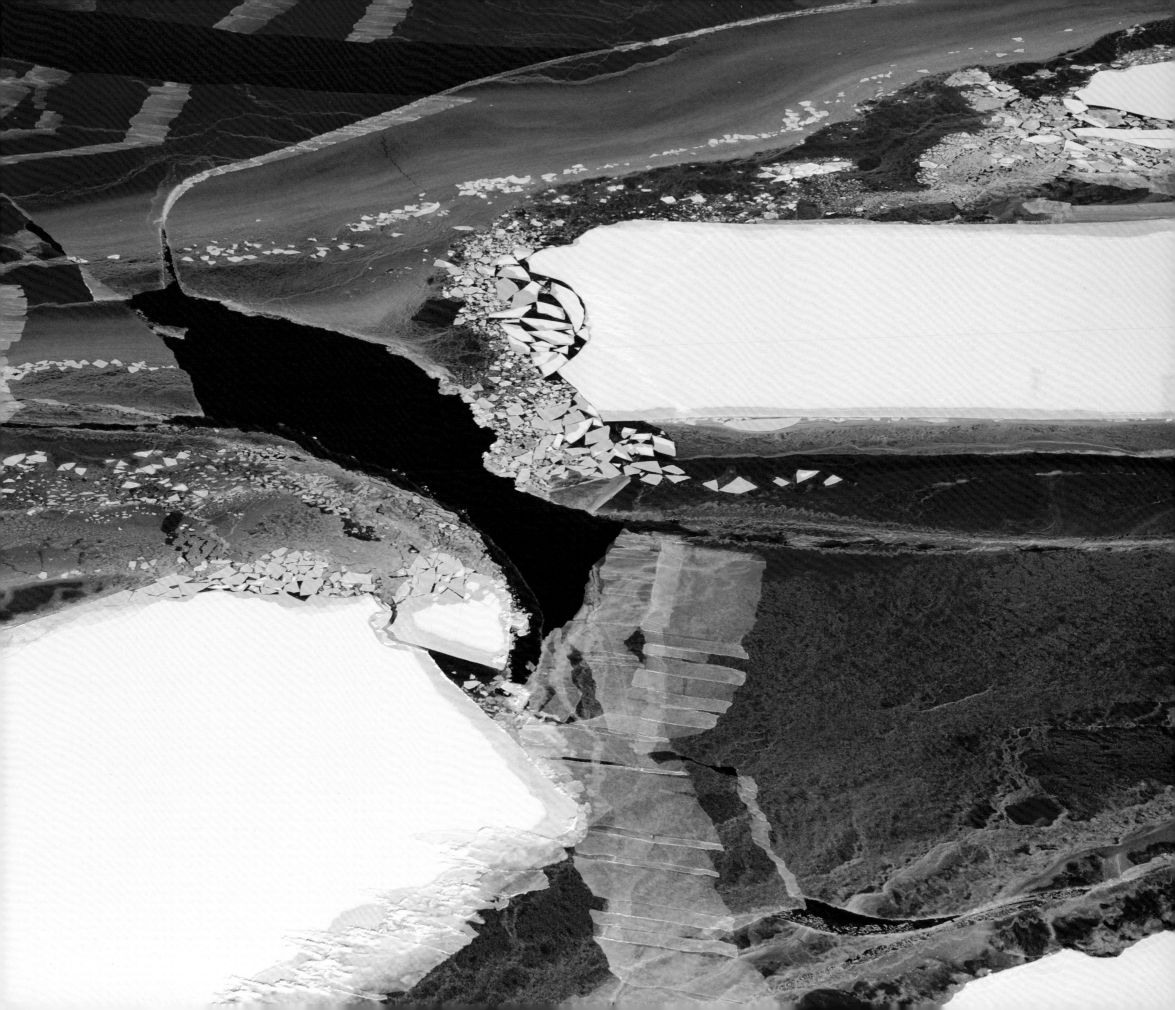

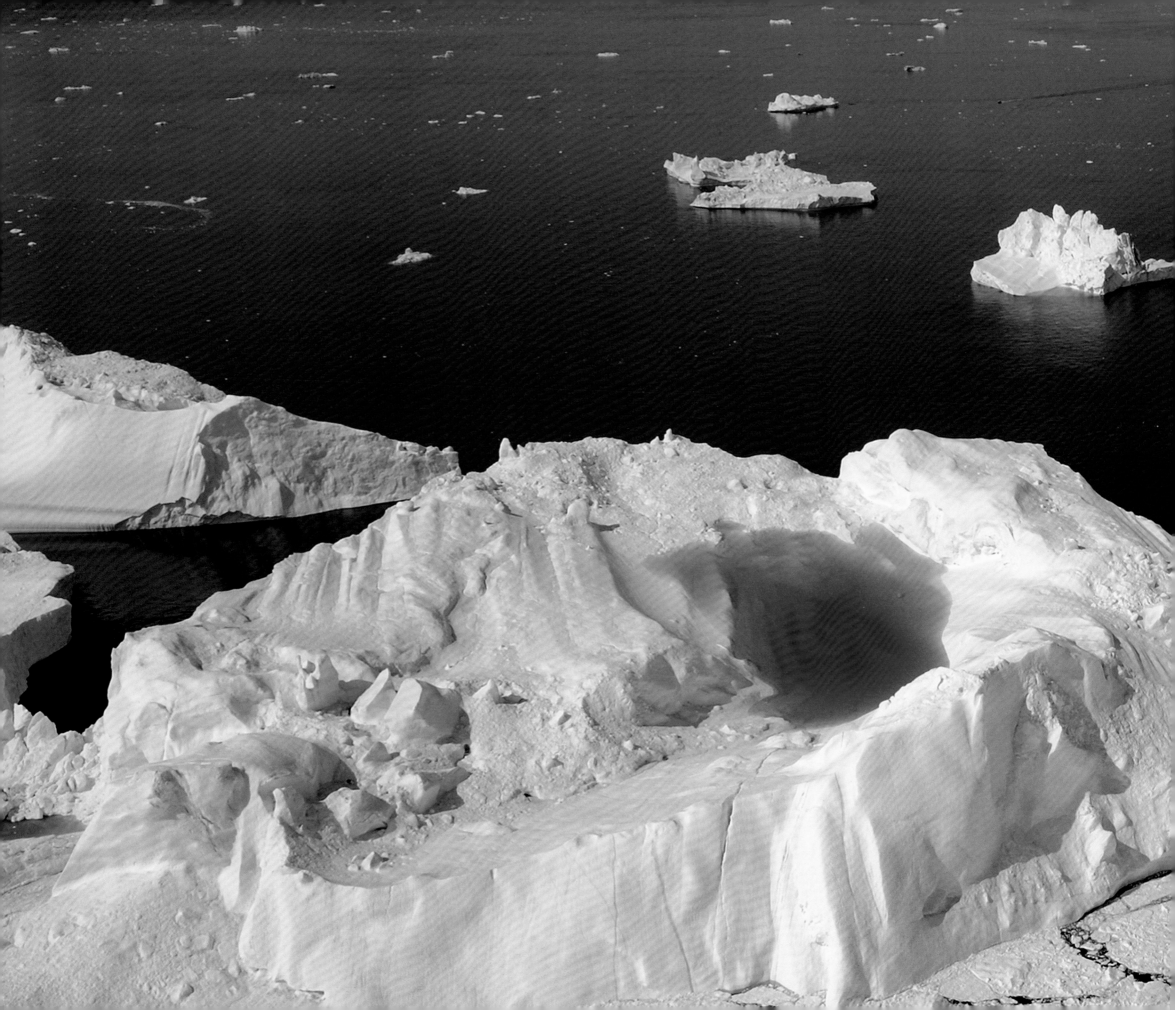

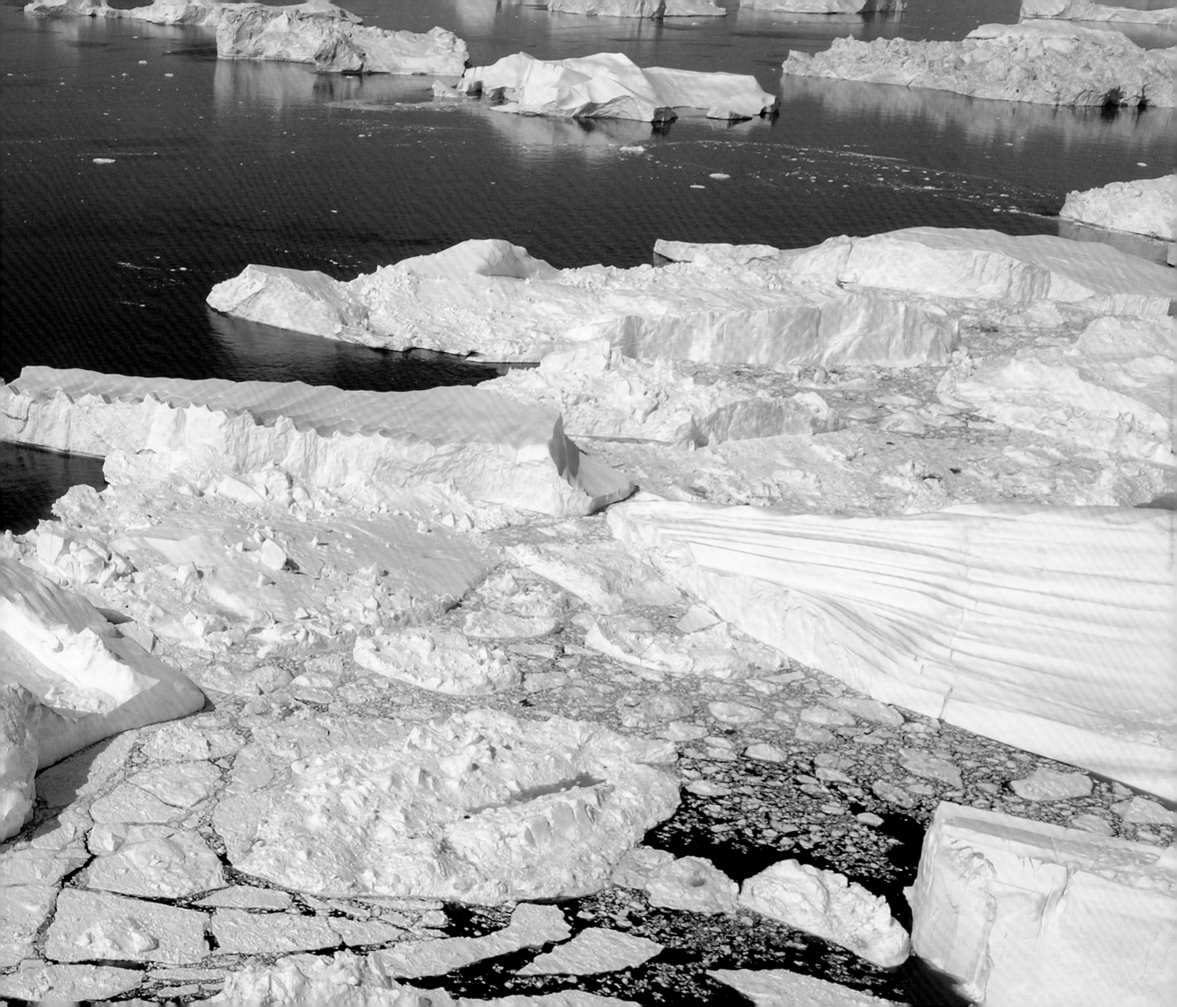

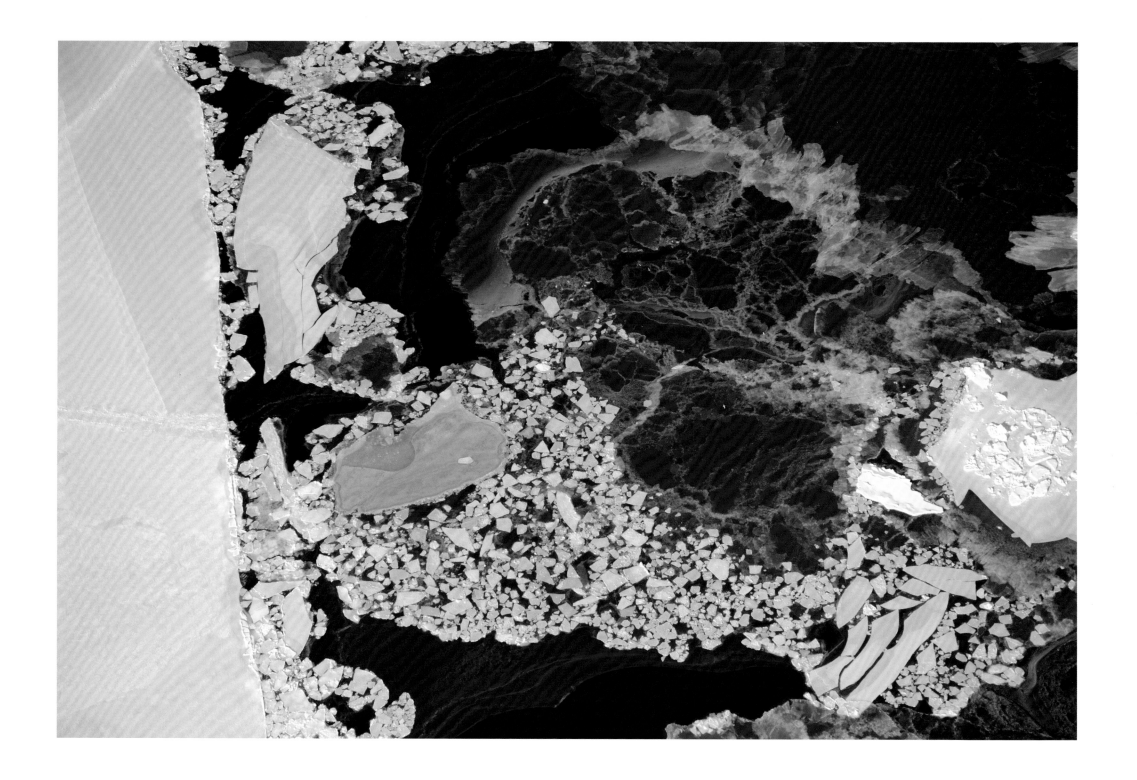

▲ Ilulissat Isfjord | **Greenland** | 15 March 2008 | Pancake ice.

▶ Disko Bay | **Greenland** | 15 March 2008 | A massive chunk of the Ilulissat Glacier floats out to sea.

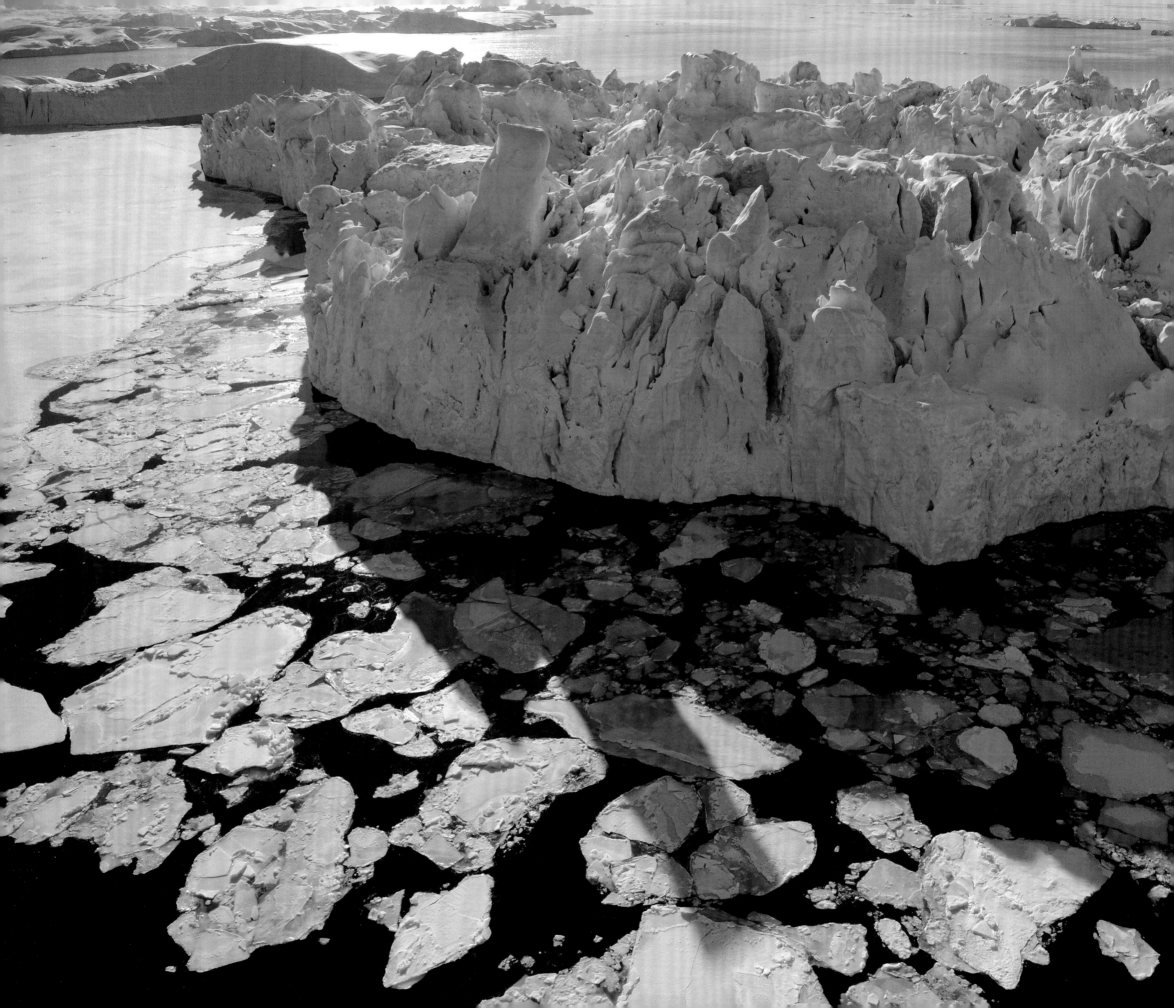

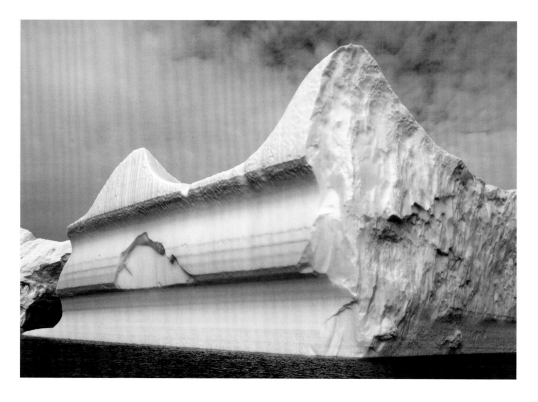

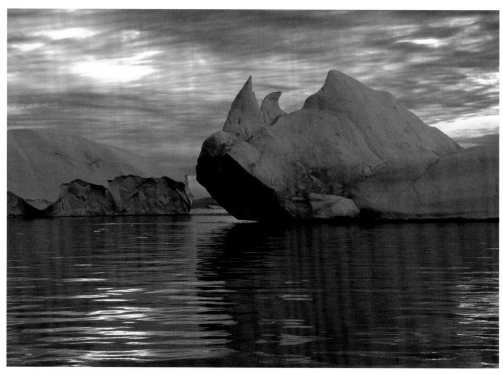

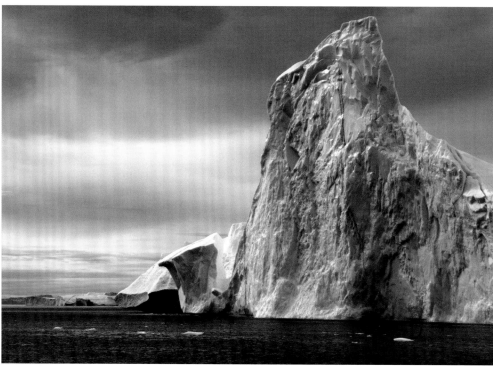

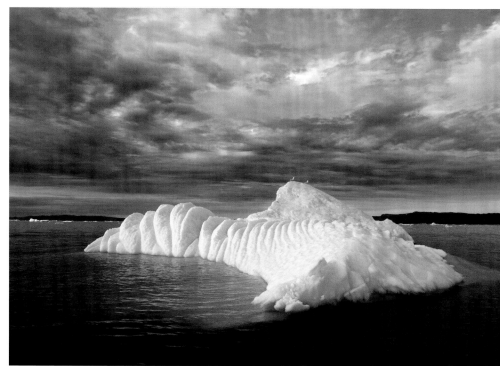

▲ ▶ Disko Bay | **Greenland** | 17–18 July 2006

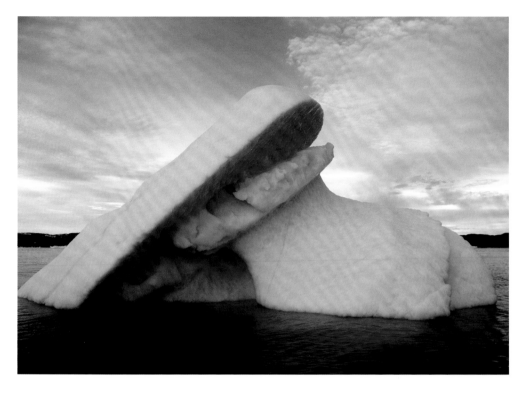

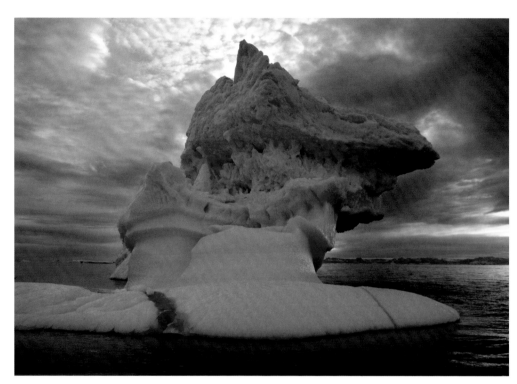

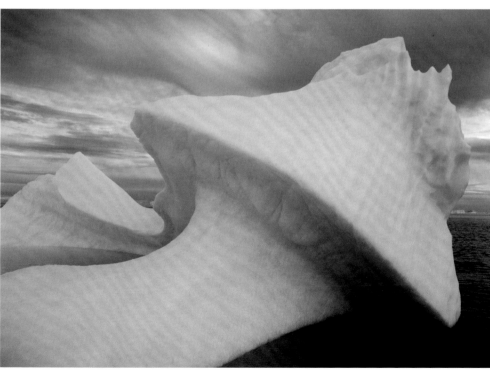

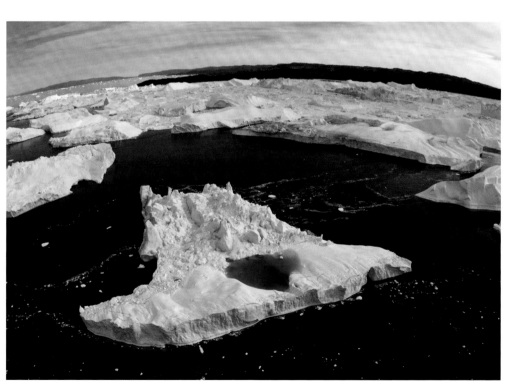

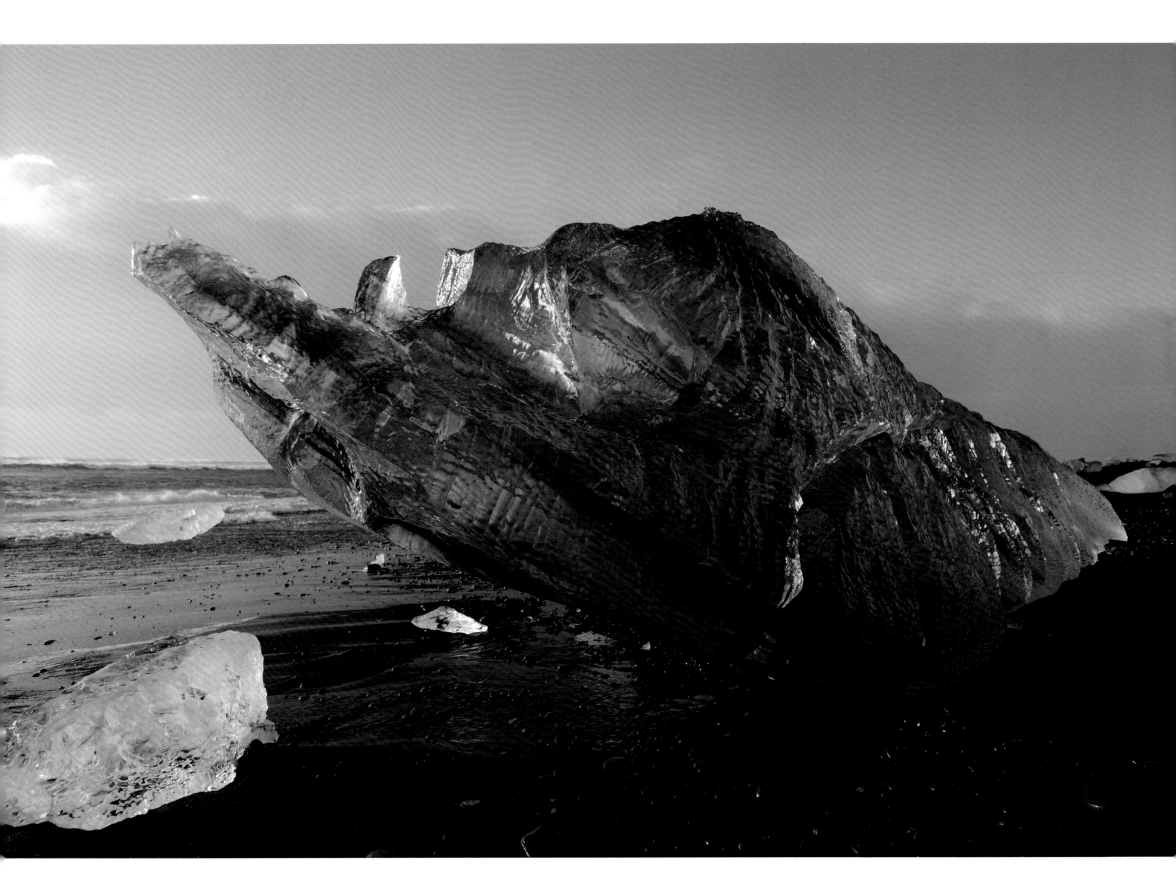

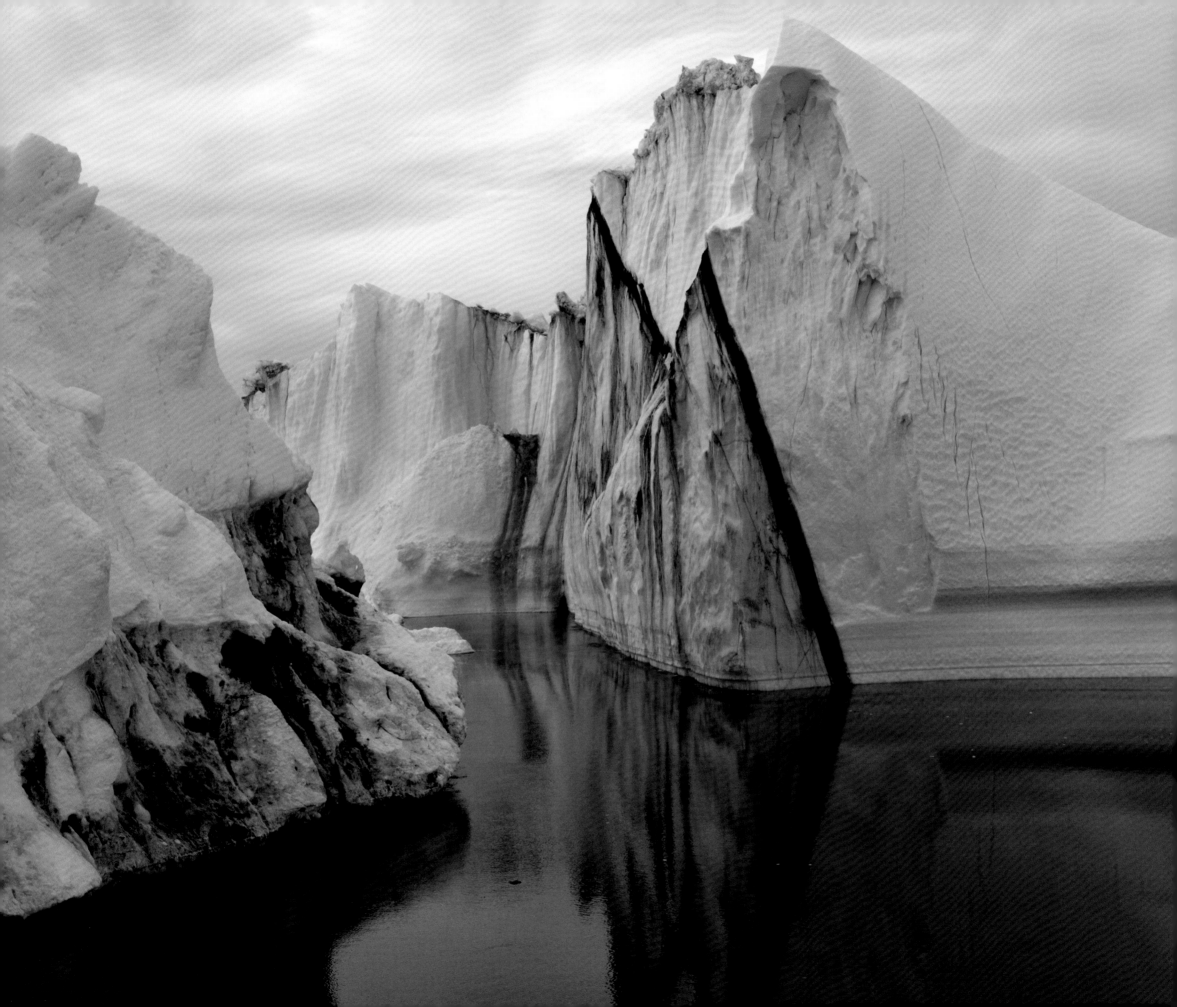

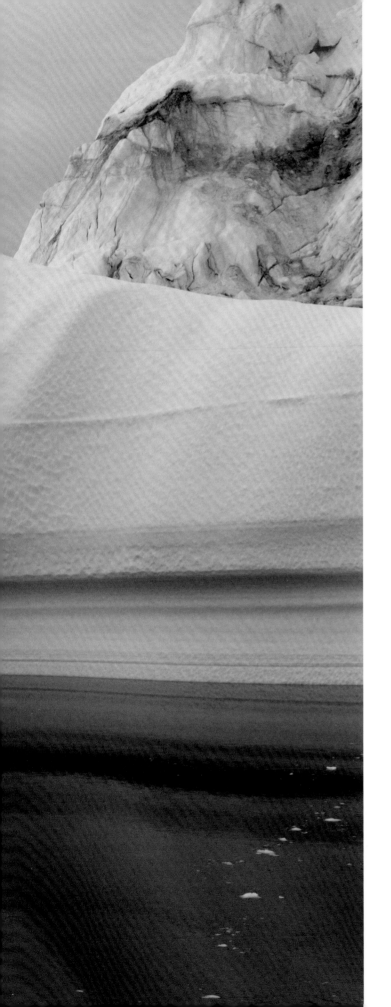

Ilulissat Isfjord | **Greenland** | 7 June 2007

▶ Ilulissat Isfjord | **Greenland** | 24 August 2007

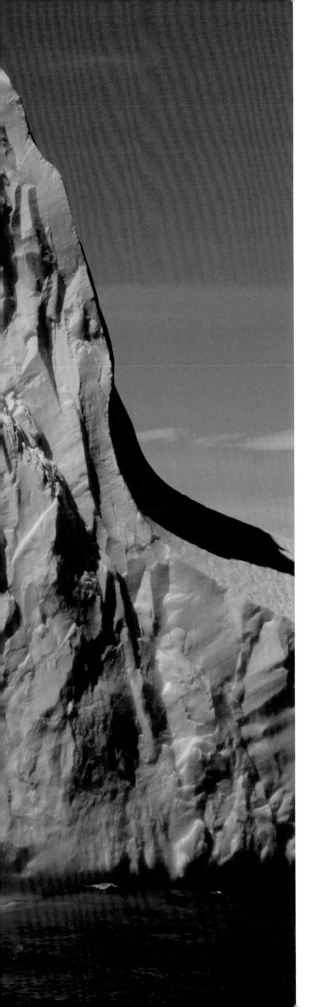

► Ilulissat Isfjord │ **Greenland** │ 24 August 2007

▼ Jökulsárlón │ **Iceland** │ 23 July 2008

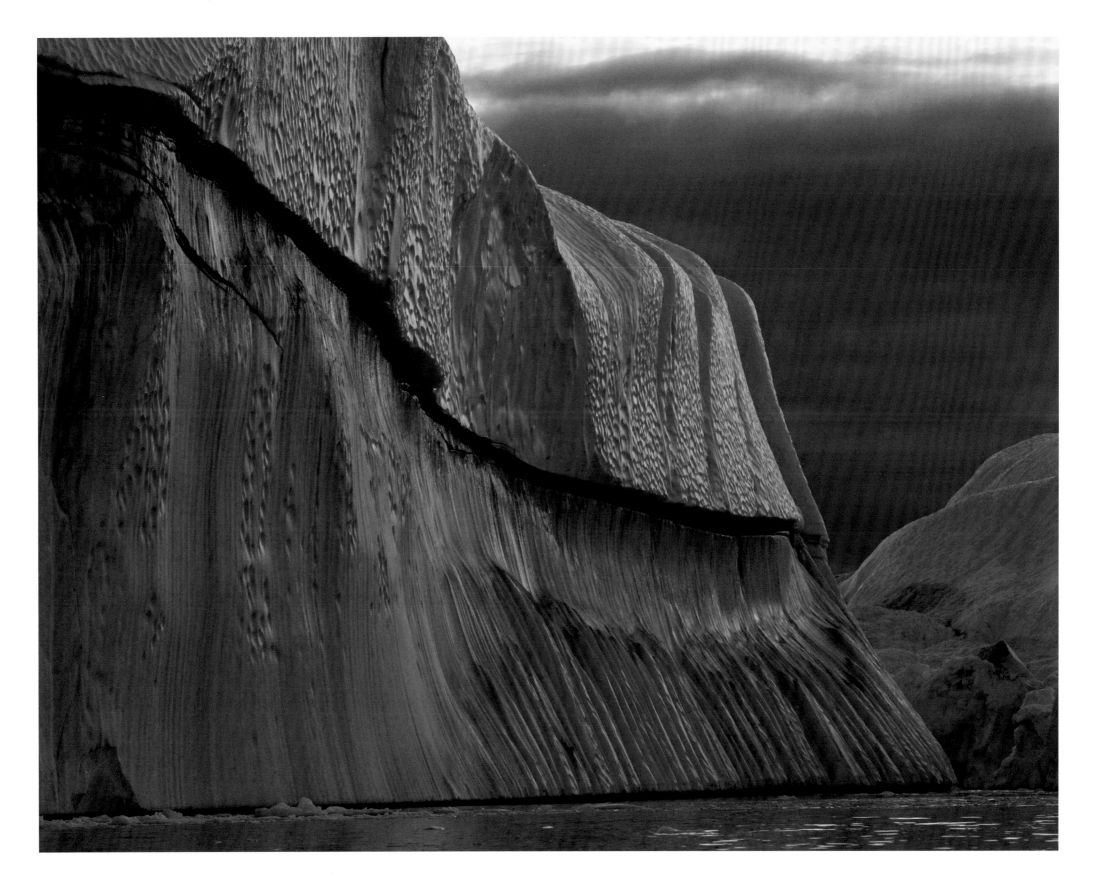

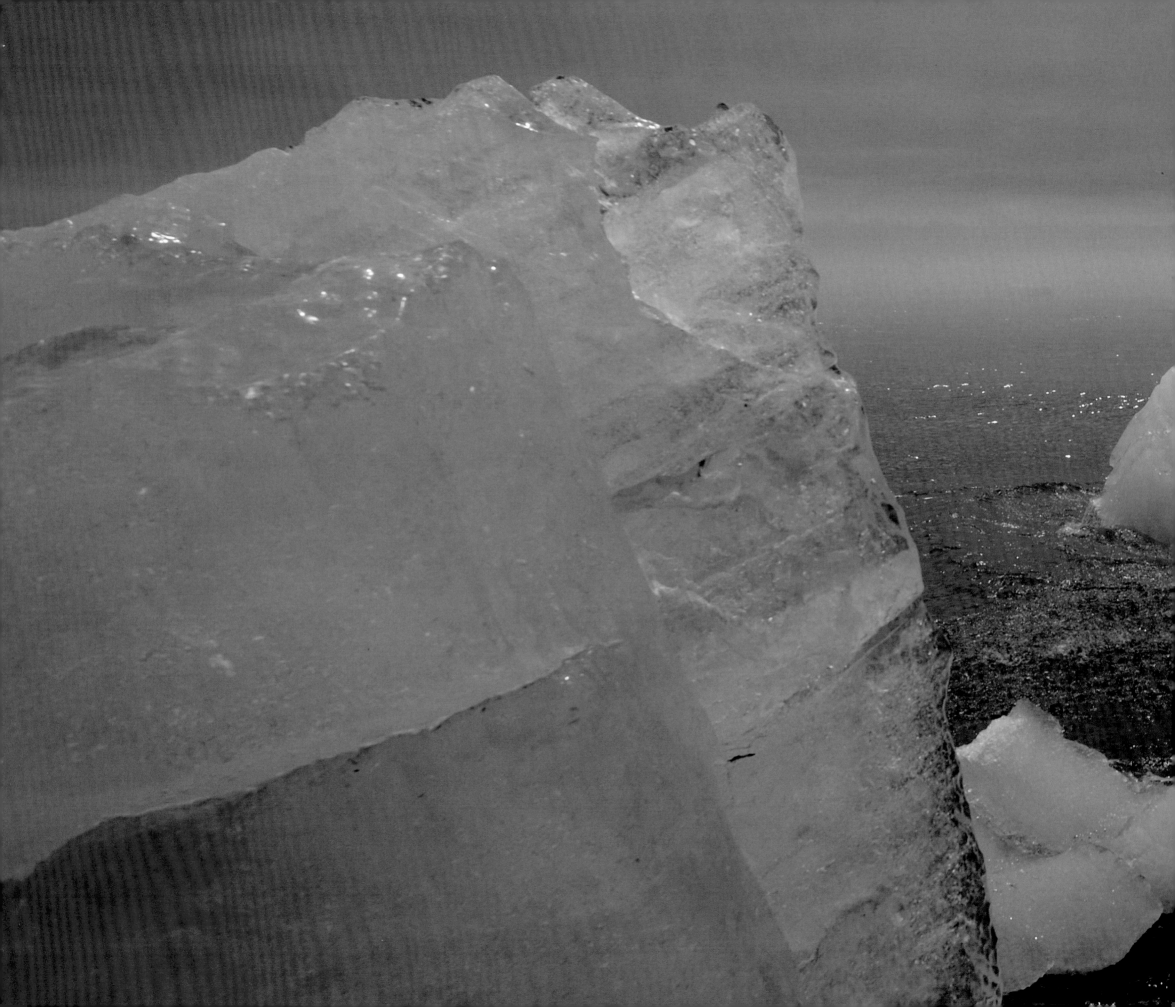

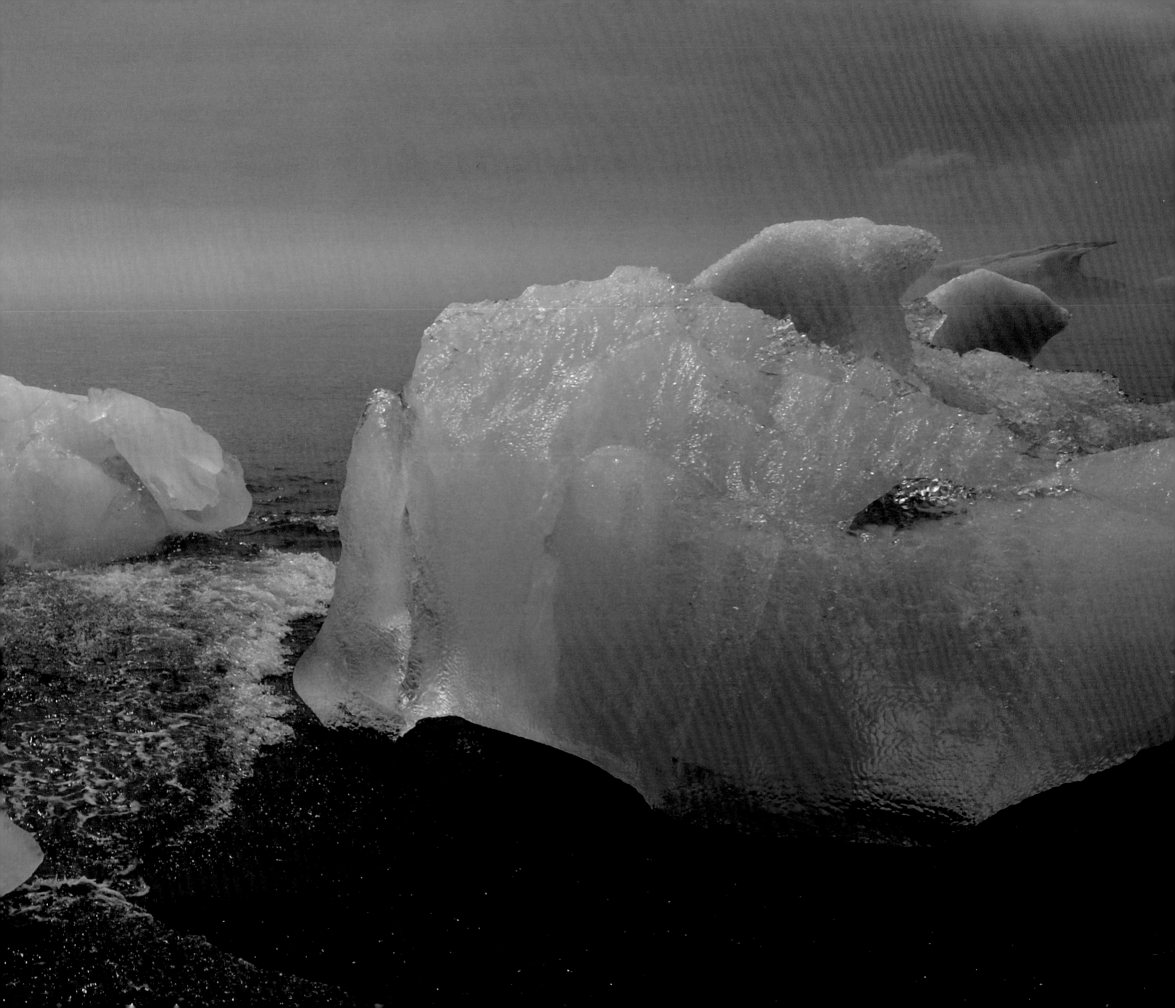

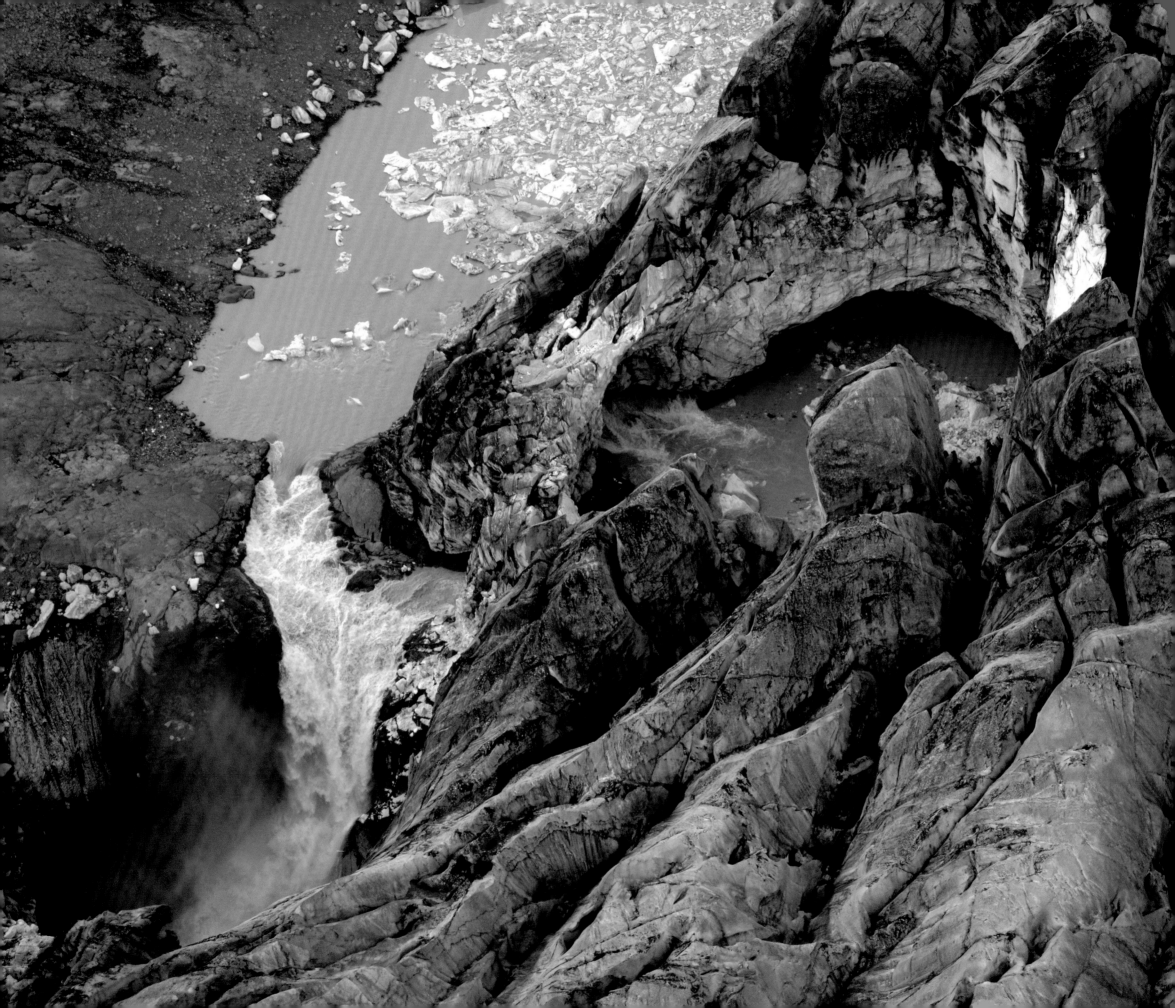

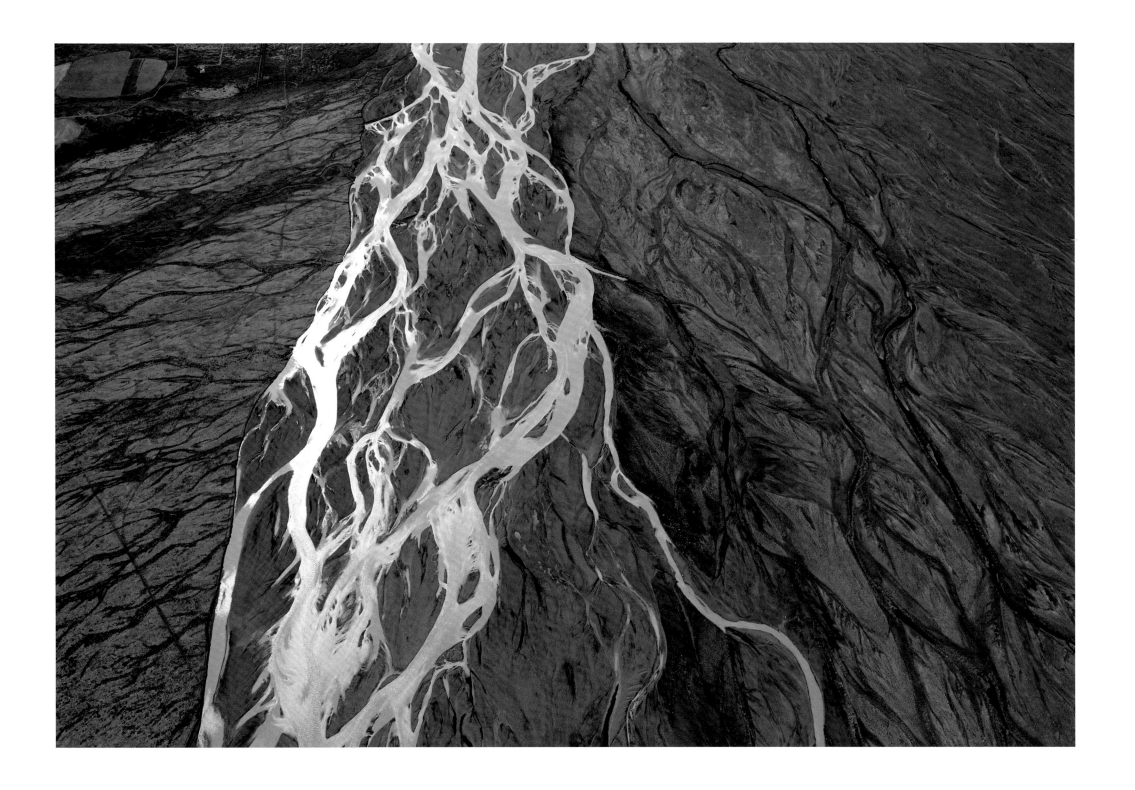

◄ Skeiðarárjökull | **Iceland** | 14 September 2007 | Meltwater runs along the glacier's edge and over a thundering waterfall.

▲ Svínafellsjökull | **Iceland** | 24 July 2008 | Meltwater heads toward the ocean.

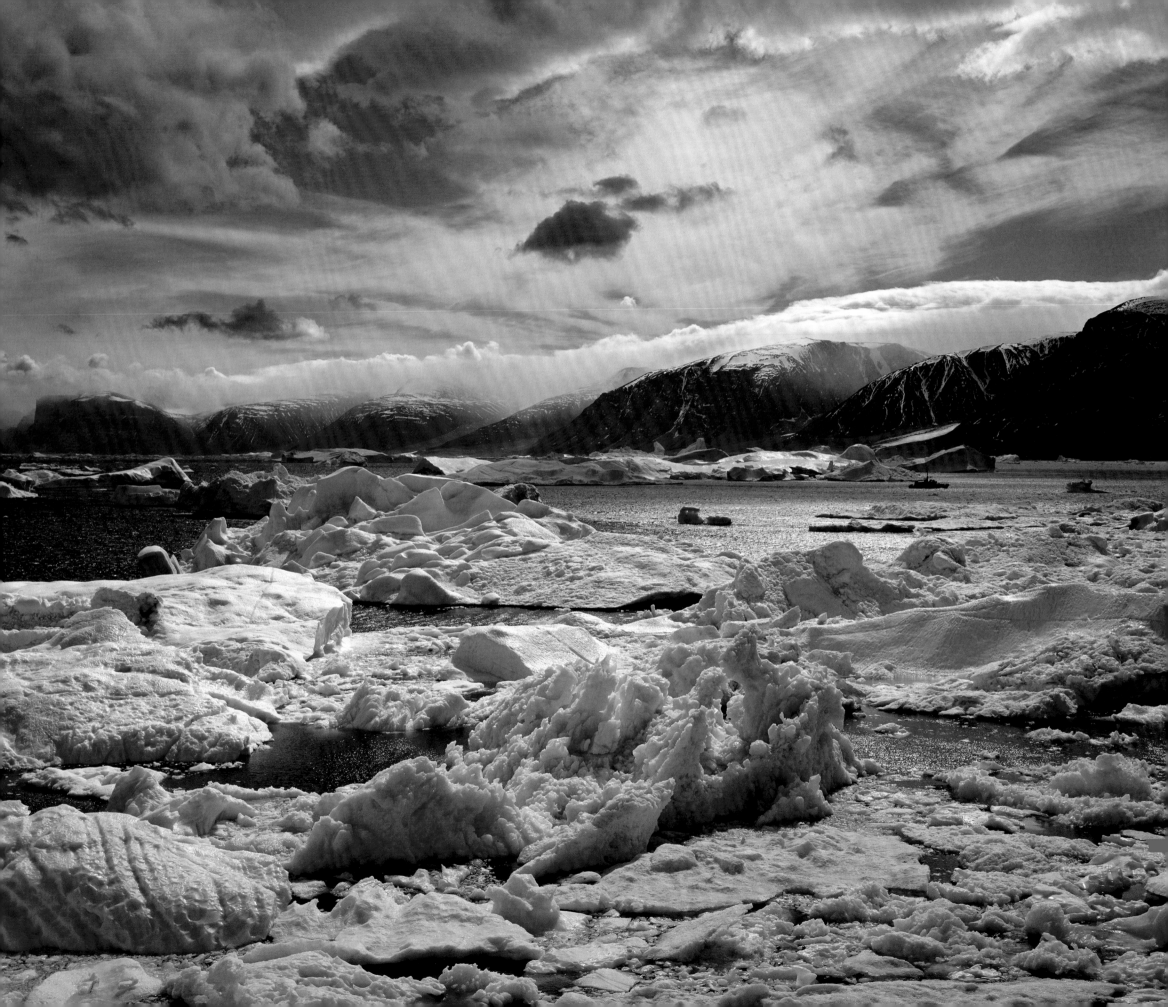

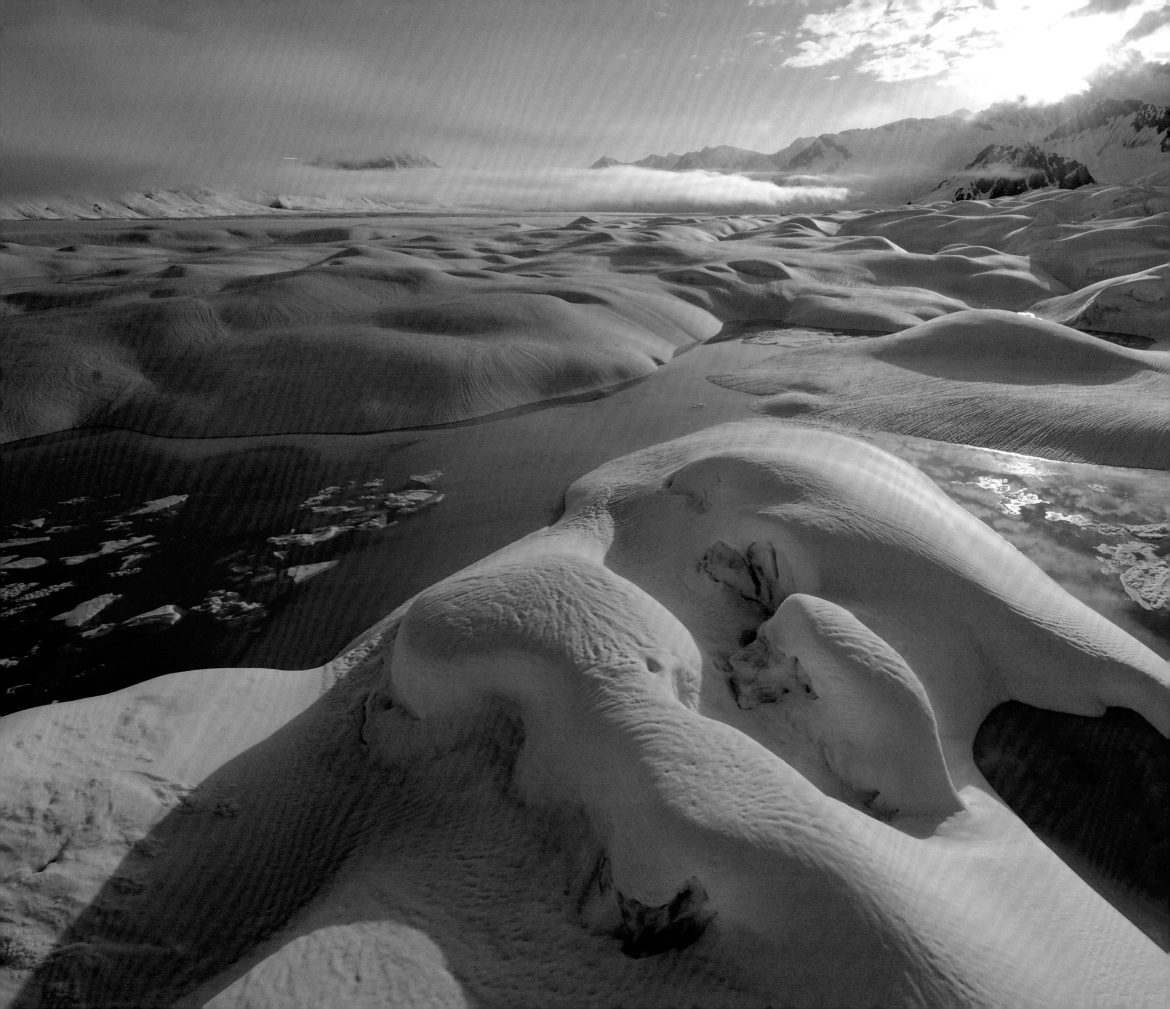

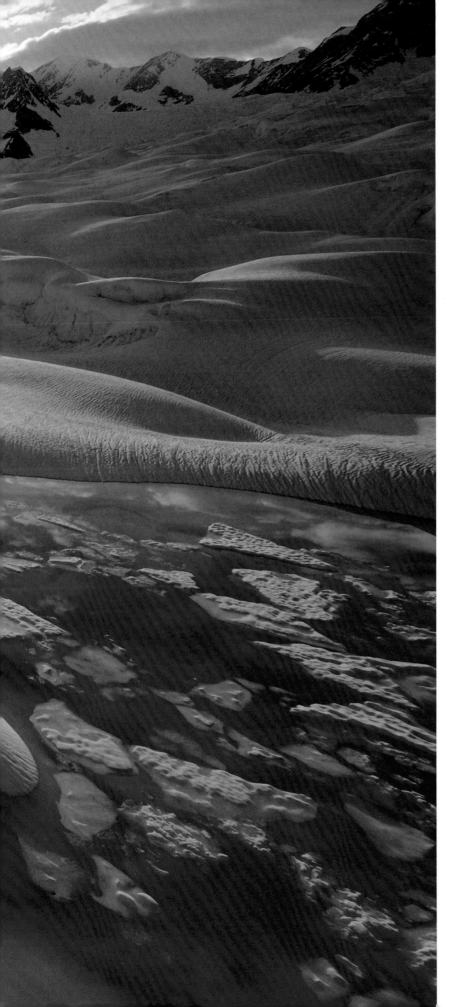

◄ Columbia Glacier │ **Alaska, United States** │ 20 June 2008 │ A meltwater lake ten miles inland from the terminus.

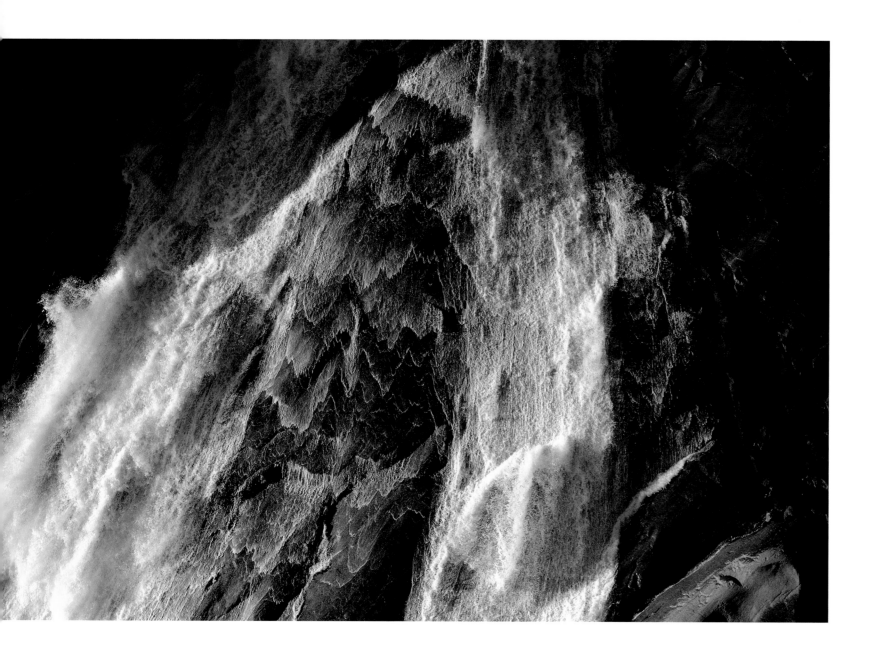

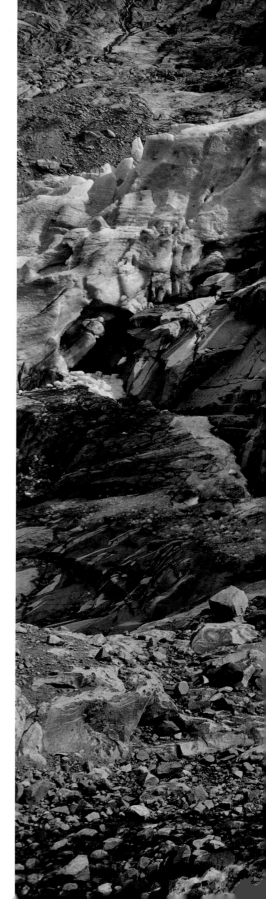

▲ Mendenhall Glacier | **Alaska, United States** | 15 September 2010 | Suicide Basin.

▶ Tahumming Glacier | **British Columbia, Canada** | 29 August 2009 | The glacier has recently retreated from this cliff.

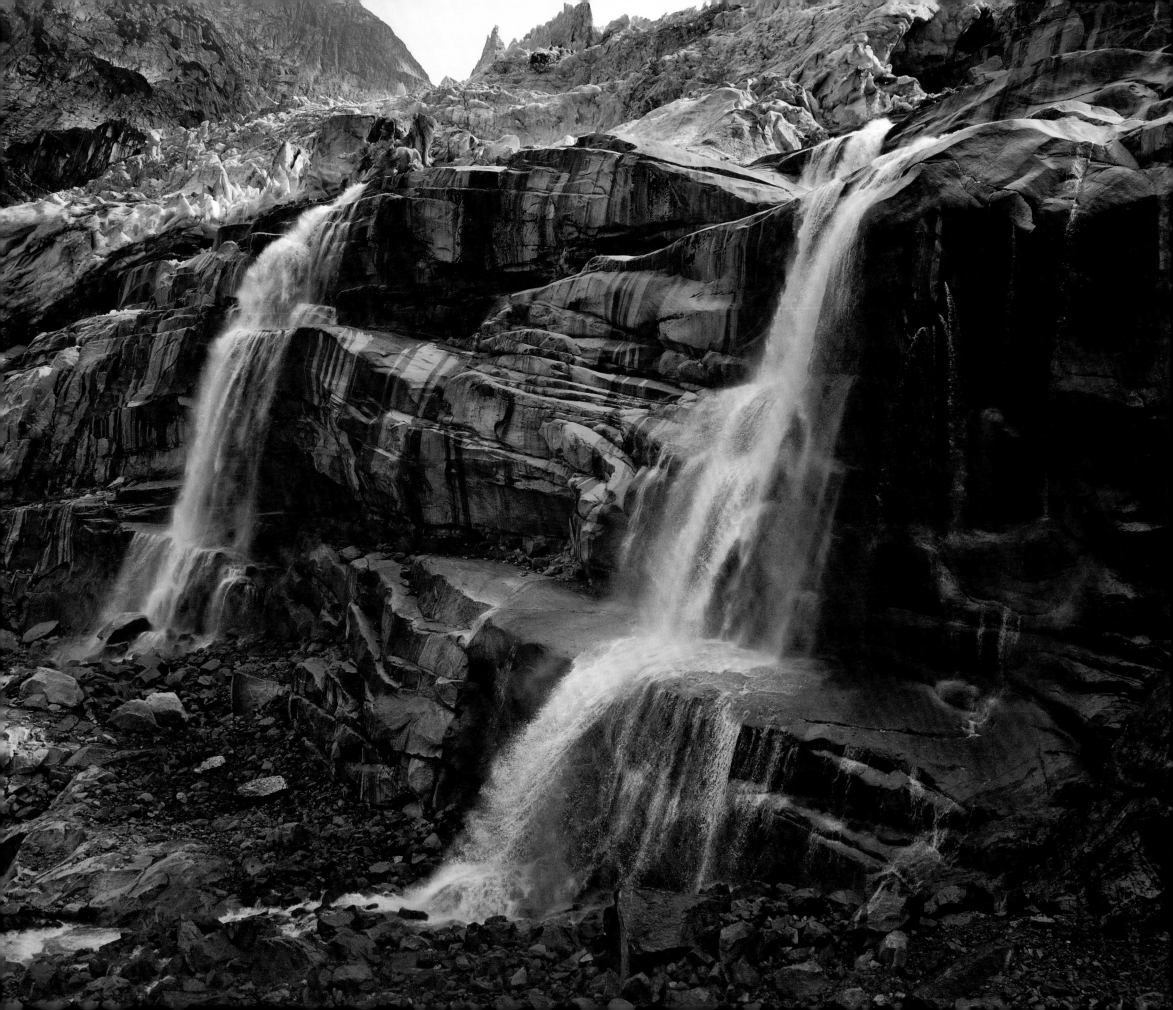

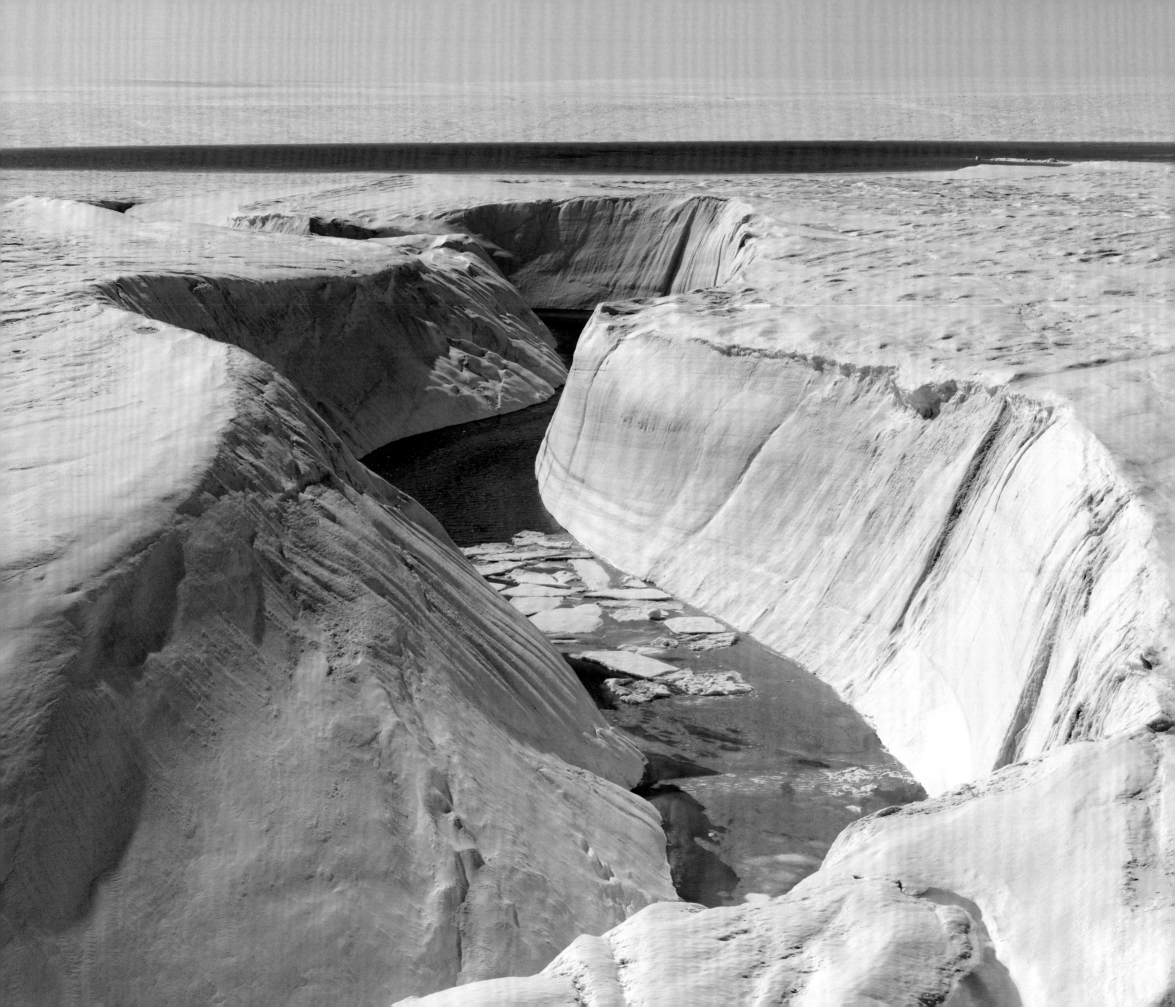

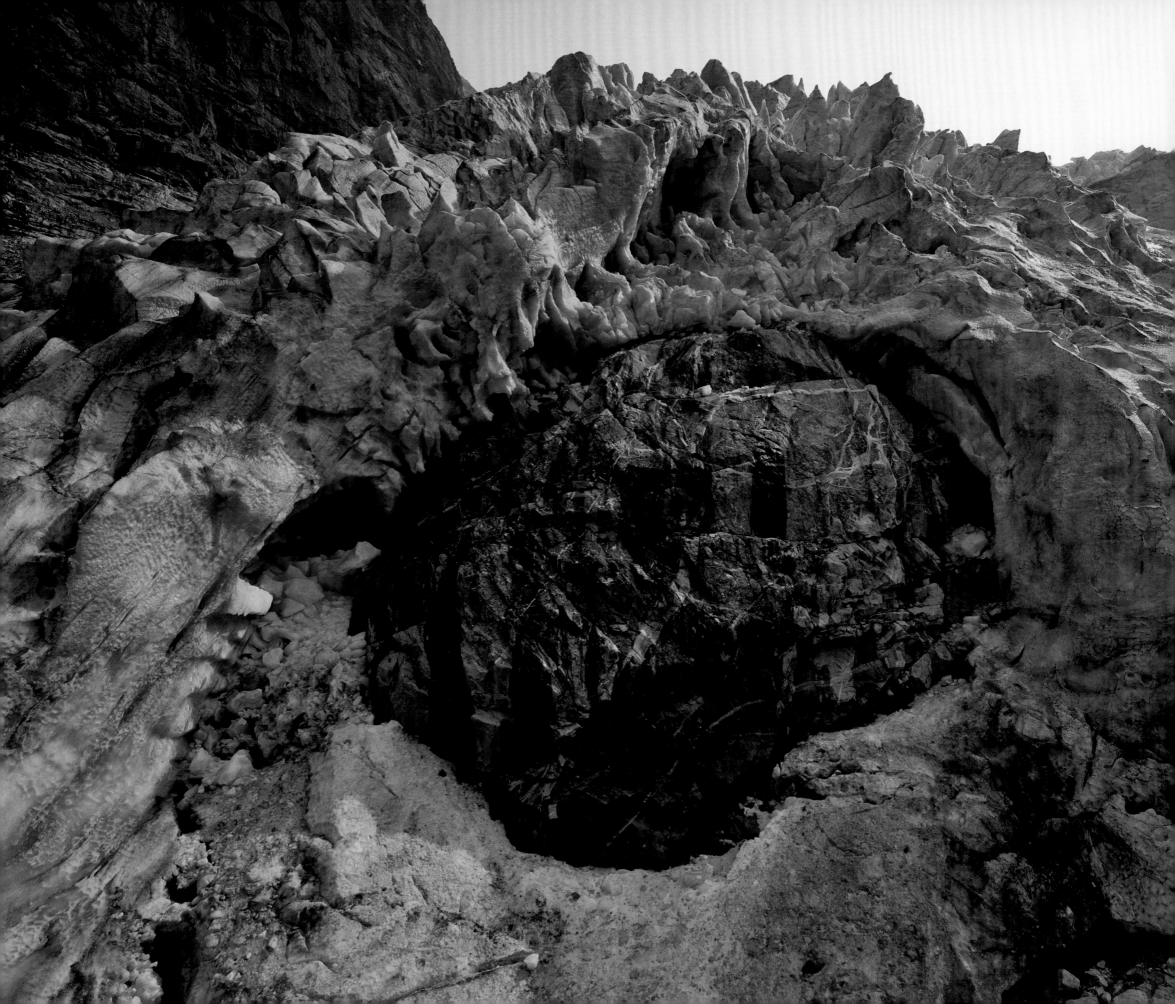

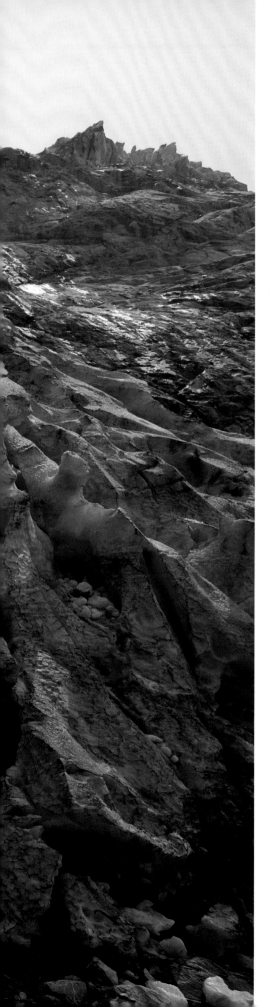

◄ Tahumming Glacier, British Columbia | **Canada** | 29 August 2009 | Bedrock revealed as glacier retreats.

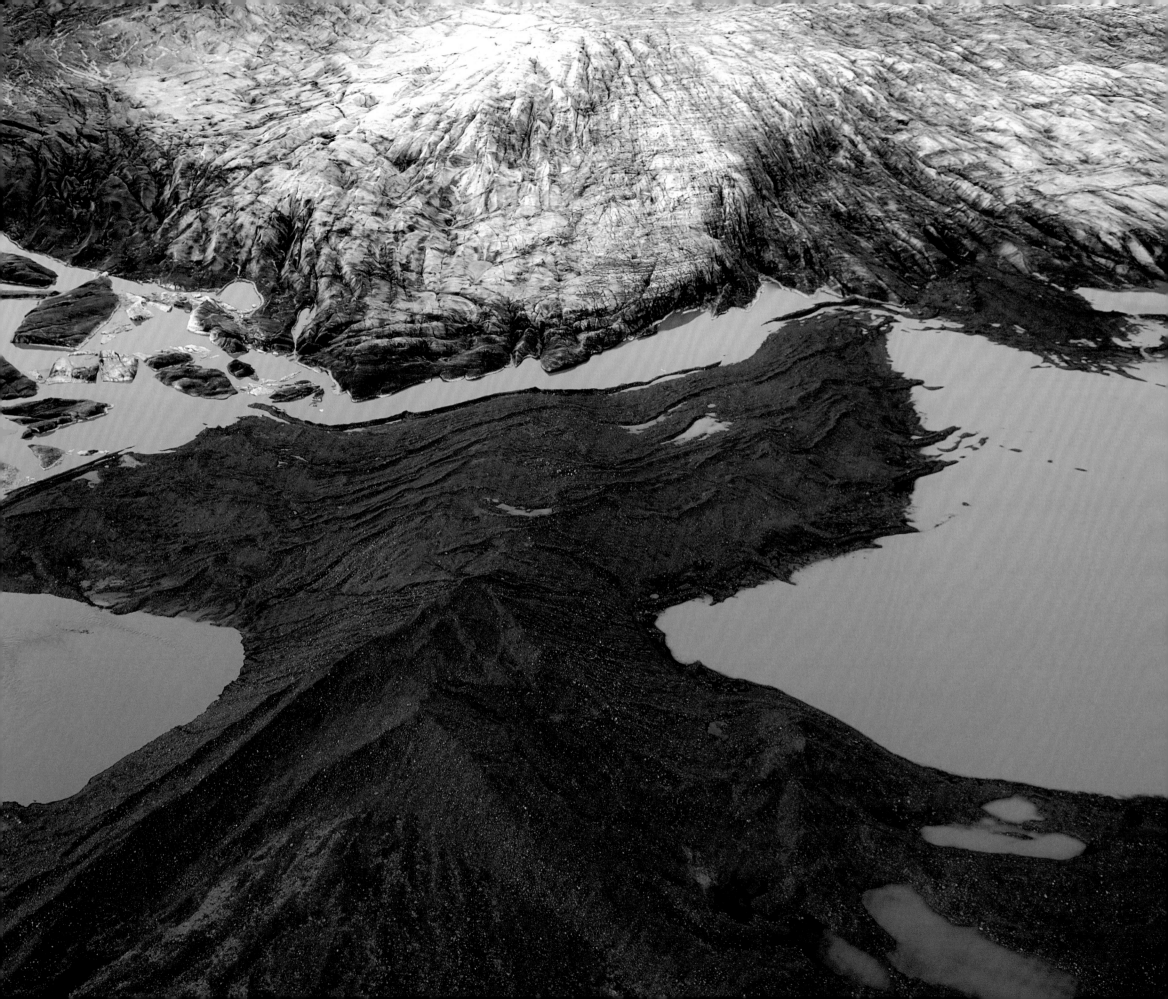

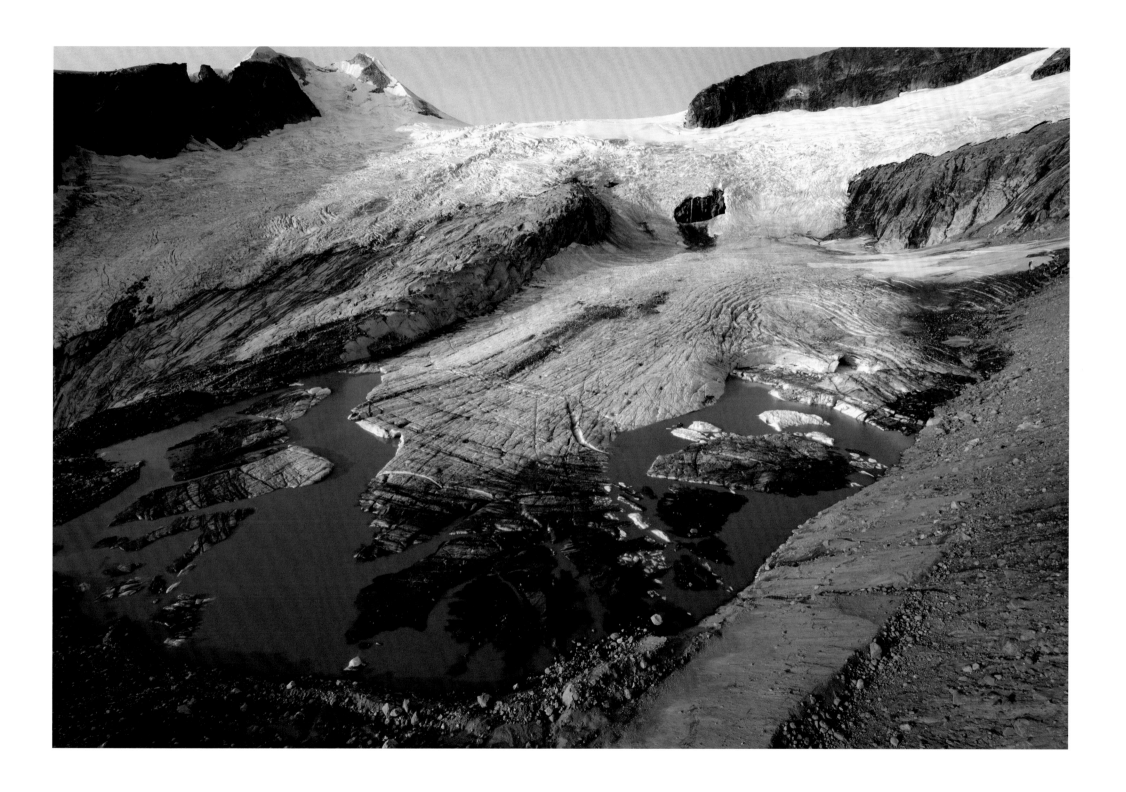

◀ Skeiðarárjökull | **Iceland** | 14 September 2007 | Retreating ice edge leaves moraine ridges.

▲ Icewall Glacier basin | **British Columbia, Canada** | 30 August 2009 | An alpine tarn in the making.

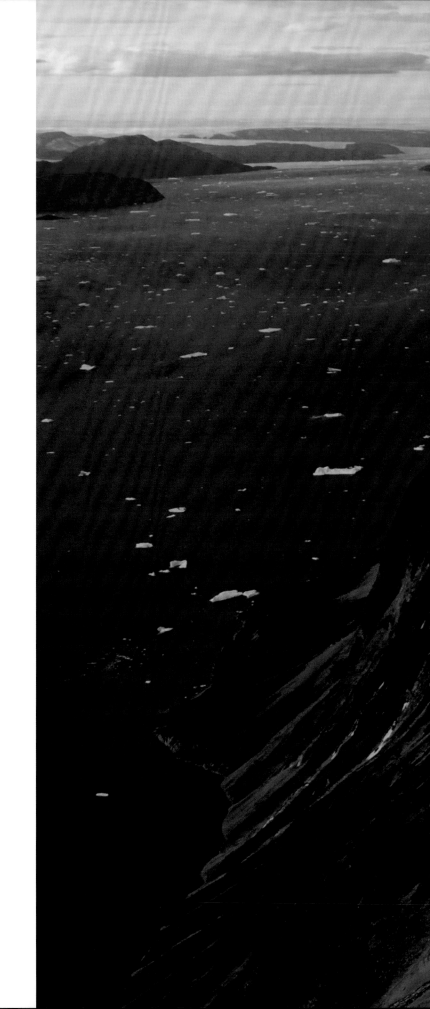

▶ Eastern ice cap, Agpat Island | **Greenland** | 22 July 2011
Deglaciation of the highlands continues.

▼ Heakamie Glacier | **British Columbia, Canada** | 29 August 2009
Bedrock on left was recently covered in ice, but is now revealed.

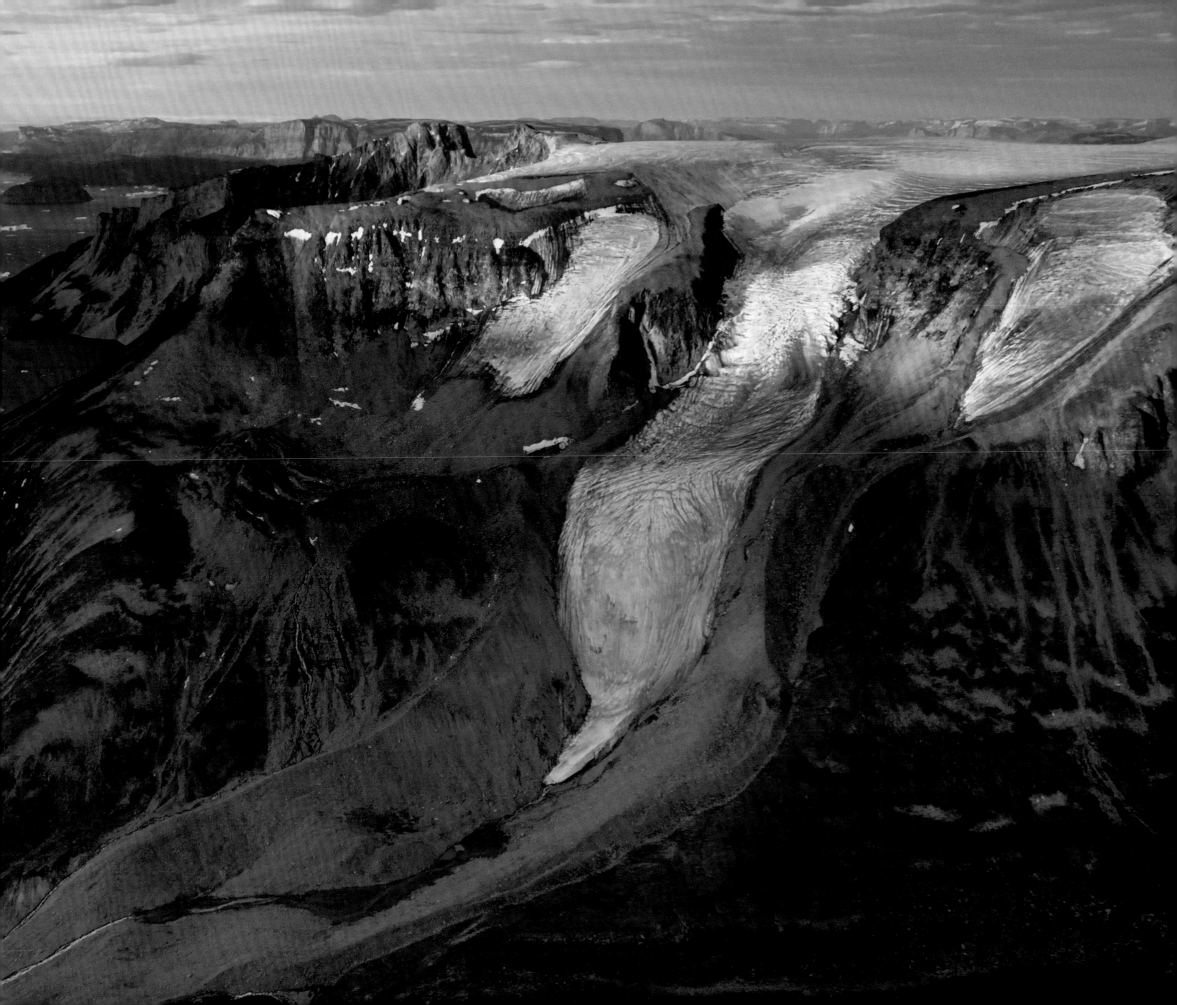

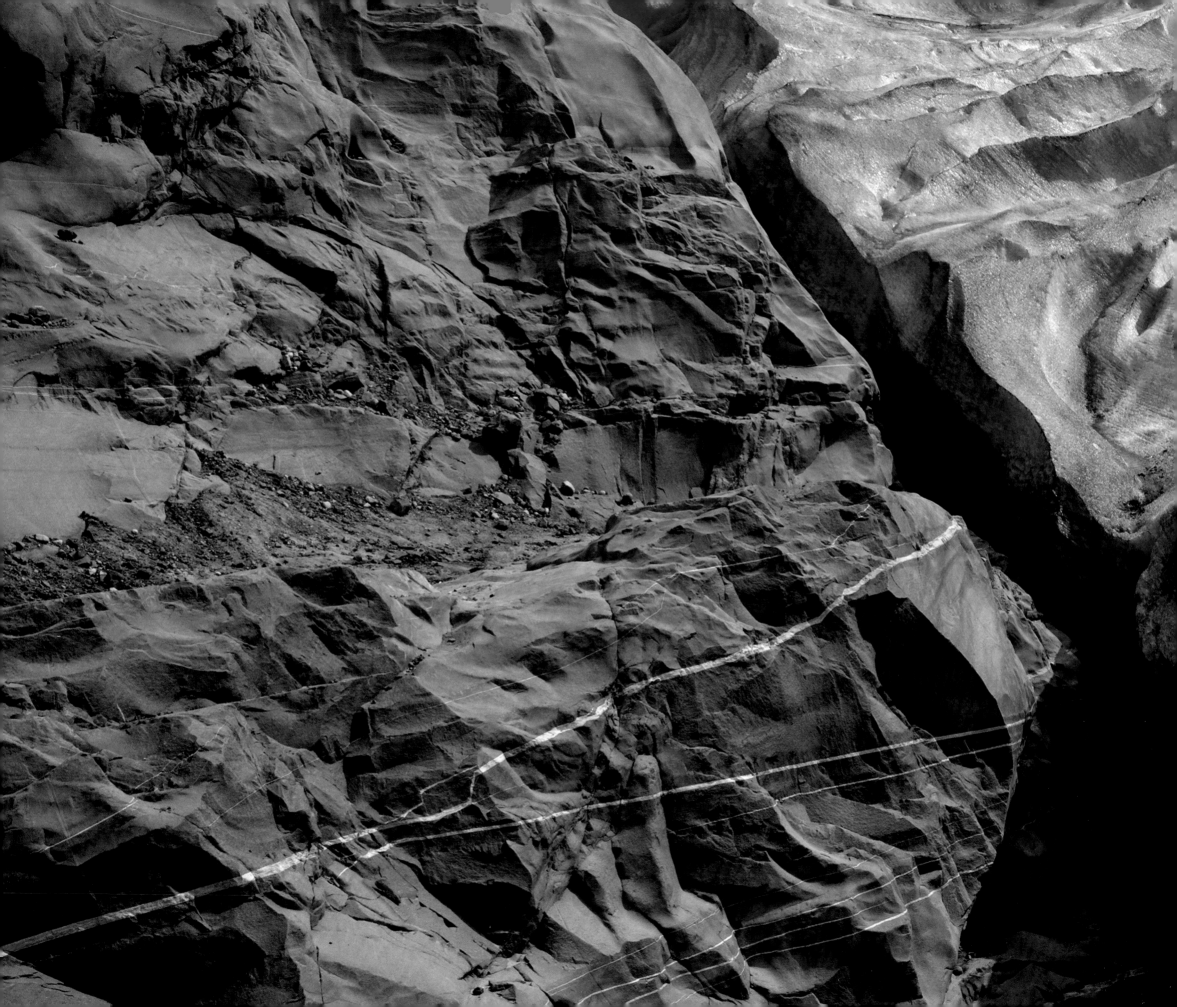

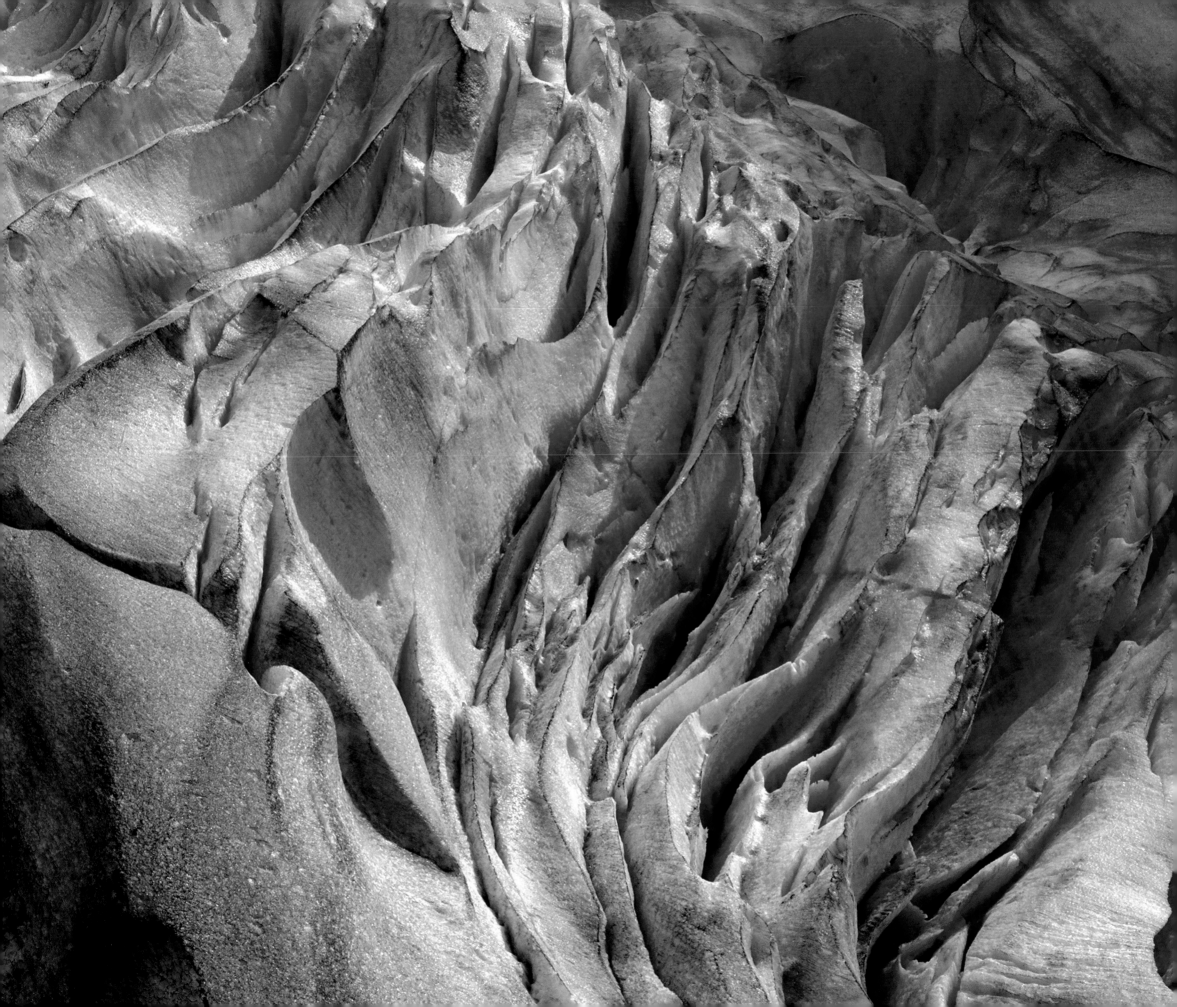

Greenland Ice Sheet | **Greenland** | 15 July 2006 | Meltwater stream with geologist for scale.

Greenland Ice Sheet | **Greenland** | 7 June 2010 | Crevasses filled with meltwater.

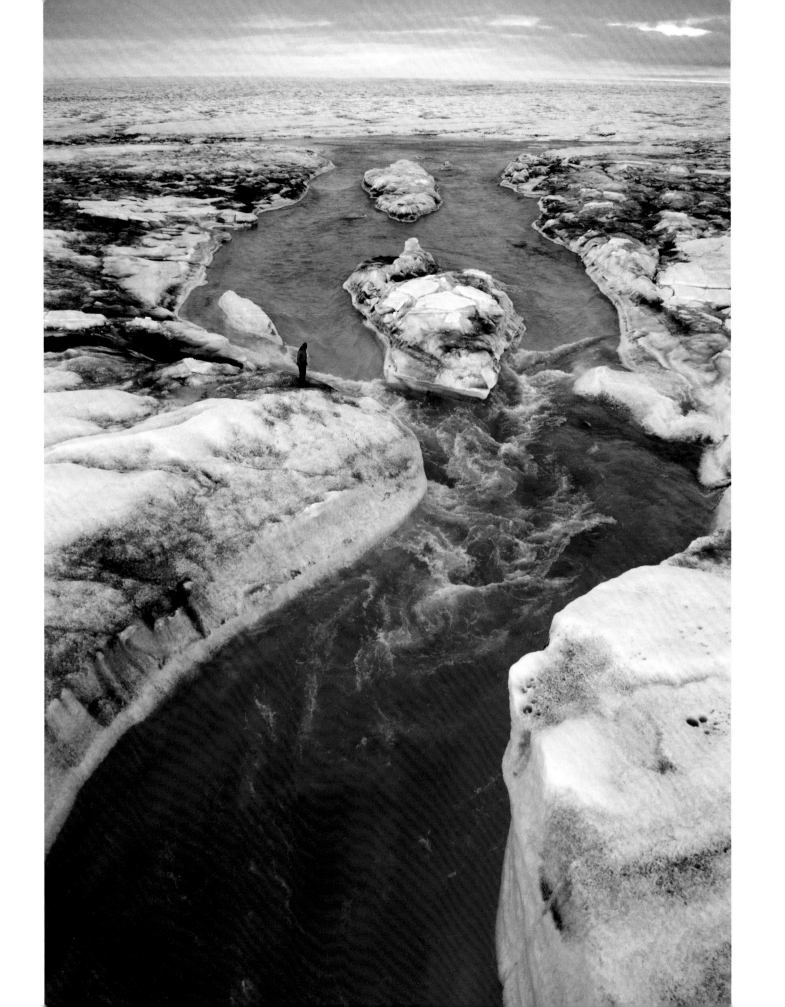

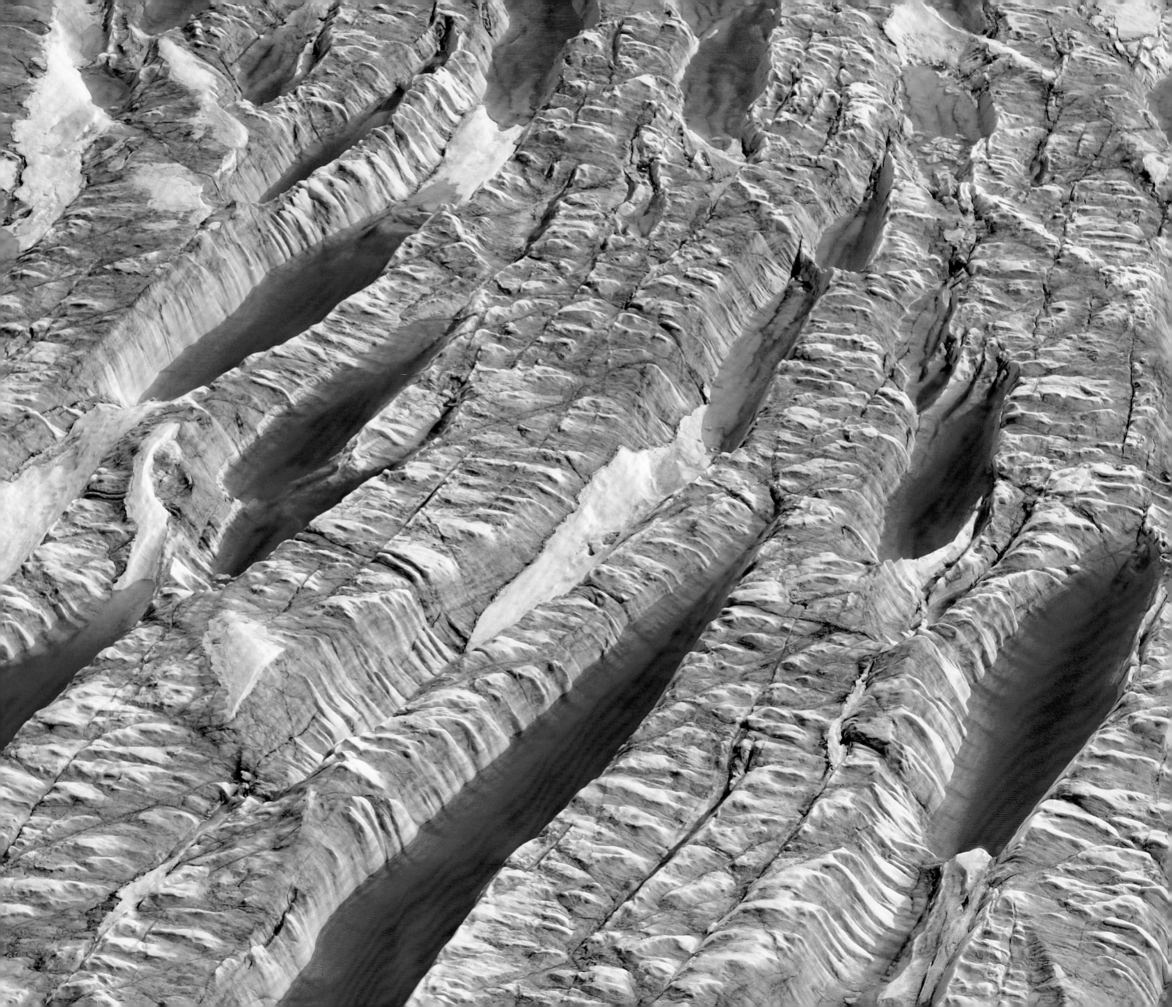

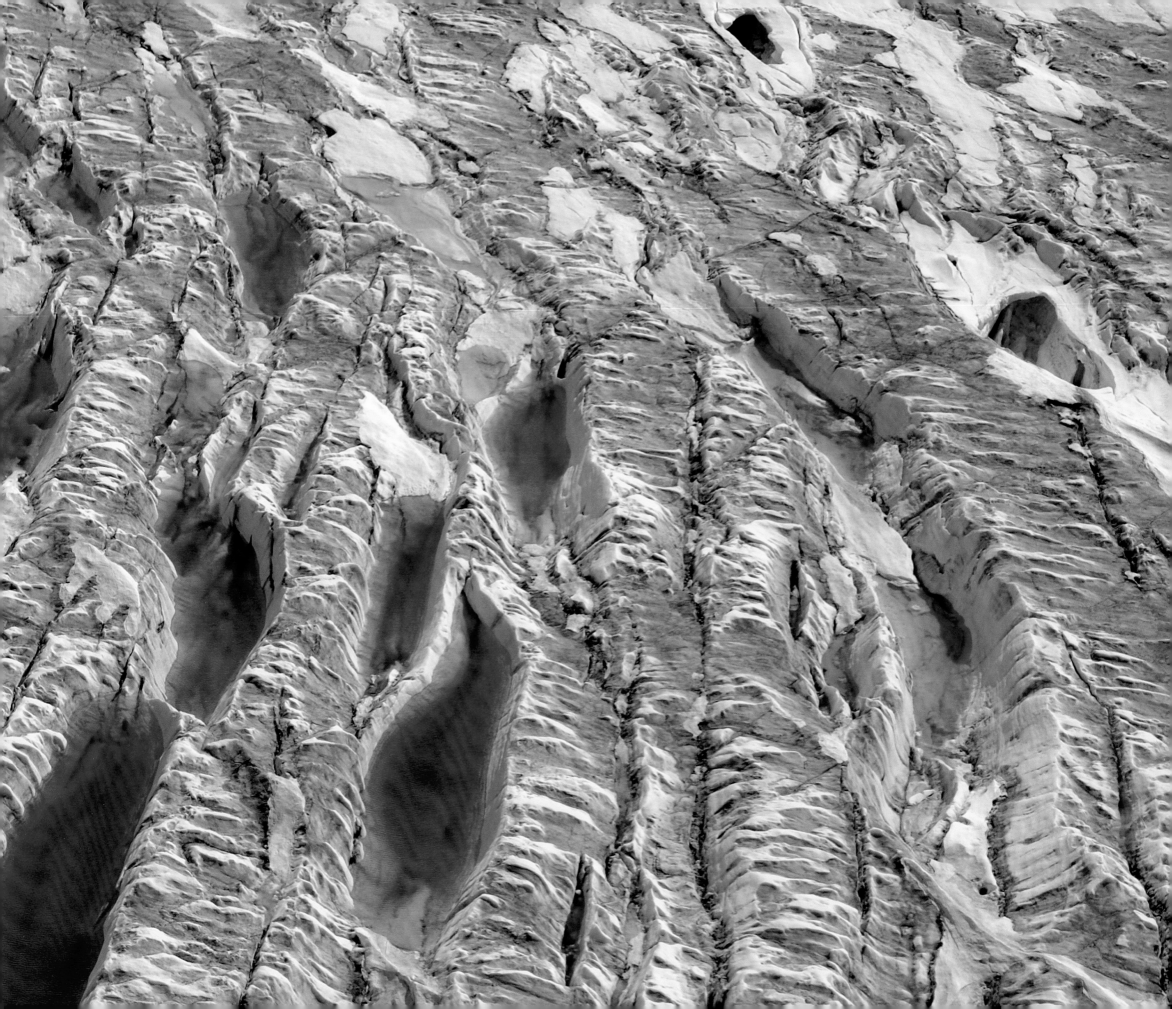

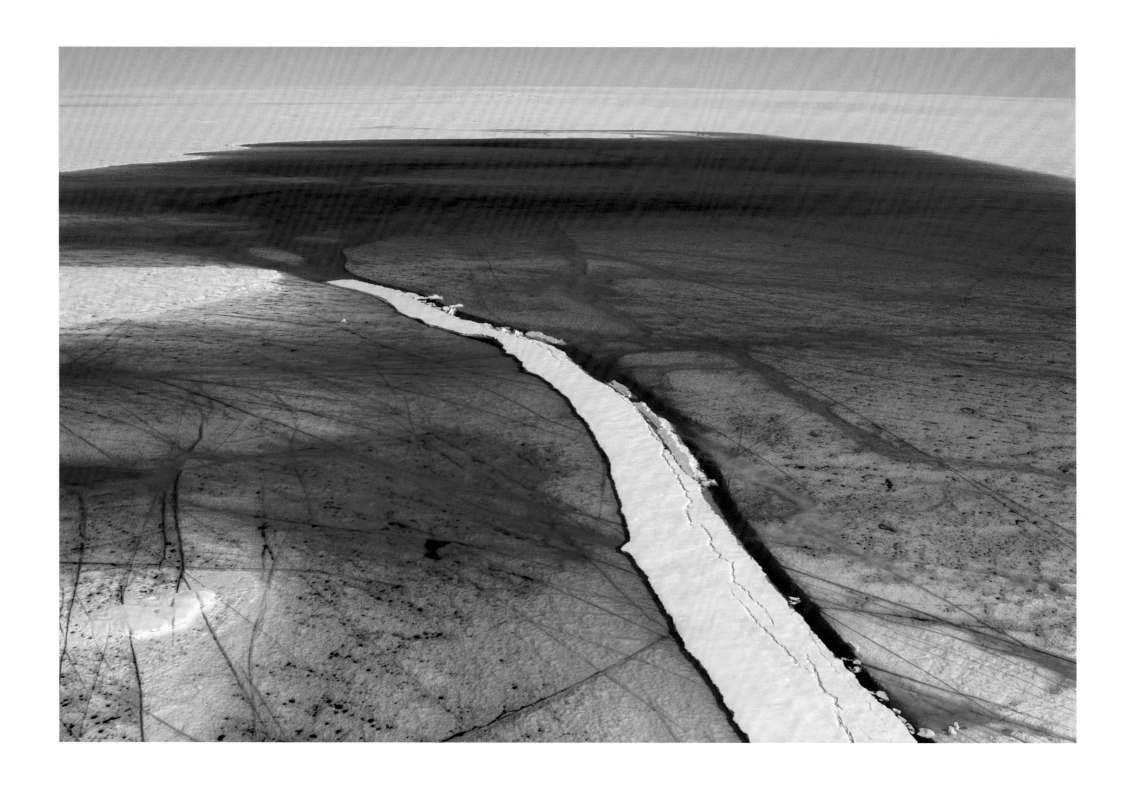

▲ Lake Ivan, Greenland Ice Sheet | **Greenland** | 28 June 2009 | Lake basins fill with meltwater, then quickly drain when downstream crevasses crack open.

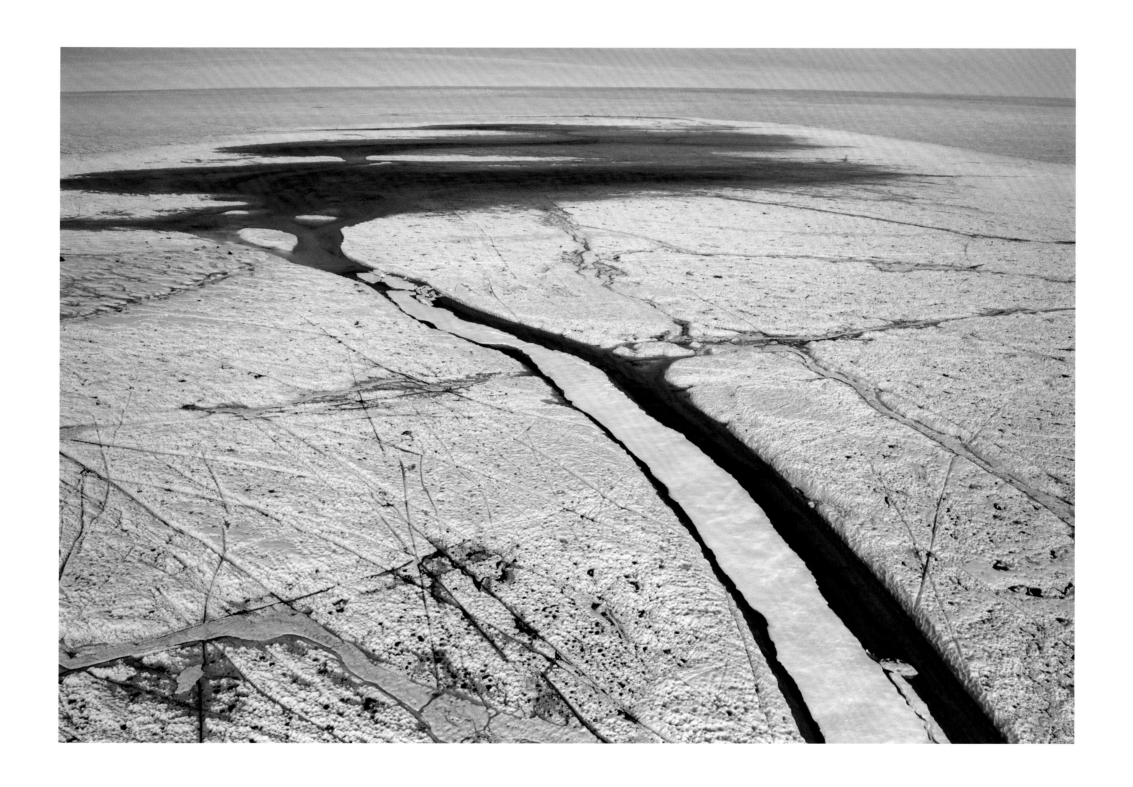

▼ North-North Lake, Greenland Ice Sheet │ **Greenland** │ 18 July 2008
Lake bed, bare after the lake has drained, shows a moulin that swallowed millions of gallons of meltwater.

▲ Lake Ivan, Greenland Ice Sheet │ **Greenland** │ 6 July 2009

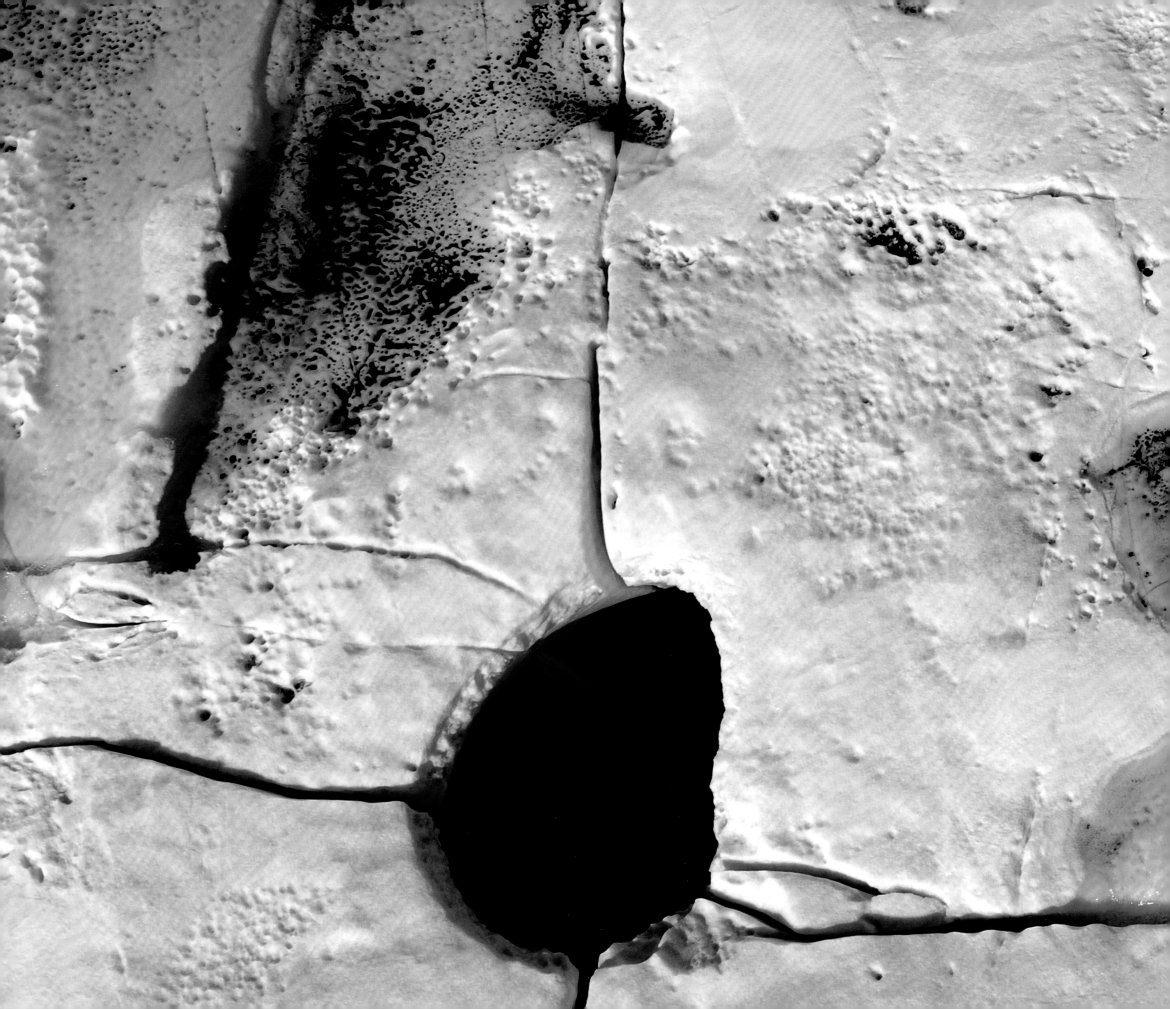

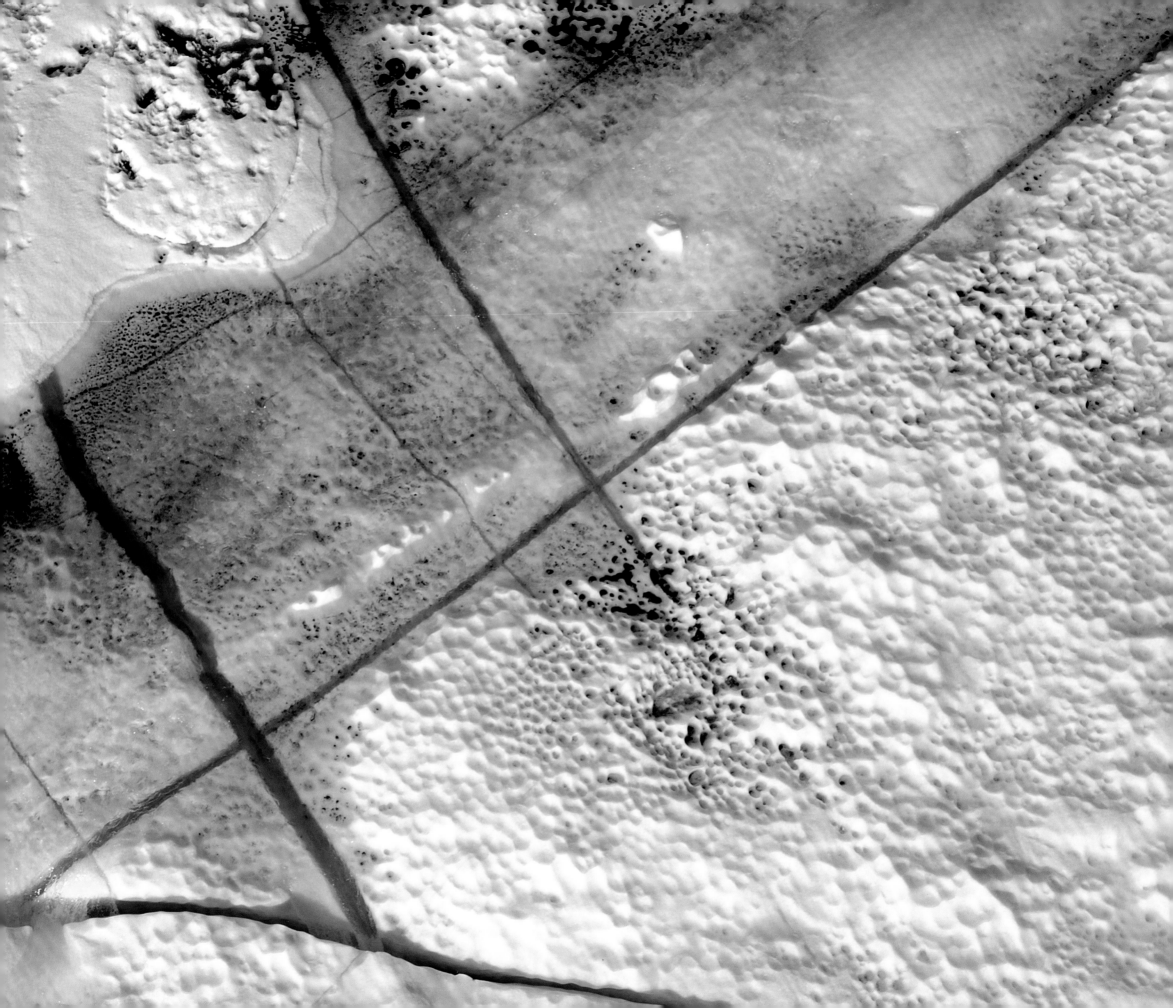

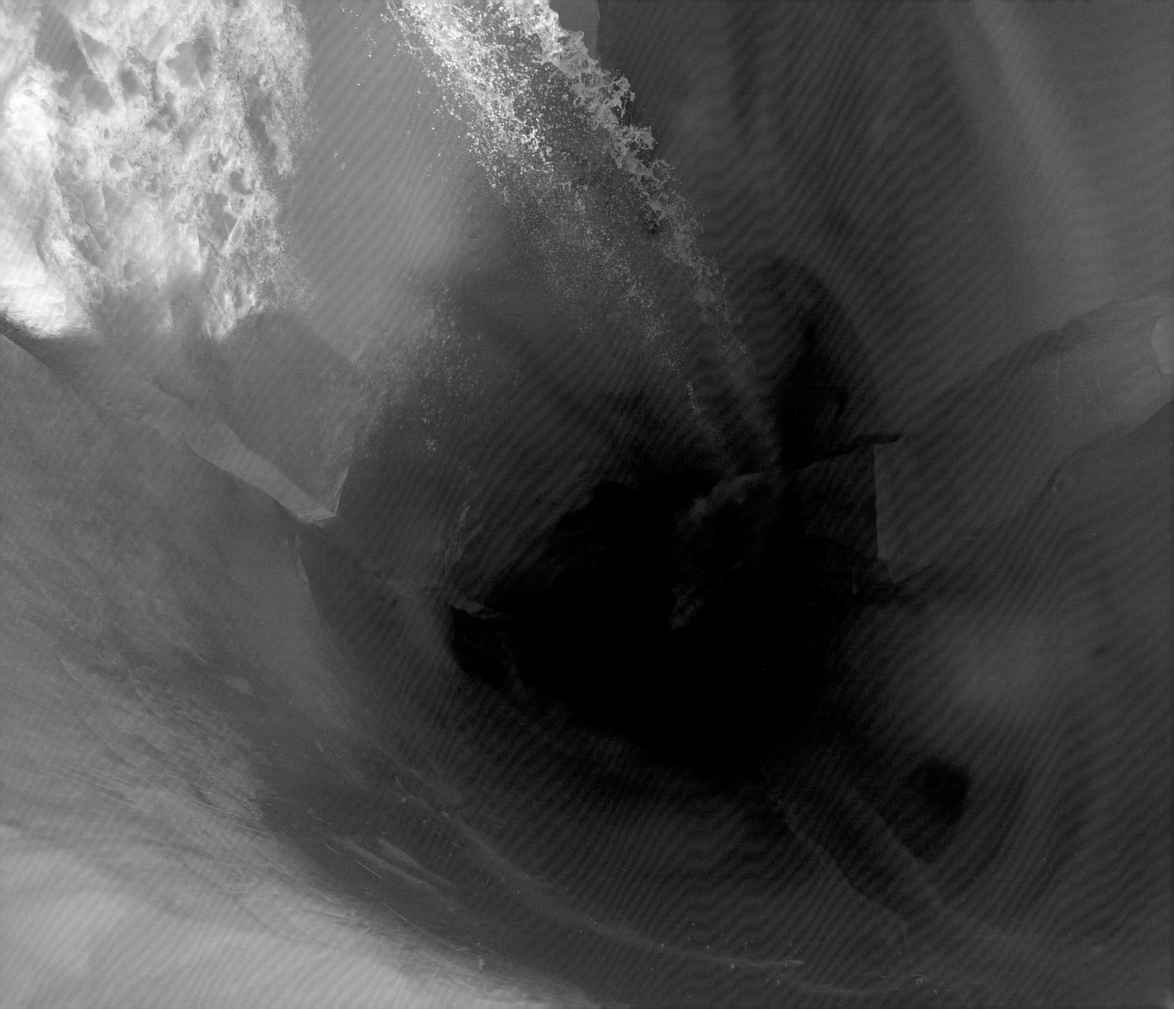

◀ North-North Lake, Greenland Ice Sheet │ **Greenland** │ 18 July 2008
Looking twenty-five stories straight down into the moulin seen on previous page.

▶ Nova Canyon, Greenland Ice Sheet │ **Greenland** │ 11 July 2008 │ Videographer Michael Brown probes the abyss.

▼ Birthday Canyon, Greenland Ice Sheet │ **Greenland** │ 28 June 2009 │ Adam LeWinter surveys Birthday Canyon.

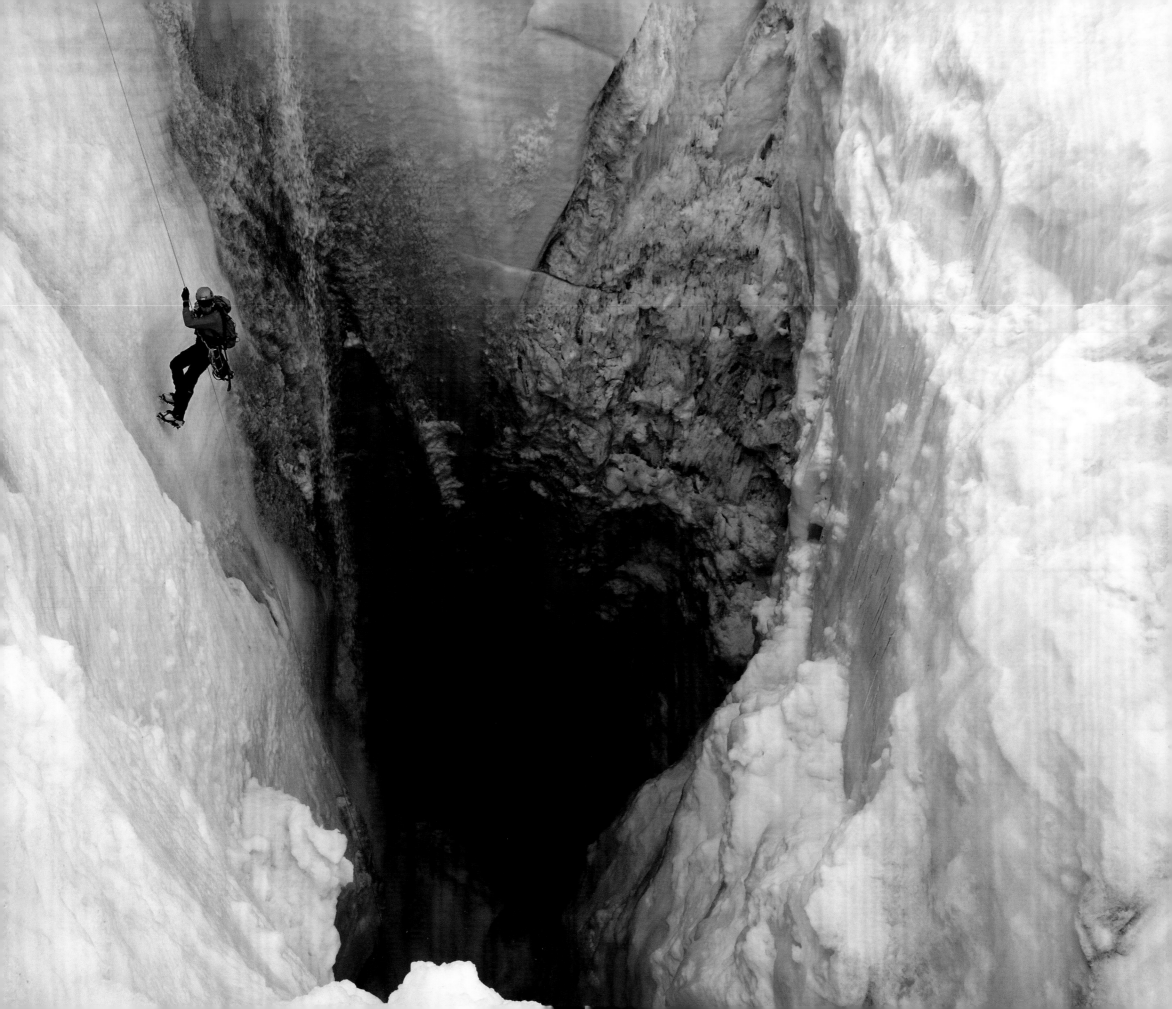

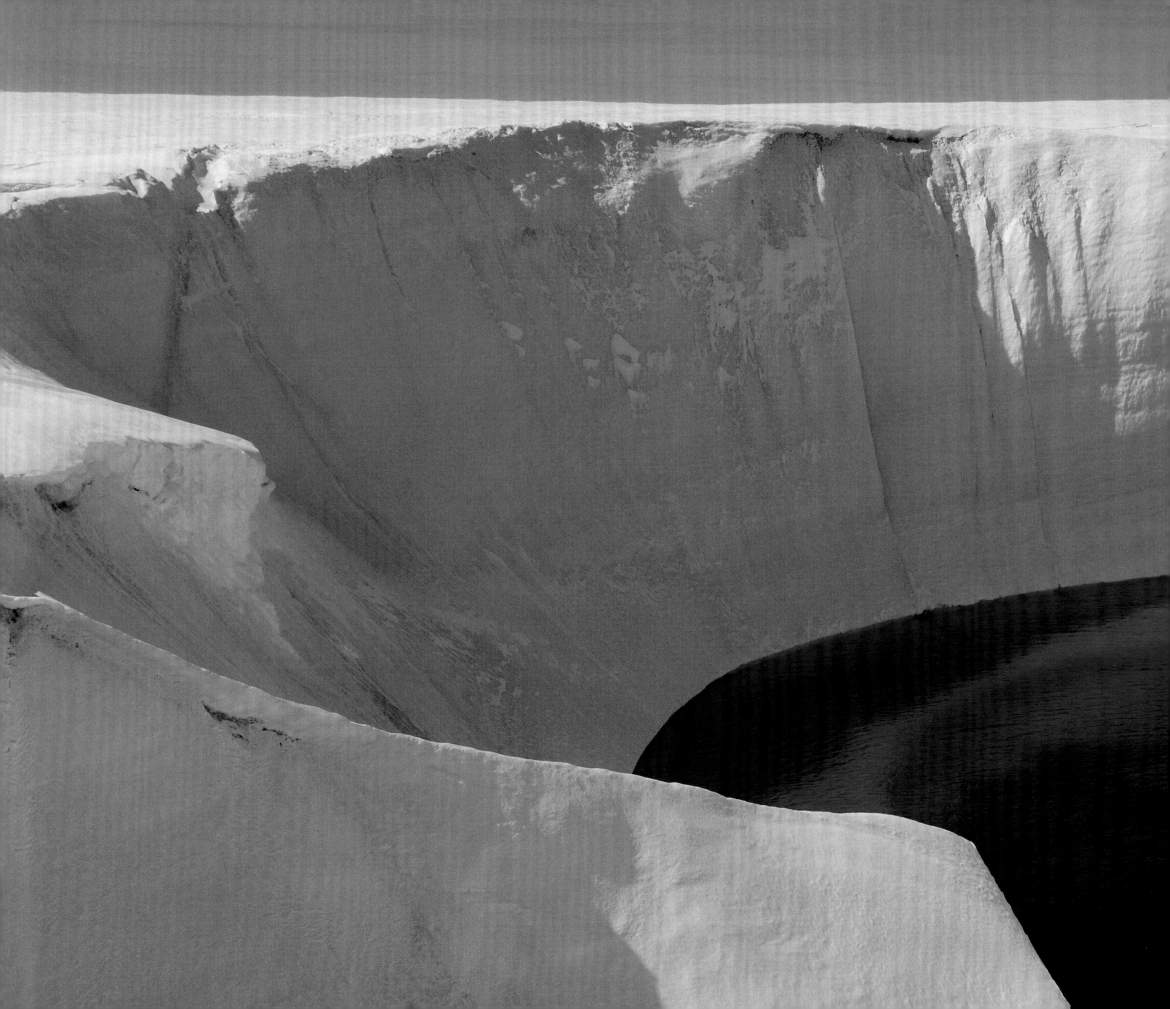

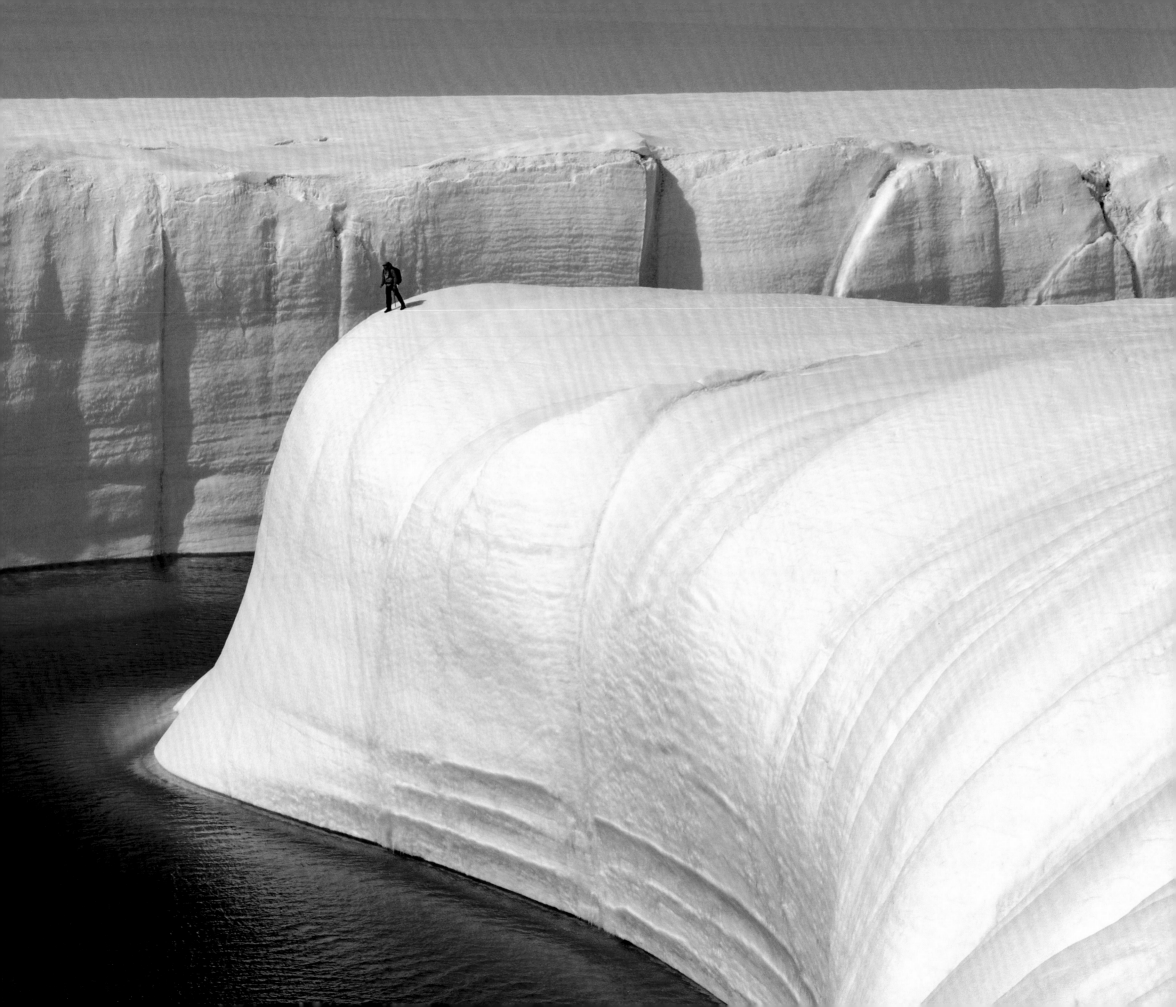

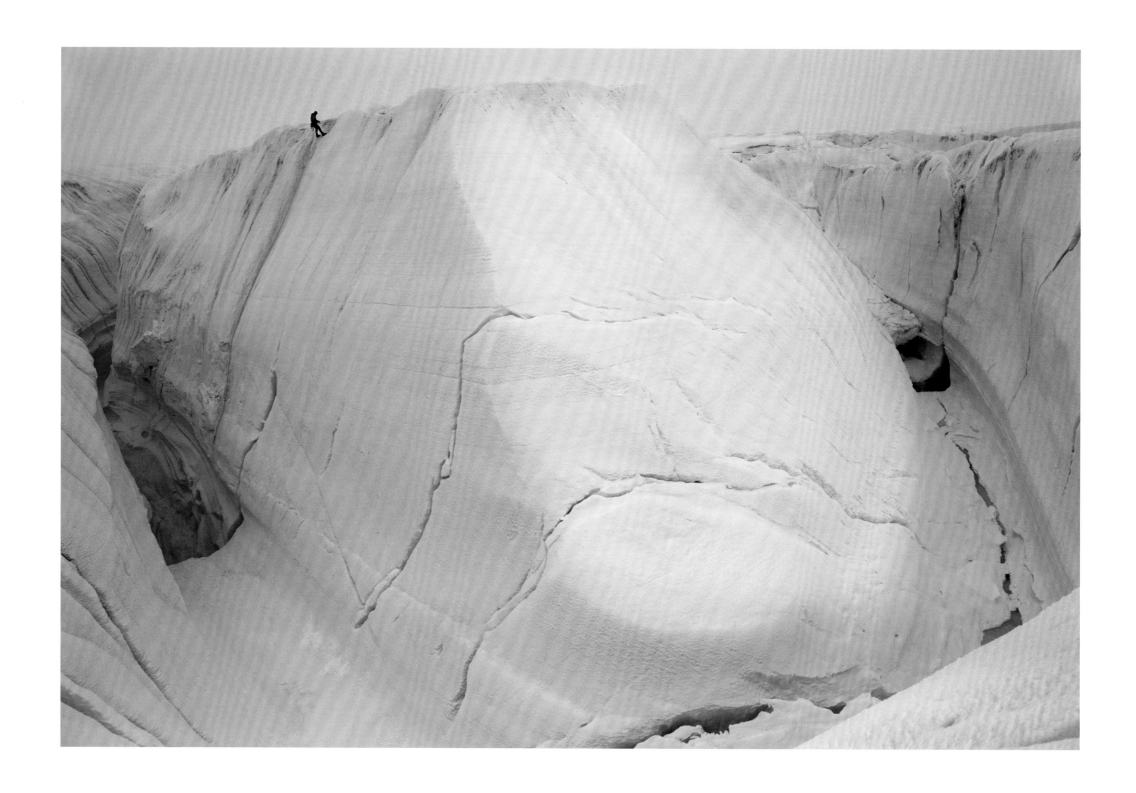

▲ Survey Canyon, Greenland Ice Sheet | **Greenland** | 2 July 2009
New fractures in the ice capture streamflow that previously carved Survey Canyon.

▶ Nova Canyon, Greenland Ice Sheet | **Greenland** | 13 July 2008
Water rushing into a moulin cuts a polished cross-section of the ice sheet.

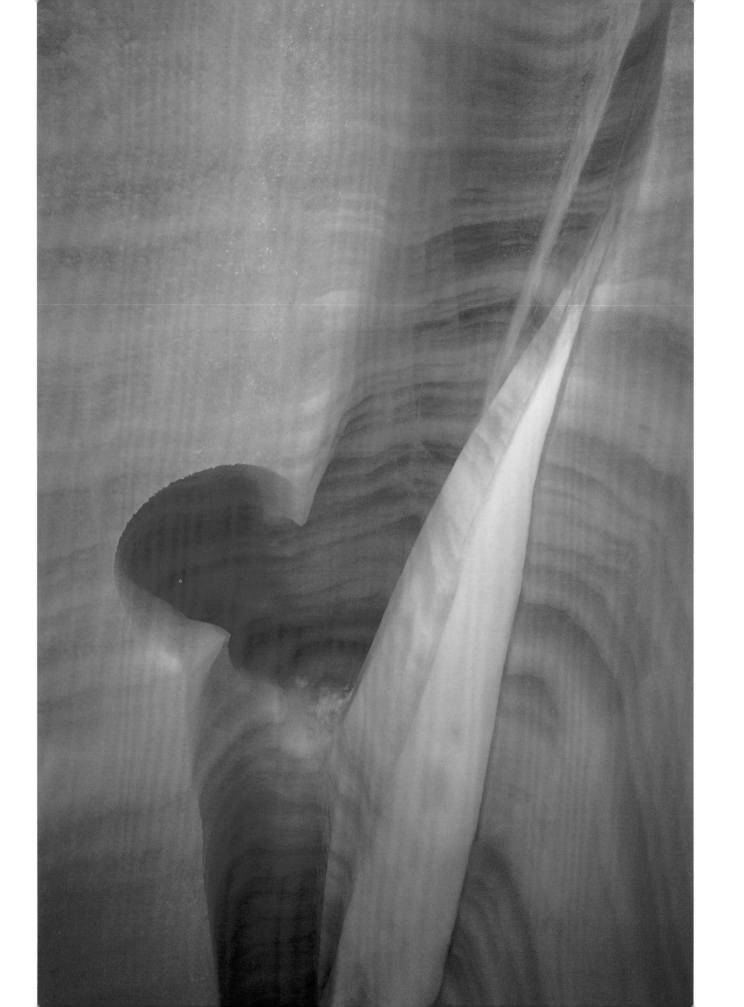

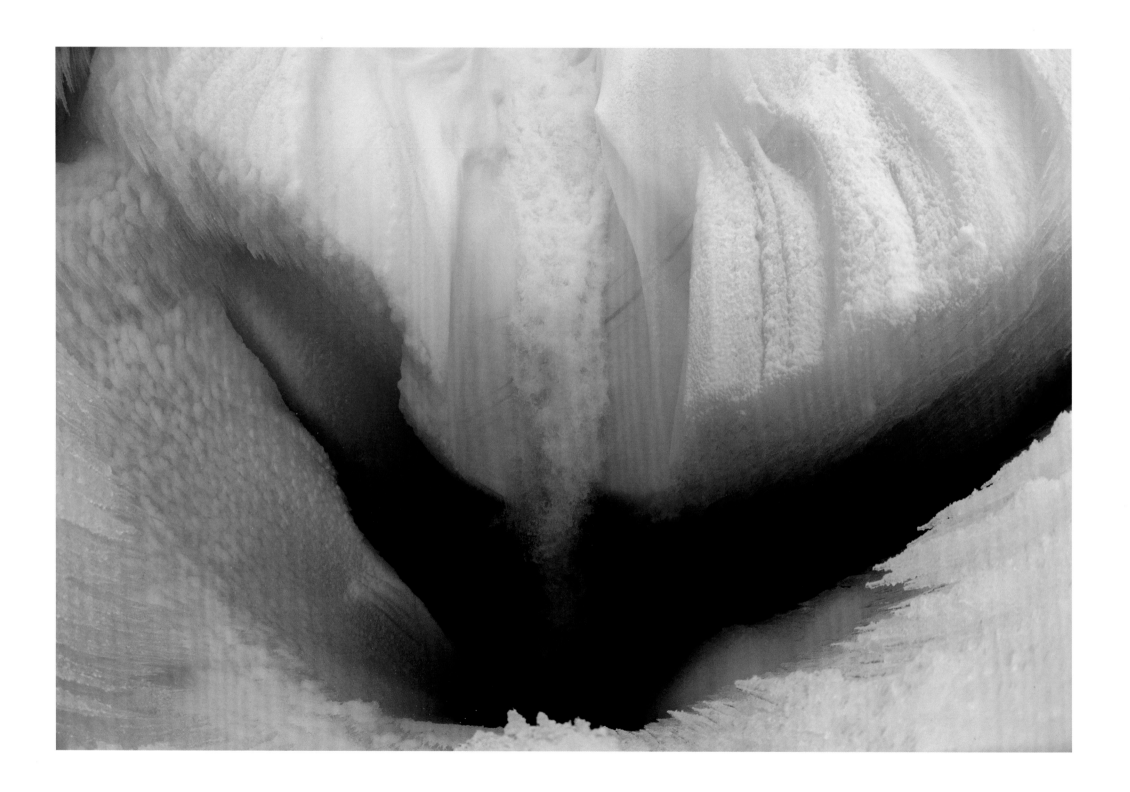

▲ Survey Canyon, Greenland Ice Sheet | **Greenland** | 1 July 2009 | The water of Survey Canyon pours 2,000 to 3,000 feet down to the base of the glacier.

▶ Survey Canyon, Greenland Ice Sheet | **Greenland** | 1 July 2009 | Adam LeWinter tempts fate.

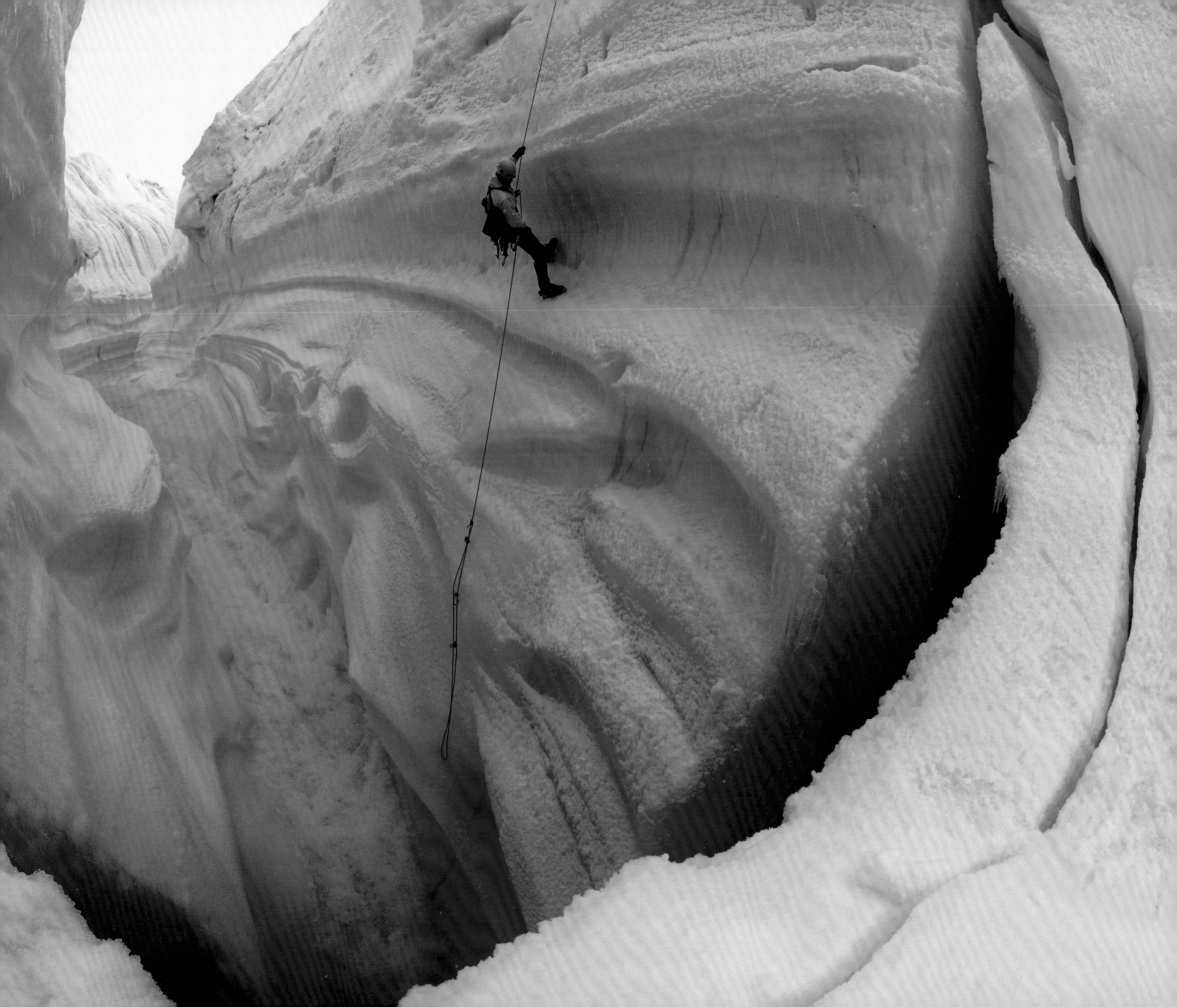

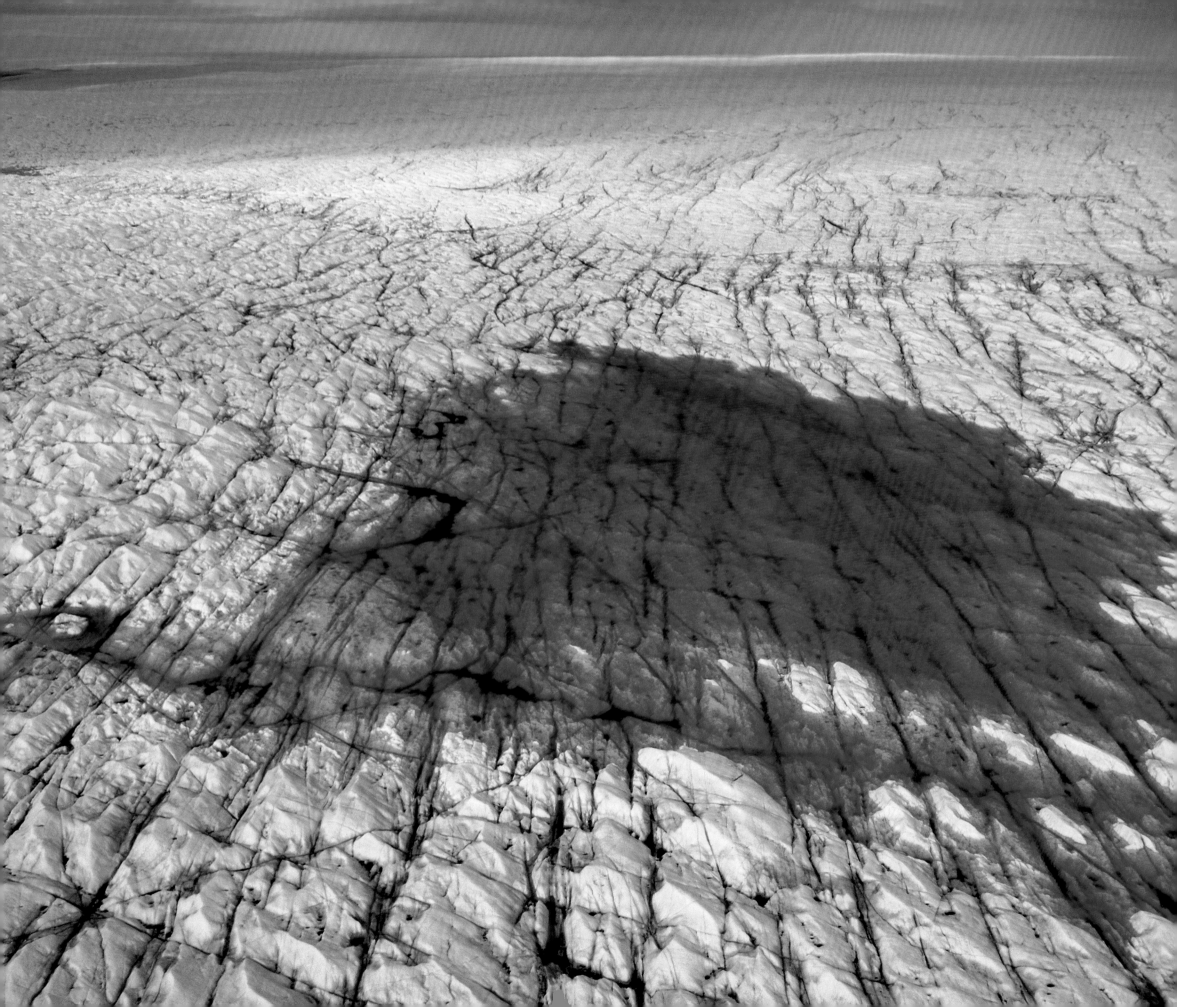

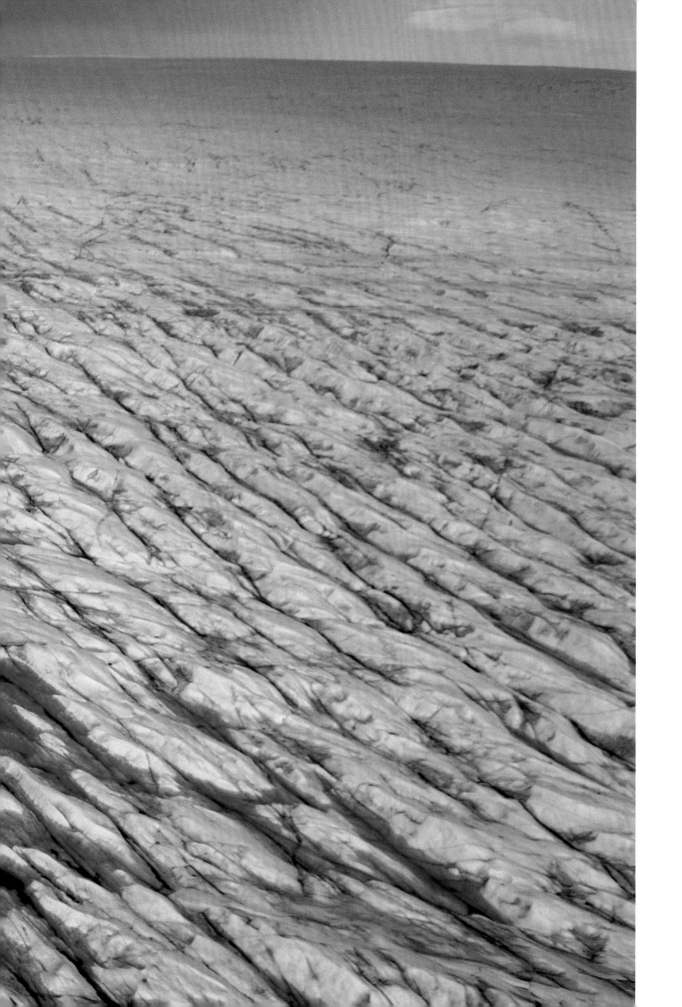

◀ Greenland Ice Sheet │ **Greenland** │ 18 July 2006
Meltwater lake perched on top of crevasses.

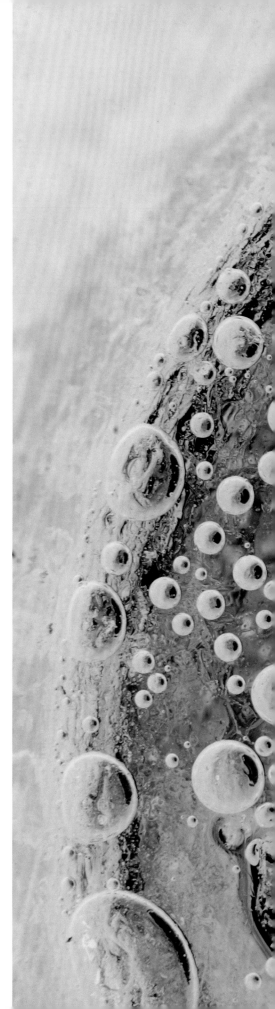

▶ Greenland Ice Sheet | **Greenland** | 14 July 2008 | Bubbles of ancient air, possibly 15,000 years old, are released as the ice sheet melts.

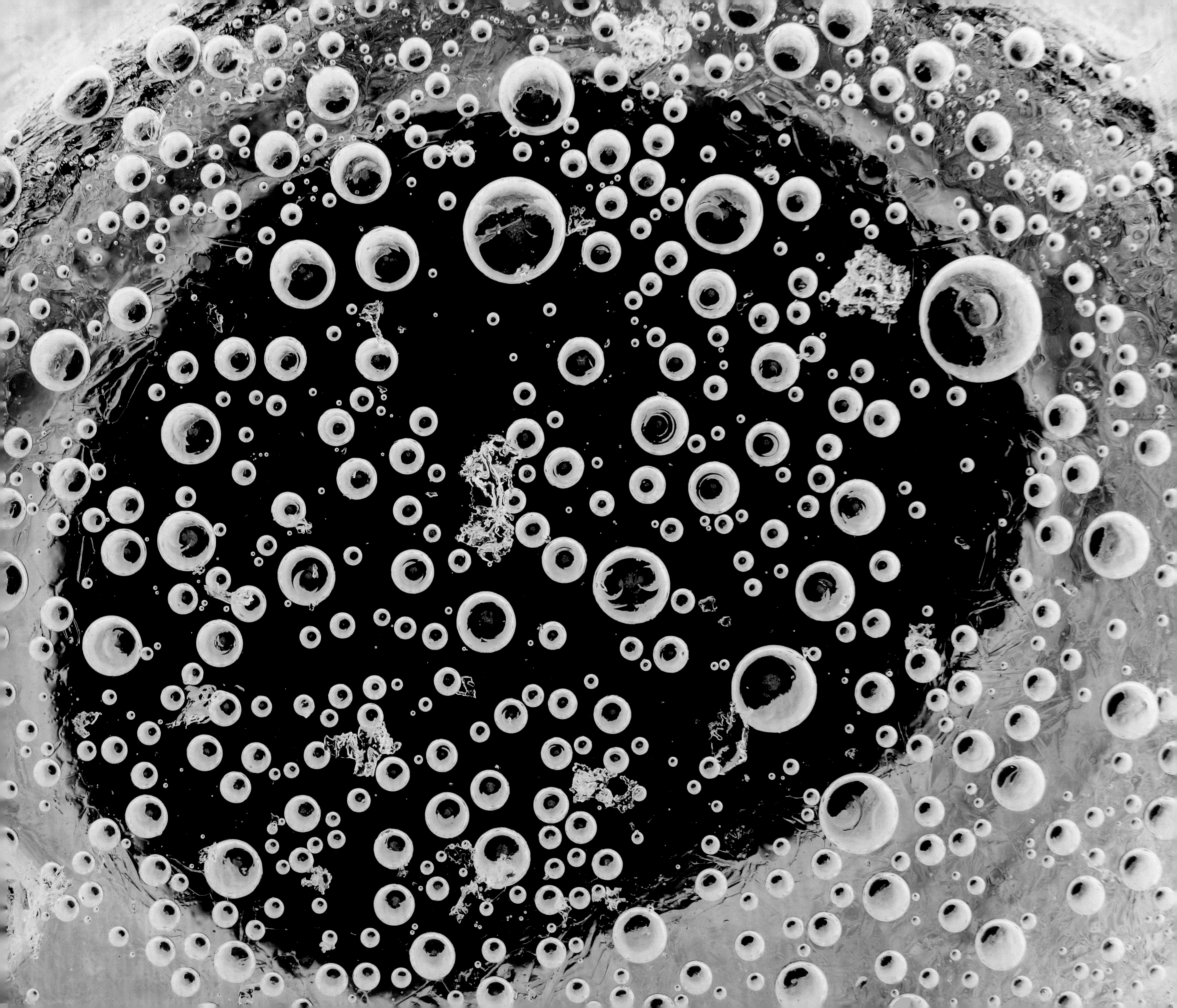

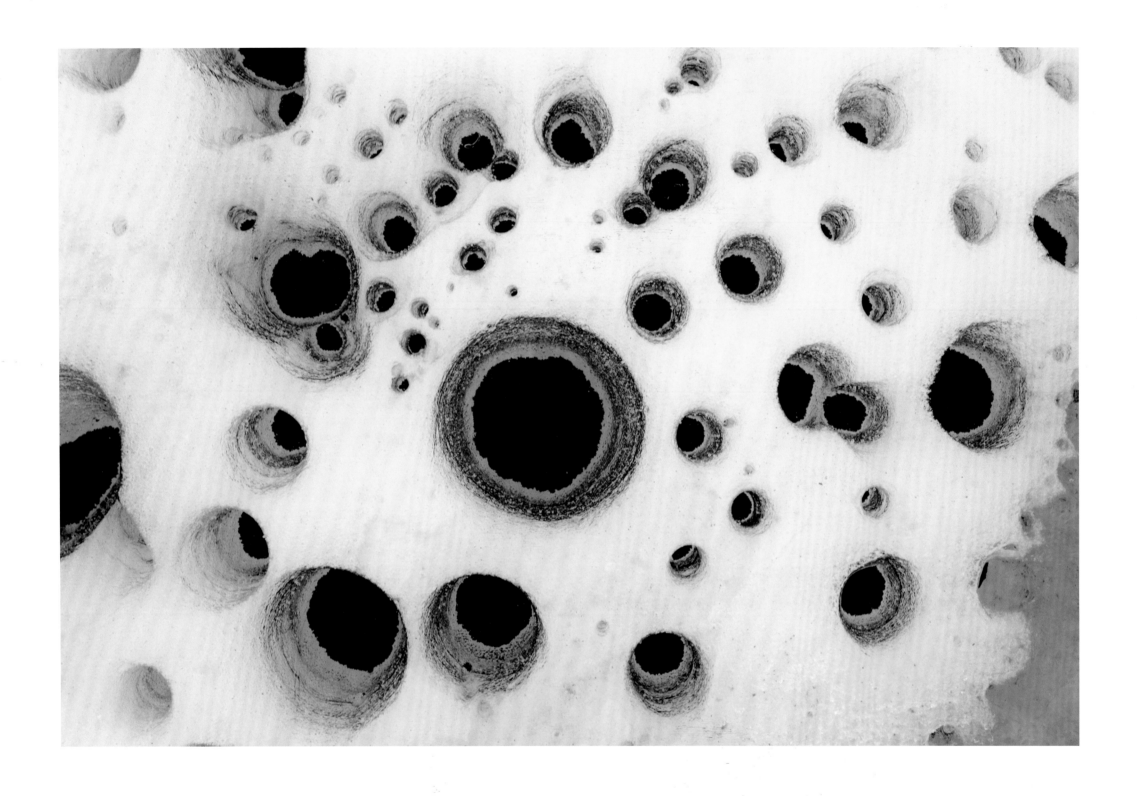

▲ Greenland Ice Sheet | **Greenland** | 10 July 2008 | Silt and soot blown from afar turn into black "cryoconite," absorb solar heat and melt down into ice.

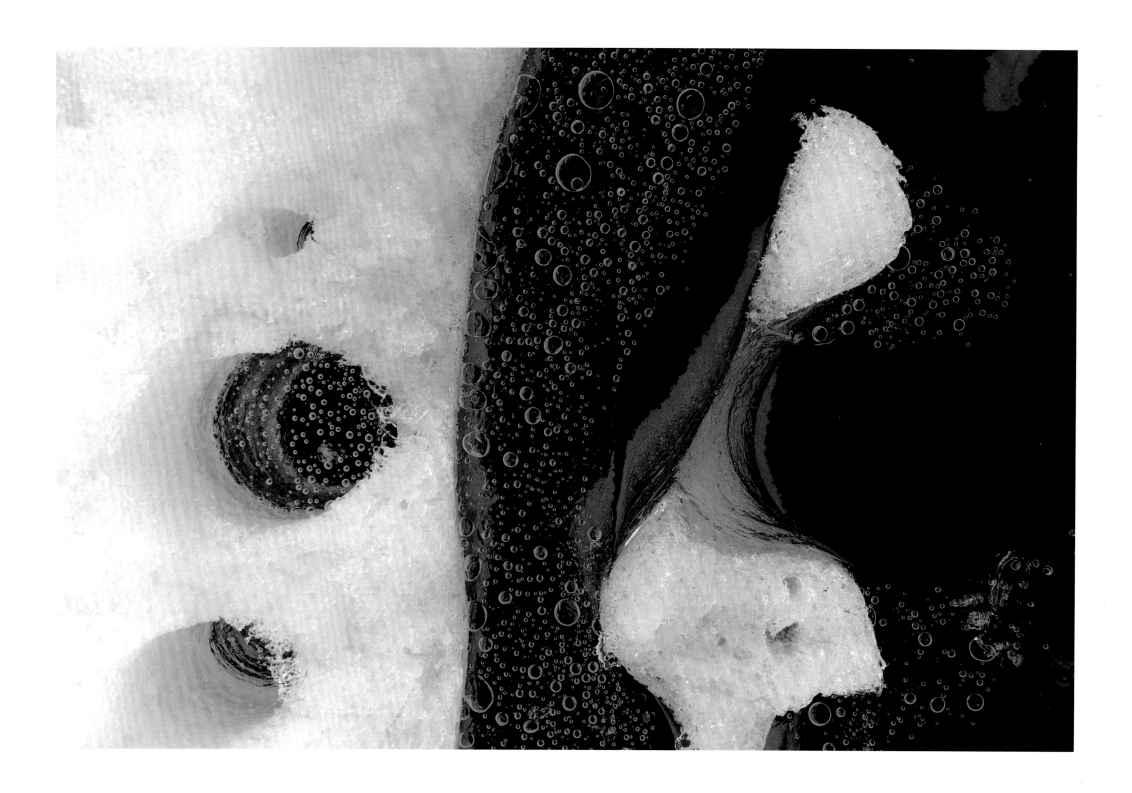

▲ Greenland Ice Sheet | **Greenland** | 14 July 2008

► Greenland Ice Sheet | **Greenland** | 7 July 2009

▼ Greenland Ice Sheet | **Greenland** | 28 June 2009 | Meltwater on the ice surface re-works cryoconite into thick deposits.

244

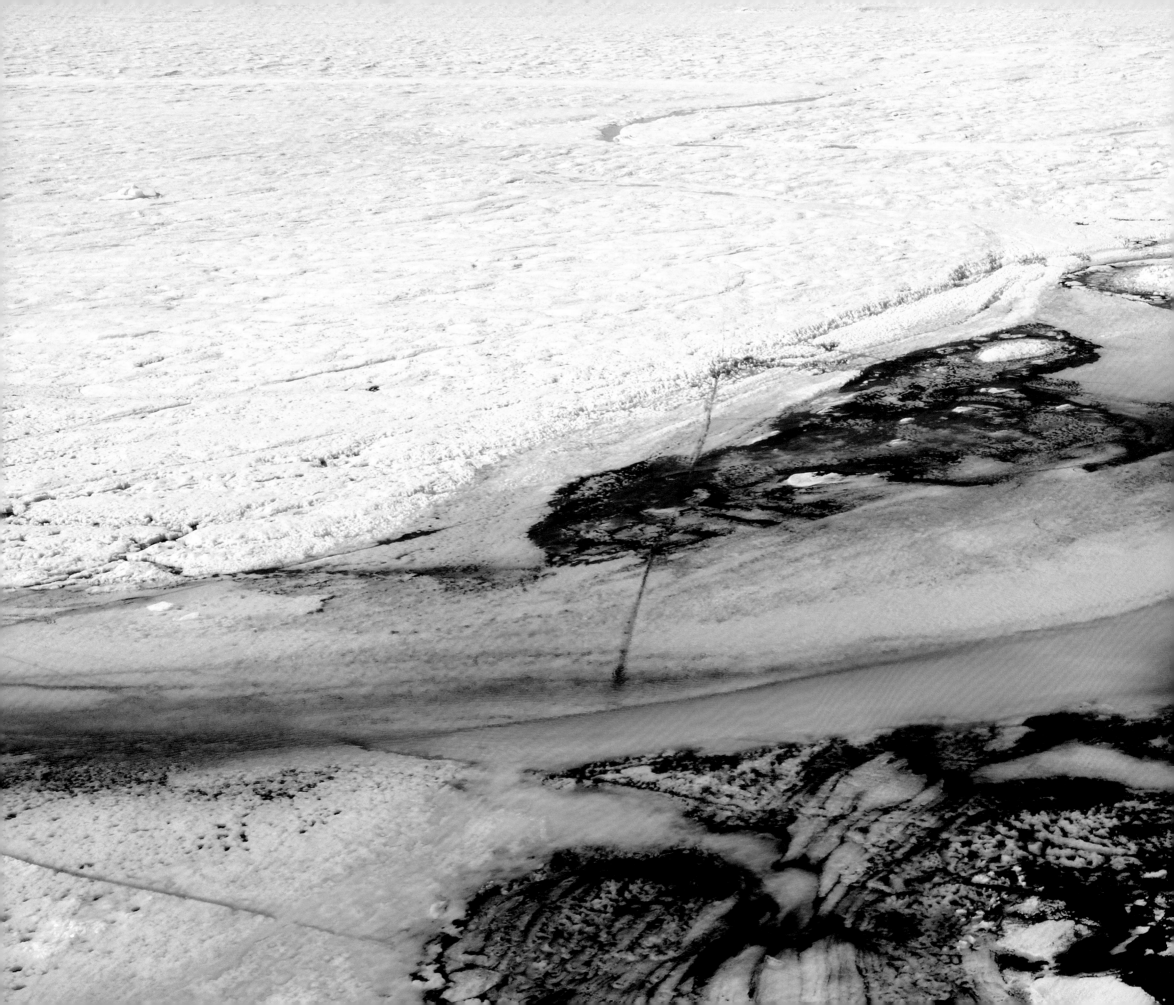

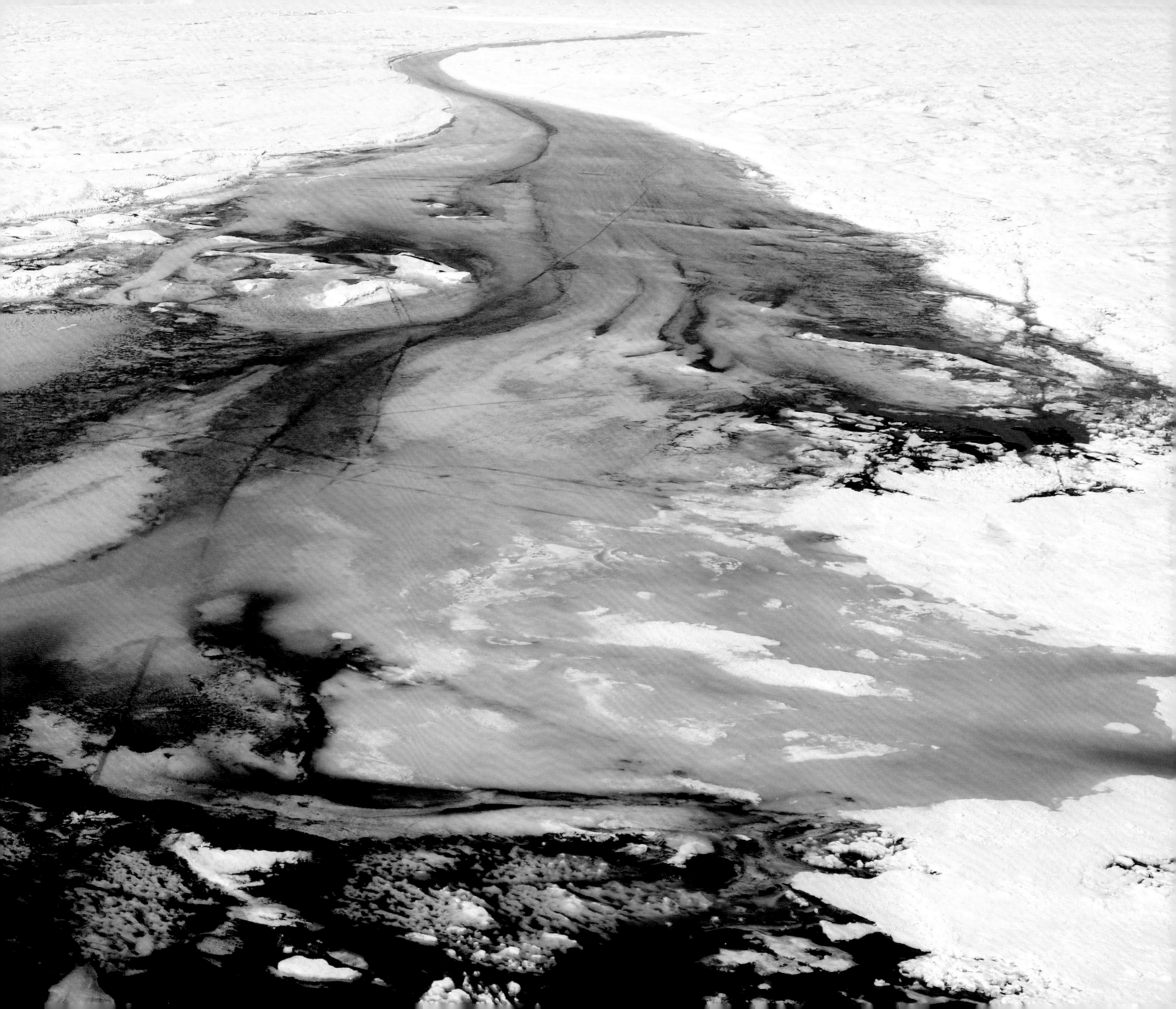

ICE DIAMONDS

Time, pressure, atoms:
carbon turns to diamonds belowground,
ice turns to
diamonds above.

Water and waves,
the jeweler's carving tools,
meet the last surviving fragments of a great glacier
in Iceland.
Bergs get
smaller and smaller and smaller.

Gray-green sea
washes broken ice onto a midnight beach.
The tide ebbs.
Polished,
no diamond like its neighbor,
they are one-of-a-kind sculptures,
Made by Nature,
never to be repeated.

In six hours the tide returns.
Fingers of seafoam greedily steal the jewels.
Beneath aurora borealis
in phosphorescent waves,
the legacy of millennia floats into the North Atlantic.
One melting drop at a time,
the diamonds add their mortal bodies to the ever-rising tide
of the great global ocean.

And then:
they are gone.

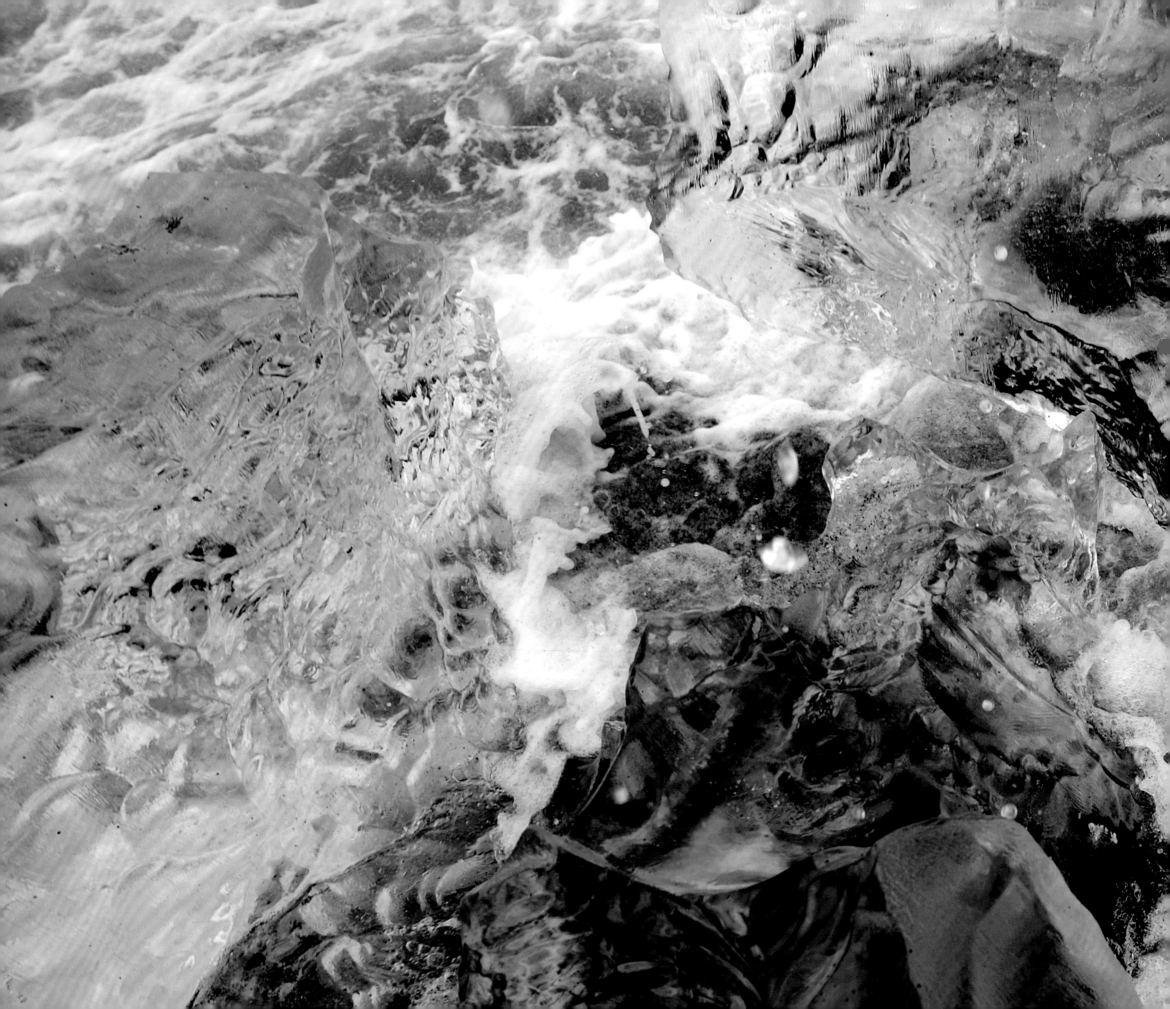

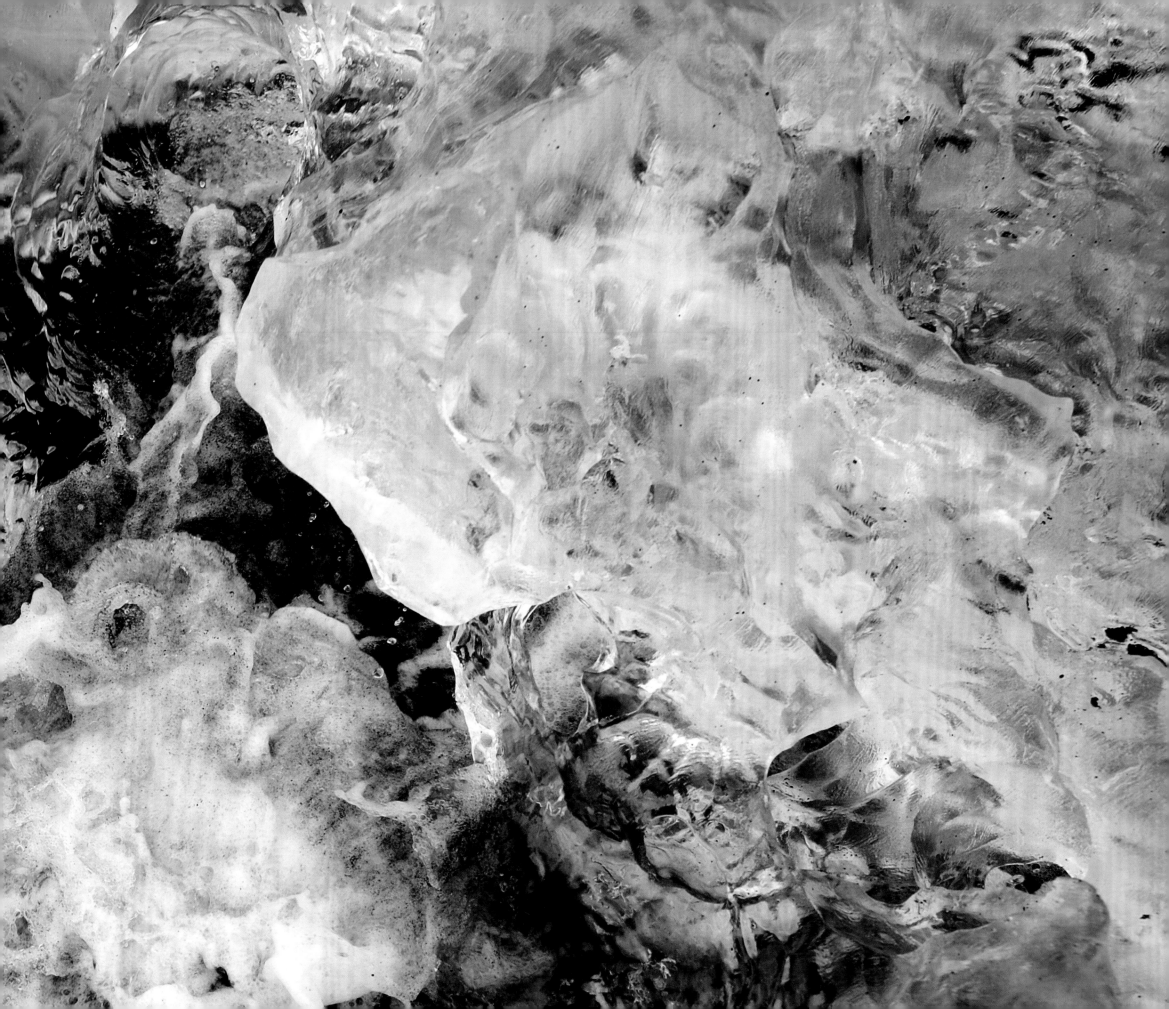

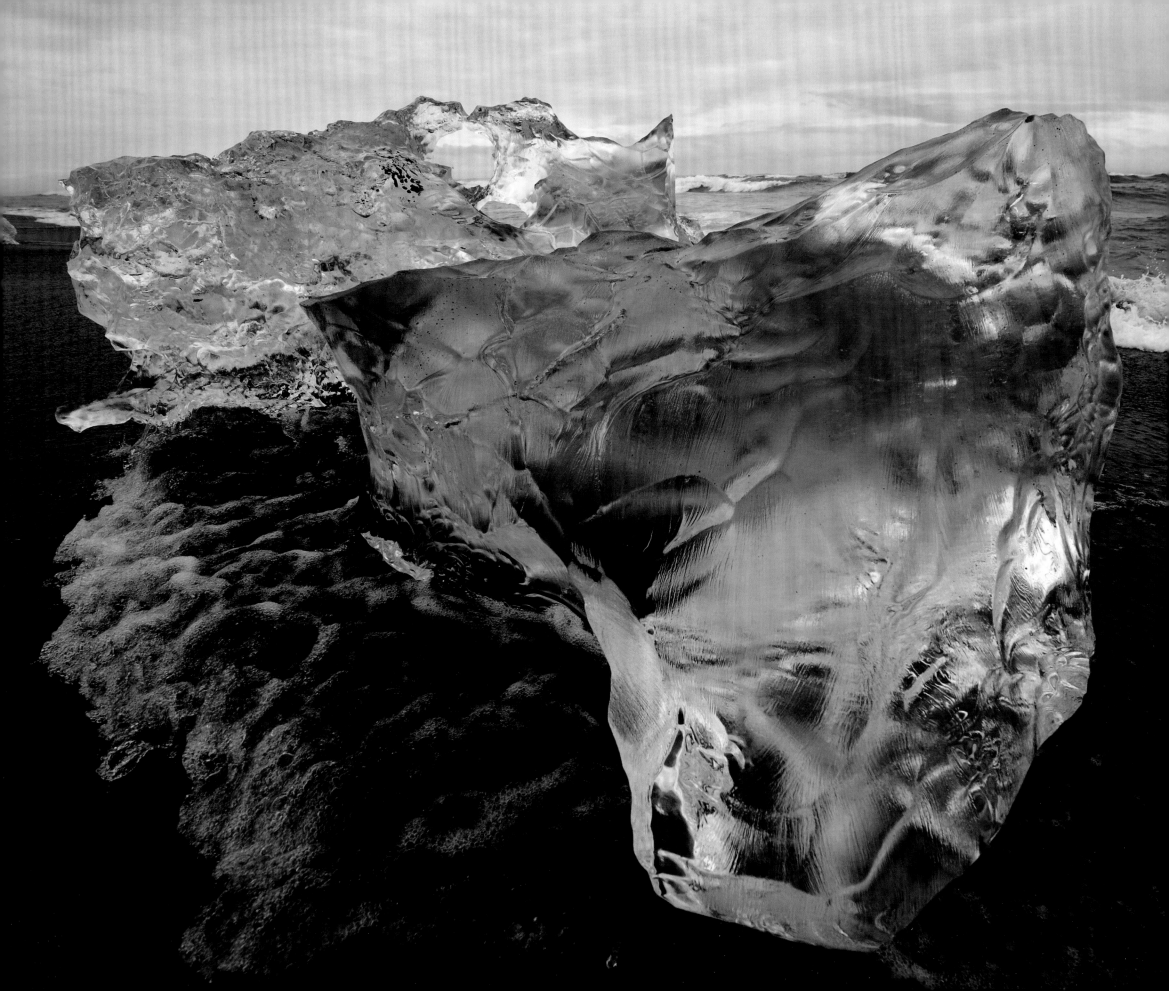

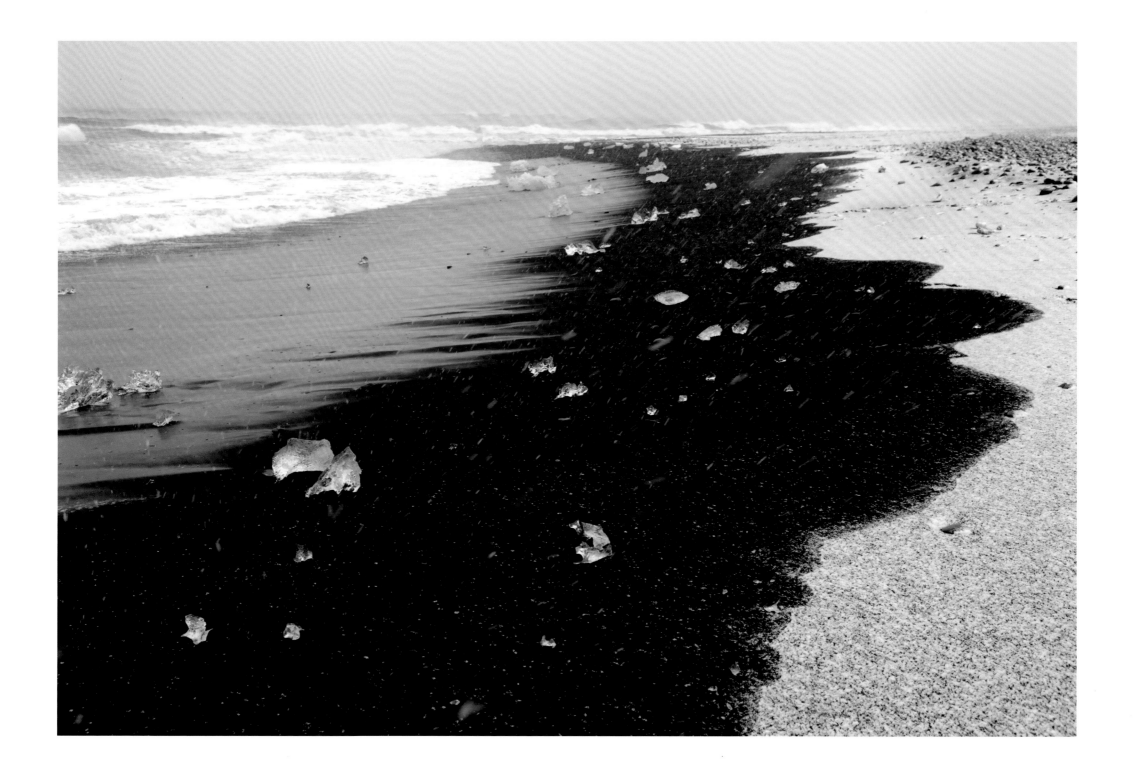

◄ Jökulsárlón | **Iceland** | 23 July 2008　　　　　　　　　　　　　　　　　▲ Jökulsárlón | **Iceland** | 15 September 2007

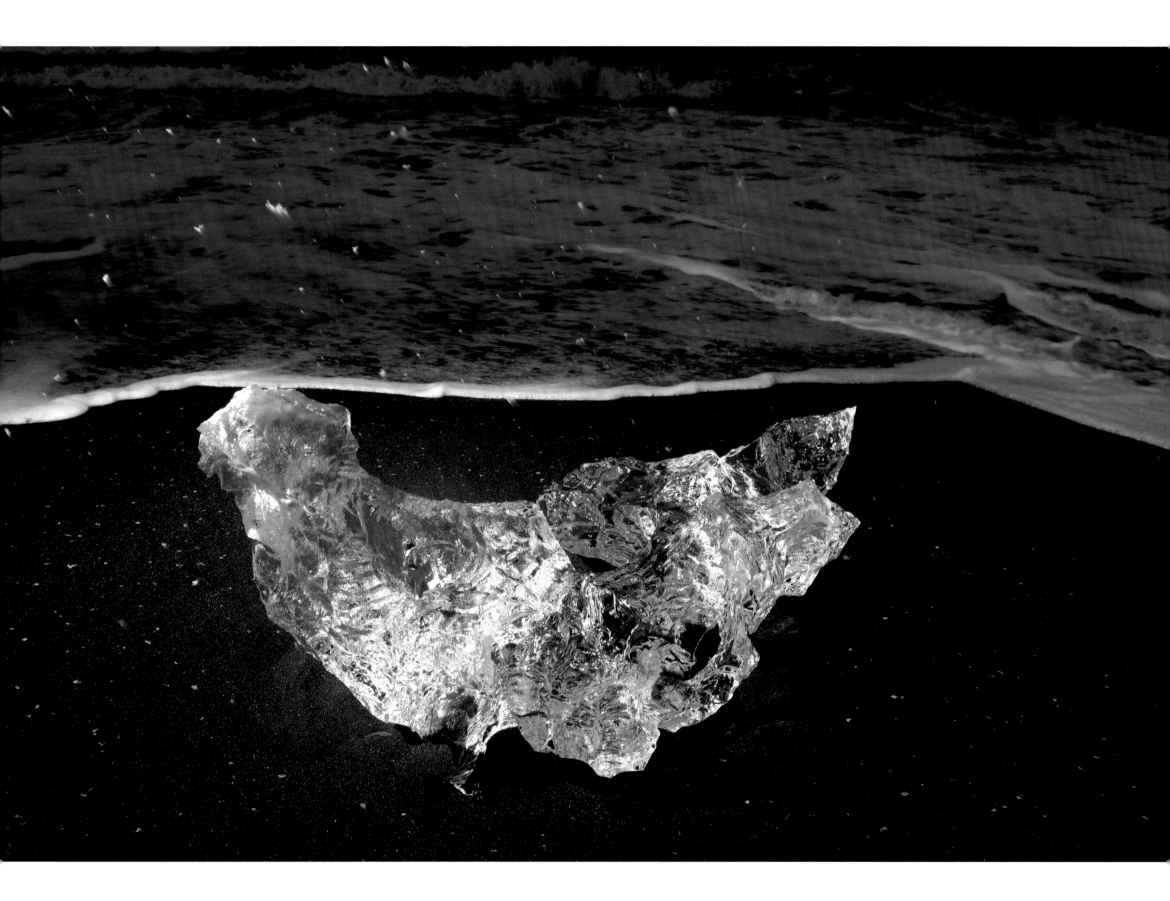

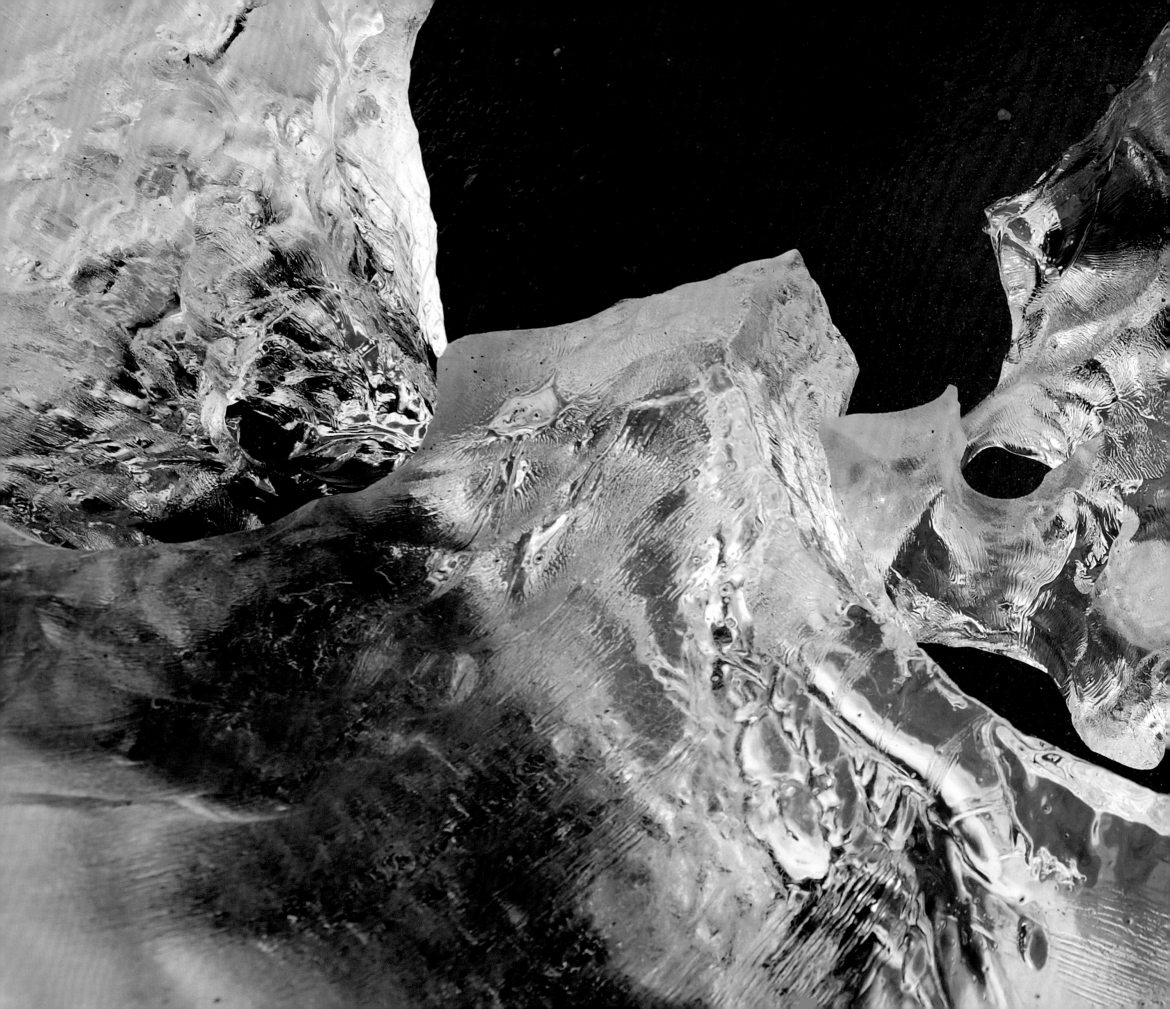

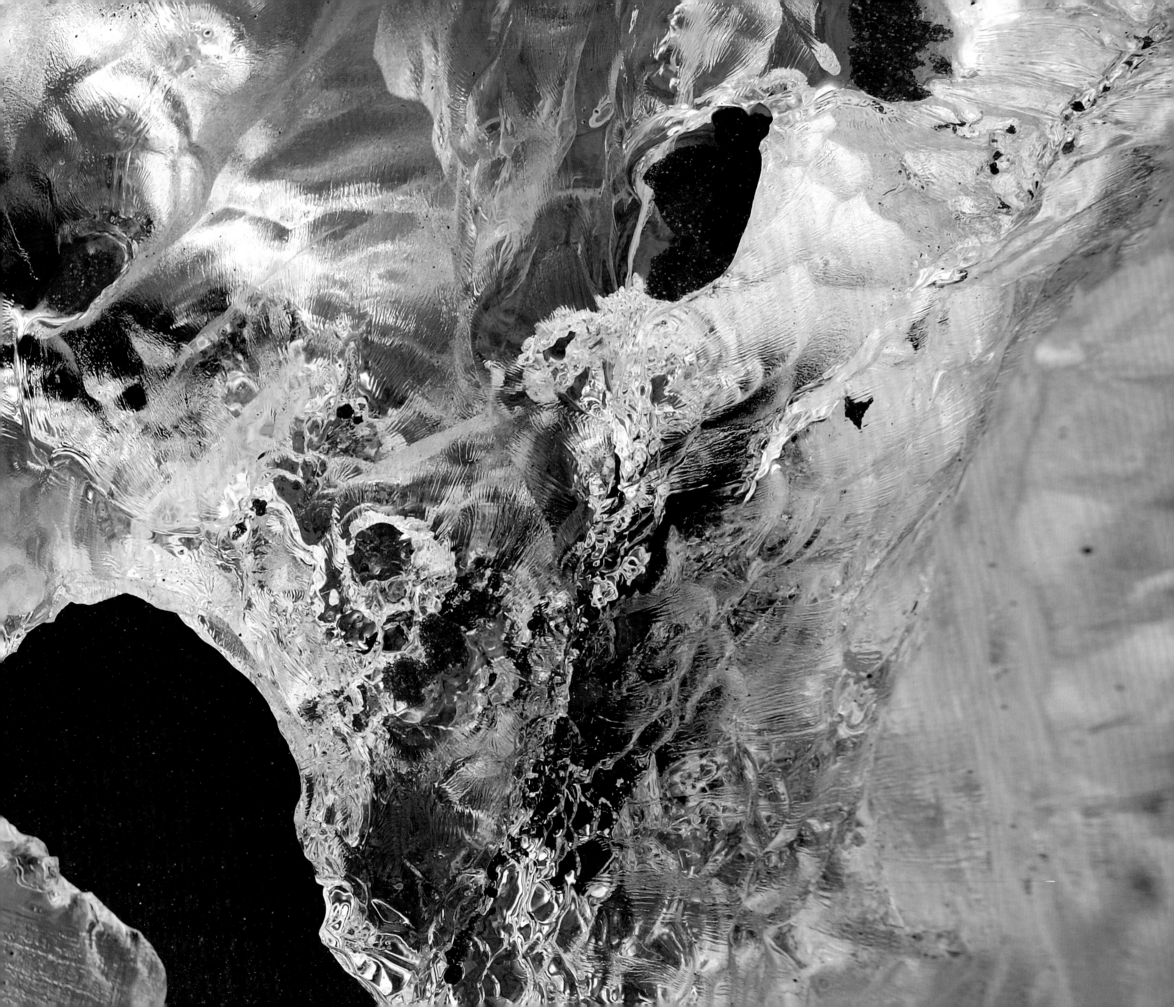

▶ Jökulsárlón │ **Iceland** │ 9 February 2008

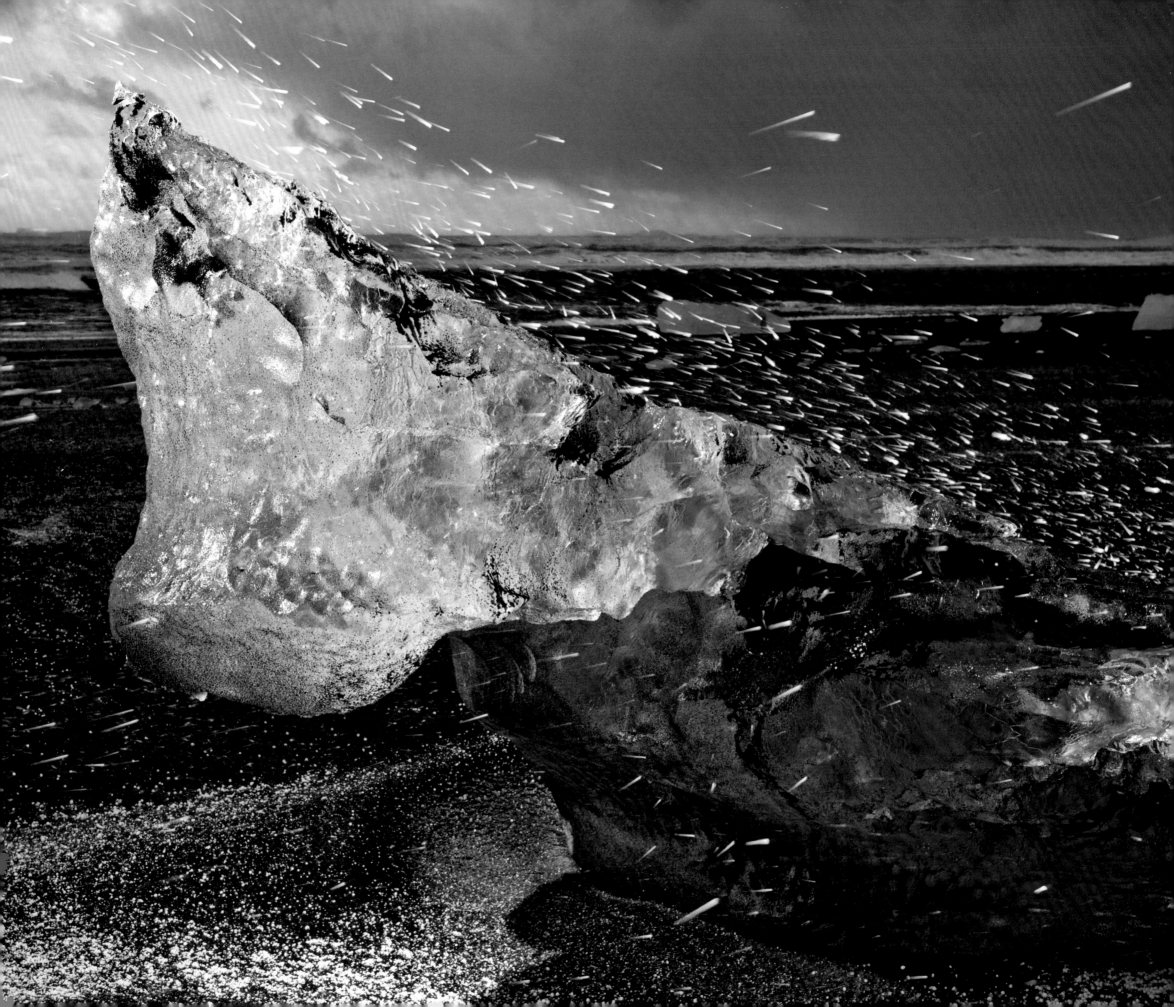

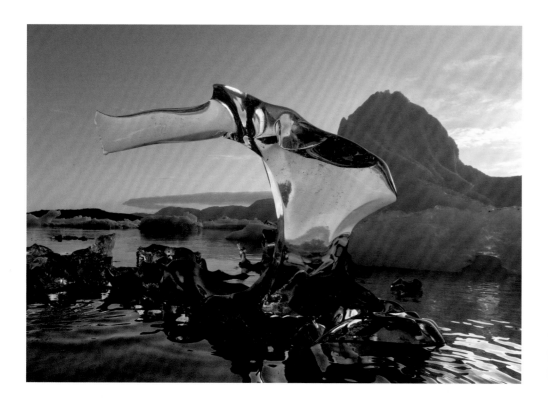

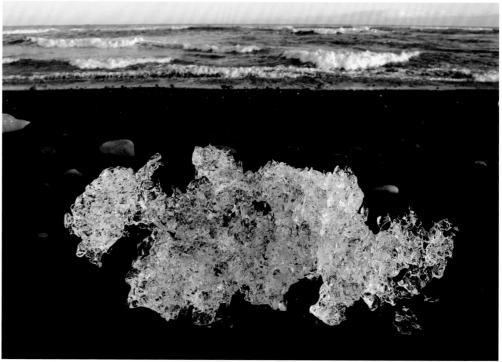

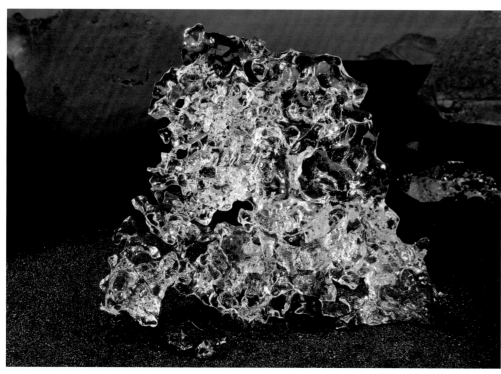

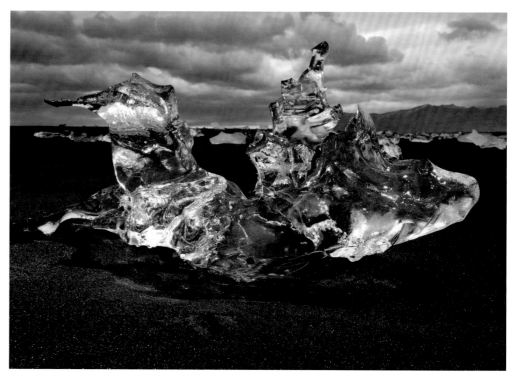

▲ TOP: Columbia Bay | **Alaska, United States** | 20 July 2007

BOTTOM: Jökulsárlón | **Iceland** | 16 June 2011

▲ TOP: Jökulsárlón | **Iceland** | 2 March 2009

BOTTOM: Jökulsárlón | **Iceland** | 17 June 2011

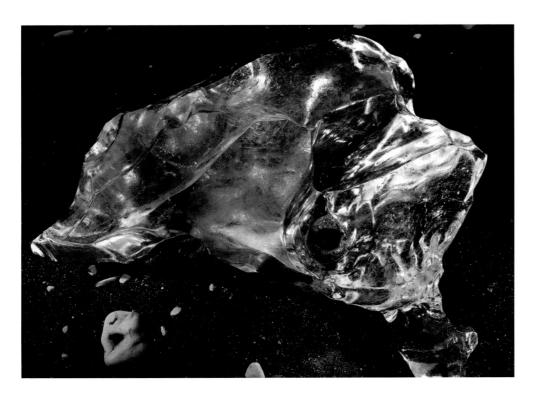

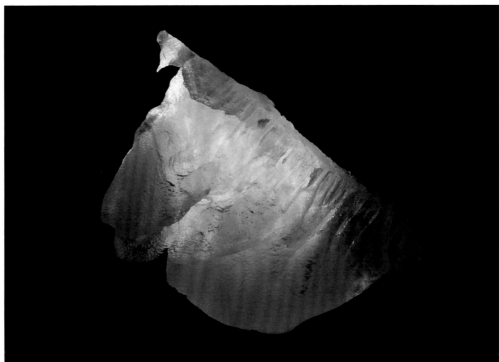

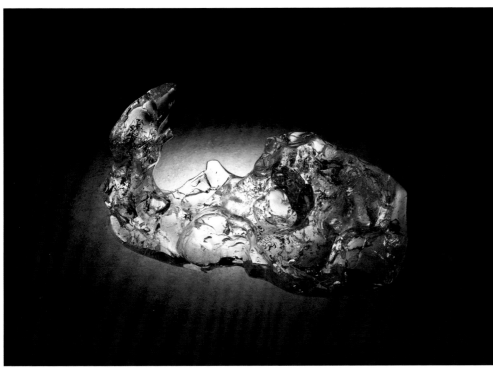

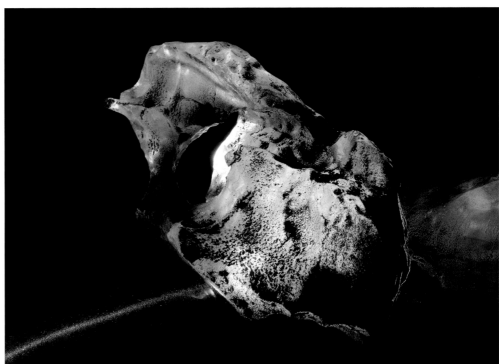

TOP: Jökulsárlón │ **Iceland** │ 17 June 2011

BOTTOM: Jökulsárlón │ **Iceland** │ 10 February 2008

TOP: Jökulsárlón │ **Iceland** │ 7 February 2008

BOTTOM: Jökulsárlón │ **Iceland** │ 9 February 2008

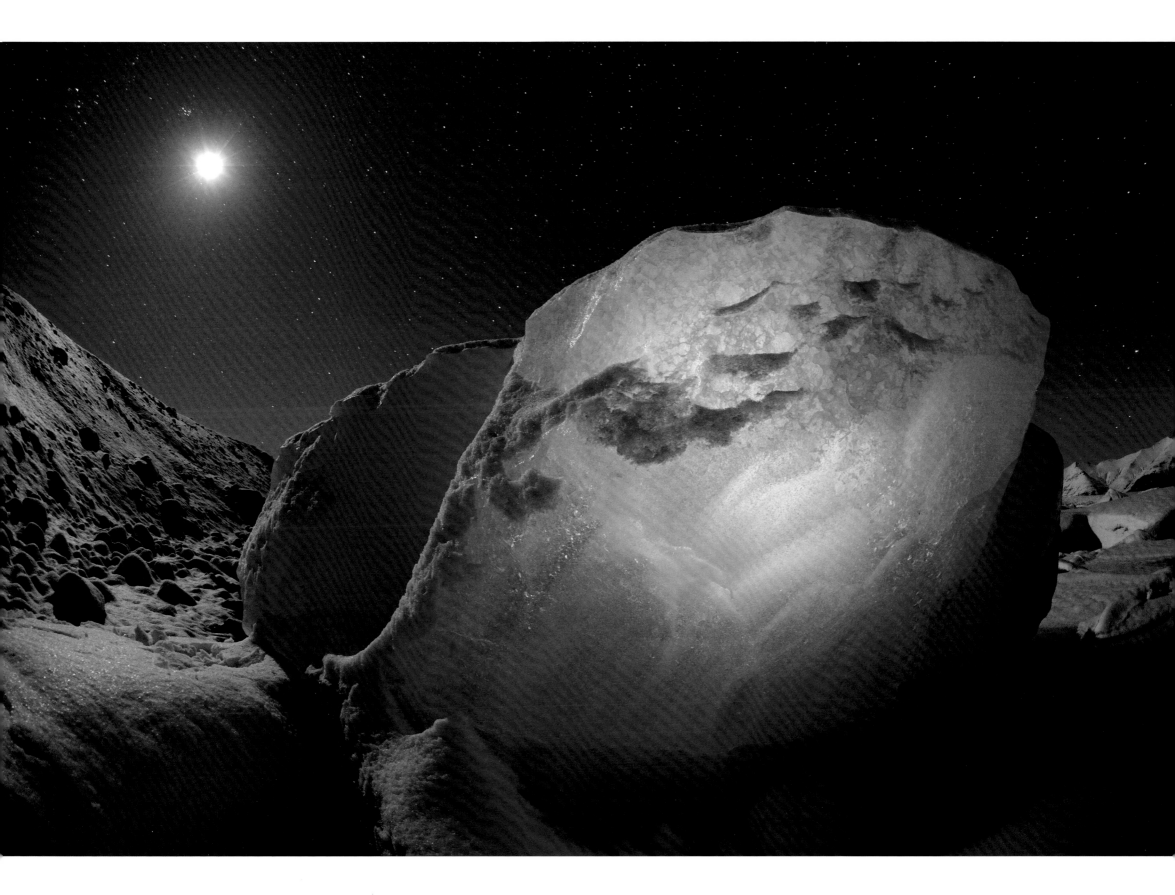

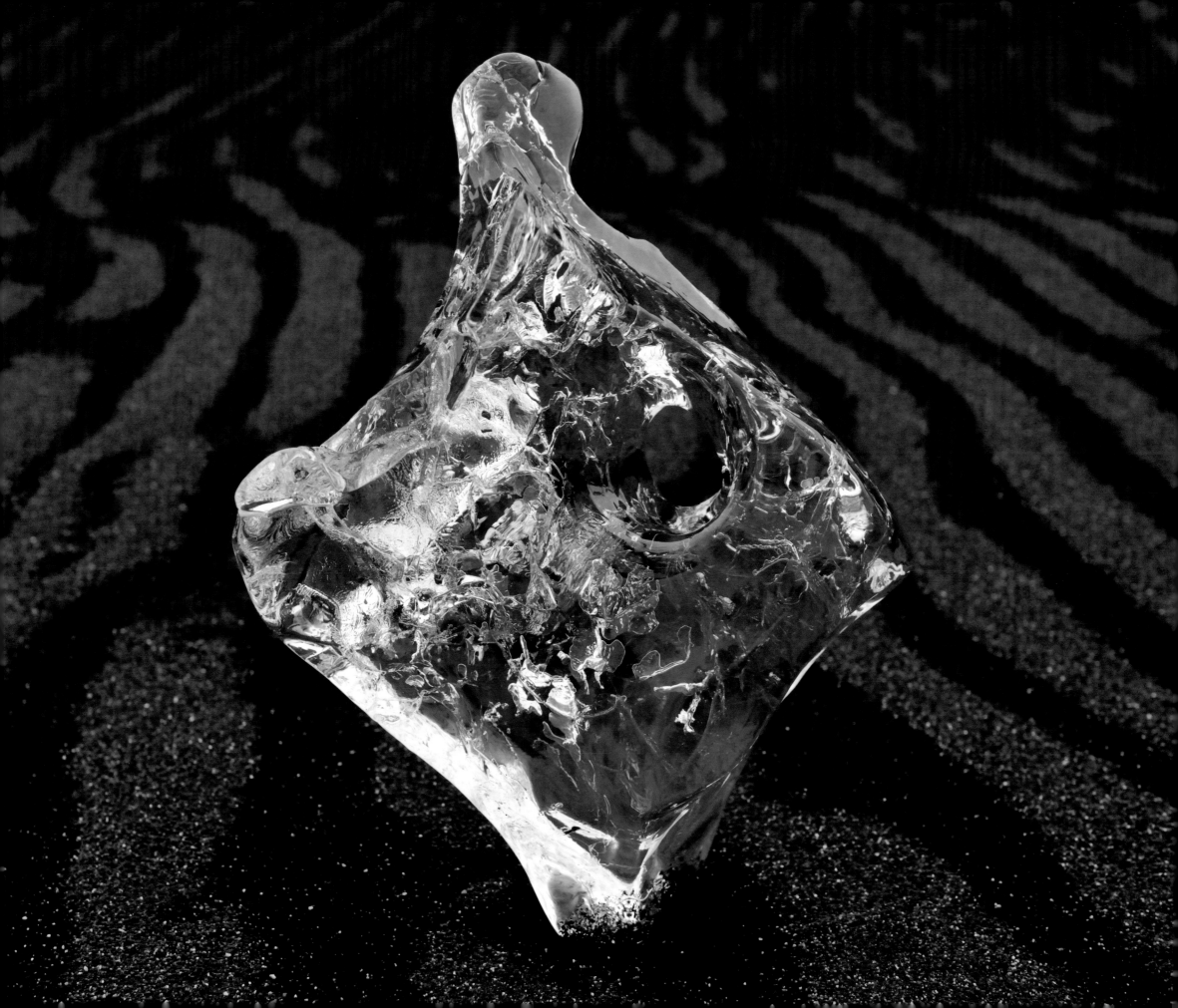

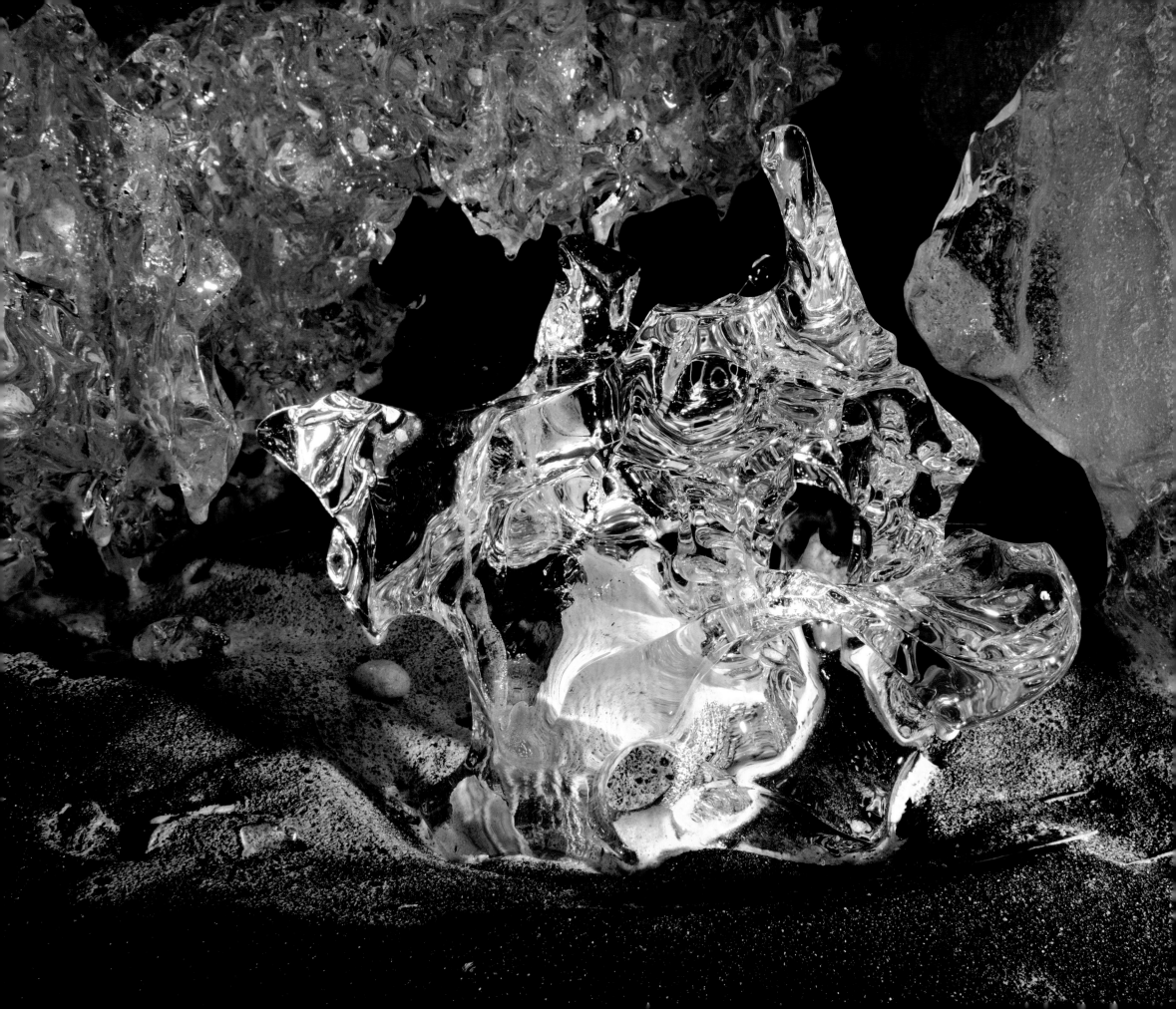

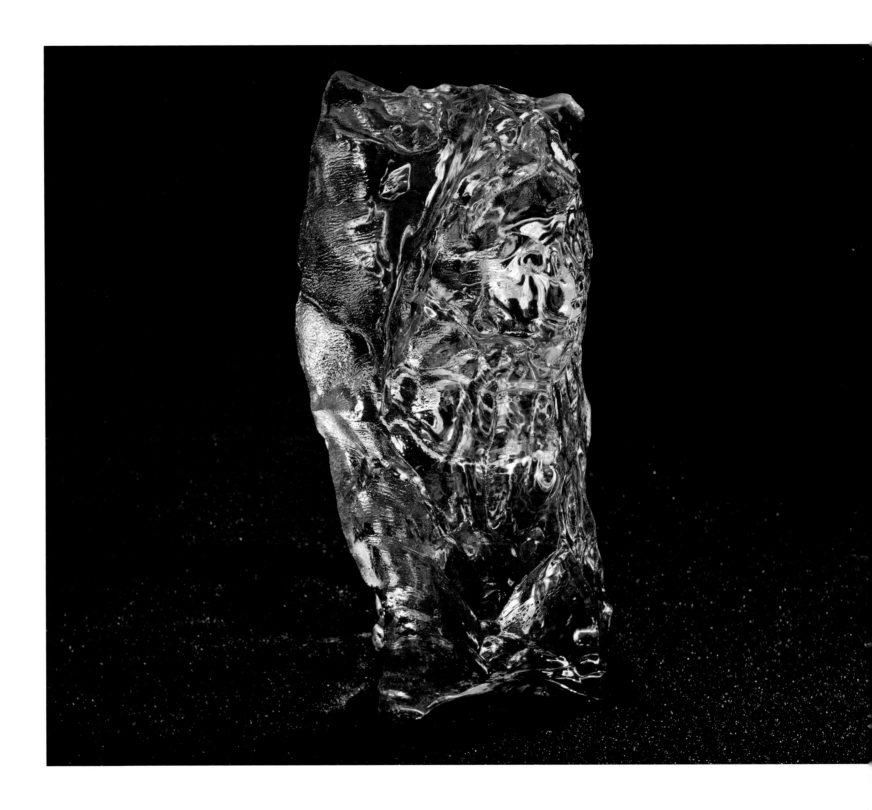

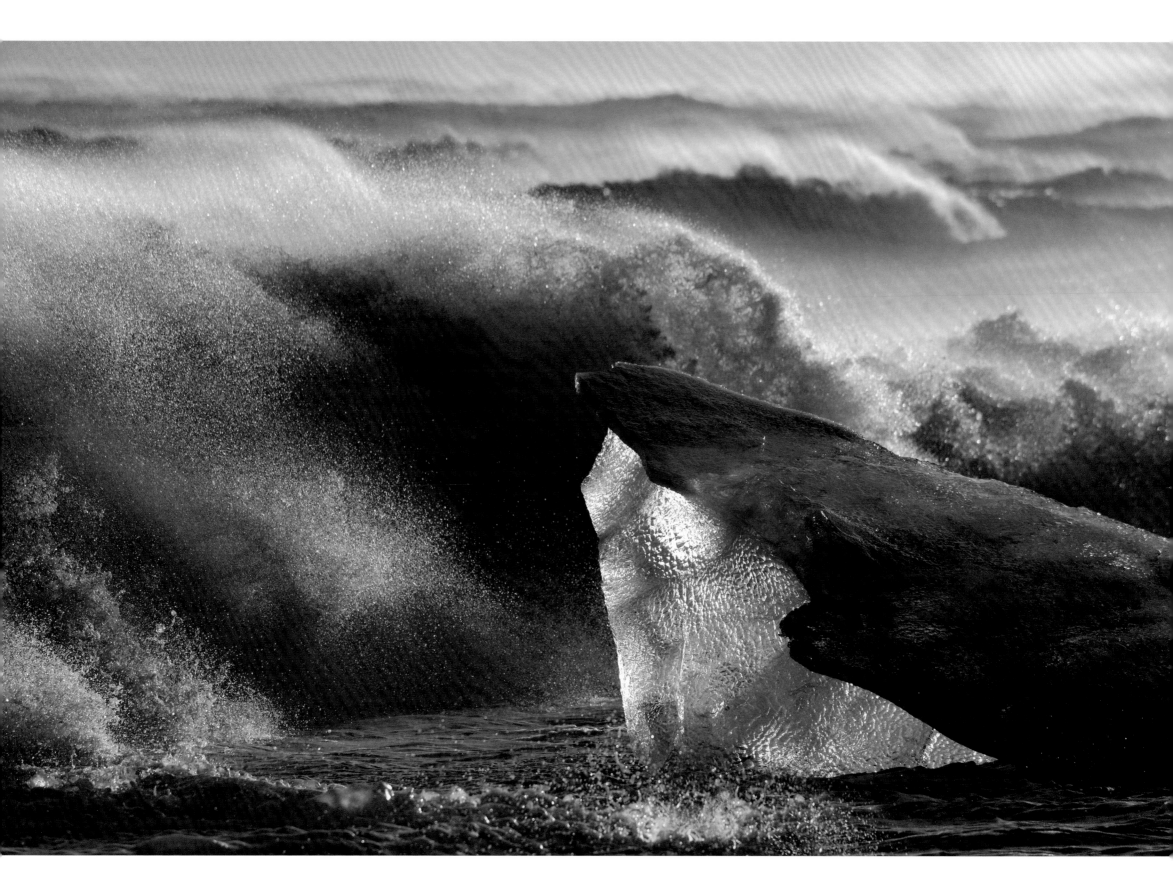

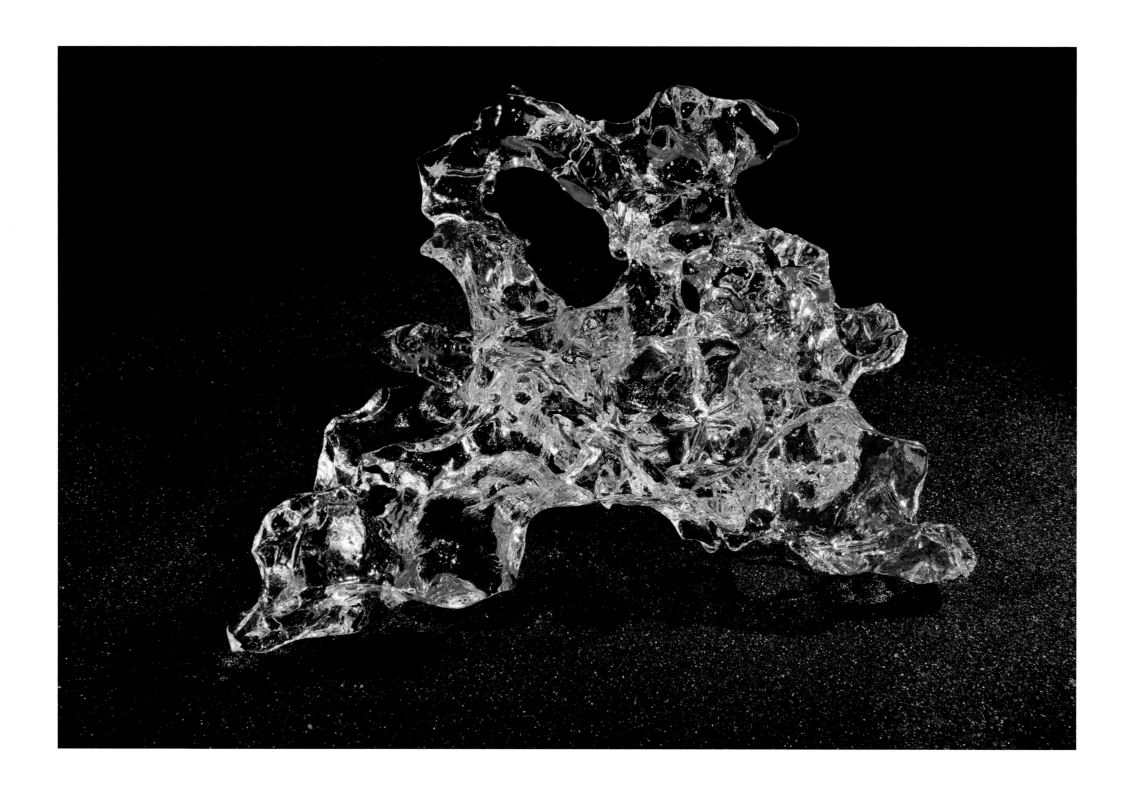

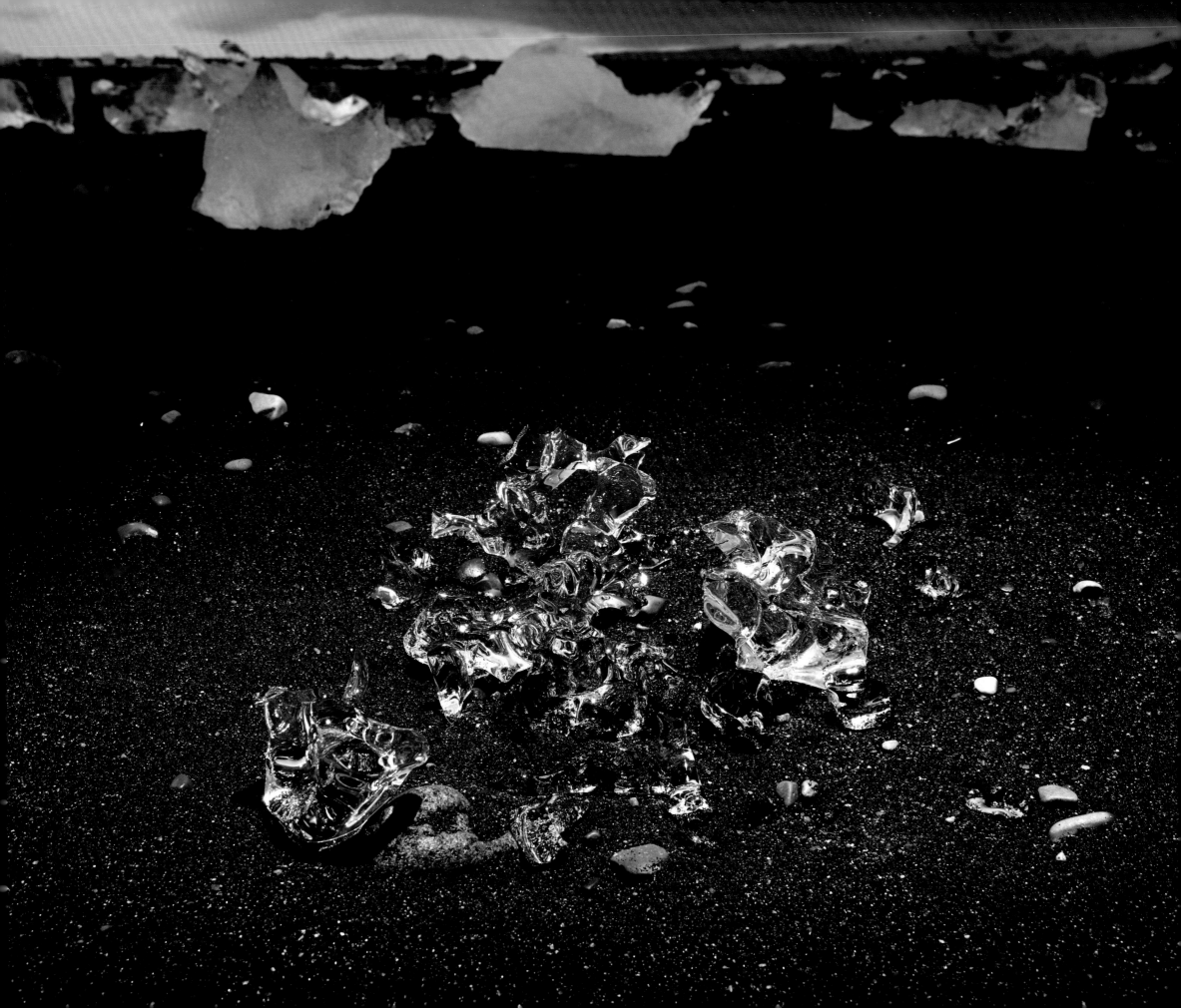

EPILOGUE

BY TERRY TEMPEST WILLIAMS

An Expedition of Beauty

I

Ice holds the history of the world.
The history of the world is melting.
The world is melting as we go about our business.
We go about our business at a speed that makes glaciers cry.
Glaciers cry and retreat—cry and retreat:
It is in their retreat that we may see
How beautiful we have become—
How powerful we have become—
How destructive we have become.

May we now contemplate ice:

Some say the world will end in fire,
Some say in ice.
From what I've tasted of desire
I hold with those who favor fire.
But if it had to perish twice.
I think I know enough of hate
To say that for destruction ice
Is also great
And would suffice.

Robert Frost was a poet with his eyes open.
James Balog is a photographer with his eyes open.
With his eyes open, change is no longer a matter of perception
But of time lapsed on film—the glaciers are crying and retreating—
Retreating much faster than we have ever imagined ice.
Ice holds the history of the world.

The history of the world is melting.

▶ Jökulsárlón | **Iceland** | 10 February 2008

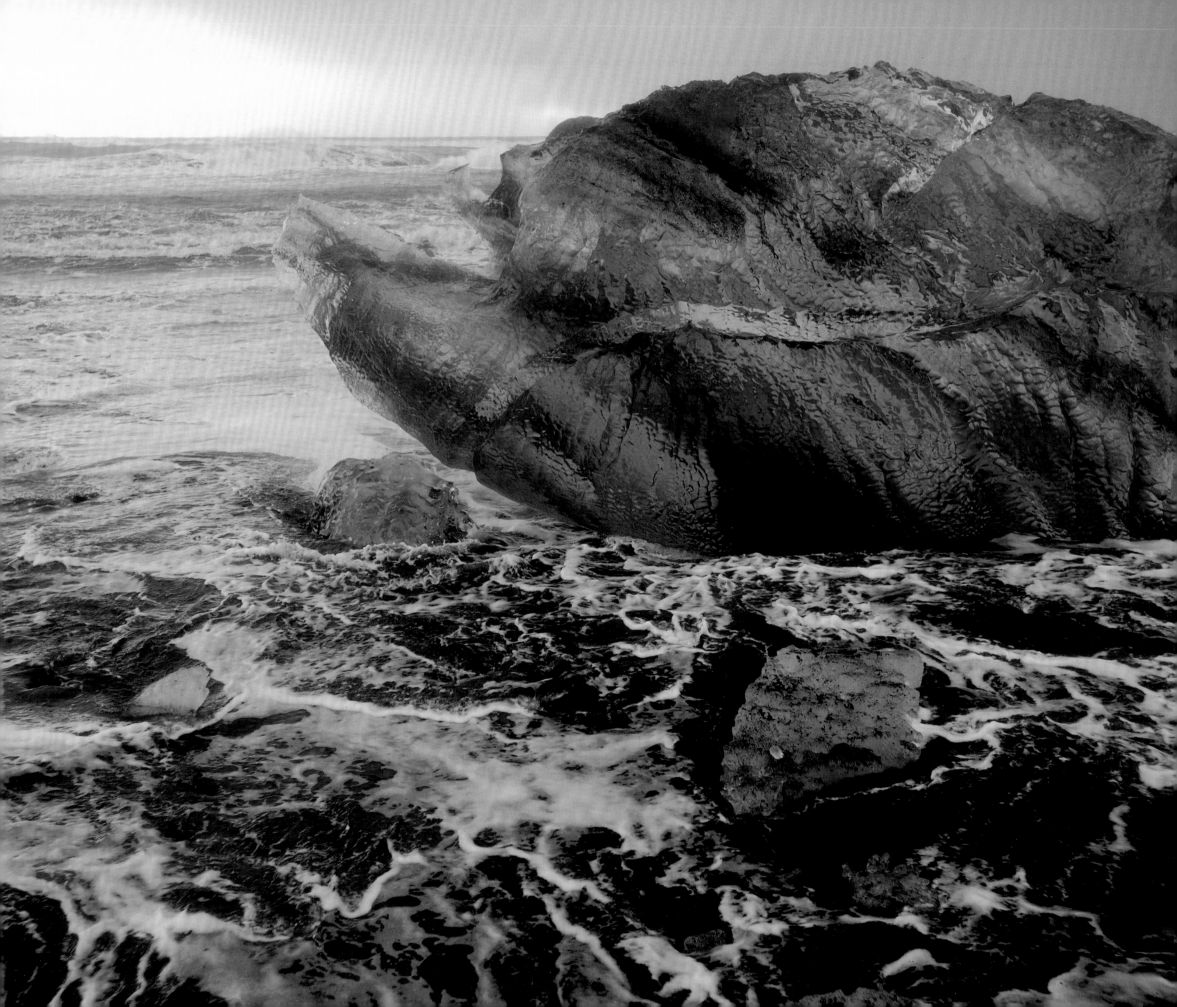

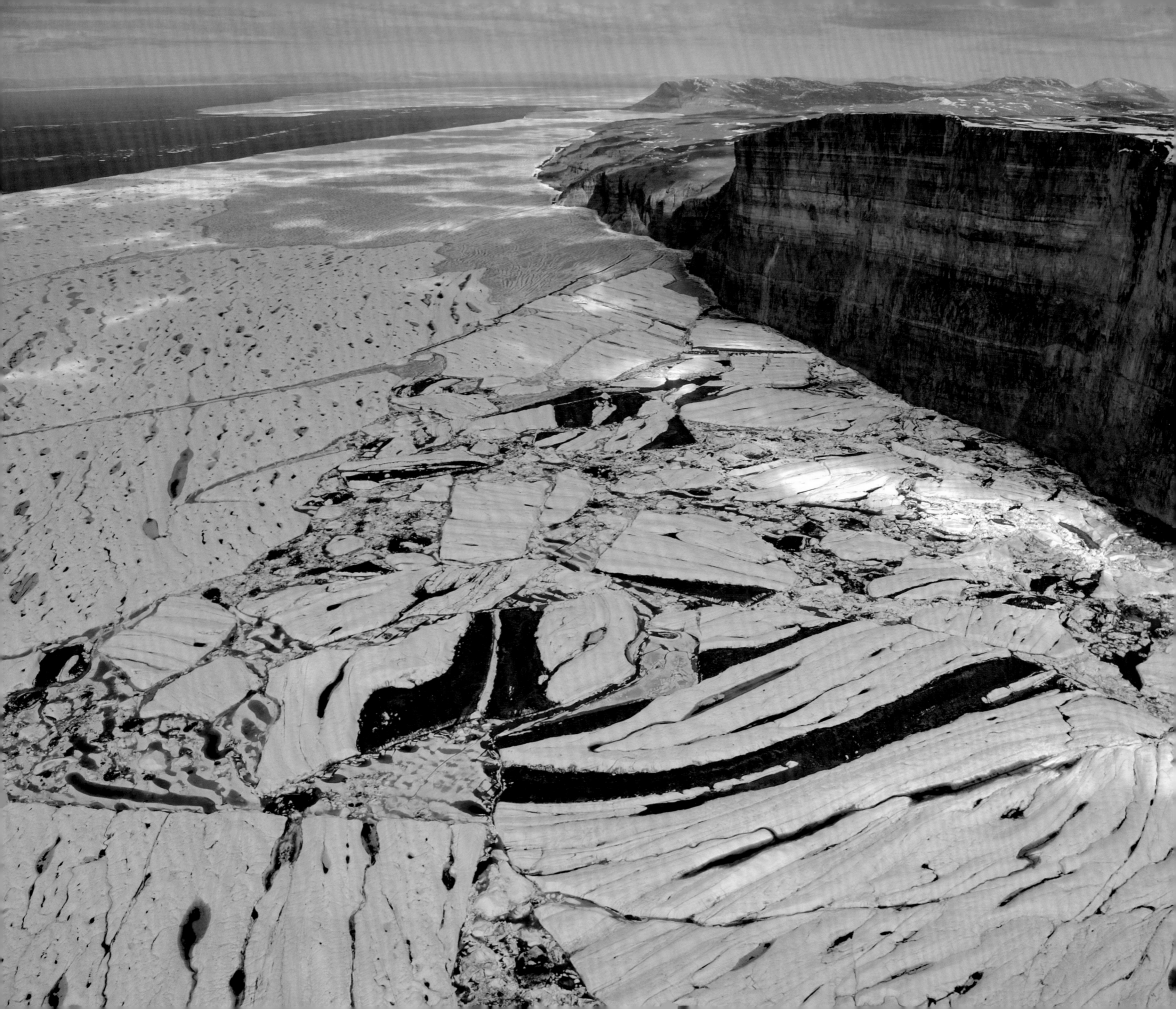

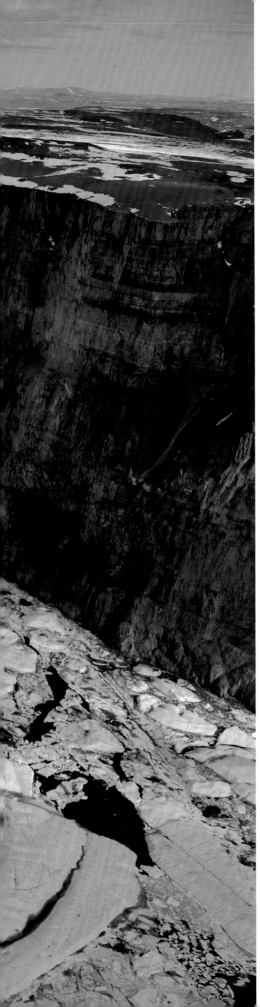

II

There are dark and light bands of ice called ogives
creating waves on the surface of glaciers.
The surface of glaciers is not to be trusted.
Not to be trusted are the ruptures on glaciers
seen as crevasses and then, seen again—

Is this the split within our own consciousness?

Our consciousness can be a dark and illumined place.
A dark and illumined place with turquoise walls of ice
becomes the descent—the descent where
James Balog begins his Expedition of Beauty.
His Expedition of Beauty is the exposure of our denial.
The exposure of our denial is bringing change to the world.

Bringing change to the world is Ice. Bare rock is being born.

Robert Adams says the two qualities
of an artist are urgency and fidelity.
Urgency and fidelity is what James Balog
brings to his Expedition of Beauty.

Beauty is the beginning and end of Ice.

Ice diamonds are shimmering on the planet.
On the planet, ice diamonds are shimmering.

◀ Petermann Glacier │ **Greenland** │ 28 June 2009

III

The world is ice being held by a child.
Being held by a child is what this exploration seeks to protect.
What this exploration seeks to protect is survival.
Survival is the history of the Earth.
The history of the Earth is Ice.
Ice is the history of the world.

The history of the world is melting.

A young artist was asked to make a snow sculpture
of the Titanic for an elementary school in Wyoming.
He said, Why the Titanic and not the Iceberg?
The Iceberg carries a different point of view.
A different point of view was created by the hands of children.
The hands of children sculpted an iceberg and stood in awe.
In awe, the children felt the force of creation instead of the force of a sunken ship.
The force of a sunken ship is no longer a useful truth.
Truth is when we watch a glacier calve and a wall of ice falls into the sea.
The sea swallows the ice. In time, the ice shoots up like a bright summit.
A bright summit floating in the arctic sea is the tip of the iceberg.

The tip of the iceberg is climate change.

Climate change comes with the criminal charge: we must change our lives.
We must change our lives and it begins with our facing the breakup of ice.
The breakup of ice becomes the break up of ignorance.
Ignorance can be measured in the chattermarks of ice.
Ice holds the history of the world.

The history of the world is melting.

▶ Jökulsárlón | **Iceland** | 9 February 2008

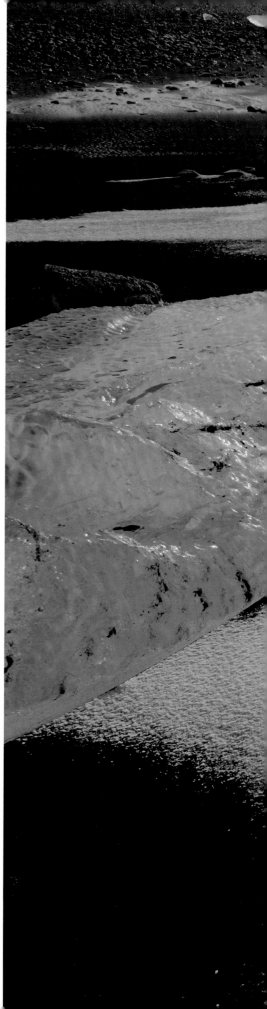

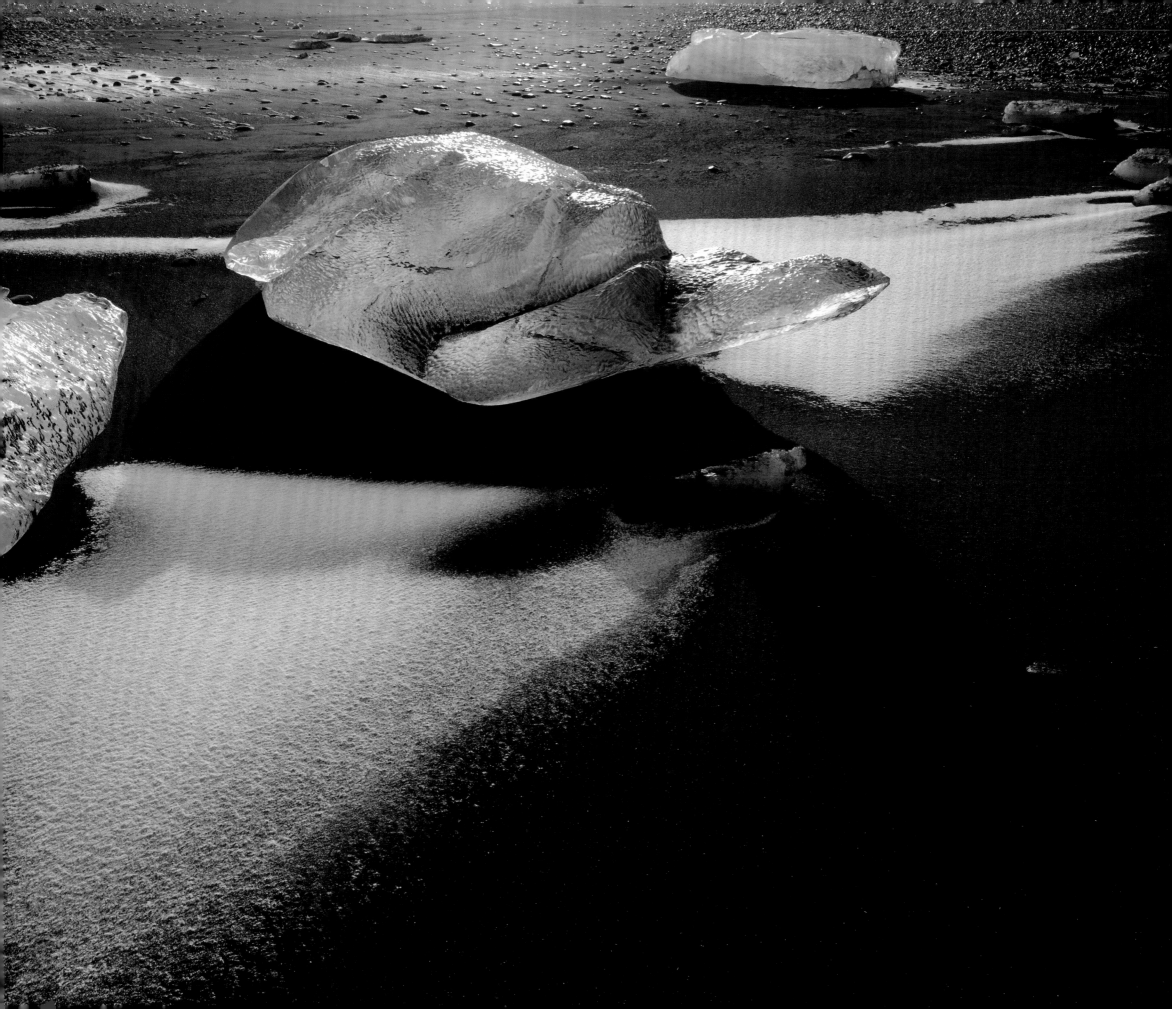

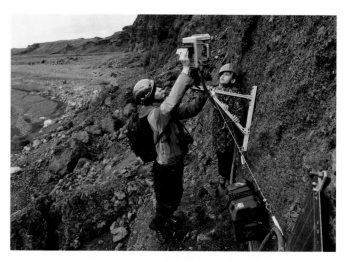
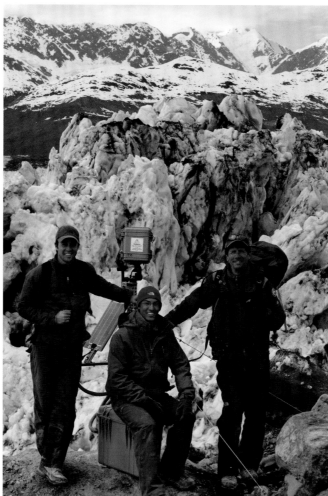
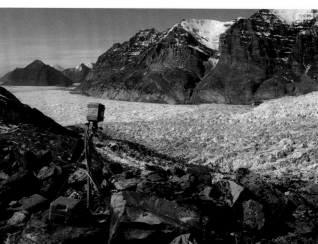
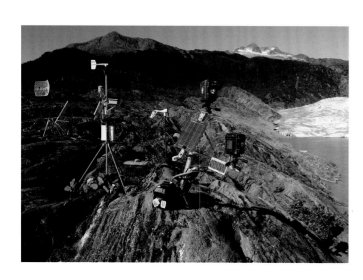
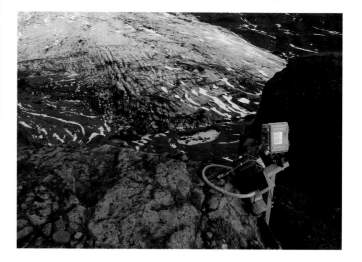

EXTREME
ICE
SURVEY

TOP ROW: Petermann Glacier, Greenland, 24 July 2011; Columbia Glacier, Alaska, United States, 25 August 2009; Svavar Jónatansson and Emily Balog, Iceland, 13 June 2011. | MIDDLE ROW: (L–R) Adam LeWinter, Jeff Orlowski and James Balog at Columbia Glacier, Alaska, United States, 20 June 2008; Umiamako Glacier, Greenland, 11 June 2007. | BOTTOM ROW: Mendenhall Glacier, Alaska, United States, 14 September 2010; Sólheimajökull, Iceland, 26 March 2007.

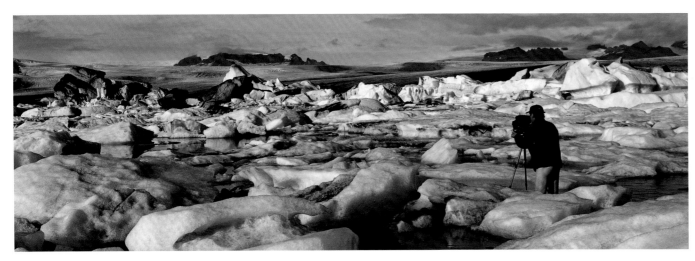

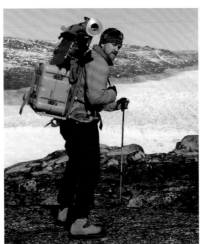

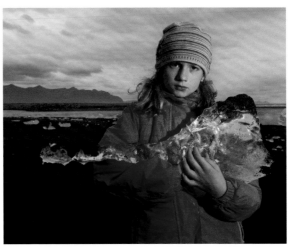

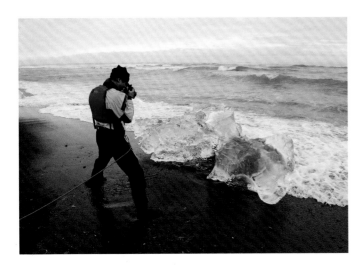

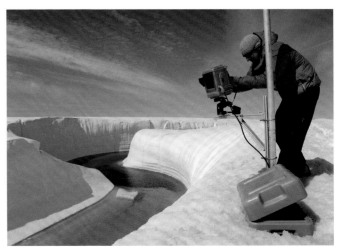

TOP ROW: James Balog at Jökulsárlón, Iceland, 3 October 2006; Dogsled driver, Niels, Greenland, 10 March 2008. | MIDDLE ROW: EIS team hiking to Sólheimajökull, Iceland, 18 March 2007; Jason Box, Greenland, 3 June 2007; Emily Balog at Jökulsárlón, Iceland, 17 June 2011; Svavar Jónatansson on beach by Jokulsarlon, plastered with frozen sea spray, Iceland, 9 February 2008. | BOTTOM ROW: James Balog at Jökulsárlón, Iceland, 24 July 2008; James and daughter Simone Balog, Columbia Glacier, Alaska, United States, 26 August 2009; Adam LeWinter at Birthday Canyon, Greenland, 28 June 2009.

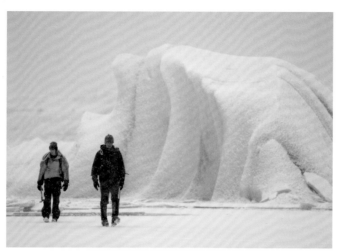
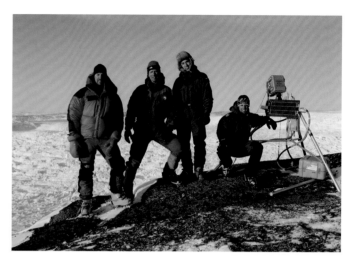

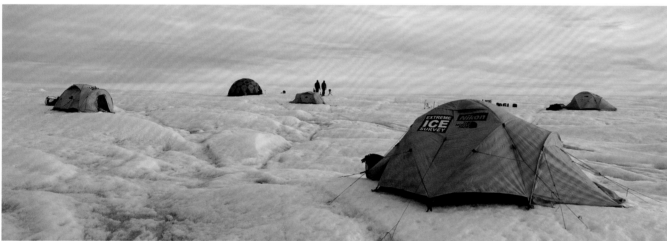

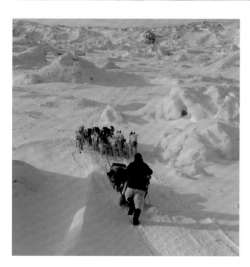
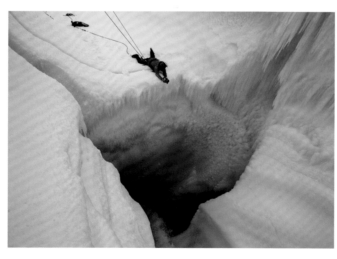

TOP ROW: Michael Brown, Shad O'Neel, Adam LeWinter, Noel Dockstader, Tad Pfeffer and Hans, Alaska, United States, 12 June 2008; Svavar Jónatansson and James Balog, Iceland, 20 March 2007; Michael Brown, James Balog, Jeff Orlowski and Adam LeWinter, Greenland, 11 March 2008. | MIDDLE ROW: EIS camp, Greenland, 29 June 2009; Emily Balog and Svavar Jónatansson, Iceland, 13 June 2011. | BOTTOM ROW: Dogsled driver, Otte, Greenland, 12 March 2008; James Balog, Survey Canyon, Greenland, 1 July 2009; Blake Gordon and Svavar Jónatansson, Iceland, 25 March 2007; Jeff Orlowski, Adam LeWinter, Brooks Fisher and James Balog, Greenland, 4 July 2009.

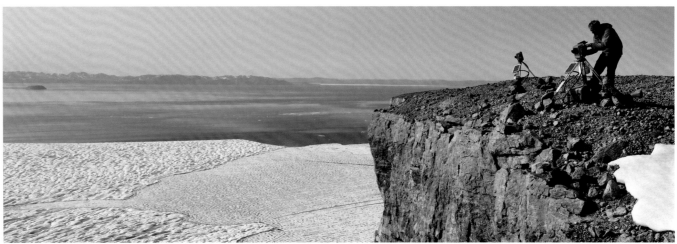

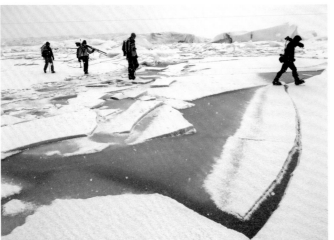

TOP ROW: Adam LeWinter and Jeff Orlowski, Greenland, 1 June 2008; Jason Box, Petermann Glacier, Greenland, 10 July 2009. │ MIDDLE ROW: Jeff Orlowski, Greenland, 30 June 2009; Jökulsárlón, Iceland, 20 March 2007; Simone Balog, Alaska, United States, 25 August 2009; Tad Pfeffer, Alaska, United States, 12 May 2007. │ BOTTOM ROW: Conrad Anker, Nare Glacier, Nepal, 16 May 2010; Cory Richards, Karma Sherpa, Pasang Tenjing Sherpa, Chhewang Sherpa and Adam LeWinter, Nepal, 7 May 2010; James Balog, Mendenhall Glacier, Alaska, United States, 16 September 2010.

AFTERWORD: AIR, ICE AND PEOPLE

AIR AND CLIMATE

▶ We humans are distorting the molecular essence of the air we breathe. This is primarily a consequence of burning fossil fuels like coal, oil and natural gas, then dumping the carbon-rich waste products from that combustion into the air. Other important factors: burning wood and animal waste; cutting and burning tropical forests; and methane emissions from the flatulence of livestock.

▶ Carbon dioxide is the most significant combustion waste product affecting the climate, followed by methane and nitrous oxide. The emissions are commonly called greenhouse gases and their impact is known as the greenhouse effect.

▶ When air contains more carbon pollution, it absorbs more radiation and the air gets warmer. This inescapable fact of nature's basic chemistry has been well understood since the 19th century.

▶ Ice layers in Antarctica have preserved physical evidence of the air's chemistry and temperature over the last 850,000 years. In all that time, the highest concentration of carbon dioxide in the air, created by nature's own processes, was never more than 295 parts per million (ppm). (Figure 1.)

▶ In 2012, our air supply had 394 ppm of carbon dioxide. Currently, we add about 2.5 ppm every year. The rate is increasing.

▶ The average global temperature has increased 1.6° F/0.9° C since 1900 because of pollution from greenhouse gasses. (Figure 2.) Atmospheric warming has been greater over land than over oceans, greater in polar regions than mid- and low-latitudes.

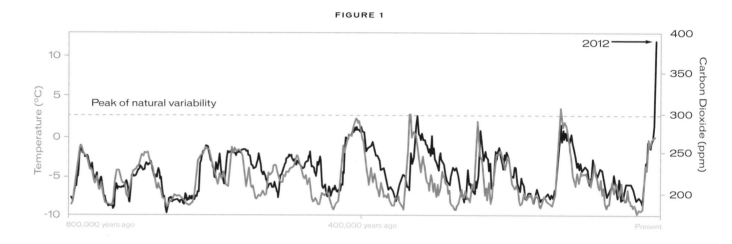

FIGURE 1

Figure 1. Nature isn't natural anymore. CO2 and temperature naturally rise and fall more or less in sync, with CO2 reaching a natural peak of 295 ppm. As of this writing, CO2 is at 394 ppm and rising. (Luthi et al., 2008, *Nature* 453:15)

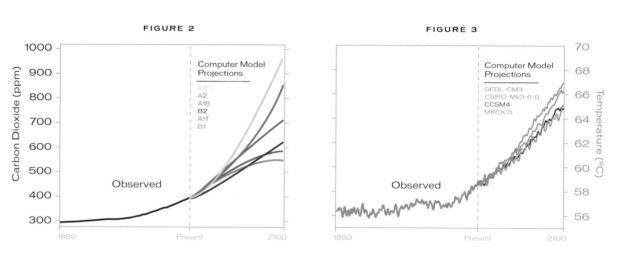

Figures 2 and 3. Greenhouse gasses and temperature have been rising steadily. Reliable computer models show those trends accelerating. They project a future that will be more like dystopian science fiction than the world we live in today. (Figure 2: http://cdiac.ornl.gov/trends/co2/lawdome-data.html; www.esrl.noaa.gov/gmd/ccgg/trends; IPCC, 2007. Figure 3: J. Fasullo, 2012, NCAR, pers. comm.)

- Specific changes:
 - Central and southwest United States: +2–4° F / 1.1–2.2° C since 1975
 - West Greenland: +4.5° F / 2.5° C since 1990
 - Antarctic Peninsula: +4–6° F / 2.2–3.3° C since 1950
- If we do nothing to limit further damage to our air supply, the concentration of pollutants will be 525-650 ppm by mid-century and 550-950 ppm by 2100. (Figure 3.)

ICE

- Glaciers are formed when more snow falls in the winter than melts in the summer.
- Glaciers are excellent gauges of climate because their retreat, growth or stasis reflects regional temperature and precipitation shifts.
- The retreat of glaciers and Arctic Ocean ice pack are the most visible indicators of climate change in the world today.
- Glacier retreat has been documented in the field by hundreds of trained observers from dozens of countries, and from satellite, airborne and ground-based photography (including EIS).
- The vast majority of glaciers in North and South America, Europe, Asia, Africa, New Zealand, the Antarctic Peninsula and West Antarctica are losing ice due to warming temperatures and changes in precipitation. The rate of ice loss has accelerated in recent decades. East Antarctica is stable. Glaciers in the Karakoram Range of south central Asia are slightly gaining mass.

IMPACTS of CLIMATE CHANGE

Climate change is a universal human issue, with health, national security, economic and environmental consequences vital to every person on the planet, now and for generations to come.

Since the invention of agriculture 10,000 years ago, human civilization has prospered within a fixed range of temperature and precipitation variability. Those conditions are disappearing. The cost of adapting to a new "normal" will be enormous. In some cases, adaptation will be impossible.

MILITARY STABILITY: According to official Pentagon studies, climate change accentuates and accelerates geopolitical instability, and will carry significant costs in manpower, money and lives.

WEATHER EXTREMES: As average temperatures go up, extreme temperatures go up. In some regions, warming air means that more moisture is evaporated from land and sea, producing more frequent torrential rains. In other regions, warming air means drought. Damage from storms, hurricanes, floods and drought has increased significantly in recent decades as the climate has changed. High temperature records are broken twice as often as cold records.

ARCTIC SEA ICE: The ice has become thinner. The end-of-summer ice pack now covers 40 percent less area than it did in the early 1980s. This is known from measurements made by U.S. Navy submarines, research and fishing vessels and satellites. By late summer 2020 to 2030, the Arctic Ocean is likely to be ice-free.

OCEAN WARMING: Loss of the ice pack is increasing heat absorption into the Arctic Ocean. This process, called Arctic Amplification, is already disrupting global atmospheric circulation and weather.

SEA LEVEL RISE: When glaciers and ice sheets melt, oceans rise. This will produce at least 1.5 feet of average sea level rise by 2100; 3 feet is possible. The increase could be even greater if major ice loss in Antarctica, which is already underway, accelerates. Gravitational forces cause sea level to be much higher than the global average along some coastlines. Sea level rise will cause 150 million people to be dislocated by 2100. The seas won't stop rising in 2100, but will keep going higher.

OCEAN ACIDIFICATION: Oceans have absorbed approximately half the carbon pollutants dumped into the air by human activity. Without this absorption, the air would contain twice as much greenhouse gas as it does now. Sponging up atmospheric pollutants has made oceans more acidic, which appears to be destroying the marine food chain.

DEPLETION OF FRESHWATER: Water for drinking and agriculture is stored in mountain snowfields and glaciers. Less natural water storage means adapting to less water or building dams.

WILDFIRE: More frequent and more severe wildfires, with a longer fire season, are already the norm in many regions. The impacts have been especially acute in Russia, Canada and the western United States.

UNITED STATES:
- Large land areas in Chesapeake Bay, Florida and the Gulf Coast will be inundated with sea water by the end of this century.
- End-of-season snowpack in the Pacific Northwest has decreased 50 percent since 1950.
- Ice in Glacier National Park, Montana, will disappear by 2040 to 2050; "Glacier-Less National Park" will be a more appropriate name.
- Runoff in the Colorado River basin (Colorado, Utah, Arizona, Nevada), the Sierra Nevada watershed (California) and the Pacific Northwest will be more variable and will be reduced for long periods of time. This will limit water availability for drinking and agriculture.

CANADA: Western Canadian glaciers are retreating rapidly. 2009 marked the most severe British Columbia wildfire season in nearly a century. Between 1958 and 2008, glaciers in the Yukon changed as follows: four advanced, ten were static, 323 vanished and 1065 got smaller; there was a 22% loss of glacier area.

EUROPE: Most glaciers in the Alps will shrink considerably or vanish by 2100.

ASIA: Agriculture and drinking water supplies that originate in high mountains, and are used by 1–2 billion people in Pakistan, India, China and southeast Asia, are undergoing large and unpredictable changes. This may trigger social and political instability. Sea level rise will displace large numbers of people in coastal areas across the continent.

SOUTH AMERICA: Agriculture and drinking water supplies from mountains in Ecuador, Peru, Bolivia and Chile are drying up.

ACKNOWLEDGMENTS

If creativity requires the willpower of individuals, it is also needs the collective energy that swells up from the currents of history, society and culture. Though space constrains my ability to describe in detail how everyone participated, I will do my best to at least mention all the people involved. The success of this book, and the historical record EIS has amassed, belongs to everyone who has touched this project.

With frozen hands and tired backs, the field teams worked tirelessly to install the time-lapse cameras and keep them running. Adam LeWinter worked on nearly all the sites. Jeff Orlowski lent a hand in most of the early deployments. Jason Box has been a key participant in Greenland. Tad Pfeffer, Shad O'Neel and Eran Hood do vital work in Alaska. Svavar Jónatansson keeps watch on our Iceland cameras. Dan Fagre and his U.S. Geological Survey staff monitor Glacier National Park, Montana. Conrad Anker watches over the Mount Everest cameras. Field teams have also included:

▶ **ALASKA** Simone Balog, Roman Dial, Chandler Engel, Dave Finnegan, Nick Korzen and Dave Sauer; helicopter pilots Jan Gunderson, Keith Essex, Marcus Roulet and Andy Wallace; boat captain Kenny Blum; and Laurie Craig of the U.S. Forest Service.

▶ **BOLIVIA** Jose Mamani Quispe and Patricio Crooker.

▶ **BRITISH COLUMBIA/CANADA** Helicopter pilot Reto Glass.

▶ **FRANCE AND SWITZERLAND** Oliver Greber, Didier Lavigne and Luc Moreau.

▶ **GREENLAND** Liam Colgan, Ian Howat, Dan McGrath, Nick Steiner, Marco Tedesco and Slawek Tulaczyk; dogsled drivers Anda, Niels and Otte; and helicopter pilots Martin Nørregaard and Janus Petersen. Special thanks to Brooks Fisher for long, cold belays; Mark Jenkins for an insane kayak trip; Mark Fahnestock and Martin Truffer for allowing us to team up with them at the Ilulissat Glacier; Silver Scivoli for a solid logistics base and a dry basement; and Alun Hubbard for an epic aerial campaign.

▶ **ICELAND** Einar Guðlaugsson, Gulli Guðlaugsson, Ingvar Helgi Kristjánsson, Árni Már Sturluson, Halldór Jónatansson, Jónatan Smári Svavarsson, Sigurður Júlíus Bjarnason and Valdimar Björnsson.

▶ **MONTANA/USA** Michael Aisner, Chris Miller, Kevin Jacks, Erich Peitzsch, Lindsey Bengston and Lisa McKeon.

▶ **NEPAL** Cedar Wright, Cory Richards, Karma Sherpa, Pasang Tenjing Sherpa and Chhewang Sherpa.

Corey Jaskolski's breakthrough innovations on time-lapse inter-valometers have been crucial. Suzanne Balog, Alberto Behar, Eric Eisen, Rollo Garabotti, Blake Gordon, Neil Humphries, Brad Kahland, Matt Vellone and Nick Weinstock played important roles in time-lapse camera design and construction. And Emily Balog must have been the only five-year-old in America who knew what a turnbuckle was.

DigitalGlobe, courtesy of Chuck Herring, Walter Scott and Amy Opperman, provided stunning high-resolution satellite images. Konrad Steffen and James W. White of the University of Colorado have provided wise counsel and steady friendship. Many other scientists have helped keep us on the right path: Yushin Ahn, Roger Barry, Robert Bindschandler, Helgi Bjornsson, John Clague, Sarah Das, Mark Fahnestock, John Fasullo, Andrew Fountain, Bernard Francou, Ian Joughin, Brian Menounos, Dan Moore, Meredith Nettles, Eric Rignot, Martin Sharp, Oddur Sigurðsson, Slawek Tulaczyk, Martin Truffer, Isabella Vellicogna and Christian Vincent.

Holding down the fort in Boulder, Colorado, is our long-time operations manager, Sport. Terri Cook, Maya Burlingame, Eva Rendle, Renee Thompson, Max Yaron, Vida Clifton and Rich Walker have also performed various administrative tasks. Michael Aisner gave invaluable help in so many ways, not the least of which was introducing me to Jeff Orlowski and Adam LeWinter. Editing a million time-lapse frames into watchable sequences is a crushing task: Jeff Orlowski and Danny Goldhaber originally handled it, with Matthew Kennedy taking over in 2009. Early in EIS, video work was performed by David Breashears, Michael Brown, Noel Dockstader, Jeff Orlowski, Ben Phelan and Dave Ruddick. After he left the EIS operational team, Jeff Orlowski produced the award-winning film, *Chasing Ice*, fueled by his own independent willpower, funding and partners; the list of film collaborators is too long for this page, but key participants included Paula DuPré Pesmen, Jerry Aronson, Davis Coombe, J. Ralph, Milkhaus and Skywalker Sound.

EIS came into being because of what I saw in the field during a 2006 *National Geographic* assignment (published in 2007 as "The Big Thaw"). The story was the brainchild of Dennis Dimick, Chris Johns and David Griffin, as was a 2010 project on Greenland, in which Kurt Mutchler played a key role. Major funding early in EIS came from the National Geographic

Society's Expeditions Council, led by John Francis and Rebecca Martin. Many others at the society played important roles: John Bredar, Marianne Culpepper, Nancy Donnelly, Terry Garcia, Tim Kelly, Victoria Kirker and Greg McGruder. In 2005, Elisabeth Biondi and *The New Yorker* helped turn my long-time creative interest in ice into a study of climate change.

Richard Goldman, who passed away in 2010 at the age of 90, supported EIS at a pivotal stage. The commitment that he and his wife Rhoda had long shown toward American environmental concerns has few parallels. Nikon USA has been a key ally too, donating many dozens of their remarkably bomb-proof D200 camera bodies and lenses; a big thanks to Bill Pekala, Melissa DiBartolo and Joe Ventura. Vance Martin and the Wild Foundation provided a fiscal relationship without which we could not have functioned. Equally vital to the progression of EIS was having Teresa Heinz and The Heinz Foundation bestow one of the 16th Annual Heinz Awards on EIS in 2010. Through the steady support of the Compton Foundation—Rebecca DiDomenico, Edith Eddy, Ellen Friedman, Martin Goebel, Stephen Perry and Jennifer Sokolove—a lot has been accomplished. Much gratitude goes to The North Face—Todd Spoletto, Aaron Carpenter, Letitia Webster, Katie Ramage, Ann Krcik and Adam Mott—for superb mountain gear.

Other partners—all of them friends and dearly appreciated allies—include: Annie Griffiths Belt, Brook and Shawn Byers, Yogin and Peggy Dalal, Jesse and Betsy Fink, Brooks Fisher and the extended Fisher family, Bill and Mary Head, Susie and Eliot Hulet, the Hillman family, Ginny Jordan, Bob and Gail Loveman, Teresa Luchsinger, Janis Mendelsohn, Gib and Susan Myers, NASA (Tom Wagner, Waleed Abdalati, Ming-Ying Wei, Winnie Humberson and Maurice Henderson), the Simonds family, Martin Sommerkorn of the WWF International Arctic Programme, Georgia Welles, Peter Welles and Galen Weston. The cameras live inside waterproof boxes by Pelican Products (Michelle Kerkvoorde), which in turn are supported by tripod heads from Manfrotto (Kris Brunngraber). National Science Foundation grants OPP 0741610 and 0732726 to Tad Pfeffer helped with Alaska fieldwork.

Colorado Governor John Hickenlooper, Sylvia Earle, Jane Goodall and Jane Lubchenco (director of NOAA) provided warm words of encouragement at just the right times. The Balog family—James, Alvina, Michael and Stephen—were cheerleaders for EIS; my parents deserve a special thanks for believing in all my Anthropocene photo projects before this one. Many other friends of EIS have helped in various ways: Aspen Institute (Walter Isaacson, Eliot Gerson, David Monsma and Kitty Boone), Hugh Bollinger, John Calderazzo, SueEllen Campbell, Rich Clarkson, Kim Day, Esther Gray, David Holbrooke of Telluride Mountainfilm, Charlie Knowles of Wildlife Conservation Network, Sven Lindblad of Lindblad Expeditions, Bill McKibben, Cristina Mittermeier and the International League of Conservation Photographers, Bob Morehouse at Vermilion Design, Louis Psihoyos, Corey Rich and Frans Lanting of the Rowell Award for the Art of Adventure, Diane Rosenthal, Michael Shnayerson, Bill Shutkin, Robert Socolow and Diane Stern. A special thanks to our dear supporter Dan Friedlander, who is critically ill as this book goes to press.

This book never would have happened without the persistence of James Muschett at Rizzoli International Publications and Charles Meiers, Rizzoli's president. Melissa Veronesi cheerfully guided the production. Susi Oberhelman did an amazing job with graphic design. The eloquence of Terry Tempest Williams, both on the printed page and in person, has been a delight. John Rasmus provided wise counsel on the texts.

EIS has imposed considerable stress on all the families involved: long absences, financial strain and physical danger are burdens no sensible person would embrace. Yet love and good cheer came our way. For that, we profusely thank all our family members, particularly Klara Box, Timi Montoya, Ann Pfeffer, Emma Templeton and Regula Steffen (who passed away in 2011). My wife Suzanne and my daughters Simone and Emily are the absolutely vital foundation on which EIS is built; my family is the hearth to which this Odysseus happily returns after innumerable absences. For their cheerful, patient support I give my deepest gratitude.

Vanishing ice and accelerating climate change isn't just an issue for our time—or even, as others have said, for the seventh generation to come. It's an issue for the people of uncountable generations. To imagine what the temperature on this planet will be like in a hundred years, with atmospheric carbon dioxide at more than 600 ppm if business as usual continues, is the stuff of a sci-fi nightmare. In the hope that the vision we provide will lead to a more sustainable world for everyone, we dedicate the Extreme Ice Survey.

James Balog | Boulder, Colorado | May 2012

SOURCES

A vast archive written by knowledgeable professionals documents the facts about ice, climate change and people. This entire book could be occupied by a bibliography, but we direct interested readers to key websites and publications:

Cuffey, K.M. and Paterson, W.S.B. *The Physics of Glaciers*. Burlington (MA): Elsevier, 2010.

Geophysical Research Letters: http://www.agu.org/journals/gl/

"Global Climate Change Impacts in the United States," Sue Hassol: http://www.globalchange.gov/usimpacts

"Trends and Implications of Climate Change for National and International Security," U.S. Department of Defense, Defense Science Board, October 2011: http://www.acq.osd.mil/dsb/reports/ADA552760.pdf

MunichRe – Climate Change: http://www.munichre.com/en/group/focus/climate_change/default.aspx

NASA-Global Climate Change: http://climate.nasa.gov/

Nature: http://www.nature.com/

NCAR-Climate Change: http://ncar.ucar.edu/learn-more-about/climate

NOAA: http://www.noaa.gov/

NSIDC: http://nsidc.org/

Science: http://www.sciencemag.org/

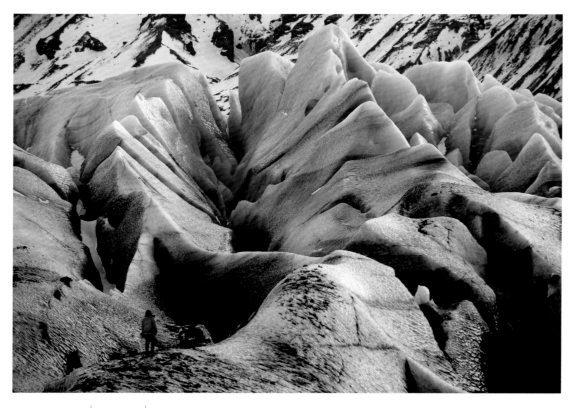

Svínafellsjökull | **Iceland** | 7 October 2008

First published in the United States of America in 2012
by Rizzoli International Publications, Inc.
300 Park Avenue South
New York, NY 10010
www.rizzoliusa.com

© 2012 James Balog
Produced in collaboration with Earth Vision Trust.

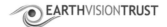

Epilogue © 2012 Terry Tempest Williams

All photos by James Balog except:

Jason Box: pp. 4–5, 68–69, 276, 283 (top right)
Patricio Crooker: p. 99 (bottom)
Blake Gordon: p. 282 (top middle)
Alun Hubbard: pp. 216–217, 280 (top left)
Svavar Jónatansson: p. 281 (top left and bottom left)
Adam LeWinter: pp. 20–21, 281 (bottom middle), 282 (bottom 2nd from left), 283 (bottom left and bottom middle)
Jeff Orlowski: pp. 99 (middle), 281 (middle left), 283 (top left)
Tad Pfeffer: p. 56
Kevin G. Smith: p. 283 (bottom row right)
Konrad Steffen: p. 40, 41

Satellite images provided by DigitalGlobe: pp. 57, 84–85, 172, 173

Endpaper map by James Daley

Epilogue poem: "Fire and Ice" by Robert Frost from *Harper's* Magazine, December 1920

Project Editor: Melissa Veronesi
Book Design: Susi Oberhelman

ISBN: 978-0-8478-3886-8
Library of Congress Catalog Control Number: 2012931974

2012 2013 2014 2015 / 10 9 8 7 6 5 4 3 2 1

Printed in China

FSC

MIX
Paper from
responsible sources

FSC® C104723